From Cubism to *Guernica*

The A. W. Mellon Lectures in the Fine Arts

BOLLINGEN SERIES XXXV: 58

PICASSO AND TRUTH

T. J. Clark

National Gallery of Art, Washington

PRINCETON UNIVERSITY PRESS
Princeton & Oxford

Requests for permission to reproduce material from this work should be sent to Permissions, Princeton University Press

Published by Princeton University Press, 41 William Street, Princeton, New Jersey 08540

In the United Kingdom: Princeton University Press, 6 Oxford Street, Woodstock, Oxfordshire OX20 1TW

press.princeton.edu

JACKET ART AND FRONTISPIECE: Pablo Picasso, detail of *Guitar and Mandolin on a Table (Still Life in front of a Window)*, Juan-les-Pins, 1924. Oil with sand on canvas, 140.7 × 200.3 cm. Solomon R. Guggenheim Museum, New York. 53.1358. © 2013 Estate of Pablo Picasso / Artists Rights Society (ARS), New York.

CHAPTER-OPENING IMAGES: page 1, *Nude, Green Leaves, and Bust*, 1932 (detail); page 23, *The Blue Room*, 1901 (detail); page 59, *Bread and Fruit Dish*, 1908–9 (detail); page 111, *The Three Dancers*, 1925 (detail); page 147, *The Studio*, 1928–29 (detail); page 191, *Woman Throwing a Stone*, 1931 (detail); page 235, *Guernica*, 1937 (detail).

Library of Congress Cataloging-in-Publication Data
 Clark, T. J. (Timothy J.)
 Picasso and truth : from cubism to Guernica / T.J. Clark.
 pages cm.— (The A.W. Mellon lectures in the fine arts ; 58)
(Bollingen series ; 35:58)
 Includes bibliographical references and index.
 ISBN 978-0-691-15741-2 (hardcover : alk. paper) 1. Picasso, Pablo,
 1881-1973—Criticism and interpretation. I. Title.
 N6853.P5C595 2013
709.2—dc23 2012039423

This is the fifty-eighth volume of the A. W. Mellon Lectures in the Fine Arts, which are delivered annually at the National Gallery of Art, Washington. The volumes of lectures constitute Number XXXV in Bollingen Series, sponsored by the Bollingen Foundation.

British Library Cataloging-in-Publication Data is available

This book has been composed in ScalaOT and Swiss 721

Printed on acid-free paper

Printed in Italy

10 9 8 7 6 5 4 3 2 1

Contents

PICASSO AND TRUTH

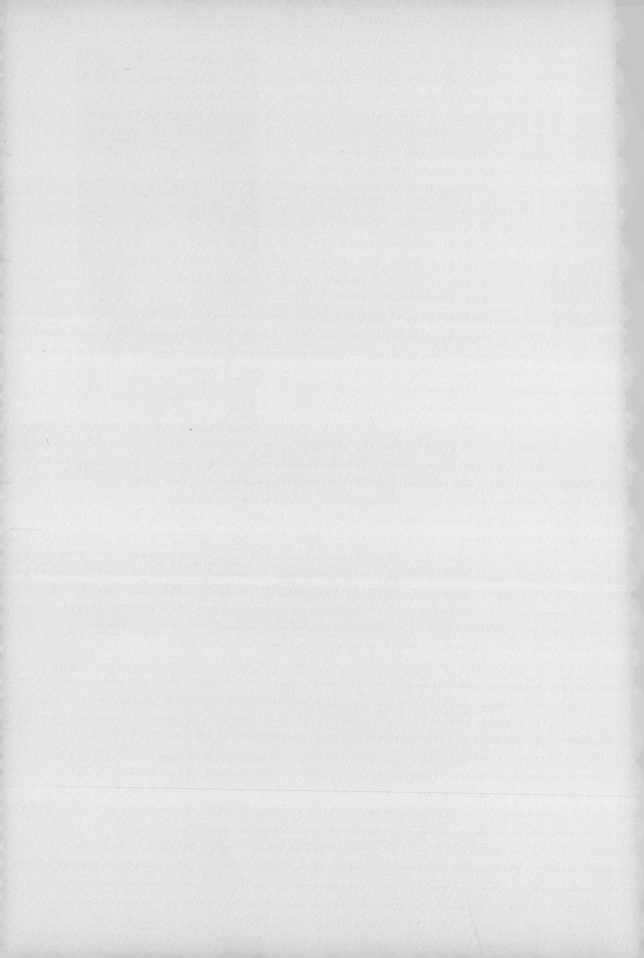

Pound, Parker, Picasso.

To Philip Larkin's list of twentieth-century destroyers—those who had tried to rob him of the joys of Sydney Bechet and the consolations of Thomas Hardy—I would want to add only Jackson Pollock, and perhaps, breaking with alliteration, Samuel Beckett. But I am not sure (any more than Larkin was) what making the list is meant to do. It cannot be exorcism: even Larkin in his "Who is Jorge Luis Borges?" mood never imagined his villains' achievements were reversible. In his *Oxford Book of Twentieth-Century English Verse*, he reprinted Basil Bunting's poem "On the Fly-Leaf of Pound's Cantos," with its picture of Pound's horrible energy and its verdict on Pound's nonreaders:

> There are the Alps. What is there to say about them?
> They don't make sense. Fatal glaciers, crags cranks climb,
> jumbled boulder and weed, pasture and boulder, scree
>
>
>
> There they are, you will have to go a long way round
> if you want to avoid them.
> It takes some getting used to. There are the Alps,
> fools! Sit down and wait for them to crumble!

Larkin, I think, had given up waiting. He knew his poetry was a thing of the past. Poetry as he understood it—art as he understood it—had been

destroyed by certain artists between 1907 and 1949. Of course, the de-struction had called forth a tremendous, reparative countermovement from within modernism itself: Stevens and Eliot, Proust and Lawrence, late Schoenberg and Bartok, Matisse and Bonnard and Mies van der Rohe. But that was something Larkin on the whole chose not to see.

The point of his and my lists—this is my best shot—is to keep a kind of resentment at modernism alive, in order to keep modernism alive. Modernism—the high art of Europe and the United States in the twenti-eth century—could have been otherwise. It ought to have been otherwise. And this is not a judgment brought to the period's masterpieces from outside (from a before or after that Larkin sometimes pretended he could speak for) but the judgment of the masterpieces on themselves. They are what preserves the tragic experience summed up, and conjured away, by the blank term "modernity," and therefore what goes on telling us how much modernity's aesthetic—its discord, its senselessness, its destruc-tion of difference, its self-congratulatory "Less is more"—is to be regretted at the same time as it is fed on. Toujours à respirer si nous en périssons.

■ ■ ■

Anyone adding a book on Picasso to the thousands we have owes his read-ers an explanation. Mine will be a little roundabout. There must be a rea-son, I feel—a historical reason—for the abominable character of most writing on the artist. Its prurience, its pedantry, the wild swings between (or unknowing coexistence of) fawning adulation and false refusal-to-be-impressed, the idiot X-equals-Y biography, the rehearsal of the same few banal pronouncements from the artist himself; the pretend-moralism, the pretend-feminism, the pretend-intimacy ("I remember one evening in Mougins . . ."); and above all the determination to say nothing, or noth-ing in particular, about the structure and substance of the work Picasso devoted his life to: familiarity with the whole mishmash—ticking off the stale stories and dim nondescriptions as they roll by—for me never quite draws the sting. For how can it be that this—this second-rate celebrity literature—is the response we have to the century's most difficult pictorial thought; and a thought, as Picasso's fellow-artists acknowledged (often against their will), that was decisive in changing the language of poetry, architecture, music, sculpture, cinema, theater, the novel? What would we

say if the books we had on Darwin and Einstein and Kafka and Lenin were of the same miserable kind?

Yet it must have a function, the Picasso literature. It is like a set of gargoyles erected to keep an evil spirit at bay. It seems to be telling us that the spirit is powerful—in a sense *our* spirit, our present (or just-past) possibilities crystallized—but for that very reason not to be looked at. Worshipped, maybe, or condescended to; denounced, idealized, nudged and winked at, reduced to marital or extramarital strip cartoon, transposed to the empyrean of the Old Masters; but not *seen*, not treated as a coherent and in some sense necessary—motivated—account of its century.

We all know the feeling. Fixing on a Picasso painting at all directly—not swiveling away to this or that fact of the love life or cult of personality—and asking the question "What understanding of the person and situation depicted seems to be at stake here?" most often leads to places we would rather not go. It puts too many of our opinions—our views of ourselves and the past hundred years—at risk. It disperses our notion of what art should be or do.

One day in March 1932, the art dealer Daniel-Henry Kahnweiler, who had been a crucial supporter of Picasso and Braque in the high times of Cubism before the war, wrote to his friend Michel Leiris. The letter to which he was responding—Leiris was in Africa that year—seems not to have survived, but clearly it contained a not unfamiliar judgment about the state of painting in general at the time and Picasso's in particular. Painting was dead, Leiris reckoned, with Picasso the only one capable of breathing life into the corpse.

Leiris had written brilliantly about Picasso in the late 1920s, following him further into his new world of freaks and phantoms than any other critic. Kahnweiler, by contrast, had kept his distance for a decade, partly for personal reasons and partly from lack of sympathy with what Picasso had been doing. There is a hint of those reservations in the letter. The short book about Cubism that Kahnweiler had published twelve years before, in 1920, had taken a cool—which is not to say passionless—neo-Kantian line. The retreat of art from familiar appearances, of which Picasso's and Braque's painting was such a strong example, would issue, Kahnweiler hoped, in a recognition of the deep structures of "subjective" apprehension, and therefore the reconstruction of a shared world.

5

Cubism had been on the way to doing this. Kahnweiler's study *Der Weg zum Kubismus* had been written in wartime Switzerland, essentially finished by 1916. Then came Picasso's galumphing nudes of the early 1920s, followed in the final years of the decade by a parade of monsters, and in between—in 1924 and 1925—a set of lavish, often large-scale still lifes, where the question of whether the artist *believed* anymore in the Cubist machinery he was deploying seemed built into the performance itself. About these things Kahnweiler had kept silent.

So what he says to Leiris in 1932 comes out of the blue. The prose of his letter is as conversational—as spontaneous and excitable—as Kahnweiler ever could be. Few men were less inclined to gush.

> Yes, as you say, painting is only being kept alive by Picasso, but how marvelously. Two days ago, at his place, we saw two paintings he had just done. [One of them was *Nude on Black Armchair* (fig. I.1) and the other a variant of the same subject (fig. I.2). A Cecil Beaton photo from the time gives a sense of the paintings' formidable scale (fig. I.3).] Two nudes that are perhaps the greatest, most moving things he has produced. "It seems as though a satyr who had just killed a woman could have painted this picture," I said to him about one of the two. It's not Cubist, not naturalistic, it's without any painterly artifice, it's very alive, very erotic, but with the eroticism of a giant. Picasso has done nothing comparable for many years. "I would love to paint like a blind man," he'd said a few days before, "who pictures an arse by the way it feels." That's it exactly. We came away from there stunned.

Stunned (*écrasé*) may be too kind a word. The things Kahnweiler quotes from studio conversation are not likely, any longer, to impress. Men swap compliments over a nude's dead body. We have been here before.

But the tone, to repeat, is wholly out of character for this particular writer, and the verdict he produces—the judgment that the new paintings "are perhaps the greatest, most moving things" Picasso had ever done—the opposite of routine. Coming from Kahnweiler, this is very close to an admission of defeat. Eroticism, it seems, is painting's last hope. And there is something profoundly touching, I feel, for all the art-world heavy

I.1. Picasso, *Nude on Black Armchair*, 1932. Oil on canvas, 162 x 130 cm. Private collection.

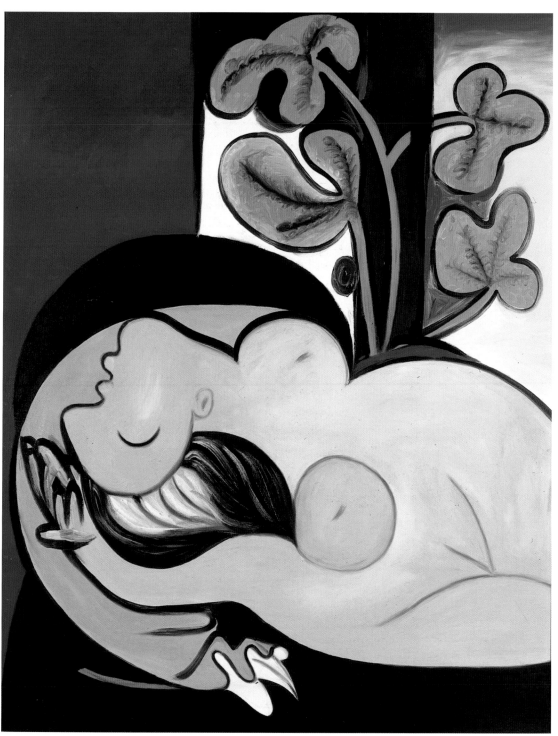

I.1

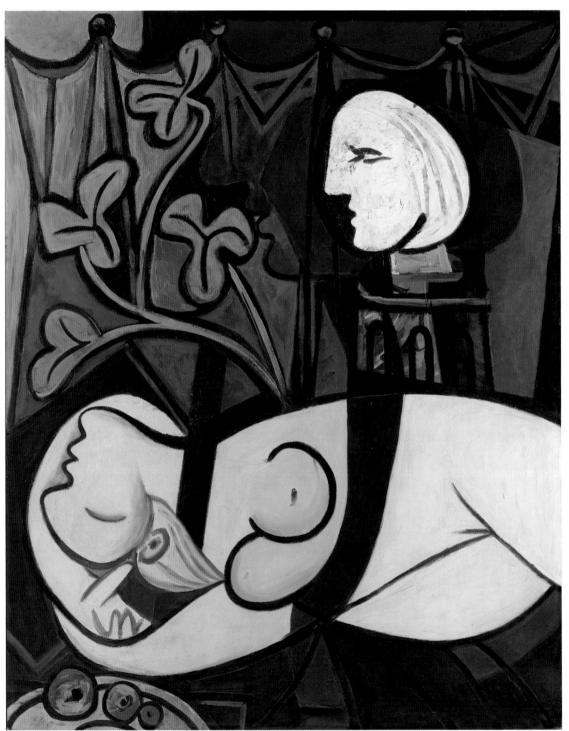

I.2

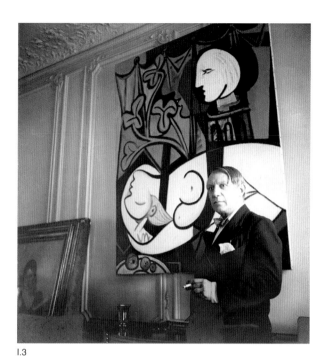

I.3

breathing, in the spectacle of the crisp Kantian losing hold of his dream of reconstruction—of a modern art made out of the rediscovered deep structures of subjectivity—and falling under the spell of Picasso's satyr-dance. Down he goes, into the world of giants.

■ ■ ■

Two reflections follow: one on the autobiographical basis of Picasso's work, and the other concerning its retrogressive nature in Cubism's wake. Autobiography first.

We happen to know the identity of the woman, Marie-Thérèse Walter, whose beauty is celebrated in the paintings Kahnweiler saw. But celebrated by whom? Certainly, empirically, by someone called Pablo Picasso. Yet one of Picasso's favorite quotations, which crops up several times in the lectures to come, was Rimbaud's "Je est un autre." (I is someone

I.2. Picasso, *Nude, Green Leaves, and Bust*, 1932. Oil on canvas, 162 x 130 cm. Private collection.
I.3. Cecil Beaton, Picasso in front of *Nude, Green Leaves, and Bust*, 1932. Photograph.

[maybe even something] else). Picasso's is an art that says "I," unmistakably; but what in the work does the saying—what force or entity or center of opposition—is precisely the painter's question. "Whether he likes it or not, man is the instrument of nature; it imposes its character, its appearance, on him." "Why do you think I date everything I do? It's because it's not enough to know an artist's works. You have to know also when he did them, why, how, in what circumstances." And immediately Picasso runs on—he is talking to Brassaï in 1943—to try to establish the point of such knowledge, which is general, impersonal, utopian. "No doubt one day there will exist a science, which perhaps they'll call 'the science of man,' that will try to penetrate deeper into man by way of the man-who-creates [pénétrer plus avant l'homme à travers l'homme-créateur]. . . . I often think about this science and I aim to leave posterity as complete a documentation as possible." "I think the work of art is the product of calculations, but calculations often unknown by the artist himself. . . . So we must suppose, as Rimbaud said, that it is the other that calculates in us." "You start a painting and it becomes something altogether different. It's strange how little the artist's will matters. . . . He was completely right, the other, when he said 'Je est un autre.'"

So it seems that Kahnweiler responds in exactly the way Picasso's kind of I-saying invites when he says that the picture of Marie-Thérèse looks as if it had been painted by a goat-man or a giant. He sees straight away that what the picture articulates is *another*'s eroticism, a dream of the body's availability as it might manifest itself in a more (or less) than human world. The remark thrown out by Picasso himself a few days earlier, about the blind man and touch, is characteristic, not least in its lack of originality, but strikes me as leading viewers in the wrong direction. Touch—the imagination of contact and softness and curvature—is consumed in the *Nude on Black Armchair* by something else: a higher, shallower, in the end more abstract visuality, which will never be anyone's property. The nude's near hand, holding on to the clawlike white flower, is an emblem of this: fingers and petals become pure (predatory) silhouette. The body's pale mauve is as otherworldly a color—as unlocatable on the spectrum of flesh tone—as the yellow and orange in the sky. Maybe in the picture night is falling. The blue wall to the left is icy cold. The woman's blonde hair is sucked violently into a vortex next to her breast. Blacks encase her as if for eternity. The rubber plant tries to escape through the window.

Which is to say—I am adopting Kahnweiler's strategy, of course, and casting about for metaphors appropriate to a metaphorical triumph—that the picture's whole point seems to be that "Marie-Thérèse" is both *there* and *not-there* in the space provided; and that the same goes, a fortiori, for who- or whatever brought her into (non)being. Is the black-and-mauve body *close* to that being, and to us looking on from that being's place? Or far away? Is it touchable or untouchable? Exultant or comatose? Compliant or self-enclosed?

Take the blonde-and-brown vortex of hair, for example. That the configuration is partly an imagining of Marie-Thérèse's open vagina is sufficiently obvious: the conjunction of hair and breast is a typical bit of Picasso sex comedy; but this only makes the hairdo's bright turbulence the more uncanny. The head, we might say, belongs to the hair rather than vice versa: the hair is a monster about to swallow its prey. And what the shape of the opening then does to Marie-Thérèse's neck and shoulders, and even to the line of her upper breast, her far arm, and the arc of the sofa, seems to speak to the opening's sheer power—its being a kind of overproductive pictorial cell, throwing off approximate versions of itself. The flower claw sums things up.

Sometimes in paintings from the late 1920s Picasso literally figures the "I" that is trying to establish a relation to—maybe get a distance from—comparable, though usually less inviting, objects of desire (figs. I.4 and I.5). But "literally" is wrong here. The paintings in question destroy the I-figure at the same time they produce it. The ghostly profiles of "Picasso," appearing in mirrors or margins or pictures on the wall, immediately cede authority—above all, spatial authority—to the creatures they share the room with. Picasso is nowhere; the monsters are right up front. "I believe in phantoms," the artist told Kahnweiler; "they're not misty vapors, they're something hard. When you want to stick a finger in them, they react."

The general lesson to be learned from *Nude on Black Armchair*, then, is unmistakable: it is weird and sad that in Picasso's case it goes on being necessary to spell it out. All the great opposites and ambivalences of subject and object rehearsed in the picture—its undecidables of color and distance and erotic availability—are achievements of *painting*. And the canvas could hardly state more clearly (almost pedagogically) that the way to particularity in art—in this case, to the terror and wonder of sex—is

I.4

I.5

via absolute aesthetic generality, mauve detachment, emotion absorbed in technique. Desire is a generalizing force. Painting's ultimate coldness is only excusable (only nontrivial) because it follows desire's path. It mimics the process—the geography—of splitting and projection, but only by having those movements of mind and feeling become nothing but moves in an aesthetic game. "Expressiveness" cedes to choreography. This is a central Picasso dialectic. And how on earth are the details of Picasso's actual dealings with Marie-Thérèse Walter (even if we could extract them from the miasma of gossip) supposed to help us with it?

Picasso is a painter who says "I." But I is someone else. Autobiography is his way of claiming centrality in the world as he sees it in 1932, and of speaking, which means also doubting and parodying, the one universal he thinks we have left. It is the universal—the fiction of subjectivity—that we should be talking about.

 ▪ ▪ ▪

But wait a moment.

Satyrs, giants, blind men, monsters, sleeping beauties . . . phantoms reacting to the touch. What is this farrago of nonsense? How on earth could a man like Kahnweiler fall for it? Isn't his letter's lip-smacking, arse-stroking chumminess in the end what matters, and sticks in the craw? And what has any of this to do with the real onward movement of the twentieth century?

An answer to this kind of doubt about Picasso—for me it is indelibly associated with my friend Benjamin Buchloh, who has voiced it ferociously from time to time—can be given only slowly, emerging, I hope, in the lectures that follow. (My account of *Nude on Black Armchair* is a first installment.) But let me at least give the reader a glimpse of the framework, the overall view of modern art, within which a defense of Picasso might make sense.

A judgment of retrogression applied to an artist necessarily involves, first, an assessment of what it is—what previous conquest or ongoing struggle—the artist has stepped back from. Second, it involves a judgment about whether there really was an "ongoing struggle," or one it was

I.4. Picasso, *Figure and Profile*, 1927–28. Oil on canvas, 65 x 54 cm. Private collection.
I.5. Picasso, *Bust of a Woman with Self-Portrait*, 1929. Oil on canvas, 71.1 x 60.9 cm. Private collection.

reasonable or necessary to join. And third, it turns on a judgment of the *value* of retrogression (or regressiveness, or primitivism, or nostalgia, or the cult of purity, or the creation of private worlds—or all the other synonyms for modern art's refusal of the century it lived in). As regards the first question, part of the answer is easy. Picasso's great conquest had been Cubism, and no doubt that style had seemed for a while—seemed—to be unfolding a new world. *Nude on Black Armchair* is unthinkable without Cubism: its opening and closing of spatial positions is still essentially working the machinery of 1914–15 (fig. I.6). But the syntax now is loosened and simplified. Hard edges are less brittle and rectilinear, the void no longer all-encompassing. Wit gives way to infatuation. The body rules.

As I say, my justification of these new tactics—my account of the worlds they were meant to create—will or will not become persuasive as things go on. But here are my basic premises. First, the longer I live with the art of Europe and the United States in the twentieth century (I mean the short twentieth century from 1905 to 1956, from the first Russian Revolution to Hungary and Suez), the more it seems to me that retrogression is its deepest and most persistent note. Picasso is far from alone. Think of Schwitters immured in his erotic cathedral, or Matisse reassembling Morocco in his apartment; of Mondrian in his desperate dream-chamber and Brancusi among the totems; of Tatlin plunging earthward in his flying machine, Bonnard in his bathroom, Malevich in his coffin; of Duchamp playing peek-a-boo through a crack in the door and Pollock holed up in his eternal log cabin; and ask yourself, "So what *is* modern art but a long refusal, a long avoidance of catastrophe, a set of spells against an intolerable present?"

It comes down—second premise—to a judgment on the century itself. And of course, to say that the twentieth century, at least as lived out in Europe and its empires, was catastrophic or intolerable is to do no more than repeat common wisdom. Anyone casting an eye over a serious historical treatment of the period—the one I never seem to recover from is Mark Mazower's terrible conspectus, *Dark Continent: Europe's Twentieth Century*—is likely to settle for much the same terms. "The Century of Violence," I remember an old textbook calling it. The time of human smoke.

I.6. Picasso, *Harlequin*, Paris, late 1915. Oil on canvas, 183.5 x 105.1 cm. Acquired through the Lillie P. Bliss Bequest. The Museum of Modern Art, New York.

I.6

■ ■ ■

But what can it possibly mean, to pass judgment on a century? The point is not to vie with one another in horror or revulsion at what happened— Buchloh, for instance, is unbeatable if this is the test—but to try to reach an assessment of the kind of horror we are dealing with. Did the century's disasters have a shape? Did they obey a logic or follow from a central determination, however much the contingencies of history (Hitler's charisma, Lenin's surviving the anarchist's bullet, the psychology of Bomber Harris) intervened? Here is where I find myself disagreeing with the picture of the century that seems to underpin most accounts of modern art we are given; and I have in mind the best of them. I do not see a shape or logic to the last hundred years. I see the period as catastrophe in the strict sense: unfolding chaotically from 1914 on, certainly until the 1950s (and if we widen our focus to Mao's appalling "Proletarian Cultural Revolution"—in essence the last paroxysm of a European fantasy of politics—well on into the 1970s). It is an epoch formed from an unstoppable, unmappable collision of different forces: the imagined communities of nationalism, the pseudoreligions of class and race, the dream of an ultimate subject of History, the new technologies of mass destruction, the death throes of the "white man's burden," the dismal realities of inflation and unemployment, the haphazard (but then accelerating) construction of mass parties, mass entertainments, mass gadgets and accessories, standardized everyday life.

The list is familiar. And I suppose that anyone trying to write the history that goes with it is bound to opt, consciously or by default, for one among the various forces at work as predominant. There must be a heart of the matter. (Art historians lately seem to have put their money on "commodification," maybe under the spell of the priority given that phenomenon, or a few of its more obvious signs, by artists in the United States from 1960 on. This love affair with the logo may prove to have been a weakness or a strength. As a key to the dynamic of the wider century, or to art's overall response to that dynamic, it strikes me as an unlikely, deeply parochial, nominee.) What I want to offer instead is not a candidate for the "last instance" in the chain of twentieth-century determinations, but a way to think about their overall character. Is there a form of words that could epitomize them, particularly as they might, more or less unthinkingly, have been *felt* by artists and intellectuals?

I think that the century was felt to be (by all the artist-escapists listed a few pages back, for instance) the end of something called bourgeois society. I know the phrase is portentous; and it is not necessary for an artist to have been capable of producing it verbally for it to have been on his or her mind. Intuitions are different from ideologies. And no doubt even "portentous" is inadequate by way of apology; for in ways that speak to the character of bourgeois society itself, the very phrase—the claim to totality—is embedded in a history of polemic. My using it at all will strike many readers as desperate or anachronistic. I do so for the follow-ing reason. I cannot avoid the conviction that somewhere at the heart of Picasso's understanding of life—this will be argued later—lay an unshak-able commitment to the space of a small or middle-sized room and the little possessions laid out on its table. His world was of property arranged in an interior: maybe erotic property (*Nude on Black Armchair* speaks to that), but always with bodies imagined in terms that equate them with, or transpose them into, familiar instruments and treasures. Between guitar and woman there is constant analogy. Many commentators on Picasso have remarked on this, often disapprovingly. Yes, it is a limitation and sometimes grotesque. But I would say that it points to the way Picasso profoundly belonged, for all his living as a young man on the margins of society, to the nineteenth-century civilization in which he was brought up. And without the view he had of the world and its occupants as essen-tially room-bound, near at hand, and entirely possessable, I do not think we would have had the *care*—the endless energy, the decades of effort to immortalize the reaching out and making-mine—that gives Picasso's art its gravitas.

That care in Picasso's case was often mixed with Bohemian insolence and destructiveness does not alter the point. For who has not grown used to the paradox that in so many of the artists who seem to us now to have spoken most deeply of (maybe even for) bourgeois society—Flaubert, George Eliot, Simmel, Manet, Marx, Menzel, Baudelaire, Ibsen, Henry James—care seems indistinguishable from distaste? Bohemia was never as withering on the subject of bourgeois illusions as the great masters of the novel. *The Communist Manifesto*, we see in retrospect, is as much under the spell of Adam Smith and Balzac as looking for a way to set their world on fire. It is the great poem of capitalism's potential. And who are the heroines of the new order if not those who stare its horrible decencies

17

most fully in the face: Olympia, Madame Bovary, Hedda Gabler, Kate Croy, *The Daughters of the Vicar, Woman with a Hat*? Maybe belonging and not-belonging, or respectability and disreputableness, just *are*—were— what is meant by bourgeois identity: they seem to be (again, in retrospect) what marks off this strange way of being-with-others-in-the-world from others before and since.

■ ■ ■

My claim, however, is not simply that many of the artists who matter most in the twentieth century still lived instinctively within the limits of bourgeois society, but that they felt this society was coming to an end— and that this was why their art took a retrogressive form. Which leads to the question of Marxism. Marxism, it now seems, was most productively a theory—a set of descriptions—of bourgeois society and the way it would come to grief. It had many other aspects and ambitions, but this is the one that ends up least vitiated by chiliasm or scientism, the diseases of the cultural formation Marxism came out of. At its best (in Marx himself, in Lukács during the 1920s, in Gramsci, in Benjamin and Adorno, in Brecht, in Bakhtin, in Attila József, in the Sartre of "La conscience de classe chez Flaubert"), Marxism went deeper into the texture of bourgeois beliefs and practices than any other description save the novel. But about bourgeois society's ending it was notoriously wrong. It believed that the great positivity of the nineteenth-century order would end in revolution: meaning a final acceleration (but also disintegration) of capitalism's pro- ductive powers, the recalibration of economics and politics, and break- through to an achieved modernity. This was not to be. Certainly bourgeois society—the cultural world that Picasso, Matisse, and Malevich took for granted—fell into dissolution. But it was destroyed, so it transpired, not by a fusion and fission of the long-assembled potentials of capitalist in- dustry and the emergence of a transfigured class community, but by the vilest imaginable parody of both. Socialism became National Socialism; Communism, Stalinism; modernity morphed into crisis and crash; new religions of *volk* and *gemeinschaft* took advantage of the technics of mass destruction. Franco, Dzerzhinsky, Earl Haig, Eichmann, Von Braun, Mus- solini, Teller and Oppenheimer, Jiang Qing, Kissinger, Pinochet, Pol Pot, Ayman al-Zawahiri.

I cannot see—here is what follows for art history—that "retrogression" in the face of such horror is an inappropriate or reprehensible response. No doubt the domestication of Cubism after the First World War, or the collapse of Constructivism, or the rise of an art of cultivated nightmare and nonsense, are things to be regretted when set against the century's first hopes. "The shit in the shuttered château" is no one's hero. But artists are seldom brave, nor need they be; and out of their honest cowardice, or blithe self-absorption, or simple revulsion from the world around them can come, in times of catastrophe, the fullest recognition of what catastrophe is—how it enters and structures everyday life. And as for artists who did *not* retreat or regress during the period in question—who went on believing in some version of modernity's movement forward, toward rationality or transparency or full disenchantment—they were too often involved (the record is clear) in a contorted compromise with the tyrannies and duplicities just listed. Better a private dreamworld, it seems to me, than a glib facsimile of the common good. Better Chagall's Vitebsk than Rodchenko's White Sea Canal—better Miró than Léger, or Matisse than Piscator, or Kahlo than Rivera, or De Chirico than De Stijl (figs. I.7 and I.8).

■ ■ ■

Yet what does it mean to pass judgment on a century? Certainly mine is too bald and summary, and seems not to recognize the freedoms the twentieth century made possible. (I am haunted by a set of family snapshots showing my lower-middle-class parents exulting in their premarital holiday with friends on the Gower peninsula. Never have office boys and secretaries looked more carefree. It was summer 1939.) Mazower and I are doubtless too bleak, but I claim at least this much for our perspective. I believe its pessimism gets us closer to Picasso's world—to Picasso's sense of the times he was living in—than those implied in the art histories we have. This is not to say that Picasso's art is one of unrelieved grimness (*Nude on Black Armchair* puts the lie to that) but that "grimness" is the ground bass, or deep presupposition, of the pleasures his painting wants to preserve. Many of us will find it impossible, for instance, to look at the *Nude*'s wonderful thrown-back profile without seeing it morph in the mind's eye into the agony of the grieving mother or the falling woman or

I.7

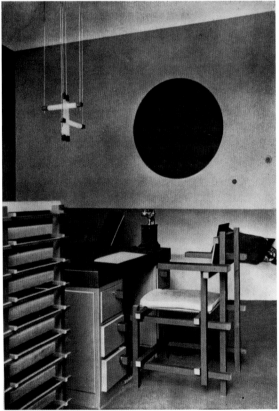

I.8

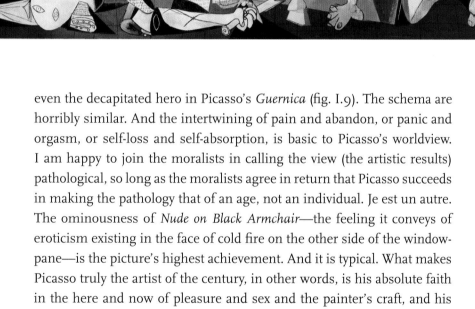

I.9

even the decapitated hero in Picasso's *Guernica* (fig. I.9). The schema are horribly similar. And the intertwining of pain and abandon, or panic and orgasm, or self-loss and self-absorption, is basic to Picasso's worldview. I am happy to join the moralists in calling the view (the artistic results) pathological, so long as the moralists agree in return that Picasso succeeds in making the pathology that of an age, not an individual. Je est un autre. The ominousness of *Nude on Black Armchair*—the feeling it conveys of eroticism existing in the face of cold fire on the other side of the window-pane—is the picture's highest achievement. And it is typical. What makes Picasso truly the artist of the century, in other words, is his absolute faith in the here and now of pleasure and sex and the painter's craft, and his absolute lucidity about the circumstance in which these things were now on offer. The room remained, but it was more and more populated by monsters. These lectures will try to show why.

I.7. Giorgio de Chirico, *The Child's Brain*, 1914. Oil on canvas, 80 x 65 cm. Moderna Museet, Stockholm.
I.8. Gerrit Rietveld, *Study for Office of Dr. Hartog*, 1922. Photograph. Collection Centraal Museum, Utrecht.
I.9. Picasso, *Guernica*, 1937. Oil on canvas, 349.3 x 776.6 cm. Museo Nacional Centro de Arte Reina Sofía, Madrid.

LECTURE 1

OBJECT

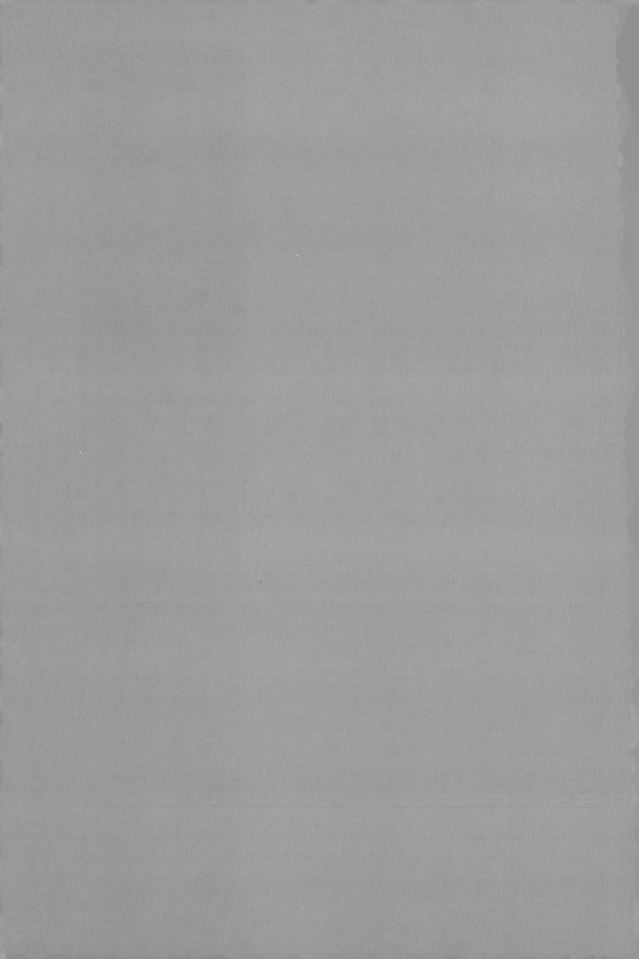

I begin with a prologue. It happens that here in Washington, in the Phil-
lips Collection, there is a painting by Picasso that straightaway conjures
the specific world—the feeling for life and its limits—my lectures will
argue was basic to Picasso's vision. The little canvas (it is two feet wide
and twenty inches high) is usually called *The Blue Room* (fig. 1.1). I shall
use it as an emblem. But it is also a very great and moving painting in its
own right, which I hope will establish from the start why Picasso is worth
caring about—that is, why it is worth trying to extract the work he did
from the horrible penumbra of gossip and hero-worship that surrounds
it. Even in the case of this picture, I dare say, there is a body of scholarship
in existence that operates on the assumption that we shall understand
what we are looking at better if we know which of Picasso's mistresses is
taking a bath, and are told a third-hand tale or two of his callousness in
ditching her a few months later. You will get little or no such "biography,"
I promise, in the series to come. What instead will preoccupy me, in *The
Blue Room* and elsewhere, is Picasso's understanding of space, and there-
fore of history—his sense of the century he was born in, for which the
little oil is an act of mourning, and his sense, necessarily much less sure,
of the terrible century beginning. *The Blue Room* is dated 1901.

Of course I am not meaning to suggest (I hope my introduction heads
off misunderstanding) that Picasso's striking through to the form and
tonality of his epoch was divorced from his connection with other people.

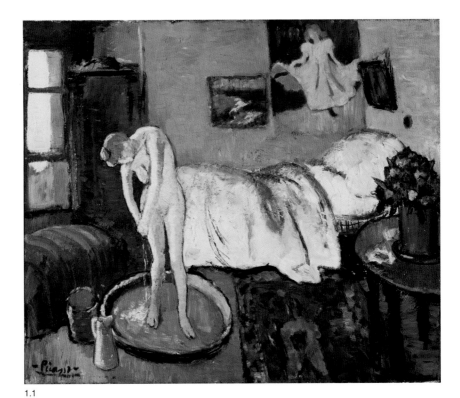

1.1

On the contrary. For me and others, the face and affect of the twentieth century are inextricable from the faces—the closeness, but also the pathos of distance—of Fernande Olivier, Olga Khokhlova, Marie-Thérèse Walter, and Dora Maar. Picasso said it himself: "Au fond il n'y a que l'amour." (At bottom there is only love.) But he also said, to André Malraux, "If I do a nude, I want you to think it's a nude. Not a picture of Mrs. So-and-so." (Pas celui de Mme Machin.) It is the pictorial work that goes to make the body in *The Blue Room*'s bath a body *for us*—a body that tells us what it was like to be naked in a room long ago and feel its walls and floor and heavy furniture as so many dependable familiars—that will be my concern.

The Blue Room is a small painting, and I am already making large claims for it. I said it memorializes a century. There are few paintings, I feel, more full of care and regret. How so? What is it in the picture that carries the weight I am responding to? Well, many things. The pervasive

1.1. Picasso, *The Blue Room*, 1901. Oil on canvas, 50.48 x 61.6 cm. Acquired 1927. The Phillips Collection, Washington, D.C.

blue color is part of it, and it is wonderful, in contrast to what happens in many Picassos from a year or so later, that the blue here is dominant without being portentous. Likewise the scale of the body in relation to the room—small enough for a hint of fragility—and its placement quietly off center. And there is the inimitable drawing of the young woman: her pendant breast, her straining shoulder, the determined helmet of her hair, her tough-guy profile, the blur of her pubis. Few painters have had more of a sense, from the beginning, of how easily the human body might be destroyed. The play between the real woman's in-turned, slightly defensive nakedness and the unreal woman's naive flouncing and exultance in the Lautrec poster pinned to the wall is of the essence. In the poster, naturally, hair is let down.

Tenderness is everywhere. The narrow window, half-hidden by a wardrobe with no other place to go, and the glimpse of the drab city; the inevitable little landscape on the wall, with its dream of an elsewhere in which the Mediterranean breaks on rocks; the rickety table, the flea-market rug, the bed with its memory of bodily warmth (the touch of yellow among the blue)—they all play their part. But most deeply of all, I shall argue, the tenderness and definitiveness in Picasso has to do with a vision of space.

This will be my series' leitmotiv. *The Blue Room* is brought on as a first brief statement of the theme, and to analyze the painting's space at all adequately would take too long. But here in a nutshell is what seems distinctive. Space in the little picture is contained and enclosed. It is not claustrophobic: air circulates in it, and enough blue distance is hollowed out. But the thing is a room—an interior. Space here is proximate; which does not mean all within arm's reach or hard up against the picture plane, but nonetheless present and palpable for any body within it (the woman in the circle of the tub) and for us looking on. Space is intimate. The rug heads off abruptly into infinity, but the sheet on the unmade bed laps over it and leaps toward us and asks to be touched. Nothing important is far away. Space, if I can put it like this, is *belonging*: a complex nineteenth-century word, which certainly in its plural form speaks to the century's dream of space as something possessable, but also—consider the longing built into the noun—something desired, vulnerable, patiently constructed, easily lost.

So much for prologue. The painting in the Phillips will reappear only very occasionally. It lies outside the lectures' purview, which is mainly

1.2

the painting Picasso did in the 1920s and '30s. Nonetheless, I shall be happy if *The Blue Room* stays in mind. It is my touchstone, my totem. Already, in a sense, it says all that Picasso was capable of saying about being-in-the-world. We shall see strange, sometimes monstrous, things done to the small enclosure in later works, and it will be a question, eventually, whether the space of belonging survives at all (fig. 1.2). But *The Blue Room* will never quite disappear. The bed, the body, the window, the tipsy floorboards, the corner of a wall with a little picture canted precariously across it: they are what space *is* for Picasso—they are what he cares for and wants to show resisting the worst the new age can do. This is my lectures' subject.

■ ■ ■

Having started with a two-footer, I continue with things smaller still. On 10 September 1920, if we can trust a note on the back of the sheet, Picasso did a painting on paper—a spare and delicate thing, using what seems to be a water-based medium, to which as usual he gave no title (fig. 1.3).

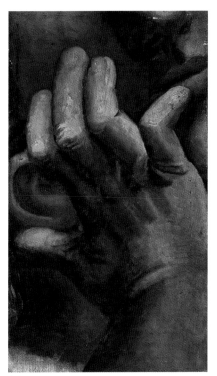

Composition is the one I shall give it. The picture is an everyday size: just a little more than ten by eight inches. Then some time a few weeks later (this work has no date notation, but the signs point to November the same year) he painted a hand in front of a face, presumably touching it (fig. 1.4). Again the dimensions are modest: thirteen inches by seven and a half.

Of course the painting in oils does not *feel* small, and is not small in relation to what it depicts. We seem to have moved in close as viewers— close enough for odd things to happen to our sense of actual sizes. Measured with a ruler, the painted hand is just a little bigger than hands usually are. But pictorially it is enormous, maybe even gargantuan. Hand and ear, in their intersection, make an ominous shape.

The painting on paper is likewise not safely and stably small. It is a model of a much larger space—perhaps, by analogy with other Picassos, of a table by a window or in a corner, with a few commonplace objects (a vase, a book, a bottle, a musical instrument of some sort) taking the

1.2. Picasso, *The Three Dancers (Young Girls Dancing in front of a Window)*, 1925. Oil on canvas, 215.3 x 142.2 cm. Purchased with a special Grant-in-Aid and the Florence Fox Bequest with assistance from the Friends of the Tate Gallery and the Contemporary Art Society, 1965. Tate Gallery, London.
1.3. Picasso, *Composition*, September 1920. Goauche and graphite on paper, 27 x 21.7 cm. Inv. MP932. Musée Picasso, Paris.
1.4. Picasso, *Fingers and Face*, 1920. Oil on canvas, 33 x 19 cm. Picasso Estate.

sun. It is a *model* of such a situation: it seems intent on reducing the room and its contents to pure locations and orientations, to solids and transparencies. It aims to abstract out from the object-world the qualities that make for equilibrium among its parts. What results is distinctive and beautiful—distinctive for its coolness and simplicity—and the beauty strikes me as deriving above all from the painting's understated momentariness: its fragility. Thickened watercolor is the ideal medium for this. It allows one to mimic the pasted-on look of collage, but have the crucial pieces (the white parallelogram especially) be like tissue paper with stronger colors showing through. Balance in the world, says the little painting, is instantly recognizable when it occurs, and fascinating—authoritative. But it can blow away at the next puff of wind. Pictures are houses of cards.

Smallness in Picasso, we know by now, does not necessarily mean modesty of ambition. The two paintings in question are formidable and representative: I intend them to stand for the poles of Picasso's effort as a whole. But maybe tactically I should, before mounting that argument, show how they connect with works that are larger. For Picasso was an artist who repeatedly scaled up his work to exhibition size, making paintings six or seven feet high, and clearly he meant these "masterpieces" to do a special kind of work. Big paintings mattered to him: he was old-fashioned about them; he thought they summed things up. The tiny watercolor is connected, in my opinion, with a canvas done in the fall of the previous year, 1919 (fig. 1.5). The first time this painting was shown in public, in Zurich in 1931, it was called *Open Window*. It is gigantic: four feet wide, over seven-and-a-half feet high. Taller, in fact, than any other painting Picasso did in the 1920s—almost as tall as the *Demoiselles d'Avignon* (fig. 1.6).

Open Window interests me for reasons I shall go into more fully in lecture two. Let me just say here that it is as close to *Composition*, structurally—in its sense of the see-through flimsiness of objects, and of the world as essentially a window pane through which light passes unobstructed—as Picasso ever came in a large-scale oil. Perhaps some will feel it comes *too* close. There are reasons why the picture, which is now in

1.5. Picasso, *Open Window*, 1919. Oil on canvas, 209.5 x 117.5 cm. Kunstsammlung Nordrhein-Westfalen, Düsseldorf.
1.6. Picasso, *Les Demoiselles d'Avignon*, Paris, June–July 1907. Oil on canvas, 243.9 x 233.7 cm. Acquired through the Lillie P. Bliss Bequest. The Museum of Modern Art, New York.

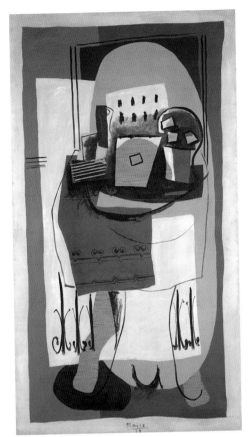

1.5

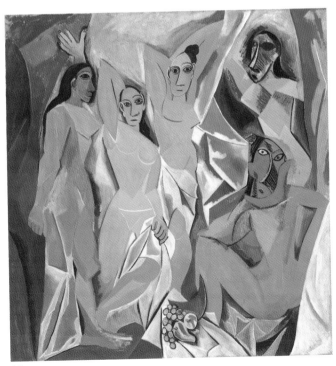

1.6

Düsseldorf, has never quite entered the Picasso canon. Weightlessness and translucency are not, on the whole, Picasso's forte—certainly not when he is working life-size (or more-than-life-size). Matisse does transparency better. A comparison with any of Matisse's *Open Windows* from the previous three or four years, which may have been on Picasso's mind, would be—well, cruel (fig. 1.7).

Enough. All that needs to be registered for the time being is that the Düsseldorf painting, failure or not, at least suggests that the feeling for the world in the little watercolor was in no sense incidental or eccentric for Picasso. There may be problems involved in his making the feeling *work* in a picture seven feet high, but the basic impulse—the wish to simplify and dematerialize, to reduce the world to a fragile balance of forces—is one moment of representation as Picasso conceived it. It occurs constantly, and gives rise to tremendous things—above all to oil paintings of middling size, around three or four feet square. Look, for instance—moving on a few months from the fall of 1920 to the following summer in Fontainebleau—at *Guitar on a Table*, 39 by 38 inches (fig. 1.8). No doubt the differences between this and *Composition* are striking. Room-space in the oil is even more elliptical than in the watercolor, but, as if in compensation, shapes and orientations have solidified, and particular objects seem on the verge of coming to life. There are apertures in things—the sound hole of the guitar and maybe the mouth or stopper of a bottle (or is it a piece of fruit in a bowl?)—but they look now to be punched through opaque material. Nonetheless, the oil and the watercolor have much in common. What they share above all is structure; which is to say, a feeling less for the specific identities of things than for the conditions of their being-together in our field of vision. A feeling for interlock and juxtaposition. A sense that objects are most fully themselves for us at their edges, as clear-cut shapes that touch others but also detach themselves—"float" is too weightless a word, "come forward" too animate—to establish their separate identities. Distinctness, we shall see, is a Picasso value. "Nature never produces the same thing twice," he said to Françoise Gilot. Even so, one should not equate distinctness in Picasso's world with being *one*

1.7. Henri Matisse, *Goldfish and Palette*, Paris, quai Saint-Michel, fall 1914. Oil on canvas, 146.7 x 111.8 cm. Gift and Bequest of Florene M. Schoenborn and Samuel A. Marx. (507.1964) The Museum of Modern Art, New York.
1.8. Picasso, *Guitar on a Table*, 1921. Oil on canvas, 99 x 97 cm. Nahmad Collection.

1.7

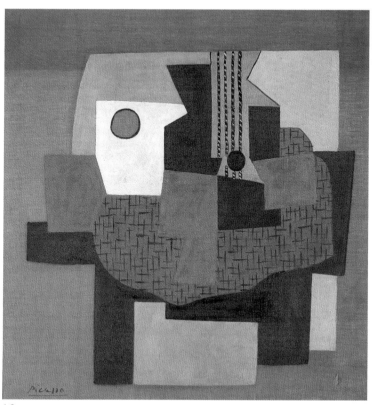

1.8

object as opposed to the form of many. Not always. The two terse flag shapes colored light brown on the table in *Guitar on a Table*—one with five sides, the other with six—are as salient as shapes can be. They are objects, or maybe parts of the same object. But what object, precisely? The question is misconceived. Precision—"exactitude" is another favorite Picasso word—may or may not depend on the painter's having struck off an equivalent for this newspaper specifically, or that liquid in a bottle on the table. It may. It may not. The distinctness of the flag shapes could as well be the sign (the stamp) of where exactly things stand—not what they are made of—or the compressed equivalent of their curvature.

Guitar on a Table is Picasso at his best. It is the kind of achievement we tend to take for granted—which I think he would have liked. It figures, incidentally, in a now famous photograph Picasso took of his wife Olga at the time, sitting in front of a series of pastels evidently meant to derive from her (fig. 1.9). The still life is half off frame, somewhat in darkness, high on the studio wall. Faces and fingers below; structure above.

∎ ∎ ∎

The photo of Olga leads back to the oil from the previous fall—I shall call it *Fingers and Face*. Again, it is easy to show that the little painting, for all its strangeness, is fully part of the main line of Picasso's pictorial thinking. Much the same arrangement of hand and mouth occurs in an even tinier oil, no more than nine inches by seven, but this time unmistakably a dry run for something larger (fig. 1.10). So it proved: the *Seated Woman*, which Picasso seems to have completed that same fall (and kept for himself), measures three feet by two (fig. 1.11). *Mother and Child*, from the spring of 1921, is bigger still: more than six feet high (fig. 1.12). You will notice that by now the accent has shifted from fingers intersecting with face to adult fingers in contact with those of a newborn. But the effect—the estranging, magnifying effect—is not dissimilar. Tenderness and monstrosity coexist in Picasso—especially, here, in the mother's hand to the right, which strikes me as Picasso's final working-out of the idea begun in the small oil. A lot of the bulbous and bloated body language from around 1930—the time of monsters at large—is latent in the detail of Picasso's classicism (fig. 1.13).

1.9. Picasso, *Olga Picasso in Fontainebleau Studio*, 1921. Gelatin silver print. The State Pushkin Museum of Fine Arts, Moscow.

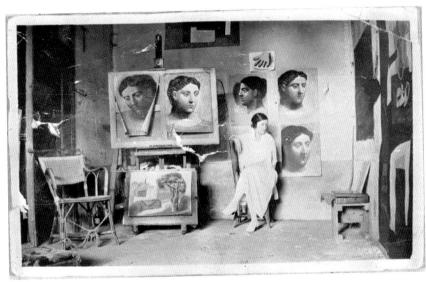

1.9

About the look of the Greek or Roman in pictures like these I shall be brief. The topic is much debated, hard to pin down, and not really connected with the story I am telling. I do not think—and the point is central for me—that the new body language adopted after the First World War brought with it any deep revision of Picasso's space. The massive paintings done in the summer at Fontainebleau, for instance—the *Three Musicians* and the *Three Women at the Spring*—may be alternately Cubist and neo-Pompeian, with a room in one painting replaced by a formula grotto in another, but the setup of depth and enclosure strikes me as not shifting an inch (figs. 1.14 and 1.15).

It is true that a slim majority of the paintings Picasso produced in the early 1920s are done in a version of antique style: there are echoes of the museum in Naples, or Attic grave stelae, or late Renoir, or Ingres and Puvis de Chavannes. Weird as it may be, even the intersection of *Fingers and Face* in 1920 is a version of—a variation on—a famous trope in a

1.10. Picasso, *Seated Woman Resting on Her Elbow*, 1920. Oil on canvas, 24 x 18.5 cm. Picasso Estate.
1.11. Picasso, *Seated Woman*, 1920. Oil on canvas, 92 x 65 cm. Musée Picasso, Paris.
1.12. Picasso, *Mother and Child (Madre y niño)*, summer–autumn 1921. Oil on canvas, 162 x 97 cm. Museo Picasso, Malaga, Colección particular. Cortesía Fundación Almine y Bernard Ruiz-Picasso para el Arte.
1.13. Picasso, *Figures at the Seaside*, January 12, 1931. Oil on canvas, 130 x 195 cm. MP131. Musée Picasso, Paris.

1.10

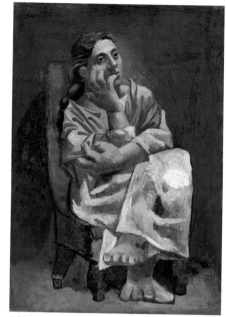

1.11

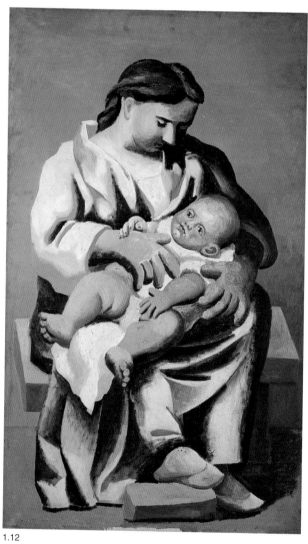

1.12

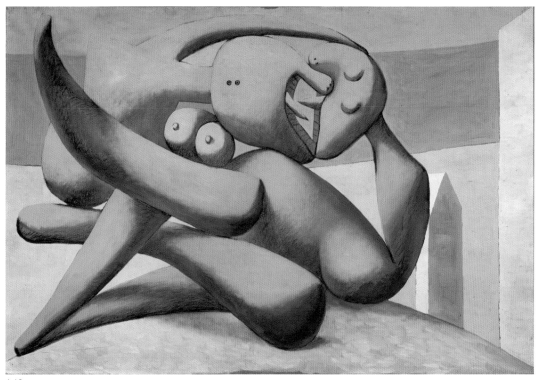

1.13

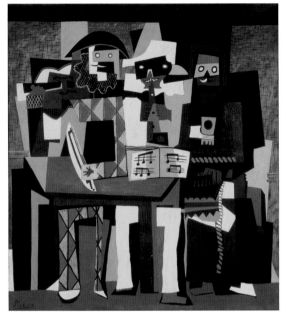

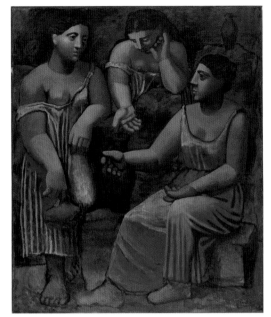

1.14

1.15

fresco from Herculaneum. And we are surely meant, looking at *Mother and Child* or the pastel heads, to feel the secondariness—the borrowed quality—of the idiom. Many of the moves look stereotyped. But it does not follow (here is where I diverge from recent writers) that the borrowings are intended to put the reality of the things depicted in doubt. Rather the opposite, I reckon. For reasons we shall never fully understand, Picasso felt the need after 1918, as he did repeatedly through his career, to see again what painting objects in their full materiality, their ordinary ponderousness, was like. One of the things it was like, at least in the early twentieth century, was being a ventriloquist. That is, it involved throwing one's voice—using someone else's language. Maybe it involved recognizing (and making recognizable to viewers) the past-ness and otherness of the language in question—the fact that it could only be mobilized now as a set of devices, not made one's own in the way of a native speaker. But again, secondariness does not necessarily mean irony or disbelief. I do not think—I do not feel—that *Mother and Child* and *Fingers and Face* are saying one thing but expecting us to see that the style says another. Manner and matter are in harmony. Ponderousess is a positive value. It is a relief to be immobile for once. The style is an expedient: Picasso may be

1.14. Picasso, *Three Musicians*, 1921. Oil on canvas, 204.5 x 188.3 cm. A. E. Gallatin Collection, 1952. Philadelphia Museum of Art, Philadelphia.
1.15. Picasso, *Three Women at the Spring*, Fontainebleau, summer 1921. Oil on canvas, 203.9 x 174 cm. Gift or Mr. and Mrs. Allan D. Emil. The Museum of Modern Art, New York.

on the outside of it but he is chillingly confident that he can turn it to his purposes: it is the best means he has, in 1920, to make the body materialize again.

■ ■ ■

I return to *Fingers and Face* and *Composition* (figs. 1.16 and 1.17). The two paintings can stand, I have been suggesting, for the poles of Picasso's effort in general. At one pole is substance; at the other, structure. Heavy opacity; weightless translucence. Relentless closeup in the oil, focusing on the body's necessary imperfections, answered in the watercolor by a strange kind of infinity—relations without entities, substance without stuff. The world is *full* in *Fingers and Face*—all object and obstruction. In the painting on paper the world is not so much empty as inhabited only provisionally. What matters most—what precedes habitation—is the character of space. And that character cannot be extrapolated from solid bodies. The things of this world open onto no-things—in their heart of hearts they do, so that what is essential to them is not their detail or texture so much as their degree of extension, their orientation, their angle of repose.

A picture of the world (this would be another way of putting it) is staged most powerfully in painting by a new disposition of space, light, and color. Painting of any ambition will therefore move beyond the particulars of subject matter toward these conditions, these structures and generalities. Space, light, and color; but of course—*Fingers and Face* makes this explicit—it is always going to be a painter's question as to how the basic conditions or gradients of visibility belong to particulars: to objects, bodies, rooms, prospects, scenes. They may belong entirely, or float free. And do not be deceived by the apparent generality of the condition-words I have been using—the space-, light-, and color-words—into thinking that we have to do here with constants. Space, for instance, has a specific character for human beings, which changes profoundly through history. *The Blue Room* is my emblem of that. Our existing in a set of surroundings, our understanding of enclosure or infinity or proximity or continuity—all this is contingent. It is inflected by the totality of events. There is a "modern" space, for certain, and it is fundamentally different—in temper, in shape and extent, in the place it gives to the human—from that of Duccio

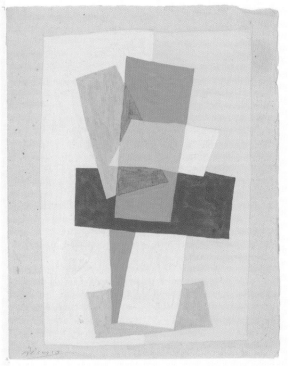

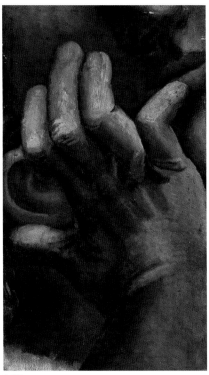

1.16

1.17

or Velázquez. But how best to lay hold of this temper? That is what *Fingers and Face* and *Composition* are trying to decide.

We are told—as a way of describing what is at stake here—that during the 1920s classicism and Cubism coexisted in what Picasso did. But the terms are not helpful. I think they prevent us from being properly puzzled by the coexistence of styles—from being goaded and even scandalized by it, as the best of Picasso's viewers were at the time. Suppose, then, we set ourselves the task of confronting the real difficulty. Is there a voice from the moment—a period grammar and vocabulary, to borrow a notion from Michael Baxandall—that might help? It turns out there is.

We are, you remember, in the fall of 1920. The following year an extraordinary short exercise in logic and ontology appeared in German, and

1.16. Picasso, *Composition*, September 1920. Goauche and graphite on paper, 27 x 21.7 cm. Inv. MP932. Musée Picasso, Paris.
1.17. Picasso, *Fingers and Face*, 1920. Oil on canvas, 33 x 19 cm. Picasso Estate.

in 1922 an English translation was published under the title *Tractatus Logico-Philosophicus*. Much of the work, which quickly established itself as one of the great philosophical statements of the century, is fiercely technical and all of it is demanding. But it had, and has, an effect beyond the closed circle of those truly equipped to understand it, because of its style. The style is aphoristic; and at regular intervals the writer, Ludwig Wittgenstein, draws back from the close moves of logical analysis to set out a picture of the nature of the world. These moments in the text have always been spellbinding, and have mattered to general readers; so I do not think I am simply plundering an arcane piece of logic if I invite you to see how the young Wittgenstein's view of things might match Picasso's. Some texts set themselves up to be plundered. Here is the passage from the *Tractatus* that resonates, for me, with the pictures we are looking at:

2.02 Objects are simple.

2.021 Objects make up the substance of the world. That is why they cannot be composite.

2.0211 If the world had no substance, then whether a proposition had sense would depend on whether another proposition was true.

2.0212 In that case we could not sketch any picture of the world (true or false).

2.022 It is obvious that an imagined world, however different it may be from the real one, must have *something*—a form—in common with it.

2.023 Objects are just what constitute this unalterable form.

2.024 Substance is what subsists independently of what is the case.

2.025 It is form and content.

2.026 There must be objects, if the world is to have an unalterable form.

2.0271 Objects are what is unalterable and subsistent; their configuration is what is changing and unstable.

I know this is breathtaking. I know that trotting it out in connection with Picasso is dangerous. Nonphilosophical readers like me will hang onto certain seemingly familiar words—object, substance, form, "true or false"—and think they are lifelines to Wittgenstein's meaning. Especially the word "objects."

Of course this is why I fastened on Wittgenstein's text in the first place. I thought that Picasso in 1920 was wrestling with the problem of how best to state—to show—what it is to *be* an object, and I believed the logician was working fiercely, with unequalled cold energy, to do the same thing. But again, beware. Philosophers tell us that what Wittgenstein means in the end by "object" in the *Tractatus* is radically unclear, and probably intended to be. The word points to whatever is unalterable and subsistent in the world we have—to some elementary and indivisible particle of being, or perhaps of knowing, or perhaps both—but it only points, it does not specify. "[The book's] elementary propositions are mysterious," to quote one commentator, "and that is a fact about the *Tractatus* which has to be accepted."

All right. But this impenetrability may prove helpful from our point of view. Let us imagine the young Wittgenstein looking at *Fingers and Face* and *Composition*. Which would appeal to him, over long minutes, as the better model of a world of objects, in the sense suggested by the *Tractatus*'s opening pages? Does Wittgenstein think we necessarily mean by objects *things*—bodies of some sort, or parts of bodies; subsistences; matters that stand in the way of our making up truths about the world out of propositions alone? "It is obvious that an imagined world," he writes, "however different it may be from the real one, must have *something*—a form—in common with it. Objects are just what constitute this unalterable form." If we think of an "imagined world" as essentially a picture (as the *Tractatus* sometimes seems to) we look to be well on our way to a new defense of realism. But wait. Wittgenstein is surely not arguing that what is unalterable about an object is its gross material being-there. He talks about an object's unalterable form. He says on the same page, "In a manner of speaking, objects are colorless." But only in a manner of speaking, because six sentences later he writes, "Space, time, and color (being colored) are forms of objects." So he would not necessarily warm to high Cubism's monochrome. If objects are essentially kinds of form, then color belongs to them quite naturally. Maybe, then, Wittgenstein would turn to *Composition* and feel himself most at home there. By objects could he not mean basic modes of apprehension—singular, irreducible ways of appearing? Or even a set of necessary conditions for being apprehensible at all? For instance, having a certain extension in space; or being solid or void; intersecting, overlapping, being juxtaposed; being in balance or off-kilter; having an orientation; possessing or lacking symmetry.

The question for us, naturally, is not which of these two models of the object-world gets us closer to Wittgenstein's worldview, but to Picasso's. I shall say this much: Wittgenstein's picture of how the world is constituted seems to move between strong assertions that the world is substantial—"If the world had no substance, then . . . we could not sketch any picture of the world (true or false)"—and equally strong ones implying that *form* is what lies at the root of things. "The substance of the world *can* only determine a form, and not any material properties. For it is only by means of propositions that material properties are represented"; and therefore (he says) material properties do not get us close enough to truth, for the world, at its heart, is independent of what we say about it.

In passages like these Wittgenstein is an aphorist as much as a logician. He is an artist—he is pointing, gesturing, to opposites that are hard to specify and are never going to be resolved. But are not his opposites Picasso's? Is not the opposition of form and substance in *Fingers and Face* and *Composition* essentially the one Wittgenstein is pointing to? And is not Picasso's project precisely to go on pointing and pressing in both directions, with always the possibility—which is present in Wittgenstein also—that the two directions may be ways of expressing the same thing?

Gilot remembers Picasso quoting Valéry on one occasion, to the effect that "I write half of the poem and the reader writes the other." And Picasso commented, "This may be perfect for him, but I don't want there to be three, four, or a thousand ways of interpreting one of *my* canvases. I want there to be only one, and in that one a viewer ought, at least to some extent, to recognize nature, even if nature tortured out of shape (même une nature torturée)." Only fools, says Picasso to Tériade in 1927, think that what he and Braque did during the time of Cubism was abstraction:

> It was just at this period that we were passionately preoccupied with exactitude. One can only paint out of a view of reality, which we tried through dogged hard work (how we applied ourselves to this side of things!) to analyze in pictorial terms. . . . How anxious we were lest something slip through our clutches (Que de scrupules de laisser échapper quelque chose). . . .
>
> Moreover, this feeling for exactitude is one I have always held onto in my researches. There is no painting or drawing of mine that does not respond exactly to a view of the world. One day I'd like

to show drawings done in my synthesizing mode (dessins à forme synthétique) next to ones of the same subject done in a classical manner. People will see my concern for exactitude. They'll even see that the [synthetic] drawings are more exact.

"My synthesizing mode . . . my classical manner." The modes are separate, and each has to be entered into unconditionally. But this is not because Picasso is a lofty agnostic who accepts that the nature of the world is unknowable and all approaches to it equally valid. His god is exactitude. And exactitude for him (as for Wittgenstein) is a transitive notion. Representations are true or false, accurate or evasive. The world *appears* in a painting—if it didn't, who would bother to look? The problem is to decide which of the two modes of appearance we have been looking at gets closer to the way things *are*. It is the problem that drives Picasso forward. And always on the horizon—here is the final point—is the possibility of the two models not just coexisting but coming together.

Coexistence . . . Coming together . . . This is Picasso's conceptual horizon constantly, and I shall explore it through the lectures to follow; but concepts for Picasso are nothing unless they are kept alive in pictures—entertained on paper, as things or "states of affairs" (another *Tractatus* term) that might actually be the case. If, in the paintings we have been looking at, *hand* stands for "object-world one" in Wittgenstein's sense (a world of substances), then what stands above all for "object-world two" (a world of forms) is *guitar*. For some reason it was the form of forms for Picasso—a guitar was the thing in the world that most opened itself to reconstruction as pure shape, pure marker and carrier of space. (Maybe this was because a guitar is an object built to make that most abstract of experiences, harmony. Its sound hole is a way into another dimension.) Hand and guitar, then—could they, in their very different modes of objecthood, be made to touch? It is striking that in Cubism, for which a man or woman with guitar is a preferred subject, fingers never seem to move across strings. Perhaps in the wake of Cubism they will.

Look, for instance, at a gouache—again it is tiny, no more than six by eight inches—Picasso dated 26 April 1920 (fig. 1.18). It is as if he had turned back to the polarities of the previous fall and dreamt of them occupying the same space. But is it the same space? The hand does not really belong in the corner of the room. It is given a halo of opaque white, and

the white is shaded, folded: hands are for touching, the world that sur-
rounds them has texture, primarily. Sometimes in the thinking Picasso
does during this period he seems pessimistic, or pragmatic. Hand and
guitar will always remain in separate compartments (fig. 1.19). But maybe
the hand can reach out (fig. 1.20). Maybe it can hold the guitar—the very
form of spatiality—in its fingers (fig. 1.21). This is a repeated idea in the
sketchbooks of 1919–20. My favorite is this, from the fall, in pencil and
black chalk (fig. 1.22). I like the fact that the guitar in the window at right
is abstracted directly from one or two actual hand-size constructions of
the scene that Picasso made at the same moment (fig. 1.23). The little
paper cutout literalizes the guitar's pure planarity, and then the drawing
makes the arrangement virtual again. And most of all I like the way the
hands top left in the drawing—three of them now—hover around a faint
transparency (almost a hologram) that is like a model-of-models of space
itself, in its folding out from a center, its offer of corners and spines and
orthogonals.

We are close to the heart of Picasso's project here—close to his utopia.
And lest you think that again I am making too much of a modest work
(the page measures nine by thirteen inches), let me add that these pictorial
ideas—and all the ideas in the sketches of these hyperactive months—are
eventually taken up in works that are the opposite of modest. Compare
the drawing with *Guitar and Mandolin on a Table*, from 1924 (fig. 1.24).
No understatement now. This is one of the biggest paintings Picasso ever
did—after *Open Window*, maybe the biggest without a living being in it—
well over six feet wide and four feet tall. It will figure largely in lecture
two. And I hardly need spell out what connects the still life to the studies
we have been looking at. Let me simply say here, with reference to small-
ness in Picasso, that it matters enormously that in this work, where most
things are over life-size, there is a moment at which Picasso reminds us
that painting, maybe in its deepest mode, *is* miniaturization. Underneath

1.18. Picasso, *Guitar on a Table and Hand*, 1920. Gouache on paper, 15 x 20 cm. Picasso Estate.
1.19. Picasso, *Studies*, 1920. Oil on canvas, 100 x 81 cm. MP65. Musée Picasso, Paris.
1.20. Picasso, *Study for Hands and Guitar*, 1919. Pencil on paper, 21 x 27.5 cm. Nahmad Collection.
1.21. Picasso, Sheet of studies: *Still Life and Hand*, autumn 1919. Gouache and graphite on paper,
19.9 x 10.6 cm. Inv. MP865. Musée Picasso, Paris.
1.22. Picasso, *Study of Hands and Guitar on a Table before an Open Window*, autumn 1919. Black chalk
and graphite on paper, 24 x 34 cm. Musée Picasso, Paris.
1.23. Picasso, *Table and Guitar before a Window*, 1919. Cardboard and mixed media, 12 x 10.5 cm. Inv.
MP258. Musée Picasso, Paris.

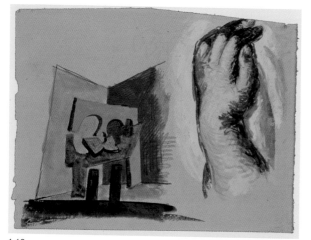

1.18

1.19

1.20

1.21

1.22

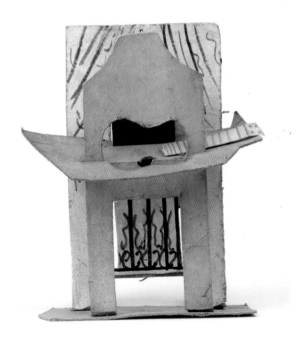

1.23

the table stands a wonderful epitome—a recapitulation—of the room and the window and the world. The rhyme with the balcony railing is strong to the point of didacticism. We are meant to see that painting is always a kind of small theater—not unlike the child's paper theater in the impenetrable still life done a year later, in 1925 (fig. 1.25).

. . .

The word "theater" here may be worrying. It leads to the question of truth. Look again at the two sentences from the *Tractatus* that say, crushingly: "If the world had no substance, then whether a proposition had sense would depend on whether another proposition was true. In that case we could not sketch any picture of the world (true or false)." Making a picture of the world, if I understand Wittgenstein, *depends* on the picture being true or false—not just being believed to be, but being. Matching up, that is (or failing to), to a world with a substance independent of our representations. Anything short of this—anything occurring *between* propositions or representations—just isn't a picture at all. And non-pictures may have charm, but they do not count.

Is this what Picasso thought? One side of me believes so. "Exactitude," "view of the world," the "one" interpretation—does not the vocabulary I have already presented point that way? Otherwise, he says to Gilot, what will painting be but "an old grab bag for everyone to reach into and pull out what he himself has put in"? (The French is a little different, but equally contemptuous: "un fourre-tout, où n'importe qui peut trouver ce qui lui plait.") Or recall the famous remark to Jerome Seckler. "Some people . . . call my work for a period 'surrealist.' I am not a surrealist. I have never been out of reality. I have always been in the real of reality." The clumsiness of the English conveys the force of the assertion. It is like Courbet boasting of being a partisan of "la vraie vérité."

Nevertheless it remains a question, as my title *Picasso and Truth* is meant to suggest, whether truth and falsity are the right terms to capture Picasso's practice, whatever he said to Gilot and Seckler. Look at *Guitar and Mandolin on a Table*. Put a typical painting from the decade

1.24. Picasso, *Guitar and Mandolin on a Table (Still Life in front of a Window)*, Juan-les-Pins, 1924. Oil with sand on canvas, 104.7 x 200.3 cm. Solomon R. Guggenheim Museum, New York. 53.1358.
1.25. Picasso, *Studio with Plaster Head*, 1925. Oil on canvas, 98.1 x 131.1 cm. Purchase. The Museum of Modern Art, New York.

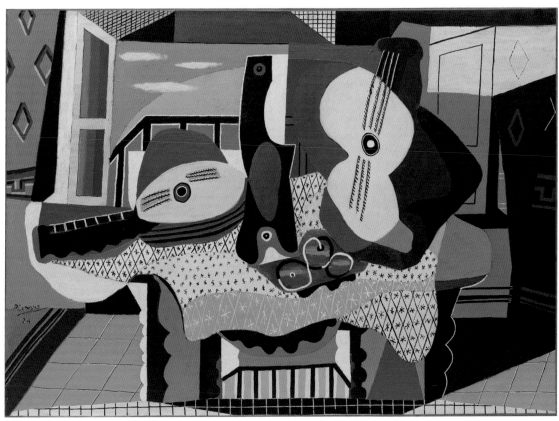

1.24

1.25

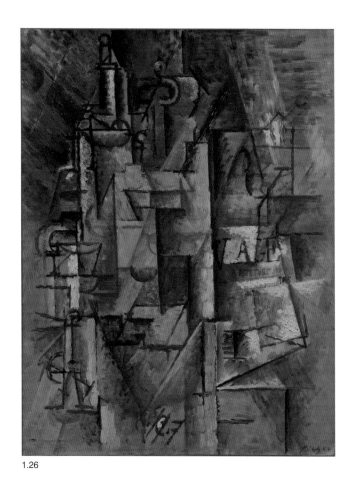

1.26

before next to it (fig. 1.26). Be impressed by the gravity of the earlier still life—by its muted complexity, its doggedness, its austerity. The magazine on the table here, part of whose title and subtitle Picasso shows us, was called *The New Age*. It came out of London, and even in London in 1911 there was a feeling that things were at a world-historical turning. (People did not know that the turn would be toward the slaughterhouse.) Paintings like the one I have chosen, in their very severity, will always be the touchstone for Picasso's art. He himself looked back on the years of the early teens with a rueful, astonished nostalgia. "It was because we felt the temptation, the hope, of an anonymous art. . . . We were trying to set up a

1.26. Picasso, *Bottles and Glasses*, Paris, winter 1911–12. Oil on paper, mounted on canvas, 64.4 x 49.5 cm. Solomon R. Guggenheim Museum, New York. Solomon R. Guggenheim Founding Collection, by gift. 38.539.

new order." For a while a pictorial language—something like a new style, with all the historical force of that word as we apply it, say, to Renaissance or Baroque—seemed to speak *for* Picasso, to reach out to the world and re-describe it. "How anxious we were lest something slip through our clutches!" The style was austere, it was impersonal: above all it was or appeared to be other-directed. Its very strangeness seemed to propose that the new art was either madness or epistemology—and when had madness ever looked like this, so calmly in pursuit of detail, searching so systematically for a new armature for seeing?

If high Cubism was not true, in other words, it was nothing. Of course even high Cubism was engaged in constant negotiation with painting's limits, with painting's playfulness, with its necessary offer of pleasure and its need to draw back from the black hole of analysis. But always at its finest and freest moments—I show you the great *Man Leaning on a Table* from 1916 (fig. 1.27)—there is a claim to have gotten the structure of the world right in ways that no previous picturing had. A man leans on a table. He has been reconstructed as a play of positions and orientations, yet the play is insubstantial if it does not signify "leaning"—leaning and facing and uprightness, the whole strange being-in-space of the human body—as never before. Using nothing but painting's means, certainly—shapes, colors, kinds of pattern and shading—but all of them means to an end. I quote Wittgenstein one last time: "Pictorial form is the possibility that things are related to one another in the same way as the elements of the picture. *That* is how a picture is attached to reality; it reaches right out to it. It is laid against reality like a measure."

Now turn back to the 1924 *Guitar and Mandolin on a Table* (fig. 1.24). Are these the terms in which it asks to be addressed? I admire the painting more than I can say. It has stood the test of looking through the years, and gets more dazzling the better I know it. It is dazzling, but is it *true*? Is it either true or false? Vivid, electric, persuasive, yes—but surely not true or false? Is not this as strong an example as one could have of a work of art that presents a "world" to us, but expects us to see and accept that its world is unbelievable? It is the world as it might be, or ought to be, if everything had its being, and derived its energy and specificity, from its becoming fully an aesthetic phenomenon.

I quote a famous late nineteenth-century catchphrase, which I dare say Picasso knew by heart: "We [humans] have our highest dignity in

our significance as works of art—for it is only as an *aesthetic phenomenon* that existence and the world are eternally *justified*." Catchphrases are dangerous. The actual meaning of this one, just as much as the dicta in the *Tractatus*, is a lot less clear than its uniquely pungent formulation. The author himself, Friedrich Nietzsche, came to weary of its vogue. "Find[ing] salvation only in *appearance*," he said later, commenting on his own line of argument—"you can call this whole artists' metaphysic arbitrary, idle, fantastic; what matters is that it betrays a spirit that will one day fight at any risk whatever the *moral* interpretation and significance of existence." Even the retraction, you notice, is double-edged. The artists' metaphysic may be fantastical in Nietzsche's view, but he nonetheless believes that it is the first form— the strong form, with a strength derived from the cult of art since the Renaissance—of a fight to the death with morality. For if the world is true or false, it is also good or evil. And these terms, which for Nietzsche now stand in the way of human awakening, must disappear— together. Do we not see them disappearing—burning up in the fire of imagination—in *Guitar and Mandolin on a Table*? Is not Picasso Nietzsche's painter? Is not his the most unmoral picture of existence ever pursued through a life? I think so. Perhaps that is why our culture fights so hard to trivialize—to make biographical—what he shows us.

Every age has the atheism it deserves. The late nineteenth and early twentieth century deserved a deep and terrifying one, and in Nietzsche it got it. We know that Picasso, especially early on in Barcelona, existed in circles for whom Nietzsche was the new Dante, his aphorisms pointing the way through hell. But Nietzsche does not figure in these lectures as an *influence* on Picasso—he may or may not have been—but as a way of making sense of what the painter did. I bring him on in the same spirit as one might bring Einstein in connection with high Cubism or Duns Scotus with high Gothic. It is not likely or necessary for the one term to have known the other at all directly: "it is not very probable," as Panofsky puts it dryly, "that the builders of Gothic structures read . . . Thomas Aquinas

52 Lecture 1: Object

1.27. Picasso, *Man Leaning on a Table*, 1915–16. 200 x 132 cm. Pinacoteca Giovanni e Marella Agnelli, Turin.

1.27

in the original." What matters is whether we find that the verbal (or mathematical) statement gives us a means of thinking about a visual idiom that before had stayed out of focus. Does Occam's razor or Nietzsche's *Daylight* apply?

I waver on this. On the one hand, if the present line of thought on Picasso had a single starting point I believe it was several years ago, on an island one summer, when I found myself reading Nietzsche's *Genealogy of Morals* and came across the following passage. I should preface it by saying that the deepest aim of the *Genealogy* is to understand—to attack, but also to enter deeply inside—the seemingly fundamental human wish to deny the world and denounce the life we have in favor of another transfigured one, far from the senses, far from the realities of power. More than once in his writings Nietzsche imagines another kind of organism, come from the other side of the universe, happening upon the inhabitants of earth and asking in utter bafflement: "How could it have been that a form of life came to deny life as one of its central approaches *to* life? This is madness. But things on this planet are madder still: the denial of life, the withdrawal from the life of the senses, seems to have been productive for these creatures—it seems to have made life bearable for them, to have fueled their most intricate creations and their longest-lasting forms of community. This is horrible. This is incomprehensible. We should not even try to understand it, lest we become contaminated by whatever is its deep appeal. Leave these creatures to their un-world. Say goodbye to the ascetic ideal."

This, of course, is my paraphrase of Nietzsche's view. But here are the actual sentences that set me thinking: they have the "ascetic ideal," which is specifically Nietzsche's coinage, directly in mind. (Read them with Picasso's *Violin* from 1912 as accompaniment (fig. 1.28). Cubism was never more bloodless and beautiful.) Nietzsche's book is near its conclusion, and trying not to despair. He draws back from the verdict of his extraterrestrials and wonders if, with the collapse of Christianity as a means of shaping a real otherness to existence (as opposed to giving acquisitiveness a repentant face on Sundays), the ascetic ideal might be dying on the vine. Has not something called science supplanted it? He hopes so, but has doubts.

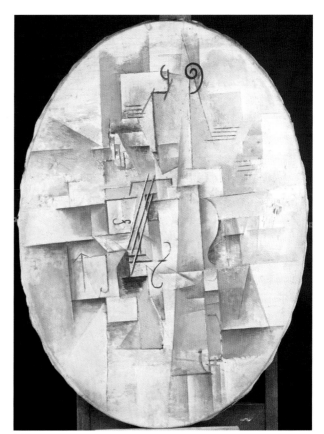

1.28

[All] these hard, strict, abstinent, heroic spirits who constitute the honor of our age, all these pale atheists, anti-Christians, immoralists, nihilists . . . these last idealists of knowledge in whom the intellectual conscience today dwells and has become flesh—in fact they believe themselves to be as detached as possible from the ascetic ideal, these "free, *very* free spirits": and yet . . . this ideal is precisely *their* ideal as well . . . if I am a guesser of riddles in anything then let it be with *this* proposition! . . . These are by no means *free* spirits, *for they still believe in truth.*

Then a few pages later:

And here again I touch on my problem, on our problem, my *unknown* friends . . . what meaning would our entire being have if not this, that in us this will to truth has come to consciousness of itself *as a problem?* . . . It is from the will to truth's becoming conscious of

1.28. Picasso, *Violin*, 1911–12. Oil on canvas, 100 x 73 cm. Coll. Kröller-Müller Museum, Otterlo, The Netherlands.

itself that from now on . . . morality will gradually *perish*: that great spectacle in a hundred acts that is reserved for Europe's next two centuries, the most terrible, the most questionable, and perhaps also the most hopeful of all spectacles.

Perhaps. We have roughly a century to go. I see that I scribbled in the back of my copy of the *Genealogy*, at the time these sentences struck home, the following note:

> So what will Art be, as part of this spectacle—along with all the other practices of knowledge on which it fed, from Giotto to high Cubism—without a test of truth for its findings, its assertions; without even a *will* to truth?
>
> It seems to me that Picasso and Matisse made just that question their life's work—and gave the question real aesthetic dignity—in ways that mark them off from the artists who first posed the question (Nietzsche's contemporaries), for whom it seems to have made painting either a brilliant charade—I think of Gauguin—or an unsustainable agony—I think of van Gogh.

The note, I concede, is naive: it is the kind of thing that reading the *Genealogy* brings on. But I do not disown it. Even the doom-laden tone may be justified. Picasso is the artist of *Guernica* and the *Charnel House* (and *Three Dancers* and *Large Nude in Red Armchair* (fig. 1.29). His art does repeatedly speak to the agony of "that great spectacle in a hundred acts that is reserved for Europe's next two centuries, the most terrible, the most questionable, and perhaps also the most hopeful of all spectacles." Portentousness—from the blue period on—is one of his main modes.

Picasso is the artist of the shrieking girl, and the silent mandolin. The *Genealogy* helps with him but so does the *Tractatus*. His God is exactitude, but also Will. Sometimes, talking to Gilot, one can hear the Zarathustran gossip on Las Ramblas still resonating:

> I have long since come to an agreement with destiny: that is, I have, myself, become destiny—destiny in action. . . . My trees [or guitars] aren't made up of structures I have chosen but structures that the

1.29. Picasso, *Large Nude in Red Armchair*, May 5, 1929. Oil on canvas, 195 x 129 cm. Musée Picasso, Paris.

1.29

chance of my own dynamism imposes upon me. . . . I have no pre-established aesthetic basis on which to make a choice. I have no pre-determined tree, either. My tree is one that doesn't exist, and I use my own psycho-physiological dynamism in my movement toward its branches. It's not really an aesthetic attitude at all.

The French text has an extra sentence: "In any case, there is no visual sensation, since I never work from nature." (Il n'y a pas de sensation vi-suelle, puisque je ne travaille jamais d'après nature.) The whole passage is a struggle with Cézanne.

"There is no visual sensation," he says. But also, "during that time we were passionately preoccupied with exactitude." "The will to truth has ended." "Who cares about a work of art if it is a grab bag from which anyone can take what she wants?" "What meaning would our entire being have if not this, that in us this will to truth has come to consciousness of itself *as a problem*?" And always in answer, with pictures like the little watercolor in mind, there comes a voice with seemingly no patience for such skepticism. "Pictorial form," it says, "is the possibility that things are related to one another in the same way as the elements of the picture. *That* is how a picture is attached to reality; it reaches right out to it. It is laid against reality like a measure."

■ ■ ■

It remains to be seen—first of all in *Guitar and Mandolin on a Table*—if these perspectives are compatible. Not logically compatible, or even emotionally—but pictorially. Are they productive of spaces, configura-tions, kinds of light? Do they tell us something about the nature of human habitation? Is the picture of space and containment in *Guitar and Man-dolin on a Table* still essentially the one spelled out so touchingly under the table's four legs—laid against reality like a measure? Or is it the one up above: all unfolding mere brilliance, marquetry and mosaic, crazy eyes outstaring us from nowhere? (Somewhere close, but nowhere.) Are the strings on the picture's musical instruments as insubstantial, finally—as far from being objects in Wittgenstein's sense—as the stars on the table-cloth or the silly clouds? Will hand and guitar ever touch?

LECTURE 2

ROOM

We seem to be standing in a room (fig. 2.1). The room has a spacious feel to it: the picture is large—just over four and a half feet high, and six and a half feet wide—and though the room is full of objects, there is a sense that air is circulating and light is blowing in from a window facing south. Over to the right, low down in shadow, a wall changes color as it turns a corner, and up above a hard quadrilateral of off-white makes the idea of "corner" explicit, bending space forward around a straight edge. After a moment we come to see that the main form in this bright oblong is not part of the wall below, but the frame of a swinging window. So the hinge is misleading. And the more we look, the weirder the overall pattern of shadows, wallpaper diamonds, and dado becomes. But the mind hangs onto the right angle—the governing room-shape—and the expository diagonal of shadow running across the floor clinches the feeling of depth and enclosure. Opposite, to the left of the table, there is something like the same setup—local uncertainties, firm overall Gestalt. The way the swinging window comes into the room here, and how it attaches to the wall, may be just as baffling when focused on specifically, but the floor grid and kickboard still hollow out the sides of a familiar (dependable) cube. The cube is interrupted and ironized, but it will not go away.

2.1. Picasso, *Guitar and Mandolin on a Table (Still Life in front of a Window)*, Juan-les-Pins, 1924. Oil with sand on canvas, 140.7 x 200.3 cm. Solomon R. Guggenheim Museum, New York. 53.1358.

The floor of the room looks to be tiled. I was about to add that the picture places us upright on it, imaginatively, with even a ceiling over our heads, but then I noticed the segment of an immense circle down at the painting's baseline, hatched black on white and white on black, which stands between us and the pink tiling—perhaps meaning to gently keep us outside the illusion. (The circle is so big that some viewers understandably do not see it as curved at all; but curved it is, maybe buckled and interrupted slightly where black meets white.) The circle is not stressed, but without it the picture would have a different tone: we would be put more decisively in contact with the utensils and instruments on the table, which rear up close in our faces, each trying to look its best for us, as if on a little stage.

How Picasso's paintings behave at their bottom edge is important. Forms arranged along the baseline are one main key to his pictured worlds' proximity to us, and this is often what the painting as a whole is trying hardest to pin down. The intimacy of *The Blue Room* (fig. 1.1), to make the obvious comparison, partly has to do with the way the figured rug and the front leg of the table come into the picture from where we are standing. We seem to be on the rug, looking down at it in much the same way as the woman looks at her shallow bath. If we leaned forward we would be able to touch the sheets on the bed. Not so with the room in *Guitar and Mandolin on a Table*. The instruments on the table here do seem, as I say, to leap forward to meet us, by dint of their color and orientation, but just as powerful is the feeling that they are untouchable, ontologically out of reach. They are appearances, not substances. Pictorial "propositions," Wittgenstein might say. Compare the bedsheets in *The Blue Room* with *Guitar and Mandolin on a Table*'s tablecloth.

I think the strange distancing of things in the 1924 painting is completed—signaled and clinched—by what happens at its bottom edge. And the device of the great circle is special in Picasso: this momentary suspension of entry, this tension between straight edge and curvature—especially spread across the whole width of the painting, as counterweight to the presence and proximity of everything—this is rare. The best I can do by way of comparison is the ground in a tiny painting done five years later called *Monument: Head of a Woman*, where the scale becomes explicitly global (fig. 2.2). The little spectators in *Monument* perch on the earth's curvature, looking up at the monster on the building.

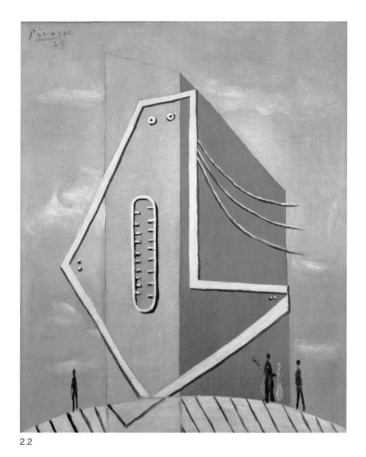

2.2

The objects in *Guitar and Mandolin on a Table* are not monstrous. They are animate and strange, but somehow cheerful and (for Picasso) commonplace: guitar on the right, mandolin at left, between them a kind of bottle maybe sleeved in black, and three pieces of fruit—or could this be a toy of some sort, with colored balls threaded on a string? In any case, a lavish setup, musical and alcholic, the objects borrowing energy from the sizzling crisscross on the cotton cloth. Over to one side, at the right, the cotton peels back to reveal the table's muscle-bound woodwork. At the other, to the left, the folds go on and on keeping the mandolin afloat, seemingly without much of a table to support them. The guitar to the right, upright and anthropomorphic like the bottle, is a kind of stem cell, exfoliating into a shape like an amoeba or a flower. The bottle has the

2.2. Picasso, *Monument: Head of a Woman*, 1929. Oil on canvas, 65 x 54 cm. Private collection.

look of a one-eyed doll. And there are other eyes—or pupils and irises—punctuating the array. Some viewers see faces, noses, a mouth.

When the picture was first shown to the public—it was painted in 1924, sold straight away to a Swiss collector, then brought back to Paris for Picasso's great one-man show of 1932—it was given the title *Nature morte devant une fenêtre* (*Still Life in front of a Window*). This is the title I shall use from now on. The ones that have stuck in the literature—*Guitar and Mandolin*, or even *Guitar and Mandolin on a Table*—leave the still life's setting too much out of account. The idea of "in front of" especially interests me. How far in front? Gaining what from the proximity? Inside or out? These are the painting's questions.

■ ■ ■

I shall get to them by way of the painting's style. Is *Still Life in front of a Window* a Cubist painting? It is often assumed to be. Clearly it has things in common with the line of pictures Picasso did with Braque in the years 1908 to 1916. Many of the key works from that series had been still lifes, though never as large and ostentatious as this. A good point of comparison for the 1924 canvas, for instance, is *Bread and Fruit Dish* from 1908, which is nearly five and a half feet high: a work from toward the beginning of the Cubist project, but already full of the feeling—the characteristic Cubist one—that the world is going to be shown us, at last, in all its difficult truth (fig. 2.3). This is as grand and definitive as Picasso's painting ever became.

I hope the resemblances between the two pictures declare themselves—I have a feeling that Picasso had *Bread and Fruit Dish* specifically in mind when he decided to paint a new still life on this scale—but of course the differences immediately strike home. If the objects on the table in 1924 are like surfers riding a wild wave, then those in *Bread and Fruit Dish* are so many stone replicas of themselves, fixed in place for eternity. They are upright with their own uniqueness. Wittgenstein would have warmed to them.

High Cubism, of course, could be less hieratic than this. Compare the 1924 *Still Life* with *Bottle, Glass, and Fork* from 1912 (fig. 2.4). I am thinking in particular of the earlier picture's sense of movement: the way

2.3. Picasso, *Bread and Fruit Dish*, 1908–9. Oil on canvas, 163.7 x 132.1 cm. Kunstmuseum, Basel.

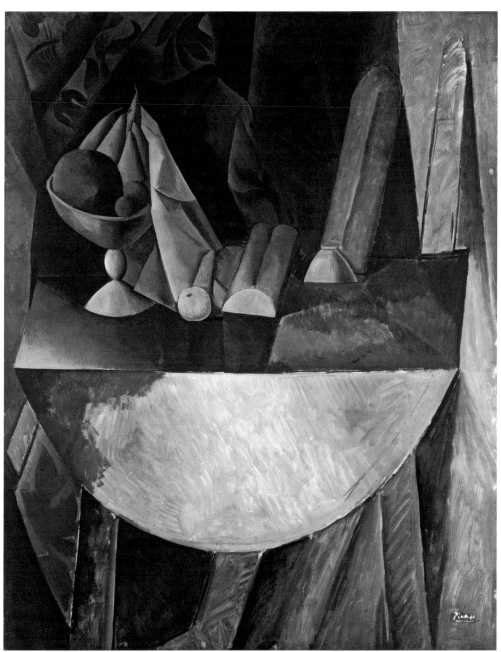

2.3

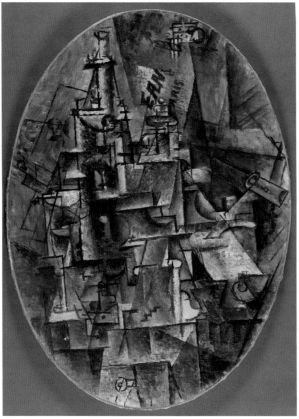

2.4

objects on the table speed outward from the center of the oval, coming toward us in a kind of optical wind tunnel. Maybe the sense of space here is analogous to that in the 1924 painting, for all the immense difference in color. But the best and fairest point of reference for *Still Life* is the cluster of large-scale paintings Picasso did eight or nine years before, in 1915 and 1916, summing up his Cubist experiment but already in the shadow of its coming to an end. The one I choose is *Guitar and Clarinet on a Mantelpiece* (fig. 2.5). It is not as large as the later still life, but imposing all the same: over four feet high, over three feet wide. Most of the picture is simple oil paint, but here and there the oil has been thickened and roughened with sand. The painting as a whole strikes a balance between solidity and high freedom, and in this is typical of the moment: all its forms are hard and substantial, but seemingly balanced on a knife-edge. (The 1920 *Composition* is, one senses, a predictable further step.) In thinking about Cubism,

2.4. Picasso, *Bottle, Glass, and Fork*, 1911–12. Oil on canvas, 72 x 52.7 cm. The Cleveland Museum of Art, Leonard C. Hanna, Jr. Fund 1972.8.
2.5. Picasso, *Guitar and Clarinet on a Mantelpiece*, 1915. Oil, sand, and paper on canvas, 130.2 x 97.2 cm. The Metropolitan Museum of Art, New York, Bequest of Florene M. Schoenborn, 1995 (1996.403.3).

2.5

it follows, I want to keep the tremendous immobility of *Bread and Fruit Dish* in mind, as a kind of primary implied structure persisting in the more momentary arrangement of *Guitar and Clarinet*; but also remember the particle shower of *Bottle, Glass, and Fork*, which then the 1915 painting tries to simplify and calm down—to put more firmly in a room.

What was Cubism, then? As usual, there is a deep and a shallow answer to the question, and it is not clear that the deep answer is better than the shallow one. The shallow answer settles for the set of devices that make Cubist pictures unmistakable. It is concerned with their pictorial grammar, their way of simplifying some aspects of the visual world and complicating others. We have words for what Cubism does at this level: it reduces all forms, or almost all, to a hard-edged geometry, and pushes those forms up closer and closer to the picture plane. It locks their edges together into a network or rough grid. It has special regard for flat solids, like the marvelous table leaf in *Bread and Fruit Dish*—solids that hang before us as manifestations (manifestoes) of what a painting literally is. This is true also of the key forms in *Guitar and Clarinet*. The guitar is scooped out of the picture surface and the sand in the pigment goes to dramatize the actual low relief. The guitar's white soundboard has no sand mixed in to stiffen it, but the paint still pretends (or half pretends) to be a piece of cut cardboard stuck over the instrument's inside. Cubism works on the surface, and most often it seems preternaturally aware not just of the two dimensions of the actual object it is making, but of the object's enclosing outline. Every shape inside the picture rectangle, or picture oval, somehow takes cognizance of the shape that contains it—not mechanically, not reiteratively, so that often one is hard pressed to say exactly *how* the setup on the mantelshelf never lets go of its being in, and belonging to, the brown Gestalt behind it. But it never does. The many ways in which Braque and Picasso invented kinds of tension between the forms of the object-world and the geometry of the stretched canvas were one main source of these paintings' fascination, and above all their authority for other painters. Much of the history of twentieth-century art can be written in terms of artists looking at the loaves in *Bread and Fruit Dish*—looking at how they obey and resist the force field of the picture rectangle, and assert their own materiality against that of the paint they are made from—and thinking that somehow, in this, the true strangeness of representation had been invented again. We are back with Giotto and Cimabue.

Cubism was an art of procedure, in other words, and of shape on the surface; but no one in front of *Bread and Fruit Dish* is likely to think that surface is all there is. The table leaf is one thing, the tabletop another. The angle between the two orientations is absolute. It is implacable. Painting is about making it manifest for all time. Here is where the shallow answer—the description of Cubist grammar—slides into the deep one. For Cubism as its first makers and users saw it was, or appeared to be, more than a pictorial syntax. It was a semantics. It proposed itself as a view of the world. And its view of the world, as with most such proposals in painting, hinged on a sense of space. Space had a specific character in 1908 and 1915. Perhaps it had always had this character really and truly, but it seemed that certain possibilities of painting at this moment—and even of being-in-the-world at this moment—made the character newly accessible to consciousness. This now was painting's concern. The upright loaves and the cosmological table leaf, or the clarinet's battle for life in the few inches between mantelshelf and wall, would be nothing—or anyway, much lesser things—if they did not convince the viewer that in them the actual depth (or shallowness) of the world was disclosed.

Even this is too limited. For Cubism's power did not derive simply from the nature and scope of its implied claims, but just as much from the paintings' suggestion as to who or what it was that had made such a claim in the first place. This is connected with the idea, which is a leit-motiv of Braque's and Picasso's reminiscences, that in Cubism a style seemed to carry its practitioners forward, rather than them carrying *it*. "A style spoke for us": I cannot remember if this form of words is something Picasso or Braque actually said, or something the critic Clement Greenberg imagined them saying; but it sums things up perfectly, who-ever coined it. "A style spoke for us." Meaning that the two artists seemed to be in the grip of an idiom, a new means of enunciation, whose parts interlocked and had a logic of their own; whose grammar contained and constrained them, but at the same time could be seen to open onto more and more combinations, transpositions, intensifications—like the grammar of a language, it was strict but also generative. And rather in the way of a language, this meant that very often it led its speakers along paths that were truly unprecedented—in a sense incomprehensible, even to the person officially in charge. I for one can still feel Picasso's vertigo in 1914 when he found himself returning, in a picture called *Girl with Guitar*

(fig. 2.6), to a subject he thought he had all but completed three years earlier, and began painting over more and more of it with white—stripping it down to a ghostly empty afterimage of itself, and then conjuring it back to half-life with a few pretend collage stick-ons. How could the painter of *Bread and Fruit Dish* have done this? The answer is that he was not the painter of *Bread and Fruit Dish*. In a sense he was not "the painter" at all. The painter had disappeared into the style. "It was because we felt the temptation, the hope, of an anonymous art"—I quote Picasso again, as Gilot remembers him—"not in its expression but in its point of departure. We were trying to set up a new order and it had to express itself through different individuals."

The statement, you notice, is double-edged. Picasso was a realist, and therefore (given the age he lived in) an individualist. Not for him the dream of a self wholly fused into a collective or even a perfect dyad. But at certain moments, he says to Gilot, when a new style seems to be constellating itself and the parts of the world it makes accessible rush in on its users as if clamoring to be shown, individuality *is not it*. I said that one catchphrase of Picasso's conversation in later years was Rimbaud's "Je est un autre." Meaning the "I" of the artist, primarily. The fact that it is Rimbaud speaking—odious, marvelous, sneering boy—should alert us to the fact that the four words are not a call to altruism or abnegation. This is a dictum about self-loss. About the way that sometimes in art the fiction called "me" cedes to other fictions—maybe preferable, maybe more dangerous. It is discovering oneself as *something not known* that matters here, not the ethical or cognitive yield of the discovery. Otherness; unrecognizability; self-dispossession; being suddenly nameless and uncentered, seemingly at the service of something else. As Rimbaud puts it in the next sentence: "Too bad for the wood that finds itself a violin."

So the deep answer is the necessary one. Cubism was a practice—you could almost call it a *habitus*—in which, for a while, Picasso became other to himself. There were more important things to do with painting than show what one felt or thought about *x* or *y*.

What things? What was it that Cubism called its adepts to give form to? I do not think that an answer to this kind of question can be anything other than an intuition. We are feeling for the *Grundform* of Cubism,

2.6. Picasso, *Girl with Guitar*, 1911–14. Oil on canvas, 130.2 x 90.1 cm. Gift Raoul La Roche 1952. Kunstmuseum, Basel.

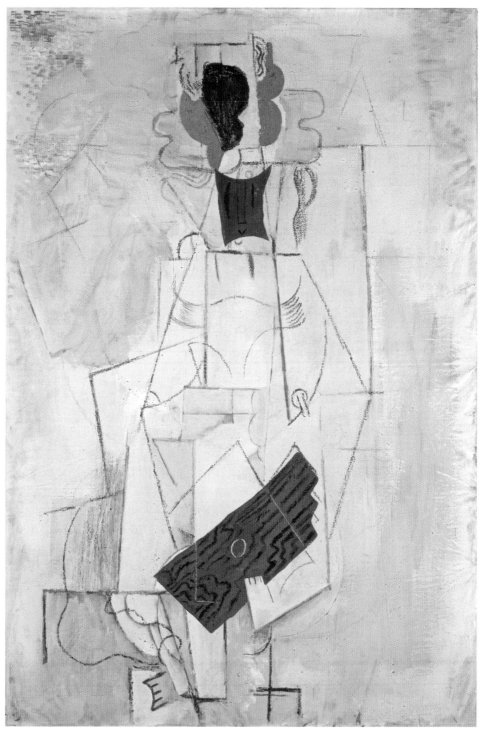

2.6

as the German aestheticians of Picasso's day would have called it: the sense of the shape-of-things that spurred it on, the form of life implicit (or maybe explicit) in its deep structures; what it took to be the real, present nature of human surroundings, human objects, ways of inhabiting and making the world a totality.

Here is my intuition. I invite the reader to assess it with *Guitar and Clarinet* and *Bread and Fruit Dish* in view, though everything I go on to say applies to *Girl with Guitar* too—maybe most powerfully, because *Girl with Guitar* is the extreme case of the *Grundform* declaring itself. *Girl with Guitar* triggers the memory of a great painting done a few months later the same year, *Portrait of a Young Girl* (fig. 2.7); and both hark back to the most ingenuous of Picasso's portraits, the *Girl with a Mandolin* from spring 1910 (fig. 2.8). Cubism, these paintings convince me, is a style directed to a present understood primarily in relation to a past: it is a modest, decent, and touching appraisal of one moment in history, as opposed to a whirling glimpse into a world-historical present-becoming-future. It is commemorative. Its true power derives not from its modernity, that is, if we mean by this a reaching toward an otherness ahead in time, but from its profound belonging to a modernity that was passing away: the long modernity of the nineteenth century.

Cubism came out of Bohemia. It is notorious that *Bread and Fruit Dish* began as a scene with figures around a table in what looks like a low-life café (fig. 2.9)—maybe shades of Degas's *Absinthe*, but also of Cézanne's fantastical *Après-midi à Naples* (fig. 2.10). Cubism is the art of strong liquor and soothing guitars—life on the slopes of Montmartre, but just at the moment when the habit of art and the dream of existence outside the warm safety of bourgeois society were turning from a provided margin (dream life, obviously, but who cares about the *reality* of utopia?) into something else, something cheaper and shoddier, a stop on the way to Paris by Night. Bohemia was ending. The great arc from Courbet to Apollinaire had touched down. But out of endings come perfections. Cubism was Bohemia's last hurrah, its *summa*; and in this last flaring it laid out before us—lovingly, ironically—the claim that the life of art had made to the pleasures of the middle-class century. The pleasures, the decencies,

2.7. Picasso, *Portrait of a Young Girl*, Avignon, summer 1914. Oil on canvas, 130 x 96.5 cm. Inv. AM 4390P. Musée National d'Art Moderne, Centre Georges Pompidou, Paris.

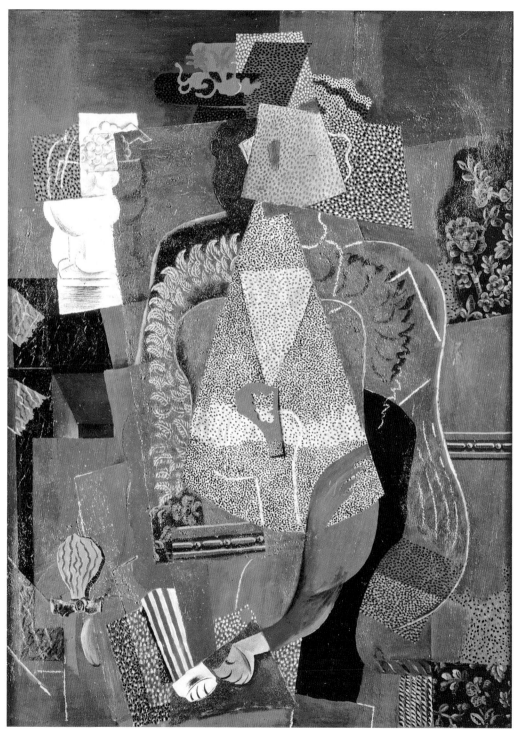

2.7

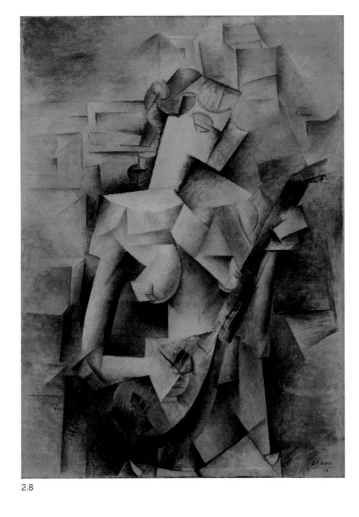

2.8

the self-possession—above all, the sense of being fully and solely a body in a material world, and of this as the form of freedom. From Martin Drolling's *Dining Room* of 1816 (fig. 2.11) to Picasso's *Bread and Fruit Dish* (fig. 2.12)—from the year after Waterloo to that of the first Model T—the way lies straight. *Bread and Fruit Dish* is most deeply an effort to preserve Drolling's intimacy and solidity—to protect and immortalize them against the flood of de-realization. (I think this is why it had to be changed from a scene in a pothouse to holy communion in a curtained niche.) Drolling's world and that of *Still Life in front of a Window* have more in common than, say, the same *Still Life* and Léger's *Hand and Hats* from

2.8. Picasso, *Girl with a Mandolin*, Paris, late spring 1910. Oil on canvas, 100.3 x 73.6 cm. Nelson A. Rockefeller Bequest. (966.1979) The Museum of Modern Art, New York.
2.9. Picasso, Study for *Carnival at the Bistro*, 1908. Blue ink and graphite on paper, 24.1 x 27.4 cm. Inv. MP623. Musée Picasso, Paris.
2.10. Paul Cézanne, *Après-midi à Naples*, c. 1875. Oil on canvas, 37 x 45 cm. National Gallery of Australia, Canberra, purchased 1985.

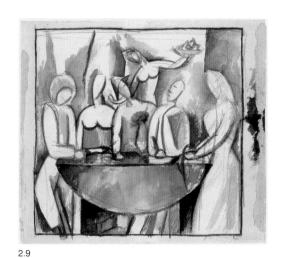

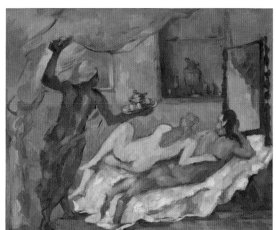

2.9 2.10

1927 (fig. 2.13). For in Léger's world objects have finally disappeared into their commodity form.

▪ ▪ ▪

I am getting ahead of myself. I still have to give an account, in formal terms, of what Cubism—Bohemia—was intent on preserving. Let me steer away from still life and focus on human figures plus the world they make for themselves. I choose two of Cubism's comic high points—and comedy, I think, *is* Cubism's high point—the *Portrait of a Young Girl* (fig. 2.7) just mentioned, done as the First World War was starting, and *Man in front of Fireplace* from two years later (fig. 2.14).

Cubism's world has the following structure. It wishes to state again, this time definitively, that the world is substantial through and through, with space only real—only felt—to the extent that it is contained and so-lidified. Physical reality is something the mind or imagination can only reach out to incompletely, for objects resist our categories; and painting can speak to this ultimate non-humanness of things very well; but only by giving their otherness the form of a certain architecture, a certain rectilinear—indeed "cubic"—*constructedness*. And this constructedness is real for us only if it is not far away, and smaller than us, or maybe just the same size. The world is a set of instruments, utensils, asking for us to reach out and take them. It is property. Bohemians tend to live in places

2.11

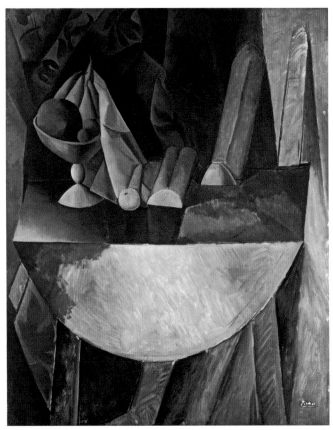

2.12

2.13

where the property is deteriorating: the wallpaper is old-fashioned and peeling, the armchair broken, the music nostalgic, the frame on the mirror a fright. But it does not matter. Walter Benjamin was right: yesterday's fashions—laughably outmoded—are where the dreaming collective lives on. And here, given form at last, is the central dream of the bourgeoisie. The world, for the bourgeois, is a room. Rooms, interiors, furnishings, covers, curlicues are the "individual" made flesh. And no style besides Cubism has ever dwelt so profoundly in these few square feet, this little space of possession and manipulation. The room was its premise—its model of beauty and subjectivity.

2.11. Martin Drolling, *Dining Room*, 1816. Oil on canvas, 64 x 81 cm. Private collection.
2.12. Picasso, *Bread and Fruit Dish*, 1908–9. Oil on canvas, 163.7 x 132.1 cm. Kunstmuseum, Basel.
2.13. Fernand Léger, *Composition with Hand and Hats*, 1927. Oil on canvas, 248 x 185.5 cm.
Inv. AM1982-104. Musée National d'Art Moderne, Centre George Pompidou, Paris.

2.14

Roger Fry says of Picasso in 1921, looking back to the line of work from 1908 to 1916—he says it a little regretfully—that "the obstinate fact remains that the limit of depth into the picture space is soon reached, that these pictures rarely suggest much more backwards and forwards play of planes than a high relief in sculpture. The immense resource [that painting has] of suggesting real distance and, perhaps even more important, the circumambience of space seems to be almost cut off, or at most reduced, in its power to persuade the imagination." Well, yes: because the imagination should not be so persuaded; because the space of modernity is only falsely circumambient: it does not surround us like a circle—the great shape at the bottom of *Still Life in front of a Window* could be understood as a parody of any such claim—it faces us like a piece of wainscoting. We lean on it like a table. We strum the strings of its guitar. We take off in our paper Montgolfier—Picasso actually made paper cutout versions of his *Young Girl*'s toys before reproducing them in paint—for a voyage around its four walls. And this proximity, this tactility, this *coziness*, is the condition of endless mad inventiveness about its particular states. Because the interior is the truth of space—for Bohemia, those last believers in the nineteenth century.

∎ ∎ ∎

"All instincts that do not discharge themselves outwardly," said Nietzsche, "*turn themselves inwards*—this is what I call the *internalizing* of man. . . . The entire inner world, originally thin as if inserted between two skins, has spread and unfolded, has taken on depth, breadth, height to the same extent that man's outward discharging has been *obstructed*." Nietzsche thought that this unfolding of the internal was bound up with forms of consciousness he wished to put an end to: patterns of self-loathing and *ressentiment*, world-refusal and bad conscience. Bohemia did not entirely disagree with that verdict, but it thought that art—the life of art—could turn internalization in a new direction. (Even Nietzsche sometimes shared the hope.) And certainly Cubism knew that the entire inner world, "thin as if inserted between two skins," could be a prison as much as a dream-house. Is *Man Leaning on a Table* (fig. 1.27) a fellow spreading him-

2.14. Picasso, *Man in Front of Fireplace*, 1916. Oil on canvas, 130 x 81 cm. Inv. MP54. Musée Picasso, Paris.

self expansively into the skins of space all round, or is their very thinness asphyxiating? In any case, the thinness—the proximity—was nonnegotiable. It was Cubism's reality principle.

This view of the world survived many changes of medium and simplifications of surface grammar. From 1908 to the mid-1920s, nothing could dislodge it. Collage—and *Portrait of a Young Girl* is collage epitomized, for all that the stick-ons in it are illusions in oil—represented the *triumph* of room-space. Not for nothing was its key material wallpaper. The space it conjured was now literally put together from the little bourgeois's belongings: his newspaper, his sheet music, his matchbox, his daughter's scrapbook, his friends' or dealers' calling cards (fig. 2.15). Never was painting more in love with nearness, touch, familiarity, the world on a table.

In 1926 Picasso did a series of large and small collages of *Guitars* that many now see as his farewell to the medium. (He returned occasionally to collage later, and at one stage in *Guernica* toyed with the idea of incorporating pasted paper elements even there. But it did not happen: 1926 was the last moment at which collage gave rise to major work.) Two of the bigger *Guitars* are made of nondescript or even potentially dangerous materials—in one nails are stuck point-first through a piece of dishcloth—and interpreters have been struck, understandably, by the mood of impatience or aggression (fig. 2.16). But again, room-space is stubborn. The unplayable instrument still hangs on a wall. Another of the three large collages has strips of painted paper wainscoting on either side of the guitar at the center, which make the "wall-ness" of the background—the support is lightly stained wood—explicit (fig. 2.17). And the large *Guitars* are accompanied by half a dozen tiny constructions—*Guitar with Tulle* and the so-called *Dark Guitar* are typical—in which the belonging of the instruments to the interior is given final, naive expression (figs. 2.18 and 2.19). The guitars are upright—little figures in doll's-house compartments, with twists of tulle to make them look pretty. The materials used—fabric, string, buttons, braid, cardboard, nails (unthreatening now), two lead pellets, a vine leaf—reach back to the child's-play origins of the form.

2.15. Picasso, *Bottle of Bass, Glass, Packet of Tobacco, and Visiting Card*, spring 1914. Crayon, and paper collage, 24 x 30.5 cm. AM1984-628. Musée National d'Art Moderne, Centre George Pompidou, Paris.
2.16. Picasso, *Guitar*, spring 1926. String, newpaper, and mixed techniques, 96 x 130 cm. MP87. Musée Picasso, Paris.

2.15

2.16

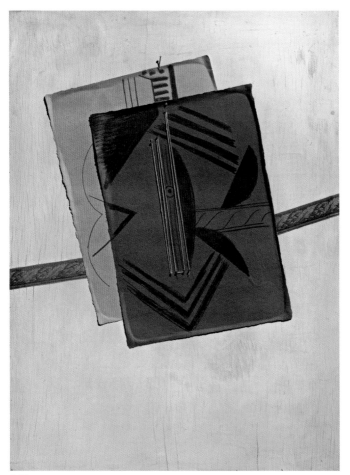

2.17

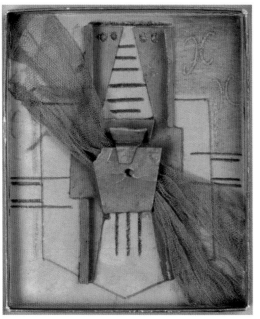

2.18

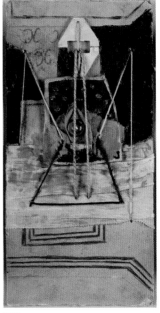

2.19

. . .

Room-space—I want to anticipate a misunderstanding—is not deriva-
tive from subject matter: it does not follow automatically from a still life
setup or figures in an interior. A landscape can instate room-space (as so
many Dutch landscapes do, with their grounds and skies as comfortable
as furniture) and a genre scene posit an unbounded world. Think of the
back wall in Courbet's *Studio* or *Preparation of the Corpse*, or the body in
the bath in Bonnard (fig. 2.20). *Las Meninas* happens in a room, but the
space that the painting as a whole proposes is the opposite of intimate
and touchable (fig. 2.21): it makes a *place* for intimacy, but only as part of
an enormous, ultimately cosmological order; and the order is there in the
room, giving it perplexing depth. There is no ontological difference, in
other words, between the room in the Alcázar and the artificial "world" set
up, with nets and temporary fences, by the Philip IV's huntsmen in the
park (fig. 2.22). All enclosures are at the king's pleasure—divisions of his
great totality, which may or may not last.

Cézanne's still lifes, to move closer to Picasso, mostly posit a space that
is absolute in its proximity to us, but at the same time—this is the true
strangeness—fundamentally unbounded and untouchable (fig. 2.23). Ma-
dame Cézanne in other pictures may be seated in a room, yet time and
again the room fractures around her or evaporates into pure (abstract)
"background." Her homelessness is of the essence. Picasso grasped this
and fed on it, but always with a view to undoing the Cézanne effect.

. . .

Cubism, to sum up, was the last of the nineteenth century's great histori-
cal revivals. And the thing of the past it aimed to resuscitate was moder-
nity itself.

2.17. Picasso, *Guitar*, 1926. Collage of wallpaper, carpet tacks, nail, paper, string, and charcoal on
wood, 130 x 97 cm. National Gallery of Art, Washington, Chester Dale Collection.
2.18. Picasso, *Guitar*, April 1926. Cardboard, pencil, thread, tulle, 12.5 x 10.4 cm. Inc. MP88. Musée
Picasso, Paris.
2.19. Picasso, *Guitar*, May 1926. Cardboard, pencil, ink, string, oil paint, 24.7 x 12.3 cm. Inv. MP95.
Musée Picasso, Paris.
2.20. Pierre Bonnard, *Nude in a Bathtub*, 1941–46. Oil on canvas, 122.5 x 150.4 cm. Private collection.
2.21. Diego Velázquez, *Las Meninas*, 1656. Oil on canvas, 318 x 276 cm. Museo del Prado, Madrid.
2.22. Diego Velázquez, *Philip IV Hunting Wild Boar (La Tela Real)*, c. 1632–37. Oil on canvas,
182 x 302 cm. National Gallery, London.
2.23. Paul Cézanne, *Still Life with Apples and Oranges*, c. 1895–1900. Oil on canvas, 74 x 93 cm.
RF1972. Musée d'Orsay, Paris.

2.20

2.21

2.22

2.23

Perhaps this view of Picasso and Braque's achievement will strike some readers as paradoxical—but only because we are so used to the notion that modern art is always, at defining moments, an arrow pointing to the future. This seems to me an article of faith (maybe borrowed from modernism's original cheerleaders), and largely counterfactual. It leaves us with little or nothing to say about the vision of history underlying many of the early twentieth century's key works—*The Waste Land* and *The Cantos*, for instance, or the regressive semiconsciousness of *Finnegans Wake*; Proust's effort of memory or Kafka's rewriting of the quest; Matisse's pastoral; Bartok's Beethoven and Schoenberg's Brahms. Not that I want to claim in reverse (repeating the mistake of the cheerleaders) that these are the only versions of temporality modern art ever thrived on. Mondrian did eventually exit from the great landscape tradition in which he grew up, and Kandinsky shook off his knights and damsels on the steppe. Malevich (for a while) made art genuinely in the spirit of his "Forward, comrade aviators!" So the claim should be modest. Modernism, as I see it, was just as backward-looking as any other art form, and most often not to its detriment. Its dream of retrieving a lost moment of modernity turns out to have been as potent a fantasy, aesthetically, as any previous regret for Christendom or craft guilds or Greek nudity. Nostalgia can be enervating or electrifying. It depends on the past one harks back to, and whether in practice it can be made to interfere with the givens of the present.

■ ■ ■

By now you will see where my argument is leading. Let me return to *Still Life in front of a Window* (fig. 2.1), and look at it alongside *Portrait of a Young Girl* (fig. 2.7). What matters is the two paintings' feeling for space.

Again it is worth mentioning real dimensions. *Young Girl* is just over four feet high and three feet wide—not monumental, but big enough. It has a portrait format. *Still Life*, by contrast, is landscape size and landscape shape. It is markedly bigger than the 1914 painting: a little taller and much wider, four and a half feet by six and a half feet. And in a sense it *is* a landscape, at least in comparison with the earlier Cubist pictures we have been looking at, which are nonlandscapes through and through. The outside world is an irrelevance for high Cubism. Picasso was once asked, much later in his career, why he had painted so few outdoor scenes. And he replied: "I never saw any [Je n'ai jamais rien vu]. . . . I've always lived

inside myself. I have such interior landscapes that nature could never offer me ones as beautiful." But what about your "open window" paintings? asks Geneviève Laporte. She points to a moment just after the First World War at Saint-Raphaël, and then again in 1940 at Royan. "An open window," says Picasso, "that's not a landscape, it's something else. And then, it was the start of the war. A window that opens when everything is collapsing, that's something, don't you think, that's hope?"

A window that opens when everything is collapsing. . . . But *Still Life in front of a Window* was painted in 1924, not 1940: there are no bombers in the offing. The painting goes back to Cubism, for sure. It is a grand demonstration of Cubist ways of doing things, but the feeling for space underlying the display has begun to shift. No doubt the interior is still primary, but an immense amount of effort and ingenuity seems to have gone into making the outside world—the balcony, the three little clouds, the dome of the heavens drawn as a light-blue parabola—part of the scene up front (fig. 2.24). The balcony railings provide an alternative container— almost a second room-space—for the mandolin. The blue parabola bends toward us, and seems to generate much of the shape of the guitar. The clouds float forward. The rails are the edges of a reversible cube. It is as if the painting wishes, at last, to see if a room can really expose itself to a sky and adjust to the outside world's dimensions—to see if the actors on the tabletop can stand up and move about, exultantly, in the light of the window. The little simulacrum of the balcony underneath the table states the ambition. Perhaps we should even see the black and white circle in similar terms. One way or another, the world must enter the room.

But here are the questions. Is this decadence? Is the appearance of the open window—the effort made to have it be part of things—just a symptom of Cubism dying, not a sign of its reaching toward a new form of life? If a scene set up in front of a window is truly to become the new Cubism's matrix, what becomes of the old Cubism's raison d'être: its feeling for matter, proximity, belonging, owning, *using*? Or, putting the question another way, is it the case that the outside *has* really entered the room in *Still Life*, and altered its phenomenology? Obviously Cubism could insert doors and windows into its decor, and ratchet up its color to suggest Mediterranean heat. Reversible cubes could let in blue. But did this mean that exteriority really penetrated—really put Cubism's fundamental metaphors under pressure? Does room-space still rule?

2.24

Windows opening onto the wider world certainly appear all through Picasso's work in the 1920s, and often in paintings of real ambition. Look, for instance, at *Bottle, Guitar, and Fruit Dish* from February 1922 (fig. 2.25). It is a painting Picasso kept in his studio as a point of reference: one can see it on the right-hand side in a photo from 1928 (fig. 2.26). A blue window is undoubtedly there in the painting, top right, and presumably the high-color hatch-work across the table is meant to indicate light flooding toward us from it, making everything glisten. But does it work?

2.24. Picasso, detail of *Guitar and Mandolin on a Table (Still Life in front of a Window)*, fig. 2.1.

Is the window more than an add-on? This is one of the questions Picasso was struggling with, after a two-year hiatus, in 1924. The six-foot *Still Life*, I should make clear, belongs to a complex series of interiors begun that spring and still going strong in winter (figs. 2.27 and 2.28). Compare the sense of window and room in *Mandolin, Fruit Dish, and Cake*, painted in May, with *The Red Tablecloth* from December. Is not the window in *The Red Tablecloth* essentially a piece of inert decor, provided as foil for the foreground silhouettes? *Mandolin, Fruit Dish, and Cake* is different. It is a painting that deserves more attention than it has been normally given. If we think of it as a prototype of *Still Life*, what is striking by contrast is the way the outside world of the balcony and sky in *Mandolin, Fruit Dish, and Cake* leaps forward, over the top of the still life paraphernalia, and lands its light in our laps. The large *Still Life* looks static by comparison. But dynamism, in the earlier painting, has been bought at a price. The outside's arrival in the room is *Mandolin, Fruit Dish, and Cake*'s whole subject, to which everything else is subordinated, including color; and the object-world on the table has been reduced to scaffolding—a set of placeholders—for that pure spatial pressure. I for one (remembering Wittgenstein) feel a nostalgia for the touchable. The *Young Girl*'s confetti finery (fig. 2.7)—tactile, vivid, various—flips back to mind.

91

I admire *Mandolin, Fruit Dish, and Cake* enormously. What holds my attention is the buckling of space within it, and the high energy of its points of light. But the picture is a structure—a set of propositions—as opposed to a place where things materialize. The extraordinary *Dark Still Life* Picasso made in these same months takes the tactic to its logical conclusion (fig. 2.29). Substance now is just a scattering of sand.

Look one more time at *Still Life in front of a Window*, and compare it to *Guitar and Newspaper* from 1915 (fig. 2.30). Here are the questions. Would it be possible for Cubist room-space to open to a further world? If it did, would that be a good thing? How could outwardness—an outside overtaking and informing the enclosed space of a room—ever be Cubism's subject? The big *Still Life* is brilliant, overwhelming. It challenges us to resist

2.25. Picasso, *Bottle, Guitar, and Fruit Dish*, 1922. Oil on canvas, 116 x 73 cm. Nahmad Collection.
2.26. Roger Viollet, Picasso and unidentified man in his studio in Paris, 1928. Photograph.
2.27. Picasso, *Mandolin, Fruit Dish, and Cake*, 1924. Oil and sand on canvas, 97.8 x 130.8 cm. The Metropolitan Museum of Art, New York, Jacques and Natasha Gelman Collection, 1998 (1999.363.65).
2.28. Picasso, *The Red Tablecloth*, 1924. Oil on canvas, 98.4 x 131.4 cm. Private collection.

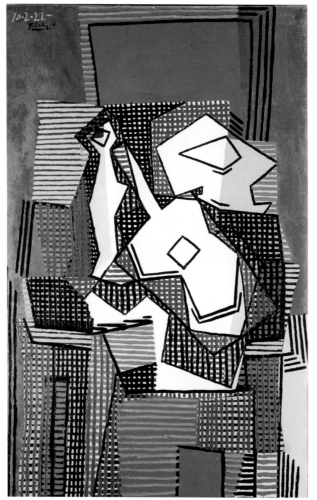

2.25

2.26

2.27

2.28

2.29

its inventiveness, but does it not at the same time admit its own *forced* quality—its theatricality, its framed and concocted stunts? "I've always lived inside myself." The outside is something I have never really seen. So maybe the room's leakage into depth—the seeming necessity now to put things in front of a window—is something I have no control over. It is, so to speak, the style producing its ending in me. But I am Picasso, after all. I refuse to obey the logic of dissolution. I shall take hold of the leakage and make it a theme—a form. Could even the forced quality of the new outsidedness be made a value? We circle back here to Nietzsche-type issues. The interior, after all, had been the *Grundform* of a Cubism in pursuit of Truth. Could the forcing—the staging—the introjection of outside into interior—be made the sign of an Art no longer under Truth's auspices?

"If the world had no substance," says Wittgenstein—meaning, for Picasso, if the world was no longer room-shaped—"then whether a proposition had sense would depend on whether another proposition was true. In that case we could not sketch any picture of the world (true or false)."

 ■ ■ ■

2.29. Picasso, *Mandolin on a Table*, spring 1924. Oil and sand on canvas, 97 x 130 cm. Inv. MP82. Musée Picasso, Paris.
2.30. Picasso, *Guitar and Newspaper*, 1916. Oil and sand on canvas, 101 x 66 cm. Nationalgalerie, Museum Berggruen, Staatlichen Museen, Berlin.

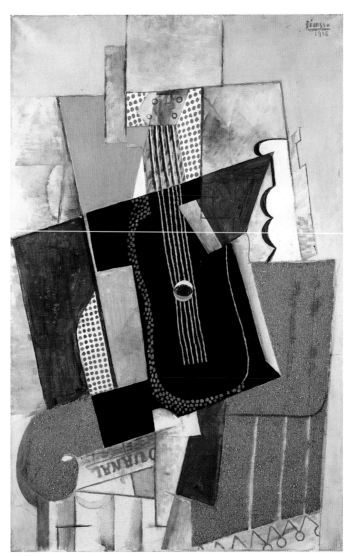

2.30

These questions can be made less all-or-nothing, I hope, by going back to 1919. Geneviève Laporte, you remember, reminded Picasso of the line of open windows he had done that summer at Saint-Raphaël. There are scores of them, and it is important that they are all small-scale and done in pencil or watercolor or gouache. Oh, and there is one with an airplane in the sky (fig. 2.31). We might compare it in passing to Matisse's view through the windshield of an automobile two years earlier, on the road to Villa-Coublay (fig. 2.32). Two landscapes—two interiors—of the early twentieth century.

The most beautiful and finished of the Saint-Raphaël paintings is a gouache measuring fourteen by ten inches (fig. 2.33). Many of the elements of the 1924 *Still Life* are already there. But the difference between

2.31

2.32

the two paintings is immediately clear. It has to do primarily with whether the still life objects are in the room or at the room's threshold. In 1924 they are up front on the table, close to us in spite of the great-circle barrier, decisively inside. If the outside world surrounds and informs them—and I think this is what Picasso wanted—it will do so by coming *into* the room, and giving the familiar objects a new kind of intensity (which may at the same time be a new kind of unreality). At Saint-Raphaël something else is at stake. Only compare the appearance of the balcony railings underneath the table, which obviously the 1924 painting is repeating. In 1919 the balcony with its bars of light and shadow is *part of* the still life. At moments it feels as far forward as every other still life element; at others it seems to draw the guitar and fruit dish back further and further into its liminal territory. The still life objects on the table have become a set of elaborate architectural transparencies. Picasso, we know, worked like a beaver at making the architecture substantial and insubstantial at the same time (figs. 1.23 and 2.34). And it had to be both (as it certainly is in the gouache) because guitar and fruit dish had to be made the place

2.31. Picasso, *Window Open to the Sea, and Airplane in the Sky*, October 1919. Gouache on paper, 19.5 x 11.1 cm. Musée Picasso, Paris. Inv. MP856.
2.32. Henri Matisse, *The Windshield, on the Road to Villa-Coublay*, 1917. Oil on canvas, 38.2 x 55.2 cm. The Cleveland Museum of Art, Bequest of Lucia McCurdy McBride in memory of John Harris McBride II 1972.225.
2.33. Picasso, *Still Life in front of a Window*, 1919. Gouache and pencil on paper, 30.5 x 22.5 cm. National-algalerie, Museum Berggruen, Staatlichen Museen, Berlin.
2.34. Picasso, *Fruit Dish and Guitar*, 1919. Mixed media on cardboard and canvas, 21.5 x 35.5 x 19 cm. Inv. MP257. Musée Picasso, Paris.

2.33

2.34

where outside becomes inside. The objects are at the threshold. They *are* the threshold; or, maybe better, in being a threshold—a just-sufficient barrier, a little labyrinth through which eye and light can pass more or less unobstructed—*they are the room*; or enough of a room for us moderns. Give Le Corbusier a year or two, and he will make Picasso's idea manifest (fig. 2.35) (The man for whom the house in the photo was built, Raoul La Roche, was one of Cubism's great patrons. On the left-hand wall is a Picasso still life from 1922.)

But Picasso was not Le Corbusier. The 1924 *Still Life in front of a Window* means to be immediately graspable as a space with objects in it, not a shifting virtuality in which objects cede altogether to planes (fig. 2.36). The space in *Still Life* is finite, and the bottle and instruments are its anchors. Certainly at Saint-Raphaël Picasso had come close to a Corbusian world (figs. 1.3 and 2.37). But he had drawn back from it.

■ ■ ■

I think that he did so because ultimately he could not make the kind of spatiality he was exploring in 1919—the new kind of threshold experience—work. He could not make paintings out of it. And the acid test of a spatial idea, in Picasso's case, was whether things tried out first in pencil or watercolor led finally to a big painting, a life-size painting—one in which the vision of space and objects went from miniature to monumental. Monumental in Picasso does not mean permanent and overweening: it means substantial, in the *Tractatus*'s sense. Big paintings, he seems to have believed, "reach right out to reality." They are laid against reality like a measure.

By the fall of 1919 Picasso was back in Paris. The Saint-Raphaël setup was still on his mind. He made two or three attempts at scaling up the summer's ideas to midsize, exhibition proportions, and then—is there a flavor of desperation to the move?—he stretched a canvas ninety-one by forty-six inches, and painted a picture larger than anything he had done since the *Three Women*, long ago in 1908. *Open Window* is the name that

2.35. Le Corbusier, Maison La Roche, Paris (view of gallery and balcony with works by Picasso and Lipschitz), 1926–28. Photo by Fred Boissonnas, 1926.
2.36. Le Corbusier, Maison La Roche, Paris (view of gallery and balcony with works by Picasso and Gris), 1926–28, Foundation Le Corbusier.
2.37. Picasso, *Table in front of a Window*, 1919. Oil on canvas, 35.5 x 27 cm. Marina Picasso Collection.

2.35

2.36

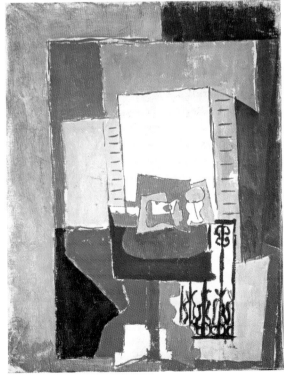

2.37

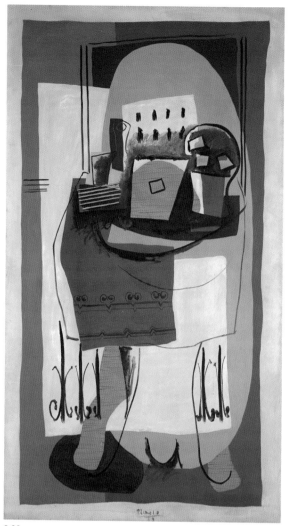

2.38

2.39

gets attached to it (fig. 2.38). (We get a sense of *Open Window*'s scale—and its saleability—from a photo taken in the stairwell of the dealer Paul Rosenberg's apartment some time in the late 1930s [fig. 2.39].)

The new canvas is ruthless. It takes the space of previous Cubism and reverses its every term; Saint-Raphaël looks half-hearted by comparison. For the picture here has *become* the window: the off-white rectangle painted on all four sides, and the light-blue and dark-blue rectangles inside it, reiterating the frame, seem meant to signal that the picture as a whole is a transparency. Matisse was on Picasso's mind (fig. 1.7). But the comparison, to say it again, is crushing. Matisse's window is realized: in it hard glass and total translucency coexist. They are concentrated—materialized—in the glass and liquid of the goldfish bowl. And this was easy, or at least possible, for Matisse because space in his painting had always been, imaginatively, infinity caught in a jar. The fishbowl, as many have said before, stands for Matisse's eyeball. The fish are brilliant floaters.

Picasso's reality is not the eye but the hand. Remember the sketchbook pages from 1919 and 1920, where the objects on the Saint-Raphaël table are edged closer and closer to the world of touch—of possession (figs. 1.18–1.22). Nothing is touchable in *Open Window*. The objects on the table have been reduced to flat tokens, with light leaking in and across their perfunctory contours. All this is deliberate, of course: the objects are clearly intended to *cede* to the light, so that the light from the window becomes the picture's reality effect. But does it? I do not think so. For me the picture's object-world goes on sliding and congealing into a vaguely humanoid ghost. Space is nowhere and everywhere. The room is reduced to leftovers: a piece of wainscoting toward the left, a hint of cast shadow, a patch of floor poured in for the table to stand on. There is no inside for the outside to enter: here is the contrast with 1924. No interior, and therefore no manifestation—no materialization—of anything.

The point is not to flog the dead horse of a Picasso failure, but to try to specify what kind of failure it is, the better to understand what happens later. With that in mind I shall do one more thing. A main sign of *Open Window*'s desperation, in my view, is the way it tries to give back its scattered pieces of the object-world a last wisp of substance by having

2.38. Picasso, *Open Window*, 1919. 209.5 x 117.5 cm. Kunstsammlung Nordrhein-Westfalen, Düsseldorf.
2.39. Unknown photographer, Picasso's *Open Window* in Paul Rosenberg's apartment stairwell, Paris, late 1930s. The Rosenberg Archives.

them take the form of a figure. The mutation of table legs into human ones is the clumsiest token of this. But a figure in Picasso—however ghostly, however counterfactual—is never blurred or evaporated by light (fig. 2.40). Light forms it, light defines it. Light gives it exactitude, to use Picasso's language. Let me ask the reader, then—I can do this without wincing because by now you know the painting too well for an art historian's stunt to spoil it—to turn the 1924 *Still Life* (fig. 2.1) from horizontal to vertical, with the dark right-hand side at the bottom. The painting is quite beautiful this way up, and begs comparison with some of the great Cubist standing figures from 1913 and 1914. But my purpose is limited. I simply want to dramatize the weight and opacity of *Still Life*'s "figure" as compared to the one in *Open Window*; and to suggest that this opacity— this obstruction—is something Picasso cannot do without. Outwardness, if Cubism is to include it—and it does seem that Cubism is now obliged to escape from the little space of Bohemia—will have to be shown coming to the object and surrounding, not dissolving, it. The room will have a window, but the picture will still *be* a room. Because being itself, for Picasso, is being "in." It is a body, a solid, reaching out to walls and floor.

■ ■ ■

To sum up. In the years immediately following the First World War, Cubist space disintegrated. This happened not just because Bohemia disintegrated, or artists like Picasso ceased to belong to it, but because the long form of life that Bohemia had represented—represented by opposing— had been irrevocably destroyed. I have deliberately refrained so far from bringing on old photos of Picasso and his friends, because I am afraid of their spurious vividness. Yet one is irresistible: Braque in the studio on the Boulevard de Clichy, taken by Picasso in 1911 (fig. 2.41). This is Bohemia's world. (Look especially at the wonderful, preposterous old wallpaper in the background, with its Douanier Rousseau dream of the jungle.) The world was fading from the photographer's plate. Suddenly the self-sufficient proximity of things, on which Cubism had rung such endless

2.40. Picasso, *Figure*, 1927. Oil on canvas, 100 x 82 cm. Inv. AM2727P. Musée National d'Art Moderne, Centre George Pompidou, Paris.
2.41. Picasso, The painter George Braque in a military uniform photographed in Picasso's studio at 11, Boulevard du Clichy, 1911. Modern gelatin silver print from original glass negative. Inv. DP 73. Archives. Musée Picasso, Paris.

2.40

2.41

changes, began to be experienced by painters as an airlessness and repetitiveness, an elegance, a set of tricks and tropes. Proximity—room-space—had to be exposed to something else, something outside it. But how to do so without everything that Cubism had made possible going into free flow? "Everything" here meaning firm structure, specific gravity, a love of particulars, complex interrelatedness, the look of inquiry and calibration.

How could these values be saved? Here is *Still Life*'s answer, as I understand it. Painting will pull back from the threshold—the window and the balcony—and place its objects firmly in the room (fig. 2.42). Room-space remains its reality. Objects and bodies are only given weight and identity in painting by being enclosed—by existing in relation to a finitude they call their own. Being is being "in." But this kind of enclosure is no longer a given. It has to be brought to life in each painting, seemingly ad hoc, and doing so can now only be managed differently: an inside becomes vivid only in relation to an outside—to what it is not. And this outside cannot simply be cited or signified, in the way it is in the worst of the mid-1920s interiors (fig. 2.28). The outside must *appear*; that is, come into the room—deep into it, flooding and electrifying its inhabitants. The objects will still be the same, but transfigured.

We have left the ontology of Cubism behind. Cubist objects existed *for us*. They offered themselves to be touched, to be played. Of course they were solid and specific, and I have been arguing that this was their glory; but—here is the central paradox—they were only specific by reason of their being part of a landscape of internalization. "I have always lived inside myself. I have such interior landscapes that nature could never offer me ones as beautiful." (How Nietzsche would have snarled at this! The idea of preferring one's miserable mental phantasmagoria to the glitter on the bay!)

But *Still Life in front of a Window* is Nietzschean. In the sense that its objects are no longer solid and serviceable, least of all for purposes to do with our inner world. They are faces. They rear up higher than us, wafer-thin. They are not *for us* any longer: the great-circle barrier intimates as much. And this is because the outside has really come to them, in from the window. It has touched the objects, stamped itself on them. They have become outsides. Outsides are all they are. Internalization, to use Nietzsche's great bad word, cannot lay a hand on them.

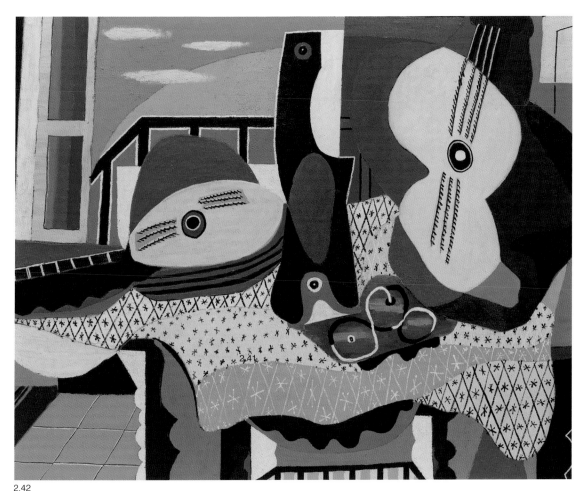

2.42

The best commentators on *Still Life*—I think of Jean Boggs and Eliza-beth Cowling—have been struck by the painting's theatrical aspect. The table is a stage, and the instruments performers. There is maybe a pro-scenium arch up above, and floodlights glare at the guitar and tablecloth. Cowling points out that just weeks before *Still Life* was started, Picasso had put the finishing touches to a series of designs for the ballet *Mercure*. She makes the link to the gloomy stageset for a scene in the ballet called *Night* (fig. 2.43). This is helpful—as long as we then insist that *Still Life*

2.42. Picasso, detail of the window in *Guitar and Mandolin on a Table* (*Still Life in front of a Window*), fig. 2.1.

2.43

is Day to *Night*'s Night. It wants above all to conjure a room in which everything is imprinted with a dazzling exteriority, and *light*—noon—is that exteriority's carrier. Floodlight is the wrong metaphor. This is sunshine, coming from all directions. Sun streaming in from behind, yes, but so pervasively, so irresistibly, that it has the appearance of doubling back on itself and coming also from where we stand. Maybe the balcony under the table ultimately signals that. We are standing on *it*, outside the window, looking in. The stars on the tablecloth are anti-night. They are pure scintillation.

■ ■ ■

I said that the objects in *Still Life* are faces. Some people, I know, see the cluster of things on the table coming together into a single enormous clown face, staring us down. The arc in the sky is the line of the skull, the two sound holes pupils, the bottle a nose, the black and blue wavy line a mouth. Nothing I say will counteract this reading, if it happens—seeing faces in things is a hard-wired human activity, especially when

2.43. Walery, Photo of Picasso's scenery for "La nuit" in the ballet *Mercure*, 1924. Archives Erik Satie.

confronted with the unfamiliar. But I do not see the face, or keep seeing the face, myself. Above all I do not see it when, all too rarely, I am in front of the full-size picture and not a miniature, disembodied reproduction of it. The array of things in reality is too big for a face, and too close, and too flat. To say it again, the key quality of the array is its combination of closeness with ontological distance. The things lack substance. They—their interrelations—have no gradient, no modeling. The stars and crosshatch on the tablecloth cancel the idea of depth. And crucially, when I am "face to face" with the canvas the astonishing strangeness of Picasso's paint handling—it is radically different from any other of the mid-1920s still lifes, and the way it is painted seems inseparable from the business of pushing still life to maximum size—cancels the anthropomorphic urge. The paint is paper thin, almost unmarked by the brush, flat as a pancake. Everything is brittle, cursory, as if stamped out by a machine. Where there has to be detail—the pattern on the tablecloth, the strings of guitar and mandolin—it is laid on with minimal, cynical efficiency. Objects are illusions—facades. (The great exception in *Still Life*—and of course it matters that it is put right next to the main array—is the painting of clouds, sky, and railings, which is crusty and thick, almost tactile. So that here too, as regards touch and substance, the mind is confronted with distance and proximity partly reversing themselves.)

None of this is meant to suggest that the elements of a face are not to be found in the central oval. Of course they are. Eyes especially—too many of them. I think we are given the elements of a face, but not offered the conditions in which the elements can become a totality. Not offered the right kind of depth or contour. Michael Fried might say that the concept that is needed in the case is "facing-ness": things in a picture set up above all to enact their turning toward us, their looking back at us, their entire disclosure. Of course always behind the notion of facing-ness will lurk the totality "face"; but the ultimate point of Picasso's painting, I am arguing, is to show the humanness implied in that metaphor—the reciprocity, the totality—replaced by something else. *A face is a form (the form) of interiority*—its outward manifestation. The guitar and mandolin are anti-faces. *Still Life in front of a Window* is trying to assemble a room-space in which the usual resonances of "interior" are put to death. Again the great *Bread and Fruit Dish* (fig. 2.3)—the visceral curtain drawn back,

2.44

the altar frontal, the objects more real than they ever have been, the air of secrecy and revelation—is the relevant comparison.

■ ■ ■

It is no mean feat for painting to put objects in a room, and *describe* the room, and have light enter it. (This is the achievement that talk of the clown face prevents us from recognizing.) We tend to think of such three-fold matter-of-factness as something the European tradition makes possible quite easily, as part of its bourgeois inheritance. *The Arnolfini Wedding, The Dream of St Ursula, Las Meninas.* But moments like these are rare. And it is even rarer to have light in a picture enter the room not as a mysterious effulgence but as an object among objects, attaching itself

2.44. Pieter de Hooch, *The Linen Cupboard*, 1663. Oil on canvas, 77.5 x 72 cm. Rijksmuseum, Amsterdam.

to things, vying with them for priority. Vermeer and De Hooch did it, and perhaps they are the best point of reference (fig. 2.44).

You may feel that next to De Hooch the Picasso looks strained. Well, yes: the equality between objects and light in Picasso, between inside and out, is inseparable from a show of cleverness. The painting is out to dazzle. We may regret the improvised empathy with space that Picasso was capable of in *The Blue Room*. The price of presence, then, in a disintegrating bourgeois world, is brashness. But even this asks for a Nietzschean twist. The art of the end of internalization, so Nietzsche hoped, would be a kind of comedy. Mediterranean brightness and frivolity; Aristophanes hooting Plato off stage. Of course one does not normally think of Picasso as a comedian. "Be serious," Marie-Thérèse Walter remembers him saying all the time. But *Still Life* is comedy, I think, in the full Nietzschean sense. Maybe the shapes propped up on the table could best be understood as masks—false faces, many of them, all with enormous fixed grins. But then the point would be, again, that in this world—on this stage— there is nothing behind the mask. Reality is all outsides. Auden writes somewhere about the kind of person who pines for surroundings "where the beauty [is] not so external,/ The light less public and the meaning of life/ Something more than a mad camp." But these may be precisely the things—the light and the beauty—that art is left with in 1924. That is *Still Life*'s proposal. They are all I can see, says the painting—all I can trust. These masks and this music. And aren't they enough?

LECTURE 3

WINDOW

The Three Dancers has always struck viewers as one of Picasso's most grave and ferocious productions, and a turning point in his art (fig. 3.1). Picasso himself, talking to a friend much later, said he preferred it to *Guernica* (fig. I.9). "It was painted as a picture, without ulterior motive." The French is cryptic: "C'est peint comme un tableau sans arrière-pensée." Maybe he meant, again with Rimbaud's dictum in the background, that the work happened essentially without him—him the thinking individual—and all he could do afterwards was look at it as baffled (and admiring) as the rest of us.

A few weeks after the canvas was finished, in early summer 1925, a photograph of it appeared in issue four of a new magazine, *La Révolution surréaliste* (fig. 3.2). Over the page was a reproduction of the *Demoiselles d'Avignon* (fig. 1.6). A year later Picasso showed the painting for the first time, in a stupendous survey of his recent work at Galerie Paul Rosenberg. Fifty-eight paintings, grandly arranged, with the accent falling on still lifes from 1924 and 1925. And presumably (photos in the Rosenberg archive suggest as much) the new painting of women dancing must have stood out, in size and temper, from the works all round. It was large: eighty-five inches high and fifty-six inches broad. Roughly seven feet tall, with the three figures each registering as life-size or beyond.

The title the painting now gets in the literature is unobtrusive, but I prefer the one in *La Révolution surréaliste*: *Jeunes filles dansant devant*

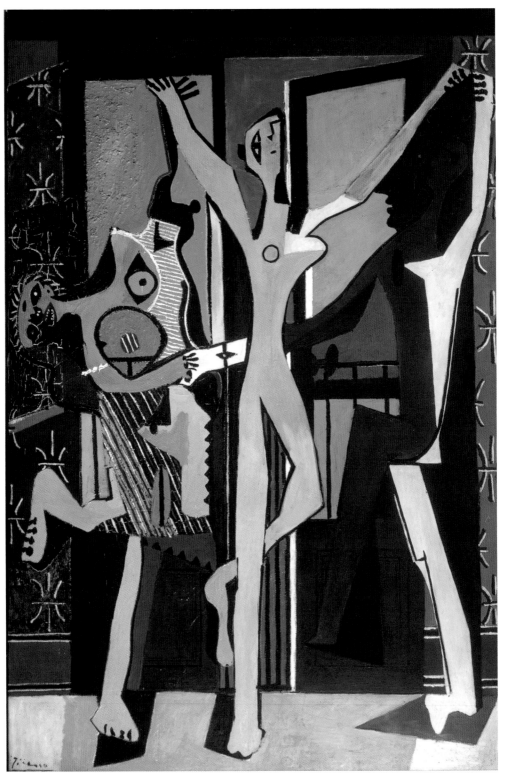

3.1

3.2

une fenêtre. (Or in *Documents* five years later: *Femmes dansant devant une fenêtre*.) Inevitably I shall shorten this to *Young Girls Dancing*, but "in front of a window" should always be understood. Because one main reason this painting, for all its standing as a totem of twentieth-century art, has been written about so badly is that its iconography—its dramatis personae and the so-called "violence" or monstrosity of their mood—is what has preoccupied historians, and its overall setup has been taken for granted. This is a mistake. An icon is only as effective as its specific staging. These dancers, like all dancers, are deploying the body in space—taking space inside themselves, trying to shape and subdue it, trying to give it human form. And space—this is always the other subject of dance—resists them. It presses in on them with its particular character. It constrains and invades them. They stand awkwardly upright in it, keeping their balance or losing it, kicking and bending, but only so far and so high.

The window and room, in other words, are for me as much players in *Young Girls Dancing* as the young girls themselves. In this sense the picture is directly in dialogue with *Still Life* of 1924 (fig. 2.1). It swings *Still*

3.1. Picasso, *The Three Dancers (Young Girls Dancing in front of a Window)*, 1925. Oil on canvas, 215.3 x 142.2 cm. Purchased with a special Grant-in-Aid and the Florence Fox Bequest with assistance from the Friends of the Tate Gallery and the Contemporary Art Society, 1965. Tate Gallery, London.
3.2. Picasso, *La Révolution surréaliste*, no. 4, photograph of *Three Dancers*, 1925.

Life's format from horizontal to vertical, and presses its (human) objects back again toward the threshold, rather in the way of 1919. It is, if you will, a return to that year's *Open Window* (fig. 2.38)—a demonstration that what the previous picture had tried and failed to do was possible. Window and body could be put in contact. Both could be materialized. It was not inevitable that in the window—in the picture as window—everything would melt and flow into bland uniformity. Figure and outside could face off, so to speak: they could do battle. I believe, in short, that the famous new mood of *Young Girls Dancing* is most profoundly a temper, a tonality, generated out of a new vision of space. It is the human clothing of that space. Of course the ultimate point of space in painting is to make real a moment of being-with-others—a disposition of ourselves as bodies, a sense of panic or potential, a feeling of confinement or power. Space is not a subject "in itself." But no other subject, in painting, can be made to count without it. Remember the sentence in the *Tractatus*: "Pictorial form is the possibility that things are related to one another"—I would say, above all related spatially—"in the same way as the elements of the picture. *That* is how a picture is attached to reality . . ."

■ ■ ■

I begin with description. Three women, hand in hand, are dancing in front of a window. Actually the windows are two, and the right-hand one seems to swing open, though whether out toward the balcony or into the room-space is as usual not clear. But open sky is visible beyond it, stage center, silhouetting the nearest dancer's head, shoulders, and waist. The blue of the sky is dominant; and properly we should speak of blues in the plural—at least three of them, if not five or six. The sky through glass is decisively different from the sky in the gap. It is lighter and brighter, and hard as nails.

I say "three women," but without the title would we be sure of all three's sex? The individual on the right has a strange, almost severe pinhead colored brown, with an eye that looks like nothing so much as a pirate eye patch held in place by a strap. Nothing in the body below seems markedly male or female. The black and white markers for breasts have been stripped down to a triangle and oval in collision, and waist and buttocks have never been less fleshly. "All the same," said Picasso to Penrose, "it's a funny thing, flesh—to be built of flesh—imagine a house built of

flesh—it wouldn't last long." The right-hand figure, to pick up Picasso's metaphor, is like a body built of cut cardboard. I am never sure if the black line tracing the edge of the deathly white torso is to be understood as the figure's backbone, or if that is what motivates the abstract vertical going down from triceps to heel. And notice the way this absolute black—this black antibody—is added to the dancer's other leg, the one that is feebly and stiffly high-stepping. (Hard to see, this; it interrupts the paneling of the door.) It falls from the calf like a shadow made of lead.

Then, notoriously, there is the dancer's shadow above. A giant head, clamped onto the small one like a mud helmet—a thick black profile, again in my view not given much of a gender, a faint gray eye, and a tall pointed skull, with what look to be short rigid dreadlocks exploding from the top. The tufts of hair, one soon realizes, are two sets of fingers, belonging to hands reaching out to grip one another. But the black skull and dreadlocks are stronger, perceptually, than the commonsense alternative.

Much has been made, iconographically, of this second face. Picasso once said that as he worked on it he was thinking of the death of a Spanish painter friend—one of the last survivors of his Barcelona cohort—a few weeks earlier. "I think [the canvas] ought to be called 'The Death of Pichot'," he told Penrose, "rather than 'The Three Dancers'." Well, why not?—as long as we resist the temptation to make the shadow head *into* Pichot, and have death be localized and personified. Death is everywhere in the picture. The black head is maybe an attempt to tie it down; but I would say that spatially—and space is what the blackness is there to create—it is precisely the shadow head's placelessness that is most uncanny. Does the blubbery profile belong in the window, like a shadow cast on its pane of glass? Or is it in front of the spindly middle dancer's forearm? Does it fit—is it clamped—on the right-hand dancer's shoulders? Or is it a void behind her?

It is the nowhereness of the death's head—the fact that none of these possibilities quite fit, or can be stabilized—that makes the eye turn back to it constantly, half fascinated half unconvinced. And the to-and-fro of locations goes along with the figure's whole indescribable *mood*. Maybe the head is death in the room, but this does not mean, in Picasso, that we are given a firm emotional register for it. It may be ominous; it may be overweight and absurd. Comedy and tragedy—the pinhead and the phantom—coexist. All the heads in *Young Girls Dancing* are double (or

even treble), visually and in terms of affect. That of the weird cavorter on the left is famously so: she has a moon mask in profile, bland and beneficent, but the mask immediately becomes the forehead and cranium of an open-mouthed, wide-eyed grinning face. Commentators on this episode most often seem sure of the affect accompanying the result: they reach for their grimmest and wildest vocabulary. I find myself hesitating to pull out the stops.

Certainly the dancer on the left is a dislocated creature. Her upper body twists back on itself so dangerously that the sky through the window seems to come right through her, through a hole in her chest, with a strange red and white bull's eye sizzling in the middle of the blue. "Nameless wildness" is a phrase that comes to mind in her connection. "Nameless" meaning on the edge of the human: in the place—to which humans go repeatedly—where normal embodiments and identities move out of themselves into ecstasy or paroxysm. Ecstasy meaning *ec-stasis*: being out of place, losing one's stance on the ground. Paroxysm meaning *paroxsys-mein*: to goad, to sharpen, to convulse. But into what other state—what other humor or mode of being—is precisely the question.

The woman is nameless wildness. Of course it is not likely that the Brethren of the Free Spirit, from whom the phrase is borrowed, were part of Picasso's mental furniture. But Greek thinking—Dionysian wildness— certainly was (fig. 3.3). Many writers have called the figure in Picasso a maenad—an adept of Dionysos dancing herself into frenzy. And the word seems right. But only if we imagine Picasso in Naples and Rome and the Louvre feasting above all on the maenad's *not-belonging* to the world of affect as normally given us—not being either violent or smooth-flowing, or manic as opposed to agonized (fig. 3.4). The point of the dance is the nowhere it leads to—the exit from the categories.

■ ■ ■

One of Picasso's great subjects was faces and doubling—the effect of doubling on the ability to name, to make human, to put in place. Rimbaud's dictum is relevant. And much the same question applies—though maybe

3.3. Kallimachus (fl. 410–400 BCE), *Dancing Maenads*. Marble, h. 143 cm. Roman copy of Greek original (c. 410–400 BC). Uffizi, Florence.
3.4. Brygos vase painter, *Maenad (Bacchant)*, Attic Wine Cup, 490 BCE. Red figure vase painting on white ground. Staatliche Antikensammlungen, Munich.

3.3

3.4

more weakly and crudely—to the figure center stage in *Young Girl Dancing*. She too wears the mask of Janus. At one moment her head is narrow and her features pinched: she seems to be looking right, with a tiny mouth, a button nose, the bare line of an eye socket. But is this really her? Isn't her head thrown idiotically back, turning upward and leftward, as if catching the sun through the window? And isn't what we initially took for an outsize ear in fact a great grinning toothy mouth, absurdly rhyming with the grin of the maenad at left? And in this case don't the two possible readings—the crude duck-rabbit substitution—exactly cancel one another out? In the two outer dancers, doubleness of features does end up making a kind of totality, which may be elusive but at least is *something*. But once one has seen the two-facedness of the middle protagonist, her identity disappears. She is neither idiot ecstatic nor prim mistress of the dance. She is nothing, one might say—a place of pure transformation, where left and right hold hands.

Lawrence Gowing, when the Tate Gallery was first given *Young Girls Dancing* in the 1960s, launched the idea that at root the picture was a crucifixion, with the central dancer nailed to the cross. Once the suggestion is made, it is hard to avoid reading the spiky black fingers as nails. But I follow Picasso himself in resisting the parallel. Penrose told him in 1965 that he "had been looking for other pictures like it and had found only [your] *Crucifixion*" of 1930 (fig. 3.5). To which Picasso replied: "No, there are no others that resemble it—none. The *Crucifixion*, yes, there's something, but it is the only one and it is very different." For what matters most in *Young Girls Dancing*—here is my main reason for resisting—is the equality or inseparability of the figures in the room; their twisting into a Moëbius strip. They are Three Graces or anti-Graces, not a victim-god plus attendants. Maybe we should follow Picasso's earlier hint and think of the painting as a Dance of Death—done with a Waning-of-the-Middle-Ages sense of doom and grotesquerie. (I like best as comparison the tiny Dance of Death illuminations that were maybe designed by Holbein (fig. 3.6). Partly I fix on them because the action takes place most often in

3.5. Picasso, *The Crucifixion*, 1930. Oil on plywood, 51.5 x 66.5 cm. MP 122. Musée Picasso, Paris.
3.6. Hans Holbein (attributed to), *Letter G, Alphabet Dance of Death*, 1524. Woodcut, 2.4 x 2.3 cm. © The Trustees of the British Museum.
3.7. Hans Holbein, *Letter Y, Alphabet Dance of Death*, 1524. Woodcut, 2.4 x 2.3 cm.© The Trustees of the British Museum.

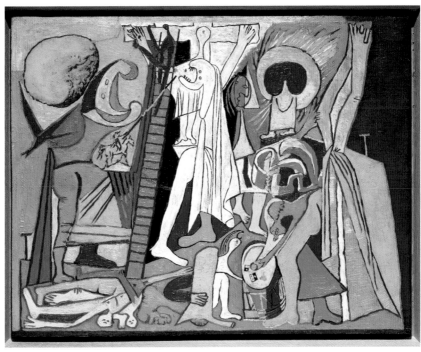

3.5

3.6

3.7

interiors; and partly they resonate with the Picasso because of their very abstractness, their schematism—the submission of death to the shape of the letter. The capital Y in Holbein's alphabet, for example (fig. 3.7), has Y itself participating in the ordinary premodern drama—Death snatching the infant from the cradle—almost as decisively as the skeleton and the wailing mother. And is not the central dancer in the Picasso just as much a letter—a capital Y—personified?)

■ ■ ■

So I end up talking iconography. Well, naturally. No one is denying that the picture triggers memories of previous models of the body in extremis.

But I still think the question is *how*—how, formally, it brings the dead models back to life.

Let me start with color. The blue, pink, yellow, red, and green of *Young Girls Dancing* are as non-artlike a set of colors as any serious twentieth-century painting—any painting that is not a stunt, not a *demonstration* of non-artness—ever deployed. How the canvas looks in a museum context is telltale. For most of the early 2000s, it was hung in a room of representative Surrealist and post-Surrealist pictures at Tate Modern, and it made the Miros, Massons, and early Pollocks look decidedly well behaved. *Young Girls Dancing*'s blues seem to come straight from the world of crude chromolithography. They speak back to Matisse's window color and at last find a way of exorcizing the ghost (fig. 1.7). Matisse's goldfish metamorphose into a patchwork of brick pinks and oppressive, dried-blood reds. Red comes in the right-hand window, midway down, like polluted sunset before its time. It acts as fringe to the maenad's skirt. It is a brace on her leg. It paints her lips and falls off her shoulder.

Add to this the green and red stripes on the maenad's skirt, and the browns, greens, and reds of the wallpaper, ugly as sin. Note the fecal-smear brown of the middle dancer's arm. Or the fairground yellow of the floor. The picture wins out—I quote from a notebook entry—against anything the coats, shoes, and accessories of contemporary Londoners can throw at it. "A young woman in violent cinnabar and neon purple [the year was 2007] stands in front of the middle dancer and fits in immediately—though even she looks a little arty in comparison, a little big-city tasteful."

Paint thickness is hugely variable. The flesh of the middle dancer is not in fact as thinly put on as it looks; but the appearance of insubstantiality is vital—it is what helps turn the figure into a paper cutout. The picture seems to have got blacker and grimmer in its final stages. The whole structure was originally hung from a top horizontal—another of Picasso's proscenium arches—that had less of the feel of a lid slammed down on a coffin. Red is still visible there in the seams. Black, once started, spread down into more and more areas: it gripped and shaped all three figures, it outlined the French windows and blotted out half of the right-hand window's bottom panel, it sliced across the wallpaper, it disfigured the maenad's face. The black seems to have been liquid, and put on in haste: it has cracked and separated with the years. In the beginning, so the cracking shows us, the left-hand dancer had much more pink flesh showing,

and the flesh was less broken into discontinuous segments (fig. 3.8). The body must always have appeared contorted and paradoxical, but I think originally it was much easier to accept as a figure in motion. What seems to have been added near the end was a set of strange stamped-on glyphs and striations and serrated templates—notably the truly indecipherable saw- or stencil-shape on the maenad's skirt, looking for all the world like a broken machine-part. It goes with the dried-blood fringe. The little puncture hole of blue next to the cutout, apparently peeping straight through the skirt, complete with a glimpse of balcony railing, is part of the dance. I see it as a kind of parody and refutation of the efforts Picasso had made, at Saint-Raphaël, to float the blue of the balcony into the room (fig. 2.33). The point now is the ludicrous discontinuity—again, the nowhereness of the blue and black. The hole through the skirt, like the sawtooth cutout, is stranded on the picture plane.

We might say that what the added emblems and stencil shapes do to the maenad, in combination with these crazy interruptions, is move her body back into the territory of the 1924 *Still Life in front of a Window* (fig. 2.1). That is, back into a patchwork of possible but unstoppable positions. Focus on the right-hand guitar in *Still Life*, for example, and its relation to the dark shapes surrounding it, and the toy apples, the tablecloth, the scene between the table legs. The maenad in *Young Girls Dancing* takes off from possibilities—spatial possibilities—Picasso saw in passages like these. Maybe he looked at this section of *Still Life* and compared it, in his mind's eye, to a painting like *The Bird Cage*, done by him in 1923 (fig. 3.9). This really was Cubism as a dead language—endless ingenuity and over-elaborate playfulness, and all in service of what? All in the service of what *space*? The bird in the cage is Picasso himself.

■ ■ ■

Still Life in front of a Window, to sum up, showed a way out of entrapment in style, and *Young Girls Dancing* took it. Of course the maenad's body is still "grammatical" in the full Cubist sense. It is a fiendishly clever performance of visual interlock, analogy, balance, paraphrase, migration and mutation of repeated shapes, kinds of line, kinds of spatial interval. Only look at the dialogue of the serrated edges with the woman's spiky fingers and toes! Or the positive-negative switching of her two—or is it three?—breasts. This is Cubism with a vengeance. We are still essentially

3.8

3.9

in the world of 1914 (fig. 3.10). But now, as in 1910 or 1911, the exercise looks other-directed again—as if it is struggling to get down something unique and substantial, something elusive, something that dictates the strange terms in which it is transcribed. *Bird Cage* cleverness seems far away. Hence the commentators' certainty about affect in the maenad's case—about terror and intrusiveness. Surely mutations and migrations like these, possessing this kind of weirdness and particularity, can only

3.8. Detail of the left side of Picasso's *The Three Dancers (Young Girls Dancing in front of a Window)*, fig. 3.1.
3.9. Picasso, *The Bird Cage*, 1923. Oil on canvas, 201.3 x 140.3 cm. Private collection.

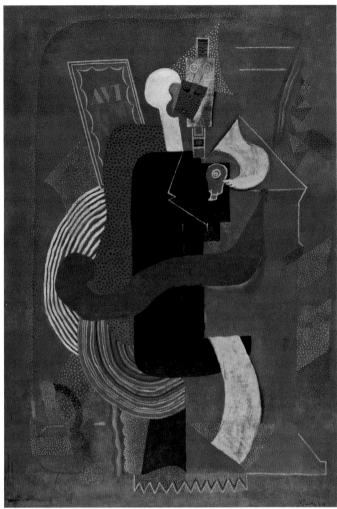

3.10

have come out of a body truly appearing—appearing like this—in a flash of fear and proximity. Or such is the claim. Such is the reality effect.

And we have hardly begun. The maenad teems with particulars. Look at the stitching of her dress's bright white shoulder strap! Look at the nick of black cut into her blue armpit, or the S-curve crossing her dress's green and red stripes—just visible if the light is favorable, brushing the back edge of the stencil shape, looking as if it were carved out of the oil paint with a razor. . . . Look at her third nipple up top to the left, a white bead borrowed from the bracelet. . . . Or the hard line of violet snaking up her torso, and the glimmer of red at her hip. . . . Look at the soft-edged dark pink put across part of the stencil shape, and the tiny gray drip coming

3.10. Picasso, *Seated Man with Glass*, 1914. 238.1 x 167.6 cm. Private collection.
3.11. Detail of the upper area of Picasso's *The Three Dancers (Young Girls Dancing in front of a Window)*, fig. 3.1.

3.11

down from her bull's-eye nipple. Is it a vision or a waking dream? If this isn't "exactitude," in the sense that Picasso so often insisted on, then what in painting ever could be?

■ ■ ■

It all comes back to the blue, the "outside." The blue is what shapes and penetrates the left-hand dancer, so that she seems at moments no more than its carrier. And blue, I believe, has also been given a face (fig. 3.11). You will have noticed that the thickest and roughest paint in the picture—it seems that in this case sand was not added to the mix, but it might as well have been—is that of the window top left. The blue here presses against the dancer's shoulders, breast, and black arm. And the right contour of the blue—final redundancy—is sealed with a thin red line. I would say that the red line silhouettes the blue, and flips it forward, in front of the black, on the same strange plane as the blue and red in the circular armpit. And for me the red puts the finishing touches to the *figural* character of the blue. It makes the blue a huge right-facing profile, its chin resting on the maenad's breast—looking across, in strict negative, to the Pichot profile.

I shall not mind if the great blue face—the red profile—looks to you accidental, too much my reading-in. Sometimes it does to me. All I want to point to, ultimately, is the pressure of the blue—its coming forward and looming over things, its positive entry into the pink body. That the blue has been given a face is perhaps only my way of saying that it has been made part of the world up front. Rather in the same way as I wanted to persuade you earlier that the objects on the table in the 1924 *Still Life* had a spatiality all their own. "They rear up higher than us, wafer-thin. They are not *for us* any longer. And this is because the outside has really come to them, in from the window: it has touched them, it has stamped itself on them. They have become outsides. Outsides are all they are." It is, in a word, the kind of space that comes to the objects and bodies in pictures— comes into them, comes through them—that is my concern. For objects and bodies, to repeat my mantra, are only really redescribed in painting by being *put somewhere*—somewhere that contains them.

■ ■ ■

I have been a little unkind toward commentators on *Young Girls Dancing* who think they can apply the word "violent" to it, or to one or two of its characters, without fear of contradiction. About the further charge of misogyny I shall have nothing to say. Calling Picasso a misogynist, though maybe accurate biographically, has as much to tell us about the nature of his achievement in *Young Girls Dancing* as calling Velázquez a servant of absolutism has to tell us about *Las Meninas* (fig. 2.21). Not nothing, in other words; but precious little. Is the maenad a male fantasy of difference and sexual threat? No doubt. But does this mean that an image of otherness—of the pains of embodiment, of splitting and introjection—has not been offered us in ways both men and women may make use of? As well ask the question of Euripides.

"Violence" seems to me unsatisfactory, then. But connected words do apply. Maybe the painting is terrible, or terrifying—terrifying in its very stateliness. For me, the question is what the terror derives from. Or where it is located. And an answer to that will only emerge if we circle back to the sentences from Nietzsche I quoted in lecture one. For the terror—this is my thesis—has to do with Untruth: with what art has to be if Truth is no longer its province.

Let me go slowly. Nietzsche's discussion of truth and truthfulness is part of a grand attempt to understand what happens to culture as Christianity loses power. Christianity, so Nietzsche believes, is the last and acutest form of the "ascetic ideal": that is, the human wish to deny the life we have—to declare it intolerable, epiphenomenal, *false*. The deepest paradox of the present age is that what appears to have destroyed Christianity—the will to truth, the spread of a disabused skepticism—may in the end turn out to have preserved its life-denying center.

> This will to truth, however, this *remnant* of [the ascetic] ideal is, if one is willing to believe me, that ideal itself in its strictest, most spiritual formulation, completely and utterly esoteric, stripped of all outworks, thus not so much its remnant as its *core*. Unconditional honest atheism (and *its* is the only air we breathe, we more spiritual beings of this age!) is accordingly *not* in opposition to that ideal, as appearance would have it; it is rather one of its last stages of development, one of its final forms and inner logical consequences—it is the awe-inspiring *catastrophe* of a two-thousand-year discipline in truth, which in the end forbids itself *the lie involved in belief in God.*

What survives the catastrophe—what is strengthened by it—is the idea that truth must be the ultimate value. But what if truth, or the will to truth (the assumption that falsity stands in the way of understanding), is inimical to *life*? That is, to a recognition—an enactment—of the being-in-the-world of one's body with others. I quote the key passage again:

> Now that Christian truthfulness has drawn one conclusion after the other, in the end it draws its *strongest conclusion*, its conclusion *against* itself; this occurs, however, when it poses the question, *"what does all will to truth mean?"* . . . And here again I touch on my problem, on our problem, my *unknown* friends (—for I as yet *know* of no friends): what meaning would *our* entire being have if not this, that in us this will to truth has come to consciousness of itself *as a problem*? . . . It is from the will to truth's becoming conscious of itself that from now on—there is no doubt about it—morality will gradually *perish*: that great spectacle in a hundred acts that is reserved for

Europe's next two centuries, the most terrible, the most question-able, and perhaps also the most hopeful of all spectacles.

You will notice that Nietzsche never says explicitly what consciousness will be like when it no longer proceeds under truth's aegis. It will not be a nihilistic free-for-all: this is a theme he often returns to (aware as he is of the closeness of his own thought to nihilism). The will to truth cannot be discarded—not simply for the obvious logical reasons, of which Nietzsche was fully cognizant, but because the *point* of the critique of truth, for him, was the further attack on morality that derived from it, and this attack could only be driven home (rhetorically, emotionally) if Truth survived as the constant enemy. To say that the will to truth must "come to conscious-ness of itself as a problem" (or even, in what follows, simply "become conscious of itself") is very different from saying that truth-claims will be replaced altogether by a play of persuasions or performances.

I said when I first cited the passage from *The Genealogy of Morals* that I believed it applied to Picasso's art, and could help us with aspects of his art we still find difficult. Not just the fact that paintings like *Young Girls Dancing* are terrible and questionable, but that the terror has to do with the world they show being unbelievable—counterfactual—but nonethe-less (one is tempted to say, *therefore*) unavoidable, inhabitable, apt. This is what Picasso's enemies will not forgive.

There is a Nietzschean solution to the problem. It is not the right solu-tion, in my view, but it is tempting and in many ways persuasive. It goes like this. Picasso *lived through* the crisis of Truth that characterized Euro-pean culture in the early twentieth century. He was its representative—its victim. Part of what makes the achievement of his high Cubism so irresist-ible, in the sternest canvases of 1910 and 1911, is the way they seem to add up to a last effort in art at truth-telling—at a deep and complete and dif-ficult encounter with things as they are (fig. 3.12). Cubist pictures are the last triumph of the ascetic ideal. The paintings' renunciation of color, their anxious maneuvering of everything into geometric order, their endless nuance and qualification: what are these but the signs of a mind and eye impatient with the mere look—the mere appeal—of the world, and there-fore feeling beneath appearances for structure, for idea? No wonder the Kantians of the early twentieth century found them irresistible. "All these hard, strict, abstinent, heroic spirits," to quote Nietzsche again, "who con-

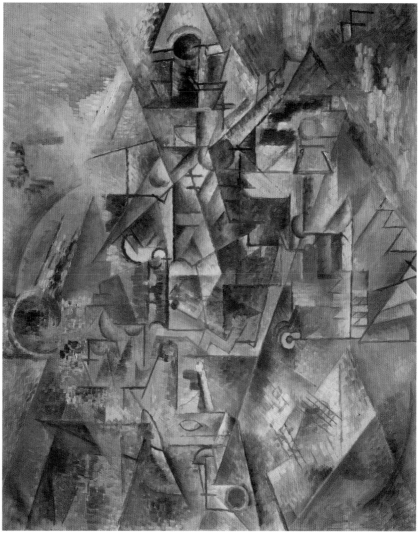

3.12

stitute the honor of our age . . . they believe themselves to be as detached
as possible from the ascetic ideal, these 'free, *very* free spirits': and yet . . .
this ideal is precisely *their* ideal. . . . These are by no means *free* spirits,
for they still believe in truth." Hard, strict, abstinent, heroic: has there ever
been an art more deserving of the adjectives than Cubism in 1911?

3.12. Picasso, *The Clarinet*, 1911. Oil on canvas, 61 x 50.5 cm. Acquired from the Vincenc Kramár
Collelction in 1960. National Gallery in Prague.

And does not *Young Girls Dancing* precisely take the weapons of Cubism and turn them *against* the ascetic ideal? Isn't this its scandal? Nietzsche, in one of his moods, would have gloried in the turn. He would have seen it as art finally recognizing its real character.

> Art, to state it beforehand . . . art, in which precisely the *lie* hallows itself, in which the *will to deception* has good conscience on its side, is much more fundamentally opposed to the ascetic ideal than is science: this was sensed instinctively by Plato, the greatest enemy of art that Europe has yet produced. Plato contra Homer: that is the complete, the genuine antagonism—over there the "otherworldly one" with the best of wills, the great slanderer of life; and here its involuntary deifier, *golden* nature.

Is this what the maenad is dancing? Isn't she the lie personified—the lie hallowing itself, the untrue (the made up) unfolding itself as the way things are? To borrow a notion from the anthropologists, isn't she deception "all the way down"? Perhaps. Sometimes, looking at *Young Girls Dancing*, I hear Nietzsche exulting offstage. For doesn't Picasso more than anyone suggest that henceforth sheer coercive inventiveness—"the will to deception [with] good conscience on its side"—sheer effect, sheer unprecedentedness, will be what art will thrive on? And doesn't he do so precisely because his is the energy of the apostate? He looks back to the somber grandeur of his own achievement in 1908 to 1912, and tries to destroy it. But it is stubborn in him. Destruction is a life's work.

■ ■ ■

These seem to me the right questions. The answer to them—again in a Nietzschean spirit—is Yes and No.

What, to begin, *is* Untruth, in Nietzsche's terms? This is a difficult moment. I wish to explain, but not to de-fang. Without doubt there is something glamorous and sinister to the notion as Nietzsche deploys it, and those who pursued his line of thought later, partly under his spell, often ratcheted up the horror. Jesting Pilate would not stay for an answer. But in Nietzsche the glamour goes along with a cogent—I would even say, sensible—set of proposals about knowledge and representation, and it is these I want to salvage with Picasso in mind. Again, it may be helpful to

put the *Genealogy* and the *Tractatus* in dialogue. Nietzsche's implicit target, much of the time, is Plato's *Republic*; but if he had read the aphorisms of 1922, he would have recognized them instantly as a new doctrine of the Forms.

Untruth for Nietzsche in philosophic vein, then, is simply the realization that *Truth is not to be known* (and if we knew it, we could not bear it). It is the idea that the otherness (the mere materiality) of the world we are part of can only be figured, not encountered—and certainly not measured, not investigated or experimented on. Wittgenstein's fierce sentences—"*That* is how a picture is attached to reality; it reaches right out to it. It is laid against reality like a measure"—are entirely mistaken. Existence is appearance. Pictures have nothing besides themselves to reach out to. And therefore the great imperative of knowledge—"to impose upon becoming the character of being"—is, though noble, no more than that: it is an imperative, a nobility, a style—not a form of realism. (These beliefs about knowledge and existence, by the way, may or may not correspond to the facts. Nietzsche prefers his set for aesthetic reasons. They are beautiful. They lead to fullness of life.)

And yes, in Picasso the Untruth of things may be the ultimate proposal. There may be nothing behind the mask. But that proposal is only interesting (only persuasive) if it is made, in practice, in the face of Truth—in Truth's aftermath—with the lie appearing as a force in the picture that has to annihilate or overtake or *be more intense than* Truth . . . with Truth always resisting the new shallowness. My lectures follow this resistance. In particular I have been pointing to the presence in Picasso of strong, repeated figures of some thing—some other, unbudgeable structure or obstacle—around which, or against which, the force of Form is organized.

> It is obvious that an imagined world, however different it may be from the real one, must have *something*—a form—in common with it. Objects are just what constitute this unalterable form.

. . .

Here again is my intuition. I believe that in order for Picasso to imagine space at all in painting, he had in practice to posit it as something enclosed or bounded, in which "appearance," however strange or unbelievable, took place within four walls. "Appearance" and "interior" seem to

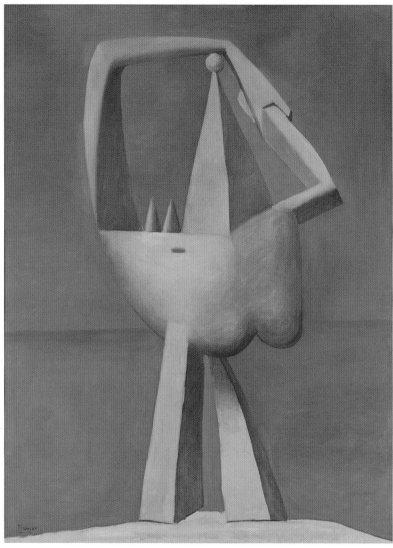

3.13

go together for him. Of course I have been arguing that in the 1920s this interior had to be opened onto an outside. But the outside is produced *by* the interior, so to speak. Proximate space—the space of a room with objects in it, preeminently those objects called instruments or women—is still the given. We shall see in lectures to come that Picasso sometimes believed there was a world elsewhere. There was the beach (fig. 3.13). There was the monument (fig. 2.2). But the great *Painter and Model*, done in the spring of 1927, still largely spells out the limits of his imagination (fig. 3.14).

Nonetheless, I am not saying that Truth just irresistibly reasserts itself in Picasso as a closed space—an interiority—in relation to which Untruth is always mere afterthought or embellishment. Untruth, in *Young Girls*

3.14

Dancing and *Painter and Model*, is a real force warring with that given. The weird spotlit apertures in *Painter and Model*, we shall see in lecture four, are meant to cancel the closed cube of the studio interior and set up a non-space instead: a not-interior, but, just as much, a not-outside; a here in which all possible theres are suspended. This is the mad ambition. I would say that Untruth in Picasso—a view of things in which Truth is finally not the issue—*is* this un-Space or non-Space.

But here is the rub: a non-Space can only exist as the opposite—the opponent—of a distinct shape *of* Space, a distinct sort of boundedness, a specific play of background and foreground. Nietzsche knew this, in fact.

3.13. Picasso, *Nude Standing by the Sea*, 1929. Oil on canvas, 129.9 x 96.8 cm. The Metropolitan Museum of Art, New York, Bequest of Florene M. Schoenborn, 1995 (1996.403.4).
3.14. Picasso, *The Painter and His Model*, 1927. Oil on canvas, 214 x 200 cm. The Tehran Museum of Contemporary Art, Tehran.

Untruth—what he called the Will to Power, in its drive to subsume and overwhelm and incorporate—is nothing without resistance. It only *is* by dint of what it is not. The room is Picasso's figure of such resistance.

■ ■ ■

Let me go back to *Young Girls Dancing*, but this time with *The Bird Cage* as comparison (fig. 3.9). *The Bird Cage* still exists in the realm opened up by the set of techniques—the "procédés paperistiques et poussiereux," as Picasso described them at the time—we now call collage. Many of Picasso's paintings in the 1920s seem to be looking for a way back to the world of wallpaper and cheap illustration. Collage had been a maker of miracles. Only slowly and incompletely did Picasso say farewell to it. *Young Girls Dancing* is a turning point above all in leaving collage behind.

We could say that Picasso eventually came to realize that, for him, collage had provided a falsely technical, falsely optimistic answer to the questions Nietzsche had put. Collage was *happy* with deception. It entertained the idea that art's main forms and compelling figures could be generated, now, out of nothing but internal, differential play between any old elements. A patch of pure color, a piece of banal illusionism; a pattern of dots, a fragment of newsprint, a calling card, a key signature: what mattered was the energy of the signs' coexistence. This produced, for a while, a realm of freedom, but it did not survive as a matrix in Picasso because its essential tropes *were* "freedom," "play," wit, paradox—brilliant one-to-one opposition of free-floating surface and depth. Collage, it turned out, could not be modulated into a key or tonality appropriate to "that great spectacle in a hundred acts that is reserved for Europe's next two centuries, the most terrible, the most questionable, and perhaps also the most hopeful of all . . ."

Untruth in Picasso is always terrible. It is a pressure from elsewhere—collapsing space, producing disfigurement. It is a condition, a fate, *a thing entering the interior of the mind*. This is the point—the intentionality—of the inside-outside distinction in Picasso. The outside coming into the room is Untruth triumphant, brilliant and glittering, but profoundly to be feared. In *The Bird Cage*, by contrast, inside and outside have fused, or folded neatly into one another. The mind rests easy.

■ ■ ■

3.15

The question the artist wrestles with in *Young Girls Dancing*, it follows, is how to make Untruth come into the room. Let me remind you of the painting's size. It is formidable: seven feet high, over four-and-a-half feet wide. In the studio photograph of 1928, Picasso is dwarfed by it: his head comes up to the Pichot head's throat (fig. 3.15). Notice the way the camera picks up the painting's central blue (the one between the window panes) and renders it as distinctly lighter than it is. I doubt that this means the color was altered subsequently, and people tell me that the limits of early twentieth-century photo processing may be responsible for the shift in tone; but the detail still serves to remind us that all the blues in the picture—all the outsides pressing forward—behave, optically, in barely controllable ways. I should state the obvious here: the blues *come forward*, and for blue—that recessive color—to come forward is something strange. The blue comes forward, but never with the rush and peremptoriness of a red. Nowhereness is written into the color, especially when it tangles with its opposite on the spectrum. The painting in general is a feast of displacements. Maybe the reason that the red bull's eye had to be striped with candy white is that Picasso was determined to get the red to be hugely far away, a spinning planet in a blue void. And the best way he could find to neutralize its coming-forward quality was to put it behind bars.

137

3.15. Picasso and unidentified man in his studio in Paris, 1928. Photograph.

It comes back to blue, then—to blue in the plural. The blues have to be *here* in the picture—here in the room—but not as any one force or thing. I have talked, in the case of this painting and its 1924 predecessor, about the outside coming into the foreground. But what this actually looks or feels like is different from case to case. In *Still Life in front of a Window* it makes sense to sum up the energy and brightness that flood the foreground as that of light. The bending rectangle of white at top right is a starting point, unmistakably sunshine stabbing across the walls. And the off-white gives the viewer the key to all the other whites on show—the guitar, the tablecloth edge, the clouds, the abstract white that doubles the bottle's black, even the whites in the little stageset under the table. They are the whites of illumination.

Whites in *Young Girls Dancing* are different. They are deathly. Even the ones picking out the central dancer's breast and shoulder, which surely were motivated in the first place by the idea of brightness coming in the window, somehow refuse to scintillate. The white armature that clamps the right-hand dancer in place is as inert as white can be. And as for the white of the same dancer's wrist and hand—the hand hanging on to the maenad's! There it is, at the painting's visual center; and it is lifelessness, bloodlessness itself—like a stretched surgical glove.

■ ■ ■

Let me sum up. The outside world—the blue of the outside—comes to the front in *Young Girls Dancing*. It takes part in the performance. The sky is on stage, under the proscenium. Blue presses against the actors, animating and shaping them, coming through them, bringing them up to and over the footlights. But the outside color is not one thing: it is neither an envelope nor an ambience. It is the opposite of the gloaming in *The Blue Room*.

Do I dare make a comparison at this point with a painting we know Picasso deeply loved—he bought an old copy of it for his own collection (fig. 3.16)? The original of the Le Nain brothers' *Horseman's Rest* is a peerless example of the magic of light—the evenness and gentleness of light—that Picasso was working to cancel.

Again I am at a crux. Because the alternative to having blue be an enveloping atmosphere—a totality—is not, in my view, having it simply become plural. This is not what happens perceptually here. The blue precisely does not break up into pieces—say, into the pieces of a board game

3.16

called "painting." I believe that the blues a viewer immediately and persistently registers as different in *Young Girls Dancing* are three, or maybe four—the blues in the holes in the maenad's body are, for me, never the same as the blue of the sky up above in the window, though they come close. The four blues in question are not-quite-four and not-quite-one. They are nonidentity made real. They are never safely *outside* the window, but that does not mean they are ever simply present on the painting's surface, next door to the flat pink or yellow. Just look at the infinite distance between the blue behind bars bottom center, foil for the central dancer's legs, and the yellow of the floor. (It is, by the way, an astonishing reversal of what happens in the same position in the 1924 *Still Life*.) Most of the blues have come near. They lean over the drama like superintending gods. But at the same time the blue is remote, artificial, slightly cartoonish. Matisse blue is nowhere in sight (fig. 3.17). There is not to be the least

3.16. Louis Le Nain, *La Halte du Cavalier: Landscape with Figures*, c. 1640. Oil on canvas, 54.6 x 67.3 cm. © Victoria and Albert Museum, London.

3.17

hint of infinity, of "depth." Untruth lacks depth, above all. That is what Nietzsche and Picasso loved best about it.

I quote Nietzsche finally, in *The Will to Power*, talking of the great religions and cults of self-denial:

> Through the long succession of millennia man has not known himself physiologically: he does not know himself even today. . . . Formerly one considered [the] conditions and consequences of physiological exhaustion more important than conditions of health and their consequences, because they are rich in the sudden, the fearful, the inexplicable and the incalculable. One was afraid: one postulated here a higher world. Sleep and dream, shadows, the night, natural terrors, have been held responsible for the creation of two worlds. . . . One believed one had entered a higher order of things when everything ceased to be familiar.

3.17. Henri Matisse, *View of Notre Dame*, Paris, quai Saint-Michel, spring 1914. Oil on canvas, 147.3 x 94.3 cm. Acquired through the Lillie P. Bliss Bequest, and the Henry Ittleson A. Conger Goodyear, Mr. and Mrs. Robert Sinclair Funds, and the Anna Erickson Levene Bequest given in memory of her husband, Dr. Phoebus Aaron Theodor Levene. The Museum of Modern Art, New York.

Here in a nutshell, it seems to me, is the other-worldliness Picasso spent his life trying to destroy.

Focus again on the maenad (fig. 3.8). Certainly Picasso is interested in the fearful, the inexplicable, and the incalculable. He thinks they are part of ordinary life. But that is the point. They are not a background or an opposite to existence; they are in the room among us. If you poke them they don't like it. They should take form in a painting, then, not as obscurity or elusiveness, not as a darkness or "unconscious." Picasso, like Nietzsche, is fiercely opposed to the idea that there are two worlds, a higher and a lower, as opposed to just one. He is a monist. Shadows make monsters, yes. The Pichot head is proof of that. The painting, we know, is a dance of death. But its deathliness is all up front: deathliness is the deadlock of brightness and darkness in it, and the way both terms—brightness and darkness, outside and inside, Eros and Thanatos—come grinning toward us.

Picasso, if I can put it sequentially, paints his way out of depth—toward explicitness, overtness, everything in the picture stiffly strutting its stuff. Things in the world have more than one aspect; but no one aspect is a hidden or repressed truth of the other, coming out from behind or underneath the ordinary. The point of Picasso's double faces, it follows, is the equality of the ying and yang. "Which face is dominant?" is as much the wrong question as "Does the window open outward or inward?" It does both.

This can lead to a final comparison of *Young Girls Dancing* with *Still Life in front of a Window*. Nietzsche, though you will have gathered I revere him, is in the end no more a reliable guide in the realm of aesthetics than he is in politics. He is desperate and erratic about both. His error with regard to art is too often to move, in revulsion against Wagner and Romanticism, away from inwardness, self-doubt, and abnegation in poetry and music, toward a set of convenient opposites. Mediterranean values, he likes to think them. Brightness, lightness, cheerfulness, clarity—art on the balcony saying Yes to the world. But these qualities in art are flimsy; and Nietzsche knows full well that they are, with one side of his mind: he knows that the aesthetic has to start from the dimensions of life that resist it. In the modern case, this means that art cannot simply move from Wagner to Bizet, as Nietzsche occasionally—maybe ironically—suggests.

What else art ought to do in the new situation Nietzsche never makes clear. It is important that he stayed ignorant of, or unsympathetic to, so

much of the art of his time. Flaubert eluded him, Cézanne likewise. Even Menzel, with whom his struggle would have been prodigious, seems to have passed him by. What I find myself wanting from Nietzsche's late notes and not finding are long-range, intuitive, "genealogical" comments—the kind he was master of—on the overall shape of fin-de-siècle aesthetics: on the positivism of French painting (Nietzsche on Seurat, perhaps), or the rise of the prose poem (Nietzsche on Rimbaud), or the new geography of the novel (not just ambivalent homage to Dostoevsky, but an account of the Russian novel as true catastrophe, a last fight with nihilism, a pushing of the fundamental genre of modernity to its limits). The best I can do, with Picasso in mind, is build briefly on hints in *The Will to Power* and *The Case of Wagner*. Art in the age to come, Nietzsche seems to recognize here and there, would need to devise a fresh kind of outwardness, having little to do with Bizet or even Monet; one in which the range of experience that Wagner had given form to—the constant exacerbation of feeling, the endless ambiguity, the insistence, the self-torture—would survive there as a modern constant, but transposed into a different key. Wagner would look pale as a result. For if the new outwardness could be materialized, by an artist who had truly destroyed the ascetic ideal in himself, then the full range of Wagner-type experiences would be figured more powerfully than ever before—because they would be overt at last, brought to light, made over into *nonenigmatic* form. It is the lack of mystery that will be most terrifying. Nietzsche had nothing but scorn, to remind you, for Wagner's skill at always producing intimations in music, always hinting at the inexpressible; he despised the composer's "playing hide-and-seek behind a hundred symbols." I believe Picasso shared the distaste. (Hence, by the way, my feeling that seekers after symbolic content in Picasso get things fundamentally wrong.) Think of the lush, chromatic eroticism of the ballet on the Venusberg, and then Carmen clicking her castanets. The *Young Girls Dancing* do both.

■ ■ ■

I see a danger in the account just given. I intend to stand by my basic intuition that the women in *Young Girls Dancing* are deeply figures—carriers, crystallizations—of a strange kind of space. If the viewer blocks out the central dancer for a moment this seems obviously true of the half-humans, or more-than-humans, at left and right. Space penetrates them through

3.18

3.19

and through. But the danger is obvious: in stitching together figures and surrounding so completely, I may end up losing hold of the three dancers' "in-front-ness." Not for nothing does Picasso's title insist on that priority. And my "if the viewer blocks out the central dancer for a moment" gives the game away. For ordinary vision does no such thing. The central figure dominates. She brings the two flanking dancers forward to meet us, she distracts us (partly) from their punctured or recessive state. In particular, she frames and stabilizes the maenad to the left: without her the figure fractures and topples.

The three dancers are demons. The woman in the middle steadies her partners' motion, holds them still for a moment, turns them to face us. I cannot see her, pace Gowing, as Christ on the cross, but I agree she is some kind of god. As much as anything she reminds me of the "mistress of the animals" in the art of the Middle East and early Mediterranean (figs. 3.18 and 3.19). Scholars of this material admit the limits of our understanding. The setup seems to issue from a deep past. There is no mistaking the basic impulse, though—an imagining of power over the world of

3.18. Mistress of the Animals; Creto-Minoan goddess of fertility feeding two wild goats, first half of 13th century BCE. Lid of a round ivory box, from Minet el Beida, port of Ras Shamra (Ugarit), Syria. Phoenician. Ivory, h. 13 cm. INV: AO 11601. Louvre, Paris.
3.19. Mistress of the Animals ("Potnia Theron"), antefix from Temple B, Civitella di Teate, 2nd century BCE. Ceramic. Museo della Civitella, Chieti.

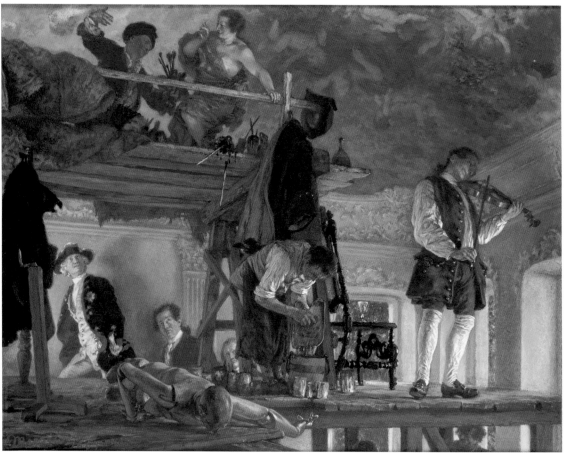

3.20

wild beasts, and a stilling of the cycle of predation. A taming. (And the actual training and subduing of animals surely must have lived on as a great episode in the invention of the human, all the more so because it was a metaphor of the taming of the instincts in general.) But why the tamer was a woman, and to what context of ritual the image—perhaps the staged reality—originally belonged: these are questions we can only guess at. In any case, I believe that the mistress of the animals was lodged in Picasso's image-mind.

The women are demons. They bring wildness into order, but also give it its head. I look at the left-hand maenad kicking her heels and suddenly see (here is my last hurrah) the dancing model in Menzel's glorious *Crown Prince Frederick Pays a Visit to the Painter Pesne* (fig. 3.20). Of course Menzel's homage to the insubordination—the Bohemian nerve—of artist and model, cavorting on the scaffold as their great patron pays a visit, is remote from Picasso's in terms of style. It comes out of the nineteenth century, and stays true to that century's stubborn vision of Enlighten-

3.21

3.22

ment. But I know of no picture of art in the making that brings us closer to Picasso's worldview.

The model and the maenad—a final comparison (figs. 3.21 and 3.22). The grinning dancer in the Menzel has become a touch ghoulish in Picasso, granted; but somehow she still exults in the great fact Menzel wished to show us: that wildness and otherness are always just *there* in the world, taking advantage of its unguarded moments—part of our ordinary nonidentity, part of everyday life. That is why "interiors" are indispensable. They keep wildness and otherness within bounds: they allow them to be figured and drawn into a totality. Of course the crown prince expects his room-space to be capacious, to the point of including an imagery of danger. On the ceiling of the ballroom Apollo is victorious over Chaos.

But Picasso and Menzel do not accept that "the sudden, the fearful, the inexplicable and the incalculable" are things that rear up from a deep below or beyond. There is a wild outside to existence, certainly, but it is threaded through the life we have, as a reality we shall never be master or mistress of. And that reality too can be represented, as "sleep and dream, shadows, the night." Or better—as blue. Blue is regularly the figure in life of indifference, apartness, infinite distance, non-humanness. But it is here with us, inside the room. We can dance it. We can wrap ourselves round it. We can dance it to death.

LECTURE 4

MONSTER

This is the last of the trio of lectures devoted to single works by Picasso from the mid-1920s. It has to do with a canvas completed in spring 1927, *Le peintre et son modèle*, which at seven feet by seven, done in a kind of oven-baked monochrome, makes even *Young Girls Dancing* look picturesque (fig. 4.1).

Put very broadly, my subject so far has been what happened to pictorial art in Europe as it found—or after it found—that the pursuit of truth could no longer be its driving force. The crisis came quickly. For Cézanne and Pissarro around 1900, to take two great instances, the truth of seeing remained an unquestioned if always elusive goal. It was not the only or even the primary purpose of picturing, necessarily—the two would have taken Flaubert's side against Zola, or Delacroix's against William Harnett—but it provided the essential leaven to any further cult of beauty or intensification of means. They were the inheritors of a project stretching back to Giotto. Twenty years later that project was dead. No doubt artists in the 1920s and 1930s (and later) persisted in making strong truth-claims for their work; but the nature of the truth they laid claim to was now so disputed and often so obscure—so lacking an anchorage in the experience of the eye—that the concept itself seemed more and more a rhetorical leftover, unconnected with the detail or structure of pictorial practice.

Why this occurred is a huge question, to which the answers in the literature remain fatuous ("illusionism" was exhausted, or had become

too efficient to be interesting; it had been made redundant by photography; the culture at large had split up into post-Kantian or post-realist or post-industrial signifying practices; Plato and Blavatsky were victorious over materialism; the Mystic North had made a comeback; that nice man Saussure in Geneva had got it right; and so on). I have aimed to avoid this kind of cod-Hegelian crux by focusing on the way one artist, Picasso, responded as he found the style called Cubism, of which he was mainly the inventor, ceasing to put him in touch with the world. This is my way of making the question art-historical—as opposed to *historical* in quotes. Cubism was the last of the great succession of pictorial styles in Europe premised on the belief that art could only renew itself by a fresh, more basic and comprehensive attention to the form of the world in the eye. The line of inquiry that resulted in Cubism's case was skeptical, idiosyncratic, and sometimes impenetrable, but truth was still its god. The ultimate test of truth for Picasso, I have been arguing, survived anything skepticism or "Je est un autre" could throw at it. Truth was proximity. An object in a painting (and we should conceive of "object" here in the extended and mysterious sense of the *Tractatus*) was true if it was tangible—meaning touchable, usable, possessable, playable. And the guarantee of this tangibility was a kind of space, a kind of containment or intimacy. Room-space, to use my shorthand. The room for the Cubist was what the river surface had been for Monet or the village street for Pissarro: the real-world condition under which appearances became substances (again in Wittgenstein's sense)—where they took a nonarbitrary form.

The room was Cubism's truth-condition. Supposing, then, that a moment arrived when this kind of spatiality began to be felt as confinement, not necessity. Suppose the back wall and tilted table came to seem not shapes the known world naturally took in a painting but ciphers—residue—of a kind of coziness, with the little possessions slotted in place too predictably, and nearness declining to flatness or claustrophobia. What would happen next? An artist less deeply committed than Picasso to Cubism's worldview might try to break out of room-space altogether. And even Picasso, we shall see, sometimes made the attempt. But not initially, and not in the paintings (after Cubism) that matter most. The room, for

4.1. Picasso, *The Painter and His Model*, 1927. Oil on canvas, 214 x 200 cm. The Tehran Museum of Contemporary Art, Tehran.

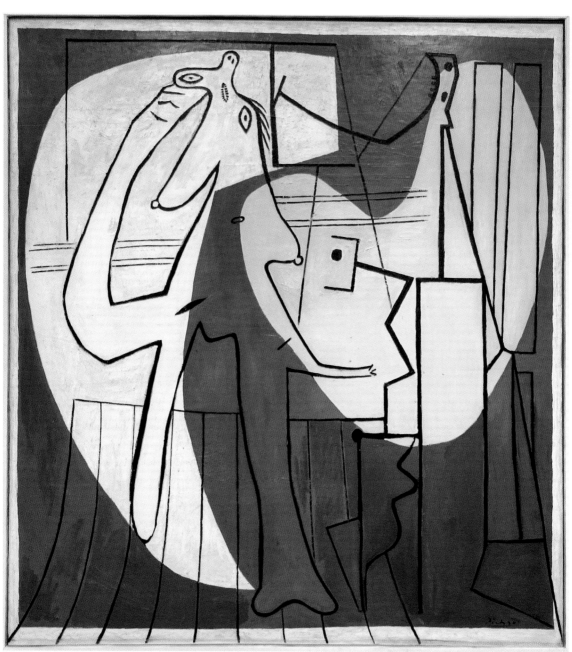

4.1

him, remained the unavoidable form of being-in-the-world. But the interior, it turned out, would now have to be penetrated—energized—by space of a different character. In *Still Life in front of a Window*, a kind of exultant outsidedness had stamped itself on familiar things, and they became unapologetically performers, masks. And in *Young Girls Dancing*, going one step farther, the outside world pressed forward through and past the figures in a great rush of nowhereness, so that the very idea of "near" and "far" no longer applied.

Picasso was not finished. The most ruthless of his three great reimaginings of Cubism was to come.

■ ■ ■

We seem to be looking into a room—maybe peering through a kind of gray-brown scrim, out of which two simple shapes have been cut as if with a stencil. The space on the other side of the scrim (though "other side" here begs the question) is a bleached afterimage of the rooms dealt with so far—a diagram lit by a flashbulb. There are bits and pieces of Cubist room-space still visible: two lines of wainscoting on what appears to be the room's back wall, jumping tracks as they emerge on one side or other of a body in front of them; one or two rectangles and trapezoids on the backdrop, with two tall and narrow coffin shapes far right, like ghosts of the windows in *Young Girls Dancing*; and down at the bottom floorboards flowing like lava, their seams pushing out toward us across a great painted frame-within-a-frame. Something—something resembling a woman—stands at the center of things. She seems to feel for a footing on the boards, or maybe she is planted immovably on two elephant toes. Her stance, and even her place in the room, call to mind the maenad in *Young Girls Dancing*, but the maenad looks poised and mobile in comparison. It is as if the upper half of the earlier figure's body—her breasts and shoulders and curving back—had morphed into a great face made out of nipples and orifices, or a body with everything except secondary sexual characteristics left out. She is a monster; but that does not mean she is horrible or disgusting, exactly, or lacking in sexual power. She holds the floor. Maybe she exults in her monstrosity.

Then we begin to see that there is a second person in the room. Over to the right, in and around an aperture shaped like a painter's palette, is a kind of linear construction or contraption, not unlike the actual steel

4.2

wire miniatures Picasso made a year later in 1928 (fig. 4.2). (The one il-
lustrated is just short of two feet tall.) But the thing in the painting stays
two-dimensional: it looks like a stand for fire irons. And yes, the thing is
a second figure. It is an artist, holding some sort of square palette in one
hand and putting paint on canvas with the other. Malraux recalls Picasso
calling the painters in his studio pictures "petits bonhommes," and one
in particular "ce pauvre type"—that poor devil. The painting from 1927
was still very probably in Picasso's possession at the time he was talking.
And the term applies. Center left, then, is a monster, and over to the right
a poor rigid fellow trying to paint her. Of course the question of whom
Picasso identifies with in the transaction is left open. Malraux remem-
bers the "pauvre type" tag being pronounced "affectionately" a propos the
painters; and Picasso, for all that is said to the contrary, was capable of
self-irony. His artists do tend to be a sorry bunch. There is a photo of Pi-
casso in his studio in 1928 with the little steel figure placed on the table
in front of him; and propped on the wall to the left, stealing the metal
construction's thunder, is another full-size monster in oil, presumably
feminine, planted four-square (figs. 4.3 and 4.4). The monster is the same
size as the man: only his Homburg gives him a slight edge.

The Painter and His Model, to repeat, is one of Picasso's large-scale
pieces, by far the most imposing of its year: seven feet high and only two

153

4.2. Picasso, Figure, autumn 1928. Wire and sheet-metal, 60.5 x 15 x 34 cm. MP265. Musée Picasso,
Paris.

4.3

4.4

inches short of seven feet across. I shall never forget the experience of coming across it for the first time years ago in Rome, hung at the end of a long gallery on the Quirinal. The great shape on the wall was stupendous. It dwarfed and dominated. Even at fifty paces one could make out the hard wrinkles and smears of its tamped-down surface. Having it enter one's field of vision was like rounding a corner and coming on a Caravaggio.

The almost square format Picasso uses for a picture of this size is unusual. It is part of what makes room-space here so unstable. The canvas shape offers us no governing orientation to the scene's imaginary depth—no decision for up versus down or vertical versus horizontal. A comparison with *Still Life in front of a Window* is telling (fig. 2.1). Everything in the earlier painting has an immediately apprehensible location. In due course we may come to doubt some of the locations, and even enjoy the contrariness of the clues on offer; but our first intuitions are unbudgeable. As a spatial structure—as an arrangement of backgrounds and foregrounds, receding and overlapping—*Still Life* is solid as a rock. You recall how it looked when turned on its side. In *Painter and Model*, by contrast, there *is* no background and foreground; or better, there are too many, going to and fro in a kind of free circulation, with no one location more convincing than another. The spilling of the floorboards across the frame is a token of that. And you may notice that part of the artist's steel-wire body likewise goes on regardless, bottom right, all the way down to the corner. So where is he?

Seven feet high, seven feet broad: the painting is an exhibition piece. Picasso had it photographed straight away, and the formidable black-and-white reproduction (fig. 4.5)—in many ways it gives a better sense of the tug-of-war between space and marked surface than any facsimile made later—appeared within months in the magazine *Cahiers d'art*, and later again in *Documents*. But it was not until 1932 that we know for certain Picasso put the painting in an exhibition—it is no. 177 in a retrospective held that year at Galerie George Petit—and only then did it acquire a proper title. The caption in *Cahiers d'art* had read simply "Appartient à l'artiste," and *Documents* told the same story. No wonder the dealers kept their distance.

155

4.3. Unknown photographer, *Picasso in His Studio*, 1928. Roger-Viollet, Paris.
4.4. Picasso, *Standing Nude*, 1928. 162 x 130 cm. Private collection.

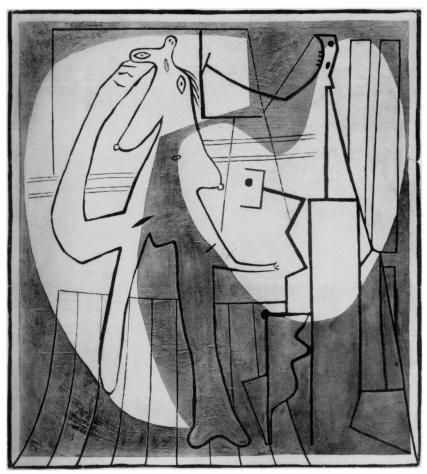

4.5

■ ■ ■

We seem to be standing in a room (fig. 4.1). There appears to be light in the room, falling or flashing across the walls and floor like the beams of a searchlight: two great shapes of light, the one on the left a deadly bone-to-ashes off-white, and the other a slightly—but only slightly—more organic pale yellow. It is the color of milk curdling or cut sandstone in a quarry. I said there was light in the room, but that may be too naturalistic. It is not at all clear that the two pale colors are meant to register as brightness at odds with surrounding gray gloom; or, if they are, that the brightness enters the room as opposed to hovering somewhere in front of it. Maybe we should understand the two shapes as stained glass; or, better, as holes punched through the picture surface—holes that dramatize and material-ize the strange fiction of European painting since the Renaissance called the "picture plane."

4.5. *Cahiers d'art*, photograph of *The Painter and His Model*, 1928.

Since so much in Picasso's painting has to do with this fiction, it needs explaining. And as usual with Western illusionism's key features, "picture plane" turns out to be a stranger idea than it seems. Nouns tend to misrepresent it. Calling it a fiction or convention, for example, or even an assumption, does not really get close to the mixture of self-evidence and ideality in the case. Let me use Delacroix as an example (fig. 4.6). When we look at a painting like *The Tiger Hunt*, which is wonderfully accepting of the practices of picturing that come down to it from Rubens and the Venetians, do we not immediately take it that the scene on offer—the little drama in the Atlas mountains—exists on the other side of an imagined transparency, through which we are viewing it as all one thing? Sometimes in the tradition from which Delacroix emerges this transparency is insisted on, and shown as an actual window, say, or an opening in a wall from which a curtain has been half drawn back. But it need not be signaled for it to appear to the mind. Maybe it acts most pervasively on us if it is not. The picture plane is an a priori. For depiction to take place at all, it says—for the very notion of appearance to make sense—hasn't what appears necessarily to appear *somewhere else than where we are*, on the other side of an ontological divide? There must be a place in representation—a virtual, invisible threshold—where the space of the scene ends and the space viewers occupy begins. The picture shows us that place. And of course that place cannot be on the painting's surface, where Delacroix is pushing his sticky pigment around. For that surface—that mere materiality—has nothing behind it. It is what it is. To talk of it as transparent is bizarre. The transparency—and look again at the Delacroix: the transparency is *there*—is an act of the mind. It may be affected by the presence or absence of brushwork "on the surface," dramatizing the painting's made-ness. Delacroix is the kind of painter who wants our attention constantly to go in that direction. But only the better to reinvent the transparency—to have the transparency thickened and animated by the naive movement of his horsehair. Thickened and animated—in this case, made bloody and animal and hot—but not for a moment dislodged.

Put *Painter and Model* next to Vermeer's *Art of Painting* (fig. 4.7). Stifle your impatience for a moment: I promise not to treat you to another exercise in Picasso and the Old Masters. For what matters immediately in the comparison is the difference, not to say warfare, between Picasso's

4.6

scene of representation and Vermeer's, and nothing one says should take the edge off *Painter and Model*'s belligerence. It is absolute and infantile; and the feeling will never go away that one thing Picasso intended to do (maybe thought painting now could not avoid doing) was to rob us of Vermeer's quiet certainty—to do dirt on it, to have the shadow of *his* studio fall ever afterwards across Vermeer's empty space. The lavatory-wall atmosphere matters, in other words. Nonetheless I do want to insist—I know in a sense grotesquely—on what the two paintings share. They are both paintings of painting, and this seems to mean that the accent in both must fall on the way painting makes its foreground, makes the transparency through which we see the scene. In Vermeer the great figured curtain down the left side is pulled—almost peeled—back primarily to act as foil for the emptiness, the pure luminosity, next to it. What painting has to offer most deeply, so Vermeer seems to believe, is light; and it should not offer that ground of experience merely in spots and patches—on the wall above the model's trumpet, on the candelabra, on the artist's white stocking—but as a totality, here in front of us, completely present, completely intangible.

4.6. Eugène Delacroix, *The Tiger Hunt*, 1854. Oil on canvas, 73.5 x 92.5 cm. RF1814. Musée d'Orsay, Paris.
4.7. Jan Vermeer, *The Art of Painting*, 1665–66. Oil on canvas, 120 x 100 cm. Kunsthistorisches Museum, Vienna.

4.7

This is the fiction of painting Picasso is working with in 1927. It is the "given" that the two apertures or spotlights—Picasso's way of drawing back the curtain—are trying to retrieve and dismantle. What would paint-ing be *without* transparency?, they ask. Again we move close to the ques-tion of Truth. For what is the picture plane's transparency if not a great figure of truthfulness, of full and immediate disclosure? ("*That* is how a picture is attached to reality; it reaches right out to it." The reaching out is a reaching through, from "picture" to "reality.") And what will painting be without such a figure? Like this, is Picasso's answer (fig. 4.8).

. . .

Painter and Model is one of the artist's great achievements—since it was bought by the Shah in the 1950s the picture has been seen only a handful of times outside Tehran, and therefore underestimated—but it is also an anomaly. Monstrosity is not Picasso's mode. Our view of him as a painter—particularly on a large scale—is, and always will be, distorted by the looming presence of *Les Demoiselles d'Avignon* (fig. 1.6). No doubt Picasso too, as he stretched the big canvas in 1927, was haunted by his previous masterpiece. Breton had negotiated the sale of the *Demoiselles* to Jacques Doucet a couple of years earlier, and the Surrealist magazines had made it one of their totems. The new picture is, if you will, *Young Girls Dancing* redone with *Les Demoiselles* in mind. But the point still stands: in its starkness and grotesquerie—in its determination to make a masterpiece out of obscenity—*Painter and Model* is hugely untypical of the line of Picasso's large-scale works.

Certainly it has precedents. The *Demoiselles* lived on in Picasso's memory; and there is a strain in Cubism—not a central strain, but one cropping up repeatedly—that specializes in sexual berserk. The exultant summer of 1914 in Avignon, from which the *Portrait of a Young Girl* emerges, sees Picasso once or twice experimenting with drawings in which a woman's naked body is pulled—twisted—into a suave piece of sexual furniture, part comic part phobic. One drawing in particular seems relevant (fig. 4.9). We know that Picasso still had the sheet in his possession in 1927, and had made it available to Waldemar George the year before for a book of reproductions of his drawings. I imagine Picasso brooding in 1927 on the breasts turned into eyes and nose in the drawing, and I even sense the curvilinear grammar from which the nude on the bed is constructed—especially her breast, belly, buttocks—underlying the two main surface shapes in *Painter and Model*. Picasso is a painter who feeds on his past. But again, what he makes of that past in 1927 is frightening, even for him. The twelve months following *Painter and Model* are filled with anxious re-doings of the big studio scene, in which, for the most part, the monstrous body of the model is absorbed into a more and more elaborate— one might almost say, disciplinary—geometric divide and rule (fig. 4.10).

4.8. Picasso, detail of the woman at left in *The Painter and His Model*, fig. 4.1.

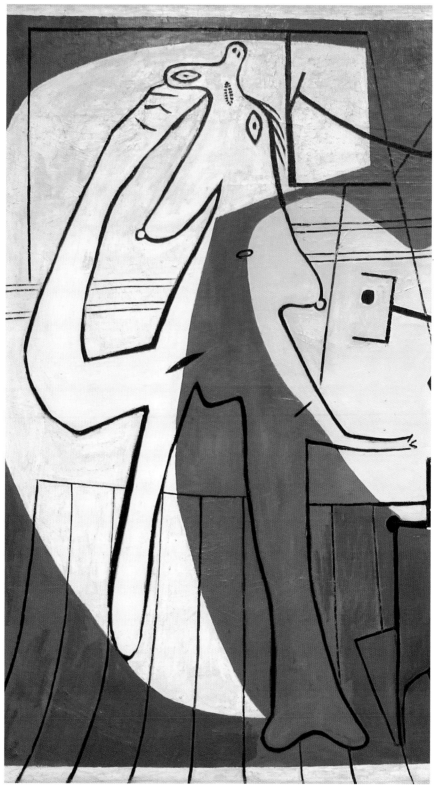

4.8

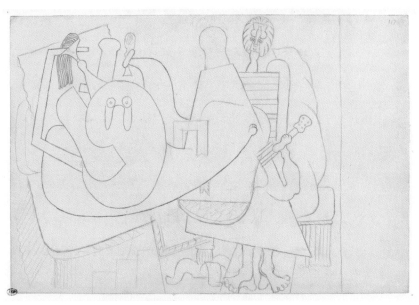

4.9

Not that the monster is simply unframed in the original monochrome; but she is framed only partly, only provisionally. The point of the two spotlights that traverse her seems to be their insufficiency. Nothing will stop her in her tracks. And Picasso appears to have felt the cold wind. The *Studio* series of 1928 is intent on putting the model back in the rectangle (fig. 4.11).

■　■　■

This is a topic for lecture five. In the meantime, there is one further way to suggest *Painter and Model*'s anomalousness—its extreme status—in relation to Picasso's work. It so happens that we have more evidence of the material from which the 1927 painting emerged, in the form of sketchbook experiments and connected loose-leaf drawings, than for any other Picasso save the *Demoiselles*. Again the exception is telltale. Much of this

4.9. Picasso, *Reclining Woman and Guitarist*, 1914. Graphite, 20 x 29.8 cm. Inv. MP760. Musée Picasso, Paris.
4.10. Picasso, *The Studio*, 1928–29. Oil on canvas, 162 x 130 cm. Inv. AM1984-DEP16. Musée National d'Art Moderne, Paris. On loan from Musée Picasso, Paris.
4.11. Picasso, *The Studio* (*L'Atelier*), 1928. Oil and black crayon on canvas, 161.6 x 129.9 cm. Peggy Guggenheim Collection, Venice (Solomon R. Guggenheim Foundation, NY).

4.10

4.11

material has been explored already, with proper intensity, by Jeremy Melius (and this is the point to acknowledge my deep indebtedness, here and elsewhere, to Melius's looking and thinking). But one or two things remain to be said. In particular, I want to present the sketchbook material and try to strike a balance between two kinds of concern: on the one hand, to trace the painting's sources in truly appalling and pitiable patterns of fantasy, hovering on the edge of madness, in which the deepest sources of the individual "Picasso"'s dream of seeing seem to be in play; but at the same time—and just *because* the deep source material has to do with the psychic dynamics of seeing, of the visible and invisible as such—to insist on the way the loony material is finally folded back into pictorial structure, and on it is floated a cool, brilliant, contrived reworking of Cubist space. For how could things be otherwise? Cubist space is Picasso's worldview. It is his interior—the depth he allows himself. If the psychic material in the sketchbook could not be made over into a new form of Cubist spatiality, then why—asks Picasso—should we be interested in it? I only leave the sketchbook mayhem behind me, one imagines him saying, because I want posterity to see the distance from image to painting, from daydream to structure, from *Acheronta* to *superos*. Above all here, where the distance was greatest.

■ ■ ■

How to begin? There are at least thirty-eight pages directly connected to *Painter and Model* in a sketchbook filled over winter and spring 1927, and another five sheets from a notebook of 1925 that are relevant, because by the look of it they are first thoughts for two larger ink drawings done in parallel to the final painting, probably during the same months it was being prepared (figs. 4.12 and 4.13). Both are scenes of monstrous beheading. The clearer of the two, and therefore the most loathsome, teems with less-than-human forms that anticipate the monster in the painting. The executioner top left is not unlike her. Once one notices the blade in the executioner's hands one can never entirely escape from the idea that the left-hand spotlight in the eventual painting is a sublimation of this original sword. The head of the victim toward the right in the drawing

4.12. Picasso, *Scene of Decapitation*, 1927. Pen and India ink on paper, 27.7 x 22.5 cm. Inv. MP1021. Musée Picasso, Paris.

4.12

4.13

is again the head of the model in embryo. The extraordinary arch-shape top right seems like a first form—a first intuition—of the aperture idea. And the archway is all the more unnerving because it is at once an opening through which a looker leans and sees all—notice the solitary ungrotesque profile right at the top—and also the body of a looker, whose slack hands sprout from its bottom ends. And if it is such a body, then what issues from it is a pointing finger, or a face, or a penis.

That all of this prepares the way for *Painter and Model* is confirmed by the second state of the ink drawing, in which many of the same sad actors are in evidence, but now—for the first time—framed by the two apertures. And who could doubt in this context that the two are transforms of the executioner's weapon? They are *the blade become the frame*—the threat become the condition of visibility. They slash and segment the various nauseating homunculae, all doing their business of gawping or violating. But in cutting and fragmenting they make things seeable: they put the monstrous beginnings of fantasy at a distance, inside a container. Or such is the hope.

I take it I do not need to labor the point that beheading, in this fantasy world, is also castration. Heads are penises, and severed necks so many holes asking to be penetrated. (There is a drawing from 1925 in which the penis-head of the still living victim is put exactly between the executioner's thighs [fig. 4.14]. And another—it looks like a starting point for both *Painter and Model* and the maenad in *Young Girls Dancing*—in which the executioner's phallus and the about-to-be-severed-head are utterly conflated [fig. 4.15].) The material is pornographic; and Picasso returns and returns to it, as if trying to tame the untamable by dint of repetition. Time and again he rehearses the shape of the model-monster, as she emerges—fairly early on—from the welter of decapitation dreams. She has slowly to be deprived of her first here-and-now-ness as a sexed body. She has to lose the hair in her armpits and around her genitals (fig. 4.16). She has to be put in a room. First of all in a room with deep perspective, and maybe a door opening onto a further world (fig. 4.17). And then a familiar Cubist corner, with wainscot and armchair, into which the monster is wedged (fig. 4.18). Models of space are tried on for size. In the drawing with the

4.13. Picasso, *Scene of Decapitation*, winter–spring 1927. Ink on paper, 28 x 22.5 cm. Inv. MP1020. Musée Picasso, Paris.

4.14

4.15

4.16

4.17

4.18

armchair, you notice, Picasso has traced a containing aperture shape with a faint dotted line, through which we peer at the thing in its grotto.

The sketchbooks and drawings are, to state the obvious, a free-fire zone for Freudian reading. They are manically overdetermined. Any attempt to reduce them to a single trail of fantasy would miss the point. But I do think there is one anchoring compulsion driving them on: the idea that it might be possible *to show the scene of castration as it takes place*—as it becomes visible, as it makes the body visible to itself and others. The blade actually falling, that is. Not just the aftermath of the castration fantasy, which all art shows (so Picasso believed)—sexual difference and anxiety, with a barely sublimated violence and *ressentiment* built into any coupling of male and female. Not just this, but the original horror—a false horror, doubtless, an imaginary origin, but one no less determinant for that.

And there is one more step. I think the drawings are trying to stage a "becoming visible" for the scene of castration that issues from the logic—

4.14. Picasso, *Scene of Decapitation*, 1925. Pen and India ink on paper, 30.2 x 23.2 cm. Sketchbook 31. Inv. MP1870 folio27recto. Musée Picasso, Paris.
4.15. Picasso, *Scene of Murder*, 1925. Pen and ink on paper, 30.2 x 23.2 cm. Sketchbook 31. Inv. MP1870 folio29r. Musée Picasso, Paris.
4.16. Picasso, *Nude Reclining in an Armchair*, December 1926–May 8, 1927. Ink on paper, 17.5 x 26 cm. Sketchbook 34. Inv. MP1873; folio40recto. Musée Picasso, Paris.
4.17. Picasso, *Figure*, December 1926–May 8, 1927. India ink, Ingres paper, pen, 17.5 x 26 cm. Sketchbook 34. Inv. MP1873; folio26recto. Musée Picasso, Paris.
4.18. Picasso, *Nude Reclining in an Armchair*, December 1926–May 8, 1927. Ink on paper, 17.5 x 26 cm. Sketchbook 34. Inv. MP1873; folio27recto. Musée Picasso, Paris.

the dramatic action—of the scene itself. The drawings will show the severed body actually reaching out to represent itself. This ambition is everywhere, but never more naively than on page thirty-three of the 1927 sketchbook, which the Musée Picasso identifies as a set of studies specifically for *Painter and Model*—mainly for the painter, with his little brush clenched in a frantic fist (fig. 4.19). (Of course at this stage model and painter are hopelessly conflated.) Or compare the page immediately following (fig. 4.20). Look in particular at the absurd configuration that tries to find form for the arm grasping the palette here—the way the palette becomes an eye, and the arm and palette a pathetic third penis. Look at the painter furthest to the left, where the eye-palette-phallus is put explicitly where fantasy most wants it. There is, in the depth of the unconscious, always a blade that swings and severs, but always a phallic eye that survives the blow; and then puts what it sees—what the male subject sees—in a frame. And to say the phallus survives the severance is weak. The phallus is the power made *by* the cutting of the body in two. Without sexual difference there would be no seeing; or rather, no seeing understood by the psyche in terms of having power, escaping from abjection, knowing everything through the eye. And this is seeing as Picasso conceives it.

Enough. The drawings are a maelstrom and looking too deep into them is bad for the health. Perhaps all I need to have established in order to move forward is how close *Painter and Model* is to the worst, the most uncontrollable, kinds of regression and repetition-compulsion; and the immense effort that must have been involved in prizing the final painting away from its matrix. One or two of the sheets just illustrated are as close to the pathological—the true overkill of "automatic drawing"—as Picasso ever got. The path toward painting, it follows, was one of repression, above all of the body's original obscene particularity: the hairiness, the dishevelment, the violence, the futile shading and erasure (fig. 4.21). Let me say again: these are fantasized attributions, which play their part, one assumes, in actual sexual relations, but tell us little or nothing on their own about their author's sexual conduct or even his first-level seeing.

4.19. Picasso, *Study for The Painter and His Model*, December 1926–May 8, 1927. India ink, Ingres paper, pen, 17.5 x 26 cm. Sketchbook 34. Inv. MP1873; folio33recto. Musée Picasso, Paris.
4.20. Picasso, *Study for The Painter and His Model*, December 1926–May 8, 1927. India ink, Ingres paper, pen, 17.5 x 26 cm. Sketchbook 34. Inv. MP1873; folio34recto. Musée Picasso, Paris.
4.21. Picasso, *Figure*, December 1926–May 8, 1927. India ink, Ingres paper, pen, 17.5 x 26 cm. Sketchbook 34. Inv. MP1873; folio30recto. Musée Picasso, Paris.

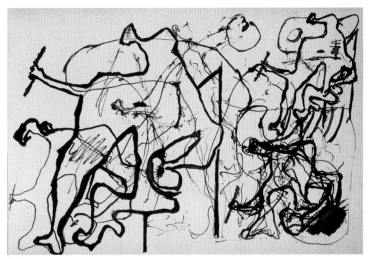

4.19

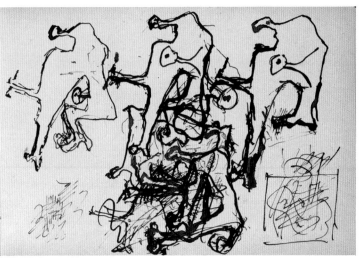

4.20

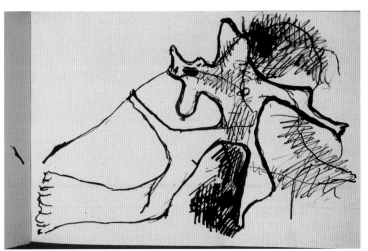

4.21

Two pages on from the scribbled mutant—part of a cluster of images in which ham-handed "shading" seems desperate to displace darkness from inside the female to the space around her (fig. 4.22)—one comes across a beautiful pen-and-ink drawing of Marie-Thérèse Walter, whom Picasso had met for the first time on 8 January this same year, when she was seventeen (fig. 4.23). Occasionally it is suggested in the literature that his new love for Marie-Thérèse turned Picasso's art in a sunnier, more exultantly erotic direction after the sexual miseries of the previous few years. No doubt. But love is one thing, sex another. Marie-Thérèse cradles her young head in her hands, in a way not unlike the monster woman's great holding-aloft of her snout. Is Marie-Thérèse the monster, then? Was it Picasso's actual reentry into the world of sex that released in him a wild rehearsal—a *Demoiselles*-type theater—of what sex, for men, most deeply consists of? Who knows? Who cares? At points like these—and they are the points that matter in art—biography is banality or speculation.

■ ■ ■

Monstrosity is a big topic in Picasso, and not always nasty or doom-laden (fig. 4.24). Monsters can be charming. Children do not cuddle up with dinosaurs for nothing. This question will spill over into lecture five, and still be with us when we confront *Guernica* (fig. 4.25). In fact *Guernica* is a good starting point.

Some would say, and did say powerfully at the time, that Picasso's inability to see the human world in any other terms than the monstrous—his automatic decision to recast pain and panic as a theater of distortion—fatally compromised his effort to speak to the public realm. Others—and they are not necessarily in the end any the less his detractors—believe that *Guernica* is his greatest painting precisely because reality, alas, offered itself in 1937 in a form that *was* monstrous, and to which his private language applied. Behind both lines of argument lies the doubt about Picasso that will never go away. Face to face with the evidence of his paintings few of us would dispute, as Roger Fry once put it, "that we [are] in the presence of one of the most sublime originators in the history of art." But is origination greatness? Is Picasso an artist who offers us, finally, *a view of the world*—one which we need not assent to, exactly, or even sympathize with, but which we recognize as a serious and in some sense complete vision of what it means to be human?

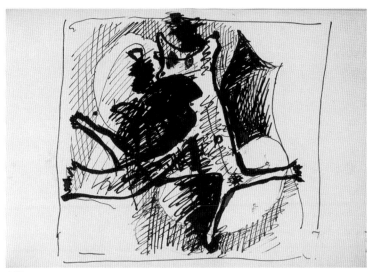

4.22

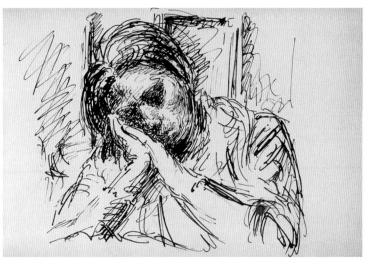

4.23

Speaking as a socialist atheist, I would say that the worldviews of Grünewald and Velázquez are as uncongenial to me—to me as a citizen, to my everyday sense of human possibility—as anything I intuit Picasso to be proposing. But assent is not it. I recognize in Grünewald and Velázquez—I fully enter into, in the act of looking—an account of the species in full. The question in Picasso's case is whether the same

4.22. Picasso, *Figure*, 1926–27. India ink, Ingres paper, pen, 17.5 x 26 cm. Sketchbook 34. Inv. MP1873; folio31recto. Musée Picasso, Paris.

4.23. Picasso, *Portrait of Marie-Thérèse Walter*, December 1926–May 8, 1927. India ink, Ingres paper, pen, 17.5 x 26 cm. Sketchbook 34. Inv. MP1873; folio32recto. Musée Picasso, Paris.

4.24. Picasso, *Bather with Beach Ball*, Boisgeloup, August 1932. Oil on canvas, 146.2 x 114.6 cm. The Museum of Modern Art, New York. Partial gift of an anonymous donor and promised gift of Jo Carole and Ronald S. Lauder.

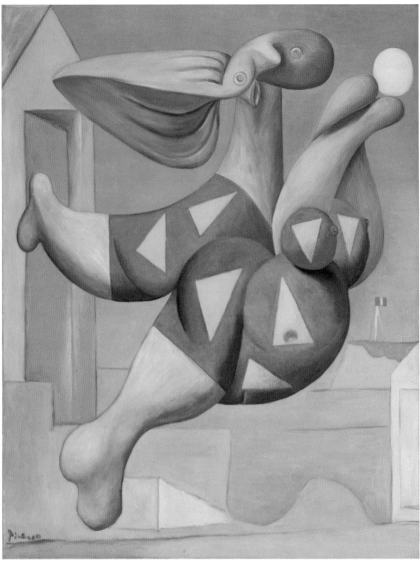

4.24

is true, or ought to be asked, of his life's achievement. I say "ought to be asked" because one answer might be that his body of work is precisely the strongest argument we have (and this is what is hateful about it) that greatness—meaning comprehensiveness, meaning the possibility of a form that claims the universal, however accepting of the partiality of its "point of view" upon it—no longer applies. It should not even be tried for. For greatness is a dependency of Truth.

This still leaves the problem of *Guernica*. On the face of it, greatness and truth are its telos. But again, some would say that this is the key to the painting's weakness—its blare of trumpets, its patchwork of disconnected episodes—and to the way our culture clings to it, as if in reaction to everything else Picasso stands for.

4.25

Monstrosity, then. Insofar as the artist himself ever bothers to explain its recurrence in his work—and he does so only indirectly—it seems to have to do partly with seeing, and partly with his and others' psychic life. Take the latter strand first. Monstrosity is linked in Picasso's thinking to various dimensions to the human he evidently values, even if they are destructive and terrifying. One day in November 1933 he came back from a meeting with the psychoanalyst Jacques Lacan in a thoroughly bad mood. "'He [that is, Lacan] claims that the Papin sisters are insane,' says Picasso." (The Papin sisters were two maidservants from Le Mans who had murdered their mistress and her daughter earlier in the year. They had gouged out their victims' eyes while they were still alive, and then gone to bed together, lying quietly naked to await the arrival of the police.) "And Picasso went on to declare [the deadpan witness is Kahnweiler] that he admired the Papin sisters, who had dared to do what everyone would like to and no one dares. 'What becomes of tragedy, then? And great feelings like hatred? (Et les grands sentiments? La haine)' . . . 'Today's psychiatrists

4.25. Picasso, *Guernica*, 1937. Oil on canvas, 349.3 x 776.6 cm. Museo Nacional Centro de Arte Reina Sofía, Madrid.

are the enemies of tragedy. . . . [S]aying that the Papin sisters are insane means getting rid of that admirable thing called sin.'"

Monstrosity, Picasso seems to believe, is what the human reveals itself to be at moments of maximum intensity: it is bound up with the claim to autonomy, and impatience with the given. The Christian notion of sin gets us close to it, as does the Greek term hubris. "Drama" is a word that keeps coming up in Picasso's conversation, alongside hurt and hatred. Hatred is the other side of love, or maybe love is a mask that hatred wears—one of many. The world is hostile, in Picasso's view. "I never 'appreciate,' any more than I 'like.' I love or I hate. When I love a woman, that tears everything apart—especially my painting." There is a certain amount of Paris-in-the-thirties banality to all this—a touch of the Georges Bataille, one might say—but no one can doubt that Picasso was of the party.

There is another thread. In the record of Picasso's talk with friends, making things monstrous—"putting the nose out of joint" is his short-

hand—is regularly justified in crude realist or materialist terms. Monstrosity, he is fond of saying, moves the picture out of the realm of art and into that of the *thing*, the object. It forces the viewer to see a nose. And maybe finally the nose will not look monstrous—or it will look monstrous in the way noses actually are. Of course these two sketched-in half-explanations may not be strictly compatible. Either monstrosity is a threatening but precious form of the human, which all cultures hem in with taboos, or it is a mechanism to put us back in touch with the real and everyday—the mere body, the body as it is. In Picasso it is both. It oscillates between the one and the other. Charlotte Corday in his 1931 *Death of Marat* would be one end of the spectrum—the Papin end, we could call it (fig. 4.26). The great *Woman in an Armchair* of 1929—implacable and integral and yet somehow infinitely gentle—would be the other (fig. 4.27). And there are many more *Women in Armchairs* than Charlotte Cordays.

"When I was a child," Picasso says to Gilot, "I often had a dream that used to frighten me greatly. I dreamed that my legs and arms grew to an enormous size and then shrunk back just as much in the other direction. And all around me, in my dream, I saw other people going through the same transformations, getting huge or very tiny. I felt terribly anguished every time I dreamed about that." So perhaps (we return to the sketchbooks) Picasso's monsters come from a level of the psyche where calling them evil or hateful or "tragic," or even claiming they are true, is all

4.26

secondary—all ascription after the event. Monstrosity is what the world first looked like. The dream is frightening because it reminds the child of a reality he is desperate to forget. So close, that otherness, and so deeply repressed.

Gilot, by the way—always the sharpest of Picasso's critics—makes the link straight away between the childhood dream and the paintings from the late 1920s (fig. 4.28).

■ ■ ■

Child psychologists talk of the special existence that objects and persons have for the baby in its first year. "Things that exist immediately and totally

4.26. Picasso, *The Death of Marat*, 1931. Oil on canvas, 46.5 x 61.5 cm. Musée Picasso, Paris.

4.27

4.28

for the child," they say (as part of the infant's immediate world of wants, needs, fears, manipulations), "possess a quality that goes beyond information from the senses; these are *ultrathings*, which may be constructed in conformity to, but distinct from, the data of reality."

This leads back to the Rimbaud formula. Monsters are regularly accompanied in Picasso's work from the late 1920s by bland stenciled silhouettes, which it is tempting to read as Picasso's own (figs. 4.29 and 4.30). Blandness here seems to be the point. The faces are empty and ineffectual—far more so than the man-eating women whose profiles

4.27. Picasso, *Woman in an Armchair*, 1929. Oil on canvas, 91.5 x 72.5 cm. Museu Coleção Berardo, Lisbon.
4.28. Picasso, *Figure*, 1927. 133 x 103 cm. Private collection.

4.29

4.30

they half-repeat. "Picasso" here is an artifice of picturing, parasitic on the frame or the frame-within-a-frame; the real presence and immediacy belongs to the Other. The Other is the first and continuing form of the Self, psychologists tell us—its true and necessary misrecognition. So for once it may really be relevant that Picasso's pictures were produced at the moment Paul Guillaume, Henri Wallon, and their collaborators were putting together the observations and theories concerning the formation of the child's initial body image which we now sum up, a bit too readily, under the rubric of the "mirror stage." Guillaume's wonderful *L'imitation chez l'enfant* was published in 1925. Elsa Köhler and Charlotte Bühler brought out their founding studies of the mentality of one- and two-year-olds in 1926 and 1928. Wallon was assembling the elements of his *Origines du caractère chez l'enfant* through these same years. His great "Comment se développe chez l'enfant la notion du corps propre" appeared in the *Journal de Psychologie* in November 1931.

Though Lacan's final summation of this material inevitably looms large, and Picasso's pictures are full of mirrors, paintings, and panes of glass, I believe what we need by way of comparison is not so much the moment of coordination in front of the mirror, but the picture that emerges from Wallon and company of the child's world *before* unison and alien-

4.29. Picasso, *Figure and Profile*, 1927–28. 65 x 54 cm. Private collection.
4.30. Picasso, *Bust of a Woman with Self-Portrait*, 1929. 71.1 x 60.9 cm. Private collection.

ation. The Other may be the form of the Self, but there are many others preceding the one in the mirror: persons or things more proximate, more deeply entangled with sucking and touching and biting and smelling and screaming fit to bust. And these seem to me the dimensions of sense—the kinds of confusion and synaesthesia—that interest Picasso most. The first picture of self, says Wallon, is formed long before the child evinces a flicker of interest in the ectopic double in the mirror. It "emerges from passionate interactions [with the immediate occupants of the child's small world]"—I am quoting Wallon in the 1940s—"in which each person has difficulty in distinguishing itself from those others and from the total scene in which its appetites, desires, and fears are bound up."

What this does not mean, to follow the analysts, is that the child's first world is blurred or indistinct. It is possessed of a vividness and specificity that only Picasso knew how to recapitulate, but one that cuts across the mere question of I and not-I, or male and female. The two spotlight shapes in *Painter and Model* speak directly to this. The hard edges of both intersect one or more of the monster woman's orifices—her anus, vagina, navel—and annex part of her lumbering body—a breast in each spotlight, and an overweight arm and hand in one counterbalanced by a preposterous false penis in the other. The thing is a comedy. The shapes seem to ironize the very idea of bodies soldered into unities by a circuit of cracks and erections. The shapes are projections—they try to invent and demarcate a world of sexual difference. But the wholes they make are hallucinatory, and neither has a hope of stopping the monster in her tracks. Is the knife blade a phallus and the palette a womb? But how do these clichés of sexuality map onto the figures seen through them? Shouldn't the model own the womb shape and the painter the knife? Or maybe the woman (in fantasy) always has both? Possible unities come and go. What counts in the world before the mirror, to repeat, is the sheer momentary intensity of the totalizing image, and its ability to bind and focus the "total scene" of desires and terrors; and such an image is, by its very power, always self and other (male and female) at the same time.

．　．　．

A child of six could do it—or a child of six months. We shall never know how many of the findings of the new psychology Picasso was aware of (though the links with Lacan are suggestive, and the cult of psychoanalysis

endorsed by many of Picasso's close friends), but there can be no doubt that the world of the child became for him, for a while, something like Truth's last refuge. *The Blue Room* gave way to a memory—a recreation—of the lost first conditions of seeing. It is a hopeless and entirely period-bound attempt to give art a new grounding. Surrealism is relevant, for all Picasso's later efforts to shrug off the connection. What is most interesting, however, is the effort in Picasso to reconcile the imaginary—the fantasmatic, the horrible and impossible, the flashing by of the deeply repressed—with his native materialism. "I believe in phantoms," to quote him again, "they're not misty vapors, they're something hard. When you want to stick a finger in them, they react."

Here then is the question that matters. Let us grant that the vision of the body in *Painter and Model* is infantile and that, precisely in the way of the infantile in us, it teeters between the terrible and the ludicrous. Let us grant that the picture's account of the terms of representation is stiflingly restricted: two characters, sort-of-male and sort-of-female, locked in a windowless cell. No wonder the artist is rendered as an insect put together out of wire. The view of the human implied may be deeply inimical, but the question (as usual in art) is: does the painting *enforce* the view? Does it make its view available to us? Does it put us in a position where we can—and in a sense must—enter into its impoverishment, or its joy in embodiment, or even its wish (a very human one) to frighten and defile? You will gather I think it does. And how else, this being Picasso, than by giving its monsters space? The metaphors of the last few sentences—"view," "entry," "being put in a position"—have to be made real.

We turn back to the territory marked by the spotlight apertures, and the way they structure our access to the scene. Again Cubism is the matrix. Cubist space and color and geometry are what the painting—what *any* painting: that is the proposal—is now bound to be made out of.

Painter and Model is a Cubist monochrome: this is the first thing about it, stamped on the eye from a distance, and it is the aesthetic fact that goes on resonating most deeply—all the more so because the tension between monochrome and monstrosity is at one level so extreme. We could see it as the picture's great argument with *Young Girls Dancing*, where color and affect are inseparable. And really the argument had been inherent in

Cubism from the beginning (fig. 4.31). One thing Cubism had seemed to argue in its heyday was that beauty and desirability in painting now stood in need of the grid and the monochrome if they were to be anything but Renoir kitsch. Painting had to purge itself of the curve, the rotundity, the fleshly, the inviting. Maybe if it did so the mark of desire—the words "My Pretty One"—could be written on top of the new construction. And maybe in time they could even be written *into* the construction (fig. 4.32). At first sardonically: the breasts in *Woman in an Armchair* from 1913 are hammered in place with wooden pegs, and the flesh- or dress-signs just to the right—are they folds of upholstery or adipose tissue?—look like bellows on a pneumatic machine. Desire would be reinvented in painting, but only slowly, against the tide.

Next to *Woman in an Armchair, Painter and Model* (fig. 4.33) looks bloodless. It puts on sackcloth and ashes again. The severity of 1910 and 1911 is revisited, as it would be later in *Guernica*, but whether in the spirit of revival or mourning or even parody is not clear. The steel-wire painter puts the point programmatically. He is assembled from the leftovers of High Cubist geometry. And he knows that he lives in a world where the sheer force of sex—the blade and the womb—is dragging every straight line into a slow-turning vortex. Floorboards warp and splay in the centrifuge. But he fights back. His pincer hand on the palette tries to hold—to stabilize, right at the picture's visual center—the sudden black dot of eye, orifice, nipple, nostril, navel. And the hand with the brush aims to harness the white light of the left-hand blade and put it in a picture—make it be part of a Cubist grid. The top of the blade is a window, or a wall tilting back in perspective. The painter's canvas presses it flat.

Poor devil. But this need not be a verdict on Cubism as a whole. The painter maybe stands for the pathos of clinging to the style's surface grammar. The painting as a whole is exploring what might now be involved in reaching back to, and reinventing, Cubism's *space*—Cubism's intimacy and proximity. I use the metaphor "reaching back to." But again the idea is more than metaphorical. For the central achievement of *Painter and Model*—and this is typical of Picasso at full power—is to literalize, materialize, the notion of "reaching back." Reaching back into Cubist space. . . .

183

4.31. Picasso, *Ma Jolie*, Paris, winter 1911–12. Oil on canvas, 100 x 64.5 cm. Acquired through the Lillie P. Bliss Bequest. The Museum of Modern Art, New York.
4.32. Picasso, *Woman in an Armchair*, 1913. Oil on canvas, 148 x 99 cm. Private collection.

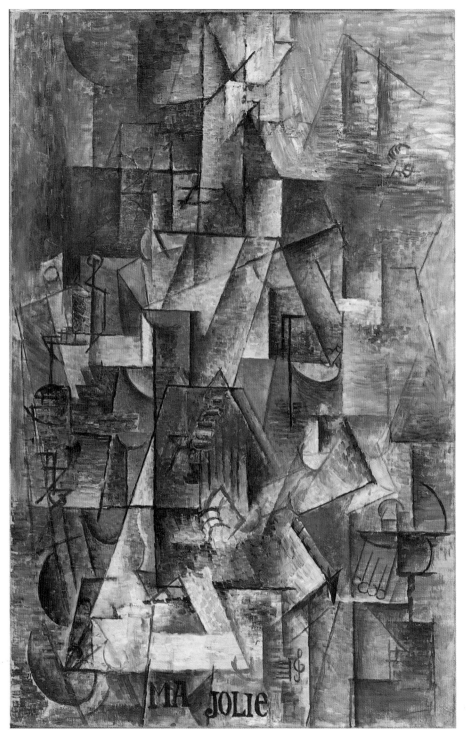

4.31

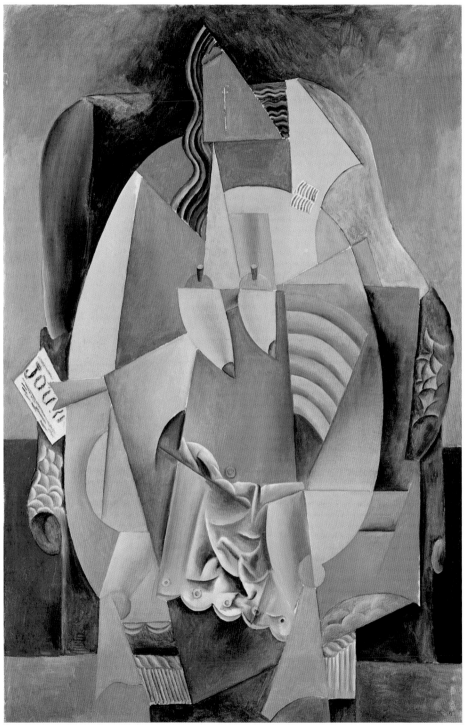

4.32

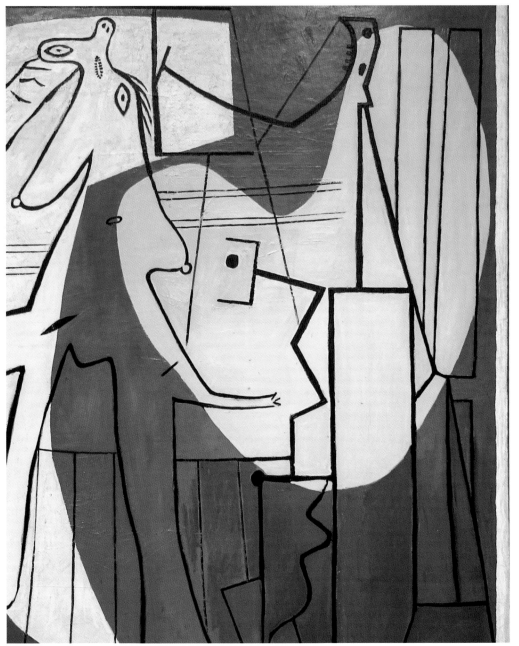

4.33

Finding a way into the lost nineteenth century. . . . The painting—above all the apertures—will give us the means to have that happen.

Language is treacherous here. "Reaching back into room-space" is one way of putting it; but I don't think it grasps what happens pictorially. Even the words "aperture" and "opening" are too crisp. For this is a painting that brings to a crescendo a kind of surface treatment Picasso had spent much of the 1920s working out: a hard, encrusted, tamped down opacity, like high-grade plasterwork or stucco stiffened with sand. So the shapes are consubstantial with the gray surrounding them. There are no holes in a painting like this, no perceptual blanks. I have toyed once or twice with the notion of spotlights picking up a horror in the dark. Again, this says something. Maybe we could call the two hard-edged shapes "projections." This has the right period flavor: there can be no doubt that somewhere in Picasso's imagination was a cinema—a great screen with an image frozen for all eternity. We are only months before the shooting of *Un Chien Andalou* (fig. 4.34). The blade cuts cleanly across the lens.

Projections they may be. But projections from where, on to what? Though the palette and blade do conjure up a kind of threshold—a passing from where we look to what we look at—it is not the case that the two forms declare themselves to be *ours*: our image or imagining, beamed onto the surface. Picasso was certainly aware that this was one thing a cast shadow, or a representation of one, could do. Sometimes in his work at this time the shadows (or their negatives) are explicitly of faces, inviting us as viewers to identify with them and take part in the lantern show (fig. 4.35). But the shapes in *Painter and Model* do not operate the same way. They are not projections as psychoanalysis understands them. They do not come from us, and they do not get inside—enter and reconstruct— the illusion. (They do not put us in the picture.) Or perhaps they do: one moment of looking can have them seem, as I said at the beginning, like light smacking against a Cubist back wall. But a contrary moment always recurs. The projections are here on the screen, the surface. Never have painted shapes been more palpable. Screen image may be all there is, with no infantile reality behind it.

187

4.33. Picasso, detail of *The Painter and His Model*, fig. 4.1.

4.34

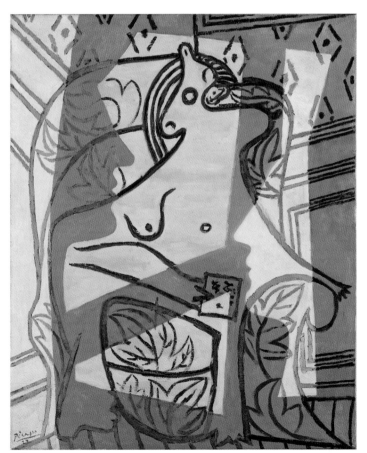

4.35

Perhaps the apertures *are* the picture plane. Does that mean they make the transparency—the "to-be-seen-through-ness"—of the picture plane wonderfully, naively present? Or should we say that they bring into visibility the fact, glanced at already a propos Delacroix, that always the picture plane is an effect—a projection, this time almost in the psychoanalytic sense—of the surface material we are certain, as part of the business of looking, *is not what makes the transparency?*

Oh, I suppose the answer is both, or all of the above. And we should not lose ourselves in the intricacies that come from talking up—talking through—an invention of form of this kind. It is intricate and dialectical, but also simple. Never let go of the fact that the device had its origins in mayhem, in pictorial and psychic chaos (fig. 4.13). And that at the beginning the monsters overlaid the apertures, overtook them: they could hardly be seen through the scrum. Notice the difference in the drawing from 1927 between the white spaces and the "doorway" through which the two penis-perceivers shove their rubber necks. The apertures here are not up front—not openings onto the scene. Only slowly, in the sketchbooks and in the making of the painting, would they become so, or would that possibility for them emerge. And it did so because in the end the openings *solidified*, became fully and only facts of painting, and lifted out of the illusion—if, that is, we mean by "illusion" chaos or Untruth. But in the process illusion too had ceased to be like that. The scene of looking and representing was still monstrous, but it was clear. *Ultrathings* had come to the surface.

And therefore—but which is cause and effect here?—the space of Cubism, which had always in Bohemia claimed to be the space of denying nothing (seeing with no taboos), came back to life. It turned to face us, again in arm's reach. Body and it were coterminous. And exactly where all this imagined proximity *ceased* was made the painting's great matter. The picture plane was opened and materialized. The room was nowhere but in it, on it. The shapes on the picture plane half-captured and remade the imaginary characters in the room, but, just as likely, they seemed

189

4.34. Luis Bunuel and Salvador Dalí, *Un Chien Andalou*, 1928. Film still. Stills Library, National Film Archive, Paris.
4.35. Picasso, *Woman in an Armchair*, 1927. Oil on canvas, 71.76 x 59.06 cm. Minneapolis Institute of Arts, Gift of Mr. and Mrs. John Cowles, 63.2.

emanations—reconstructions—of the actors they crossed. One of them a palette, the other the endless knife blow of sexual difference.

. . .

The apertures—here is my Nietzschean coda—are what becomes of space in painting when painting admits its fully and only fictional status. Nietzsche was fond of quoting Pascal, who said that without God—without Christianity—"you, no less than nature and history, will become for yourselves *un monstre et un chaos*." Nietzsche saw the danger but embraced it: so, I think, did Picasso. The task for art—the task for culture—after Christianity was to shape illusions that would admit monstrosity but keep it in check. The apertures try to do just that. They are the forms illusion must take in the face of chaos (which is truly what the human amounts to): real forms, that is, hard and clear forms, but in the end enclosures—bars of a cage. The "figures" are in them and behind them. Space from now on is projection, not perspective.

"Seeing through" the picture plane had been, in practice, the last refuge of Truth in depiction, and here finally no such refuge remains. The room—the figure of shared habitation—has never been closer. It presses forward, whispering its promise of pleasures and warmth. The picture plane seems to open itself. The distance between us and our wishes is about to collapse. But what we wish at the start of life, in the fears and fantasies of the six-month-old (and these, says Picasso, are the vortex into which Untruth is sucked), turns out to be a something else—a somewhere else—whose essence is its otherness, its threat. The illusion will keep it at bay.

LECTURE 5

MONUMENT

That I may reduce the monster to
Myself, and then may be myself
In face of the monster, be more than part
Of it . . .

 . . . not be
Alone . . .

 —Wallace Stevens, "The Man with the Blue Guitar"

Let me imagine a reader, thinking over the previous lecture with *Painter and Model* in view, beginning to have doubts (fig. 4.1). Well yes, she might say, I can see that the thing is a masterpiece. I may not warm to it, but I understand the effort of mind needed to reinvent the space of Cubism in this way—to turn its nearness to face us, and make the contact between proximity and picture plane explicit. And I even begin to grasp what Picasso supposed he was doing when he populated the new space with monsters. But I keep returning to the moment in the lecture when *Painter and Model* was put next to *Guernica* (fig. 4.25). Part of the point of the juxtaposition, if I have it right, was to suggest that when Picasso painted *Guernica* he returned in memory to the color and drawing and depth of 1927. (Maybe he did more than rely on memory. After all, the unsaleable *Painter and Model* was still in his studio.) This seems plausible, though I still want the argument about depth in *Guernica* spelled out more fully. But here is my difficulty. The whole burden of these lectures so far has been that for Picasso the only space—indeed, the only reality—his painting could fasten onto and continue to recast was private. Room-space, you called it: an interior full of familiar things: maybe with light and air coming into the room and bringing the outside *to* these familiars, but always with the intimacy and containment of four walls as a given. But is not the point about *Guernica* that its space, and its whole conception, is public? Isn't room-space a thing of the past? Doesn't the painting's achievement hinge on its

ability to show us the interior—the place of shelter and habitation—done to death? But if so, does *Painter and Model* really lead to *Guernica* at all?

I know that *Guernica* (she continues), for all its survival as a twentieth-century icon, has always had detractors. They see its action as histrionic, and its space as unconvincing—too much a matter of geometric bits and pieces forced into a light-dark straightjacket. I gather that you do not agree with this verdict, but does not your whole argument essentially lead the same way? Isn't your Picasso bound to be *lost* when room-space is shattered? What is there in his way of painting that can possibly have prepared him to imagine a city bombed to smithereens?

Then the reader asks one more question. Are there monsters in *Guernica*? Surely not. Monsters have been replaced by creatures—by creature-liness—by women and animals in pain and fear. The ability to show us this on such a scale, and with such simplicity, is what gives the picture continuing life. But from monster to creature is a quantum leap. Nothing in Picasso bridges the gap. *Guernica*, in a word, is an anomaly in Picasso's universe, a counterfactual. No wonder that when the delegates from the Republic came to ask him in 1937 for a mural for the Spanish pavilion, he told them he did not know whether he was capable of painting a picture of this kind. Open space, giant size, tragic compassion: what have any of these to do with the *Young Girls Dancing* or *Still Life in front of a Window*?

■ ■ ■

This lecture addresses these doubts. It will argue, to put it briefly, that with part of his mind Picasso sensed that *Painter and Model* had brought Cubism to an end, and that in the three or four years following he searched for ways out of its confinement—not just ways to bring the outside into the room, as we have seen him doing repeatedly, but ways *into* the outside. He tried to establish his monsters in a world—on the shore, under the sky. He wanted to see if the openness of the outdoors could be made into a picture; that is, made present and coherent within the four sides of the rectangle. Because only if exterior space could be made fully pictorial—fully consonant with the painting's actual size and shape—would it register, for us and Picasso, as human.

There is a further turn to this. It seems that making the monsters human—giving them a space in which they could be made to stand next to us, as further forms of the body we know—entailed making them into

monuments (fig. 5.1). That is to say: thinking a body in the outside world, for Picasso, involved imagining that body becoming a sculpture; and sculpture, as Picasso dreamed of that other medium in his painting, stood for a possible wholesale revision of *scale* in art. (Not always, of course, but repeatedly.) There is a canvas from spring 1929 called *Head: Study for a Monument* (fig. 5.2). It is a modest painting, not quite two-and-a-half feet high, but its implied dimensions are vast. Compare it with another small canvas from the same time called *Monument: Head of a Woman*, where the new scale is explicit (fig. 5.3). The monster head here seems to be affixed to a great monolith, maybe even a strange windowless building, and four tiny pedestrians stand underneath it as if on the rim of the globe. Picasso's ventures into the outside world are not always happy. As a picture, *Monument: Head of a Woman* is slight. I sense that Picasso himself knew this, and even signaled his knowledge, uneasily: the triteness—the jauntiness—of the blue sky is a sign of space escaping him. Maybe he wanted us to recognize the picture as comedy; but only because otherwise we would have been struck by the seriousness—the portentousness—of the whole thought-experiment, and realized how far Picasso was straying from his normal habitat.

195

Of the three paintings just pointed to, all from spring 1929, it makes sense to concentrate on the best, *Woman Standing by the Sea*. One fact of context needs stating beforehand. The period from 1927 to 1931 is extraordinarily productive for Picasso: part of my story is the restlessness and intensity one senses in his every move. But there are reasons why these years have never been given their due. They are chaotic. They contain more than their fair share of failures, or ideas only half realized. The monster in the open—the body as an improbable public fact—is a *problem* for Picasso. I admire his courage in facing it. You will gather, for instance, that I treasure the photograph from 1928 in which Picasso seems to measure himself, only half-facetiously, against a full-scale monster propped to his right (fig. 5.4). But I am not convinced by the monster-painting itself (fig. 5.5). I think I understand *Standing Nude*'s deliberate tentativeness of

5.1

5.2

5.3

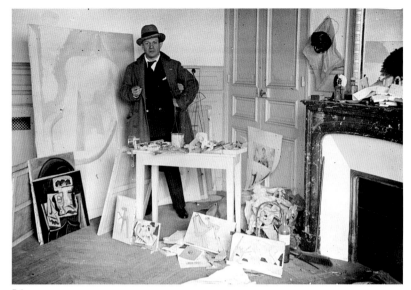

5.4

5.5

drawing and thinness of touch. It is as if the phantasmagoric quality of the apparition had to be held onto, and the absurd creation only be given life insofar as it was maneuvered—fitted and slotted—into a leftover Cubist frame. Fragments of straightedge architecture still hem the monster in. There is something vulnerable, almost touching, to the end result. But as a picture—the painting is six feet high and four feet wide—does it hold together? Has the monster been given a world to occupy, or ground to stand on? I am not sure.

Painter and Model seems to have left Picasso uncertain about where to go next. The other big masterpiece of 1927—done in the winter of the year, surely in dialogue with the painting of the previous spring—gave a brilliant, but utterly terminal, answer. *The Studio*, it is called (fig. 5.6). It is the radiant sardonic tombstone of Cubism. Cubism's little room-space has been sucked back relentlessly onto the surface, and forced into a pedagogical grid. Overlap and interlock of entities become fatuous intersection. What a revenge on the Cubist academy! And the only hope for a *life* of space, in *The Studio*, appears to be color: the ridiculous Cubist mannequin standing in front of his canvas at left (he makes the artist in *Painter and Model* look limber by comparison) is absorbed—annihilated—by the sunburst of yellow, and even the student-exercise still life on the table is saved from asphyxia by stained-glass red.

The Studio is Cubism put to death. The next eighteen months, however, are full of efforts at resuscitation (figs. 4.8 and 5.7). The paintings in question have been much admired, and they certainly crackle with energy; but it seems to me—I state this baldly—an energy that does not know when to stop. The result is overload, excess of geometry, *horror vacui*, clever repetition—a comeback of the kind of disciplinary Cubism that *The Studio* had satirized. And space—the touchstone of a world imagined—disappears into the compositional machine. This time no yellow can save it.

Compare these jampacked *Studio* paintings, understood as responses to *Painter and Model*, with a midsize canvas from the summer of 1927, done directly in the big picture's wake (fig. 5.8). It is a canvas Picasso kept for himself, and twenty years later gave to the Musée national de l'art moderne. The painting is called *Figure*, meaning "figure" in general

199

5.4. Unknown photographer, *Picasso in His Studio*, 1928. Roger-Viollet, Paris.
5.5. Picasso, *Standing Nude*, 1928. Oil on canvas, 162 x 130 cm. Picasso Estate.

5.6

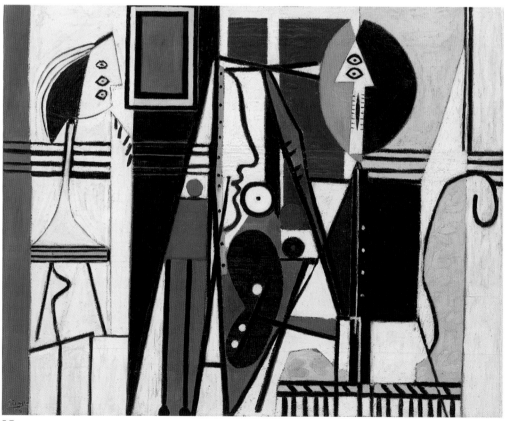

5.7

but also specifically "face," and it is a brilliant—merciless—distillation of the monster-possibilities thrown up by the previous masterpiece. Put it next to *Monument: Head of a Woman*—the two paintings are steps on the same difficult path. *Figure*, you will notice, seems to install its lone monster in a window of sorts: the right-hand strip of pale yellow conjures up that possibility. The strip is a device borrowed from Matisse, though part of the point, I take it, is to turn Matisse's great metaphor—the window (the painting) as an opening onto sensual freedom—against itself (figs. 1.7 and 3.17). The dazzling, but also opaque, quadrilateral in which the monster is framed in *Figure* is again an aperture or spotlight—maybe to be thought of as light hitting the windowpane and illuminating the horror on the other side. But of course the white diamond is also the *Figure*: it is one of the apparition's ways of presenting itself; it is the *Figure* facing us, pressing close to us, becoming a face. The question that follows, for me, is where is it facing us *from*? Is the space the monster inhabits outside or inside? Is the thing tapping with its snout at the window, desperate to come indoors? Or are we the outsiders? Is the thin double line behind the creature, dividing the painting in two, another of Picasso's back walls with wainscoting, or is it a far horizon? More likely the former. But it is enough that *Figure* can already potentially—I would say actually, with part of our minds—be imagined beyond the room. And therefore its size comes up as a question. It may be as big as a picture (fig. 5.9). It may find its way back inside the closed interior (fig. 5.10). Even *Monument: Head of a Woman* is not once and for all a public figure, glowering down on diminutive citizens. She too—it too—can be reinserted between table and wallpaper (fig. 5.11).

The point is simply that inside and outside, and public and private, become matters for experiment in the run-up to 1930. And outsidedness

5.6. Picasso, *The Studio*, Paris, winter 1927–28; dated 1928. Oil on canvas, 149.9 x 231.1 cm. Gift of Walter P. Chrysler, Jr. (213.1935) The Museum of Modern Art, New York.
5.7. Picasso, *Painter and Model*, Paris, 1928. Oil on canvas, 129.8 x 163 cm. The Sidney and Harriet Janis Collection. The Museum of Modern Art, New York.
5.8. Picasso, *Figure*, 1927. Oil on canvas, 100 x 82 cm. Inv. AM2727P. Musée National d'Art Moderne, Centre George Pompidou, Paris.
5.9. Picasso, *Figure and Profile*, 1928. Oil on canvas, 72 x 60 cm. Inv. MP103. Musée Picasso, Paris.
5.10. Picasso, *Head*, 1927. Oil and chalk on canvas, 100 x 81 cm. Gift of Florence May Schoenborn and Samuel A. Marx, 1951.185. The Art Institute of Chicago.
5.11. Picasso, *Head*, 1929. Oil on canvas, 54 x 45.5 cm. Moderna Museet, Stockholm.

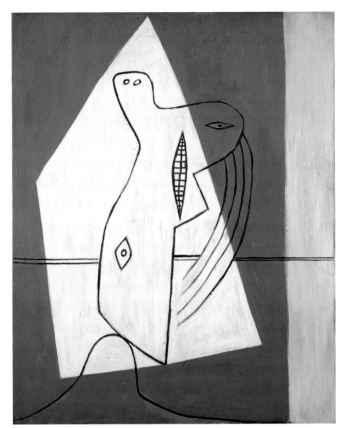

5.8

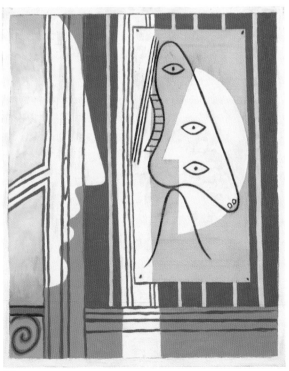

5.9

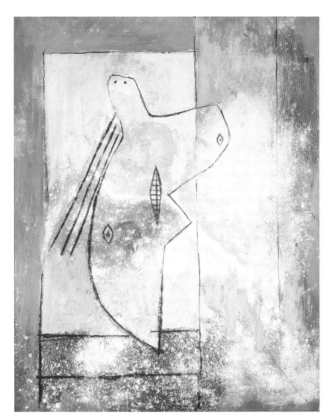

5.10

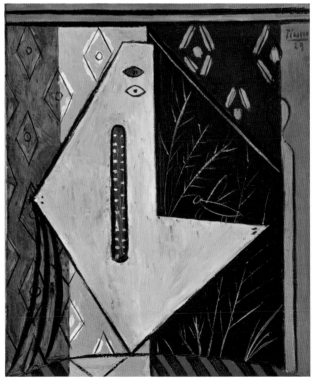

5.11

is now an option: not an easy or natural one, but one that Picasso devotes his whole energies to imagining.

. . .

A woman, or something like a woman, is standing on the shore (fig. 5.1). The sea is behind her, and she is alone. The light strikes her evenly. She is something like a woman, but also like a statue. Her body seems as if chiseled from stone—in places the surface is chafed and abraded by some special tool so that it looks almost fleshlike; and at others, notably the neck, the legs, and the hand clasping a wrist, it is left in blocked-out form, like a rough cut fresh from the quarry. The woman is naked, but her nakedness does not in my experience set off much of a hue and cry of desire. It is the nakedness of evidence—of exposure to sunlight more than the gaze. Such things happen naturally on the beach. The curious position of arms and hands over the head, almost using the head as a fulcrum, is again more gymnastic than erotic. It is a stretch—a piece of calisthenics. But the figure is facing our way. She seems proud of the body she puts through its paces. She is monstrous and misshapen, but she does not seem to know she is a freak. Picasso was once asked if he minded being called a monster (I think his love life was in question), and replied: "I am like the giraffe, who doesn't know it is monstrous." The analogy is helpful. Or maybe the creature in the painting is meant to have come from the sea. She could be a kind of marine Venus, minus seashell and accessories—facing the world without the concept "beauty" having yet violated her mind. As so often with Picasso, Ingres, that great rival in monstrosity, is lurking in the background (fig. 5.12). "What *is* beauty, anyway?" Picasso asked Françoise Gilot. "There's no such thing." What matters is standing, solidity—phantoms you can stick a finger into. Ingres's Venus is untouchable, and floats, more than stands, on spermatic foam. Picasso's is planted on the sand: no surreptitious cherub will ever give *her* toes a stroke. Ingres's world is lozenge shaped, an extrapolation from Venus's transfixing belly. Picasso has given his monster a marvelous squarish container—its actual dimensions are fifty-one by thirty-eight inches—which makes her four-squareness absolute.

Up till now in these lectures almost nothing has been quoted from critics writing in Picasso's lifetime. This is because what they have to say about individual paintings, or even the logic and intention of particular

5.12

styles, strikes me as by and large unhelpful. (The critical literature on Cubism is a study in irrelevance.) There are, however, exceptions. Early in 1930 the young poet-anthropologist Michel Leiris published an essay on Picasso's recent work in the magazine *Documents*. It seems to apply to *Woman Standing by the Sea*. (This in spite of the fact that the picture was not reproduced in *Documents* until a few months later, in an issue of

5.12. Jean-Auguste-Dominique Ingres, *Venus Anadyomene*, 1808-48. Oil on canvas, 163 x 92 cm. PE433. Musée Condé, Chantilly.

the magazine given over entirely to Picasso. There it occupied a place of honor. Leiris most likely had *Woman Standing by the Sea* in mind as he wrote—it was in Picasso's studio, and the photographs for the special issue were being assembled as the essay went to press—but he was also responding to paintings completed more recently. The article had a full-page illustration, for example, of a study of a bone monument now in Chicago [fig. 5.13].) His argument is complex, and I shall do no more than tear a few threads from it.

The main problem for viewers of pictures like these, according to Leiris, is how to tune in and match up to Picasso's matter-of-factness. The strangeness of the paintings has to do most deeply with Picasso's easy "familiarity" with the worlds he makes up—with his certainty that they are extensions of the world we live in, and his ability to convince others. Notice that the issue as Leiris sees it is not just the look of the individual monster, but the world—the space and ground—the monster occupies. Picasso is "someone who is on an equal footing with everything (qui se tient de plain-pied avec toutes les choses), [and] treats things as familiarly as possible." "In most of Picasso's paintings," Leiris writes, "you'll notice that the 'subject' (if that's the right word) is almost always grounded, in any case never borrowed from the murky world of dream, nor susceptible of being converted into a symbol—in other words, not in the least 'surrealist'." (The key words in the French here are *terre à terre*, "grounded," which could also be translated as "on a level with us," or even, with a mind to the metaphor shaping the phrase, "commonplace.") Never was an artist surer, the article goes on, of "the exact weight of things, their measure of value, their materiality." His monsters "are creatures unlike ourselves, or rather, the *same* as us, but with a different form, a more dazzling structure, and, above all, marvelously evident to the eye." (. . . ou bien plutôt, les *mêmes*, mais d'une forme différente, d'une structure plus éclatante, et, par dessus tout, d'une merveilleuse évidence.) Creatures, that is, "situated neither below or above the forms of the everyday world, but real like them, though different."

I think that what Leiris would point to as *Woman Standing by the Sea*'s humanness and everydayness—for him the painting's most challenging qualities—derives primarily from its color. The painting is blue and gray. The blue of the sky and water is sober, and the day maybe a touch overcast, but the blue does not have a melancholy feeling to it. It is not

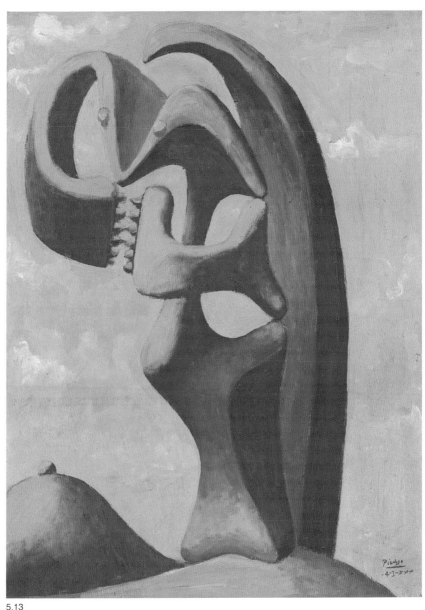

5.13

infinite; it does not absorb or overshadow the main player. No *Monk by the Seashore*, this one. Picasso, of all painters, deploys blue with a sense of the color's affective power, and of the risks one runs in making use of it. *Woman Standing by the Sea* is partly an answer to—a correction of—his

5.13. Picasso, *Abstraction: Background with Blue Cloudy Sky*, 1930. Oil on panel, 66 x 49.2 cm. Gift of Florene May Schoenborn and Samuel A. Marx; Wilson L. Mead Fund, 1955.748. The Art Institute of Chicago.

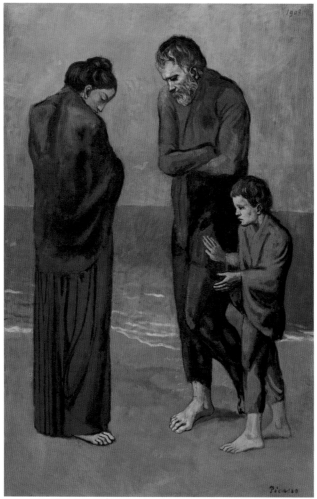

5.14

own Blue Period. Its blue speaks back to the Puvis-type *misérabilisme* of the paintings done thirty years beforehand; especially, perhaps, one of them which at just this moment acquired the title *Tragedy* (fig. 5.14). Tragedy is the register to be avoided.

The kinds of blue Picasso has decided to use in *Woman* are in themselves an antidote to affect, and even to a play of mind. They are as solid as the sky in Giotto. (Compare the sky in *Standing Nude* [fig. 5.5].) But the quality of the color is not in the end separate from that of the light, whose warmth and strength—whose real-world character—we infer from the body's interception of it. The sky may lack glitter, but the *Woman's* skin collects and diffuses what sun there is (fig. 5.15). Around the blur

5.14. Picasso, *Tragedy*, 1903. Oil on wood, 105.3 x 69 cm. National Gallery of Art, Washington, Chester Dale Collection.
5.15. Picasso, detail of *Woman Standing by the Sea*, fig. 5.1.

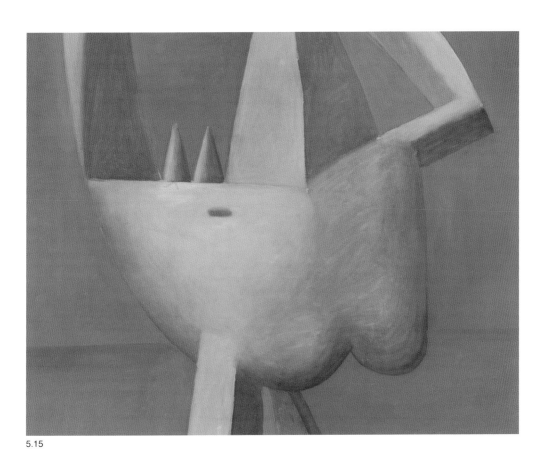

5.15

of the umbilicus the brightness is almost fierce. On the little cones of the breasts—small and regular like pieces in a board game—the light is crisp and even. It does not glare. It does, as usual in painting, expository work—giving us gradients, things to imagine in the round.

The *Woman* holds herself awkwardly, but in a way that does not come across as strained. A stretch is not necessarily stressful. The hold one hand takes of an arm, and the seeming slight contact of wrist and pinhead, are part of an overall quiet rebalancing—a recalibration—of the body and its parts. Breasts are moved left of the spinal column, buttocks moved right; neck and legs—or is it torso and legs?—are repeats of one another, but reversed top to bottom and cantilevered out from the abdomen in slightly skewed directions. The body parts are shifted around their center of gravity. The basic lateral symmetry of the human organism is broken; but only in order for uprightness—balance and integrity—to reassert themselves as dispositions *of* the body, "finding its feet," righting itself, recreating its standing. There is no special glory to this—no absurdity, no portentousness. The fall of the light, and the absolute worldliness of the blue—its true and wonderful lack of spirituality—keep everything in the here and now.

The line where sea meets sky is warped, à la Cézanne, as it passes behind the body, but not precipitously or perplexingly. The sand is laconic to the point of vanishing, but solid as a rock. The fabulous deadpan continuity of the blue as it appears in the body's negative spaces, between the legs and in the emptiness made by the arm stretch—this *lack* of disruption, or even slight disconnect (where a broken-down "Cubist" ethic might have seemed to call for figure-ground conjuring tricks)—is a triumph of antimetaphysical tact.

Then finally there is size. The humanness and everydayness of *Woman* have to do most deeply with the painting's dimensions—just over four feet high and three feet wide—and the slight, but decisive, scaling down of the figure from lifesize that results. The *Woman* herself is—what?—a touch over three feet six. This is not a noticeable miniaturization (from four yards away the *Woman* still looks imposing) but it is enough to counter the danger of the figure's aloneness coming across as poignant or heroic. Likewise the format, and the amount of space the format allows the figure at the sides. Enough to put the creature in perspective—to suggest an envelope of empty space—not enough to have the emptiness seem oppressive. I would say, following Leiris, that in *Woman* the outside world is *there*, fully realized—in the shape and size of the picture, in the quality of the blue deployed, in the placing of the figure in relation to the frame.

■ ■ ■

Apparently *Woman Standing by the Sea* is dated on the stretcher 7 April 1929. So its proper partner in the spring campaign that year is a painting dated just a month later, May 5 (fig. 5.16). It is a big painting—over six feet high and four feet wide—which makes one aware again of *Woman*'s limitations. For reasons one can only guess at, the *Large Nude in Red Armchair*, as it came to be called, never formed part of *Documents*' gallery of Picasso's recent work. But surely it was meant as *Woman*'s antithesis. We are back once more in the Cubist interior—the space of the maenad in *Young Girls Dancing*. The dance has stopped. Figure and wall and door and mirror collapse into one another. The Other's integrity flows out of her, and the body here, like an extracted tapeworm, becomes so much flat stuff draped on a scaffold. The blue departs, overtaken by reds, greens, yellows, purples, brick pinks. Light seems to glimmer faintly across the little

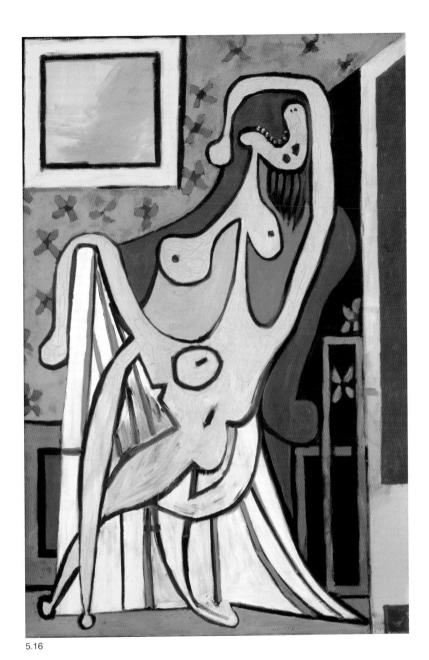

5.16

rectangle—maybe a painting, maybe a mirror—hung on the wall top left. But it is powerless against the scene's fundamental stifling airlessness.

Leiris says at one point of Picasso—it is his most wish-laden sentence, and I have saved it deliberately till now—that "each new object, each new combination of forms that he presents us with, is a new organ we attach to ourselves, a new instrument that allows us to insert ourselves more

5.16. Picasso, *Large Nude in Red Armchair*, May 5, 1929. Oil on canvas, 195 x 129 cm. Musée Picasso, Paris.

humanly into nature, to become more concrete, more dense, more alive."
I have no wish to make fun of this claim. In many ways it strikes me as a
better account of Picasso's purposes than most others we have. The reader
may see its connection with my argument about Picasso's trying, at this
time, to make his pictures open to a wider world. But the sentence on its
own does, I think, make Picasso too much of a humanist. "Nature" is only
fitfully present in Picasso, even in 1929. The beach is the leftover edge
of things. The interior is where human beings belong. It constantly reas-
serts itself. Monsters and room-space go together. And if one tries out the
Leiris-type exercise of using *Large Nude in Red Armchair* as an organ or
instrument to insert oneself more fully in the material world—to become,
by identifying with the monster, monstrously alive—one soon hits a red
and green wall. Maybe this is not what the "instrument" we are looking at
was constructed to do. "Then Pablo started off," recalls Gilot, "on a long
philosophical monologue in which he quoted Kierkegaard, Heraclitus, St.

John of the Cross, and St. Teresa, building to a disquisition based on two
of his favorite themes: *Todo es nada* and *Je meurs de ne pas mourir*—what
in a more amiable frame of mind he often referred to as his *philosophie
merdeuse*." I doubt the disquisition was impressive. But its themes bring
us closer to *Large Nude*, alas, than Leiris's "plus denses, plus vivants."

It would be idle to pretend, in other words, that monstrosity in Picasso
is not regularly bound up with fear or despair or the wish to do harm.
"Let's play at hurting ourselves," says one of the characters in Picasso's
pantomime from the late 1940s, *The Four Little Girls*. It is a game Picasso
was fond of. And the little girl's idea reminds me of nothing so much as
the lines from Browning's *Flight of the Duchess*:

> As though an artificer, after contriving
> A wheel-work image as if it were living,
> Should find with delight it could motion to strike him!

. . .

Leiris is out to convince us that Picasso's new objects are instruments—
means of identification, ways of reinserting ourselves in nature. But
even he is aware of the risk. Monstrosity is a means, he thinks; but he
knows that for some it reads as an end. And the end, one may feel, is cor-
rupt. More than one admirer of Picasso (I think in particular of Clement

Greenberg) has seen Picasso after 1925 as essentially trapped in the monster world he made for himself—enjoying too much, like the artificer, the thrill of make-believe danger. This is Greenberg in 1956:

> Picasso was a very great artist between 1906 and 1926, and the achievements of those years will, I am sure, bulk as large in time to come as any Old Master's. But he has been a very uneven artist since then, and in the last twenty years not even a good one on the whole.

After the *Three Dancers*, says Greenberg, Picasso

> began apparently to think in art-historical terms more than ever before, and to hanker for a 'grand,' epic, museum manner. This hankering makes itself felt in his projects for monuments and other kinds of sculpture, in his Cubist treatment of the hitherto un-Cubist theme of artist and model, in the studies he made for a *Crucifixion* in 1929 and 1930, and in various other things he did at that time. But out of this came little that was resolved, little that transcended the interesting.

Picasso, to quote another formulation, became "obsessed by a . . . nostalgia for the monstrous, the epically brutal, and the blasphemous." And because this *was* nostalgia, for qualities that are no longer available to the artist except in the form of pastiche, in practice it had "something too literary about it—too many gestures and too much forcing of color, texture, and symbol." The "error consists"—this is Greenberg in 1947—"in pursuing expressiveness and emotional emphasis beyond the coherence of style." So that Picasso in his weaker moments "localizes the excess emotion . . . in gestures, the grimace on a face, the swelling of a leg, in anatomical distortions that have no relation to the premises upon which the rest of the picture has been built."

It is a characteristically serious case, and a welcome antidote to most of what passes for comment on the subject: maudlin Picasso-worship marinated in Picasso gossip. (Give me a sentence of Greenberg's for any five hundred from Pierre Daix or Ariana Huffington.) And how is one to reply? In a sense I have been doing nothing else. My account of *Woman Standing by the Sea* is meant to suggest how it happens that, in certain Picassos, we are "made familiar" with monstrosity—that is, with ourselves. What Greenberg would call the painting's premises—its spatial structure,

213

its overall light, and its feeling for how much or how little of bodily substance can be indicated by painterly touch—are entirely consonant with the pathos of the central figure. The epic and brutal have nothing to do with it.

■ ■ ■

So—description is one thing: in art history it is always the best defense. But I still need to speak more generally and analytically to Picasso's tactics after 1927. In particular there remains the question of monsters and monumentality, and why the two terms are so often intertwined in his work.

One final qualification. Obviously I think Picasso's attempt at this time to recalibrate his sense of the body and its surroundings is important, and leads to tremendous painting. Leiris had it right. But this does not mean, we have seen, that the effort was consistent, or that it did not often issue in failure (figs. 5.17 and 5.18). The outside world is not Picasso's territory. Remember his answer to Geneviève Laporte, when she asked him why he painted so few landscapes. "I never saw any . . . I've always lived inside myself." What space the single figure ought to inhabit, and how large it should be, are questions Picasso went on finding peculiarly hard to solve. I have argued that part of the triumph of *Woman Standing by the Sea* is its middling size—its monumentality without inflation. And the problem with the *Standing Nude* from the year before (fig. 5.5) may derive simply from its bigger surface area: moving up from four feet to six feet, as Picasso does here, is for him a change of mode—almost a change of genre. The first idea for a single figure in the open seems to have come to Picasso in the summer of 1927, in work done in ink and pencil in a sketchbook (fig. 5.19). There are scores of sketches, but only one—spellbinding, utterly ferocious—oil (fig. 5.20). The oil is tiny: seven inches by six inches. The nude is a kind of ju-ju figure, ready for its quota of nails: body bristling with holes and protuberances, twig-limbs sharpened, eyes beady, muzzle canine, hair in greasy points. It stands in a wilderness, sniffing the air for predators. The door to the bathing cabin—the way to the warm

5.17. Picasso, *Female Bather with Raised Arms*, 1929. Oil on canvas, 73 x 60 cm. Collection of Phoenix Art Museum, Gift of the Allen-Bradley Company of Milwaukee.
5.18. Picasso, *Study for a Monument*, 1930. Pencil and oil on panel, 63.5 x 47 cm. Private collection. James Goodman Gallery, New York.
5.19. Picasso, *Bather by a Cabin*, 1927. Graphite, 30 x 23 cm. Sketchbook 35. Inv MP1874; folio31recto. Musée Picasso, Paris.

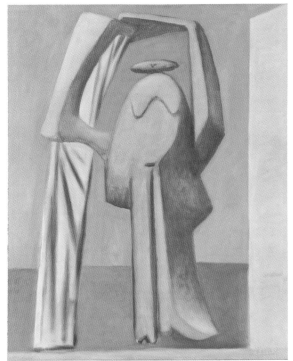

5.17

5.18

5.19

5.20

interior—is resolutely closed. Back in Paris in the fall, Picasso made one or two attempts to reimagine the figure on a four-foot canvas (figs. 4.28 and 5.21). The results have a comic energy, but the outside world—the empty horizon—of the tiny panel is the first thing to go.

In the following year there were other false starts. In the photograph taken in Picasso's studio in 1928, for example, there looks to be a massive painting propped against the wall behind the easel at left (fig. 2.26). You catch sight of the snout of a monster, and even the geometry of a bathing cabin. No painting corresponding to this has survived.

Scale and space are a problem. Over the course of 1929 Picasso pursues an essentially new line of thought, in which the statue-figures become less stone monoliths and more bits-and-pieces assemblage of bone (figs. 5.13 and 5.18). The assemblages eventually become larger than life-size (fig. 5.22). I shall speak to their final appearance in due course. But again, for the moment what interests me is Picasso's initial lack of certainty about what these new forms were, and where they belonged. One

5.21

of the paintings in the series that seems to have mattered most to him was a *Figure* measuring three feet by twenty-eight inches (fig. 5.23). It played a role in several Picasso exhibitions at the time—for instance in the great retrospective of 1932, where Picasso himself did the hang (fig. 5.24). On two occasions, in 1930 and 1932, it was paired with one of the tremendous monster-interiors of 1929, the *Woman in an Armchair* (fig. 4.27), as if to emphasize, by contrast, *Figure's* standing alone in an empty sky. But all of this came slowly, or at least with a great deal of hesitation. The first idea for *Figure* crops up in Picasso's sketchbook on a page marked "10–11 June 29" (fig. 5.25). Then a day later the theme is revisited (fig. 5.26). The

5.20. Picasso, *Bather by a Cabin*, 1927. Oil on canvas, 18 x 16 cm. Whereabouts unknown.
5.21. Picasso, *Nude on a White Background*, 1927. Oil on canvas, 130 x 97 cm. Inv. MP102. Musée Picasso, Paris.
5.22. Picasso, *Seated Bather*, Paris, early 1930. Oil on canvas, 163.2 x 129.5 cm. Mrs. Simon Guggenheim Fund. The Museum of Modern Art, New York.
5.23. Picasso, *Figure*, 1929. 92 x 73 cm. Private collection.
5.24. Alfred H. Barr, Installation view of Exposition Picasso at the Georges Petit Gallery. Photograph annotated by Margaret Scolari Barr and Alfred H. Barr, Jr. Paris, France, 1932. Photograph. Alfred H. Barr, Jr. Papers, 12.a.8, The Museum of Modern Art Archives, New York. (MA682).

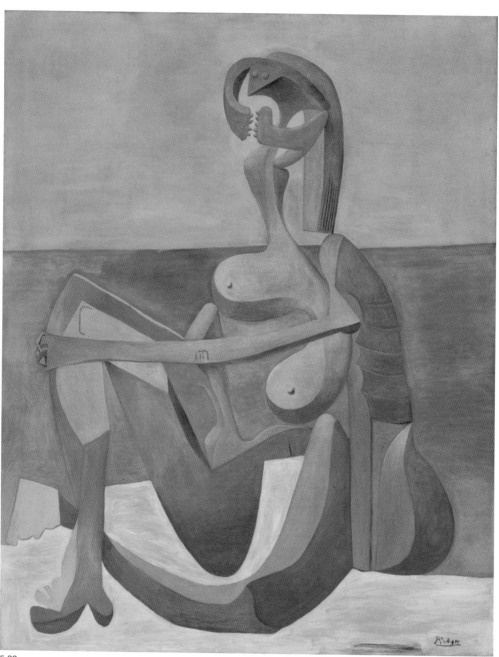

5.22

5.23

5.24

assemblage top left is still poised in empty space, and for a moment takes on more specifically the look of a skeleton: a row of teeth is set along its jaw. But across the page, framed as a possible picture, is *Figure* transformed into a fruit bowl crowned by an apple, with what appear to be curling leaves on either side. The still life setup is exquisite. Wall and wainscot reappear. There is a pattern of soft foliage on the tablecloth, which Picasso spells out for himself bottom left. The world is that of *Bread and Fruit Dish* (fig. 2.3)—as it so often is when Picasso dreams directly, pencil in hand.

From room-space to monument is a difficult step. Always the few square feet of Cubism lie ready to recapture the imagination. It happens repeatedly. If Zervos's catalogue is to be believed, the only full-size painting Picasso did in the summer of 1927 at Cannes—the summer of the first monster-bathers—was *Woman Standing*, which measures just over four feet by three feet (fig. 5.27). By the look of it she is standing in a void. The woman's uprightness is abstract. Her body is reduced to a number one. But here too the abstractness, which in Picasso's mind is always associated with emptiness, seems to have come painfully. We have a sheet of drawings, presumably from much the same time—maybe ideas for the painting, or afterthoughts once it was finished (fig. 5.28)—and once again, top right and bottom left, the standing figure migrates back into the world Picasso knew. Doors half open; floors present themselves; a shadow triangulates a picture on the wall.

■ ■ ■

To sum up. We should not be led astray by the myth of Picasso: monsters are not his forte. They take center stage in the final years of the 1920s, and something difficult is being tried for in them—a move into a different spatiality, which for Picasso equals a different view of the human. Monsters and outsidedness go together; therefore monsters and monumentality; therefore, maybe, a weird reconstruction of the public realm (fig. 5.3). It is all tentative, experimental. But great things come out of it: a strange sobriety, a new kind of feeling for human frailty and composure (fig. 5.22). You will gather that all the talk in the books about the bone figures' ghastliness

5.25. Picasso, *Two Studies of Figures for Monuments*, 1929–30. Graphite, 23.5 x 30.5 cm. Sketchbook 38. Inv MP1875; folio52recto. Musée Picasso, Paris.
5.26. Picasso, *Studies for Figure*, 1929–30. Sketchbook 38. Graphite, 23.5 x 30.5. inv. MP1875; folio-53recto. Musée Picasso, Paris.

5.25

5.26

5.27

5.28

strikes me as utterly missing the point. To see a figure as skeletal may or may not be to see it as moribund. The *Seated Bather* of 1930, for instance, seems to face the sun implacably, sturdily, with a strange kind of patience. A body made of bones is one made of what is most enduring. Enduring but fragile: the ethereal color here, and the infinitely careful paint application, speak to that. To see the body as a skeleton may be above all, in Picasso's case, to see it moved out of the space of desire for once—into the space of care and survival. It is a typical irony of the Picasso literature that those who bay loudest at Picasso the desirer of women are most offended when his bodies obey a different logic.

What then, finally, do I take the monsters to signify? And is there a way in which answering that question can bring us back, full circle, to the problem of truth and untruth? Well yes, I hope so.

Put the skeleton *Bather* next to the great painting from the following year, *Figures at the Seaside* (fig. 5.29). I think the latter is comic and celebratory, in the way of a great Rabelaisian banner—it is four feet high and well over six feet wide—and what it celebrates is sufficiently clear. Partly, then—this is the first answer—monstrosity is sex. Not always, but insistently. Sex is central to Picasso's metaphysic. "Basically," to remind you of the remark made to Tériade, "there is only love." By which he means much more than sexual intercourse, obviously, but the "much more" is inextricable from the doings by the side of the sea. Somewhere at the heart of being human, Picasso's art tells us, is the moment when bodies present themselves as so many bearers of roundnesses and orifices, things to suck or suck with, to bite, to penetrate, to swallow whole. This is an entirely ordinary, not to say necessary, dimension to life; but it has about it something intrinsically frightening—or at least recurrently surprising, unfamiliar. "Let's play at hurting ourselves." No wonder sex is hemmed in by taboos. And with it—this may have been what mattered most to Picasso as a painter—go specific conditions of seeing. The seer in the act of sex sees the body close to, looming up, taking the form of peculiar part objects. And this very proximity and fragmentation—I have no doubt that sexual seeing is the first modality, so to speak, of the Cubist

223

5.27. Picasso, *Standing Woman*, Cannes, 1927. Oil on canvas, 130 x 97 cm. Private collection.
5.28. Picasso, *Sheet of Studies: Standing Woman*, 1928. Graphite, 34.2 x 24.2 cm. Inv. MP1025. Musée Picasso, Paris.

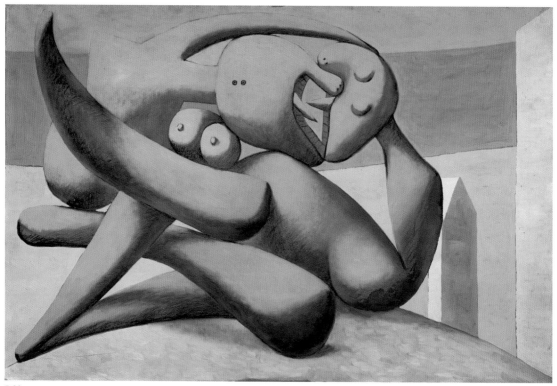

5.29

space that held Picasso captive—is itself a deep form of otherness, of re-moteness, maybe even of weirdness and danger. Medusa's head is not far away. Sometimes the artist imagines the weirdness with a frame around it, and the viewer looking at it from the side (figs. 4.29 and 5.9). One could interpret this in two ways. Is it a picture of the constant male effort to contain—to still and stabilize—a phantasm that goes on laughing at the effort? Or does the picture say that sex is always a picture—a picture within a picture—with monstrosity just a male invention? Maybe monstrosity *is* a game in Picasso. It does not ultimately seem meant to frighten anyone much.

But this is too cozy. Sometimes the phantasm looks to be devouring the fantasizer, and the male is the one who seems less than real (fig. 4.30). The gold frame around him seals him off from the world; his pro-file is more and more tentative. Monstrosity—this would be a second an-swer—is Otherness, alarming and even hurtful, at least potentially. It is the product of a psychic to-and-fro between subjects—between male and female, preeminently—in which the moment that matters is when *some-*

thing else takes form in the mind. Something specific (remember Picasso's stress on exactitude), but that collapses the normal terms of identity and difference. Je est un autre.

If this still seems too abstract, supplement it with a slogan from François Gilot. She tells the story of André Gide paying a call on Picasso in the 1940s, and daring to say that the two of them had attained the age of serenity. "There is no serenity for me," Picasso shot back, "and, what's more, I don't find any face charming." Again the French word *figure* occurs. A few pages before, Gilot records Picasso as saying "Toutes choses nous apparaissent sous forme de figures." Everything appears to us in the form of figures, that is; and no figure is charming. "What is beauty, anyway?" he asks. "There's no such thing." Inflect all these dicta with the terrible remark, again made to Gilot, a propos certain paintings of Dora Maar (fig. 5.30): "Like any artist, I am primarily the painter of woman, and, for me, woman is essentially a machine for suffering . . . I want to underline the anguish of the flesh, which, even in the hour of its triumph, its 'beauty,' is frightened by the first signs of the alterations of time." (Compare a comment recorded by Malraux: "When I paint a woman in an armchair, the armchair, it's old age and death, isn't it? Too bad for her.")

These seem almost like syllogisms. "I" is someone else. I am a painter of woman. Woman is essentially a suffering machine. And then finally, in conversation with Geneviève Laporte, Picasso comes up with the concluding aphorism: "I am a woman." We are close at this point to *Guernica*, one of whose signal characteristics is that, at the moment of absolute suffering, the actors—the victims, but also the seekers and protestors—are either animals or women (fig. 4.25). The warrior male in *Guernica* is not even a monument: he is a shattered statue under the women's feet.

■ ■ ■

Monumentality in Picasso—looking at monster and monument separately now—is aloneness (fig. 5.31). It is being set apart. Sculpture is its necessary matrix, then, since what is sculpture but the act of stilling, isolating, making over the mobile and vulnerable into a material which allows

5.29. Picasso, *Figures at the Seaside*, January 12, 1931. Oil on canvas, 130 x 195 cm. Inv. MP131. Musée Picasso, Paris.
5.30. Picasso, *Woman Dressing Her Hair*, Royan, June 1940. Oil on canvas, 130.1 x 97.1 cm. Louise Reinhardt Smith Bequest. The Museum of Modern Art, New York.
5.31. Picasso, detail of *Woman Standing by the Sea*, fig. 5.1.

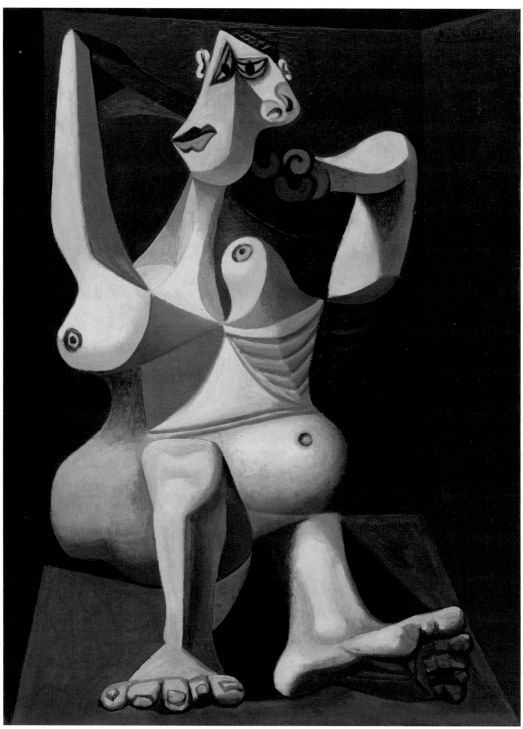

5.30

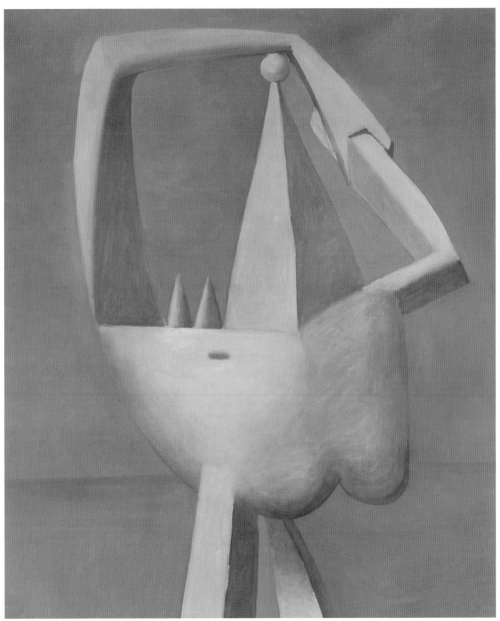

5.31

it to persist—petrifying or metallizing it, giving it a suit of armor that *is* (so the statue persuades us) what the body is capable of being? Here is what sculpture does most deeply. It makes the human a singular upright, with us moving round it, keeping our distance instinctively, knowing that the point of the monolith is its apartness from the world of our wishes. And a version of this kind of distance, says Picasso, is all the monumentality we are now capable of—in its odd way heroic, but not perfect or complete, and not putting the spectator in awe. Singleness is aloneness; maybe monstrosity is partly a marker of that. Even if she wanted to, *Woman Standing by the Sea* could never fully reenter the ordinary world she signifies. The beach, which Picasso delights in and often tries to populate with heavy careering and exultant display, is always ultimately the place of emptiness, barrenness, "bone[s] wave-whitened and dried in the wind."

Of course monumentality—sculpture—need not, and maybe should not, be like this. It should be accompaniment, familiar idealization, sewn into the texture of everyday life. "The statues," as Wallace Stevens puts it, "will have gone back to be things about." That seems to be the future *Monument: Head of a Woman* imagines, but it is very far away.

We are close, I think, to the causes of Picasso's crisis of confidence in Cubism. The crisis, as Greenberg constantly reminded us, was part of a general implosion after 1914 of high modernist faith in technique—faith in the possibility of an ongoing manipulative knowledge (on the part of experts) of a disenchanted world, faith in sensation and explicitness and totality, faith in a "view from nowhere." Whether the totality aimed for in Cubism had been playful and hypothetical, or rational and self-explanatory, hardly mattered: always, as a goal, there lay ahead some final overallness of achieved relations—some state of unity and necessity—that would be inherently transferable, repeatable, a model for further experiment.

This is what the paintings of the late 1920s no longer believe in. They have no confidence in any totality not derived, contingently, from some accidental touch of the Other (real or imagined). What is chilling in Picasso's later art, therefore, is the way it proposes that *worlds*—space, difference, identity, substance—*come out of figures, not the other way round.*

So the common wisdom is wrong. Picasso's paintings make no claim to representativeness, to typicality. They are not of their time. It is precisely because his pictures after 1920 do not pretend to "speak to the modern condition," or to speak to any condition except the one that gave rise to this

picture on this occasion, that they are so hard to bear. And in any case, is "condition" the right word? "Condition" comes freighted with the implication of shared fate. In Picasso the last thing there seems to be is a human or modern condition . . . there are these bodies . . . and it is important that they are not, or not properly, human at all . . . their non-humanness, their monstrosity, is most deeply a device to make them nongeneralizable, nonrepresentative . . . to have them speak to the singularity of creatures (meaning us) on two legs. The creatures are upright, mostly, and bipedal almost invariably. They are us, but in our essential non-humanness—us not existing under the description "man" or "woman."

The nearest Picasso gets to putting these matters into words is in conversation with Geneviève Laporte. "Je suis une femme," he says. And then plunges on, characteristically: "Any artist is a woman and has to be lesbian. Artists who are pederasts cannot be real artists because they love men. As they are women, they fall back into normalcy." (Tout artiste est une femme et doit être gouine. Les pédérastes artistes ne peuvent pas être de vrais artistes car ils aiment des hommes. Comme ils sont des femmes, ils retombent dans le normal.) These are perplexing sentences. Set aside for a moment the ludicrous condescension toward the "pederast," and hold on to the glimpse we get of Picasso's conception of the structure of desire in representation. Representation, he never tires of insisting, is desire's derivative (Au fond il n'y a que l'amour) and therefore dependent on sexual difference; but the driving force of art, he seems to be telling Laporte, is its moment of identification *with* the different, its desire for a woman *as a woman would enact (would feel) the desiring*. As desire for the same, in other words, as desire for what a woman already is. But always in the knowledge that this identification-in-representation is a great "as if"—a breaking of taboo. Here lies the problem of the homosexual artist, so Picasso imagines. Of course a homosexual is drawn to painting men (this seems to be the logic), but from a position—of Woman— that he occupies "naturally," continuously, in the everyday life of desire. Therefore the act of representation does not disrupt the normal circuit of fantasy—of identification and difference. It confirms it. And this is bad news: it means the otherness, the particularity, the unknownness of the object of desire is not jolted into the foreground of perception as the painting gets done. It means that the love object does not appear *otherwise* in representation, as seen from somewhere—some other subject-position—

that only representation makes possible, and then fleetingly, dangerously. Monstrosity is unknownness.

As an account of fantasy and homosexuality, this smells of Paris in the age of Breton. But as a wild theory of representation and heterosexuality—of the one's interference with the other—it is interesting. It has something to tell us about Picasso's life's work.

．　．　．

For good and ill, I mean. The body as it comes to be in a Picasso painting is almost always female, and subject to the force of male fears and wishes. Desire is a will to power. Not without exception, of course; not without there existing a necessary countervailing dream of mutuality, identification, tenderness, care; but these qualities or possibilities are only imaginable as part of—inflections of—a more constant will to manipulate and consume. In such a force field, insofar as the other's body—the other's identity—can be posited at all as self-moving, self-possessed, and in touch with its world, it is in the form of something monstrous, something granted power only grotesquely. The other is conjured up as a *fantastical* threat; and we are always in doubt (and meant to be) as to whether the monster is just a momentary phantasmagoria, a wish fulfilment of the male doing the fantasizing, or whether it really does register—and try to aestheticize—the moment of dominance that the other, the woman, always actually possesses (and is punished for) in the game of sex.

If this is an explanation for monstrosity, it is not an excuse. And the worst one could say of Picasso's monsters is that they attempt to beautify a world of sexuality whose monstrosity is—the testimonies and statistics go on telling the story—all too real and banal, all too ordinarily acted out. A million Marats take their revenge.

Nonetheless, I do not think the world would be better without Picasso's creatures on the beach. Because they are the pictures we have—in some sense *our* pictures, sharing our strange myth of individuality—of bodies belonging fully to a world; pictures of self-possession and self-movement; of elation and abandon and composure (fig. 5.32). They are images of identity in the making—of the body turning itself to others, without self-loss or abjection or mere ruthless projection of its wishes. In a word, they have life. Leiris's claims for them make sense. And I would go further and say—as I tried to of *Woman Standing by the Sea*—that in many a painting

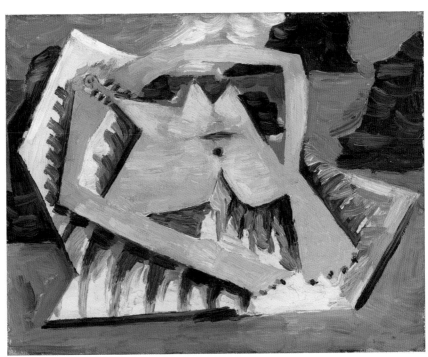
5.32

by Picasso even the "I am a woman" is realized. Gender in *Figures at the Seaside* (fig. 5.29), for example, is a secondary ascription; being takes its place. In the contact of epidermises, difference doubles back on itself.

The clinching instance is *Woman Throwing a Stone* (fig. 5.33). It is a marvelous, crazy, appalling image, which strikes me as coming as close as Picasso ever did to an ultimate—a metaphysical—statement of his materialism. Once again it stayed in his hands till he died. (*Woman Dressing Her Hair, Woman Throwing a Stone*—Picasso's twentieth century.)

■ ■ ■

I return to Cubism. The style, we know, had truth as its goal. Of course it scorned the idea of piece-by-piece matching of appearance in painting, and reveled in estrangement. But its standard of truth was inflexible. Either the painting was rooted in a particular lived experience of space, and

5.32. Picasso, *Bather*, 1928. Tempera on vellum, 19 x 24 cm. Private collection.

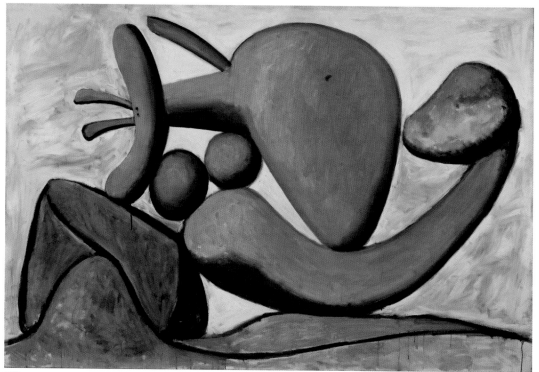

5.33

offered itself as an analogue—a specific modeling—of that experience
and its limits, or it was nothing in particular. It lacked exactitude.

Now suppose this picture of representation ceased. Suppose that
a painting no longer edged toward structural equivalence to aspects of
the world enacted by the full coordination of all of its parts, but instead
had to recognize itself as pure *device*. Suppose it now aimed therefore to
release—to produce—an effect of the world simply being present in the
painting, as an immediate, irresistible totality. What was the test of that
presence to be? Sheer vividness? Particularity coming out of nowhere?
The presence or absence of something unprecedented?

This is the notion of picturing that the maenad ushers in (fig. 3.1).
It is a conception that *happens* to Picasso, more than being proposed or
concocted by him; and it happens as part—as result—of Cubism's com-

5.33. Picasso, *Woman Throwing a Stone*, March 8, 1931. Oil on canvas, 130.5 x 195.5 cm. MP133.
Musée Picasso, Paris.

ing to an end. It is unavoidable, but frightening. For vividness, Picasso knows, is something too easily achieved in painting, and too little susceptible to criticism or correction. Picasso, though he often strikes through to a final simplicity, is essentially an artist of adjustment. He works—we have seen it in the sketchbooks—by opening the first idea to more and more aspects, more intricately or unexpectedly related. The will to power, so Nietzsche constantly tells us, is nothing without an Other to itself. It needs something to overcome. "It is the highest degrees of performance," writes Nietzsche in the notebooks, "that awaken the belief in the 'truth,' that is to say the reality, of the object. The feeling of strength, of struggle, of resistance is what convinces us that there is something here that is being resisted."

Perhaps monstrosity, then, is Picasso's substitute for truth. It is what prevents vividness degenerating into a box of tricks. Because monstrosity is the Untruth—the strangeness and extremity—inherent in everyday life. Sex is one form of it, the one Picasso returns to, but there are many others. Ecstasy is one example: the maenad's mad rictus goes far beyond gender. Mortality is another (fig. 5.22). So is murderous violence, and the human appetite for giving pain (fig. 4.26). But on the beach, thank goodness, even deformity is unthreatening. For the beach is the outside world. The sky is gray, the creature feels the weight of the stone in her hand. A being stirs into life. She is like the giraffe, who does not know she is a monster.

LECTURE 6

MURAL

This last lecture has to do with *Guernica* (fig. 6.1). It will not pretend to give an account of the painting and its circumstances as a whole—anything short of a book cannot hope to do that—but rather, to think about *Guernica* formally, with the questions that have come up in previous lectures now asked of this very different object. Questions of space, primarily—of outside and inside, public and private, proximity and loss of bearings. Even monstrosity, though a separate and potentially overweening dimension of Picasso's practice from the 1920s on, and central to *Guernica*'s effect, is ultimately bound up with a reimagining of space. Or it is when things go well. Monsters are most "matter of fact" in Picasso, to adopt Leiris's formula, when they are felt to be the necessary inhabitants of a new—comic or tragic—spatial order. *Guernica* is nothing if that feeling is absent.

The approach I take to Picasso's mural is deliberately limited, then: I want to concentrate on what is in the picture and how its parts fit together. But the limits will constantly break down. To talk of *Guernica* at all is inevitably to broach the issue of Picasso's contact as a citizen with the events of the twentieth century. My assumption, like everyone else's, is that the century shaped and informed his worldview. But it did so, I have been

6.1. Picasso, *Guernica*, 1937. Oil on canvas, 349.3 x 776.6 cm. Museo Nacional Centro de Arte Reina Sofía, Madrid.

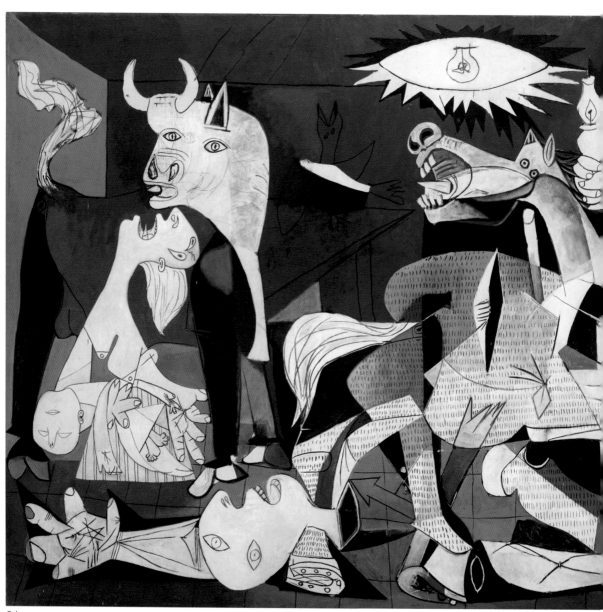

6.1

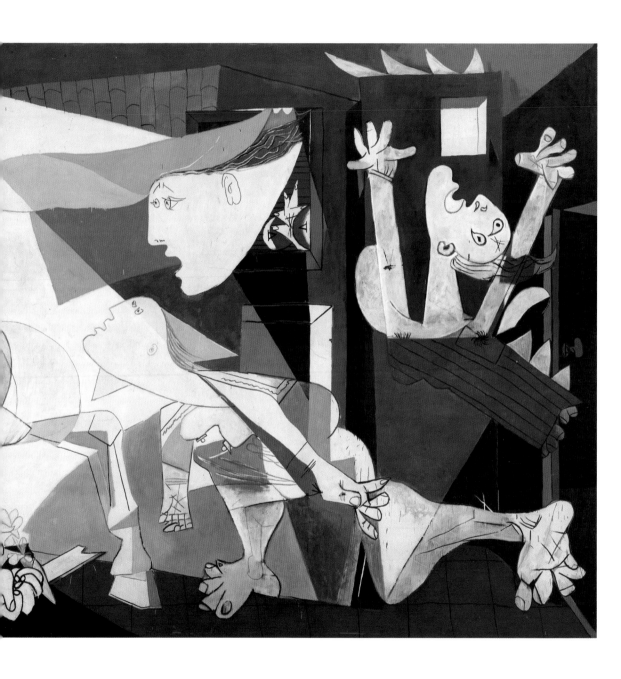

arguing, on a structural level: the epoch only really appeared, to Picasso as a painter, in the guise of a form of life—a specific shape and depth to experience—coming to an end. This remains *Guernica*'s subject. But now the end is treated epically—as the agony of a polis, played out by monsters and heroes. The scale is public and the subject drawn from yesterday's news. I have to begin, therefore, by laying out at least some of the facts of *Guernica*'s occasion and surroundings—facts that impinged on the work in hand. I shall pare things to the bone.

Guernica is a painting in oil on canvas, measuring 139 by 307 inches: twenty-five and a half feet long, and more than eleven and a half feet high. It was first shown to the public at large in July 1937, in the entrance hall of the Spanish Republic's pavilion at the Paris World's Fair (fig. 6.2). It was a mural. The painting did not exactly fit the space reserved for it, but clearly Picasso had sized up the entryway's dimensions and mulled over the architect's plans. On the opposite side of the entry, facing *Guernica* and filling the wall, was pasted a blown-up photo of Garcia Lorca, "poète fusillé à Grenade." In between the two stood a death-dealing fountain by Alexander Calder, with runnels of mercury falling into a pool. (Mercury was a key Spanish export.) Out past the steel pillars of the inner courtyard was a cinema set up under a flimsy ceiling, showing films of the Civil War (fig. 6.3). Luis Bunuel was in charge.

Guernica is a picture of an air raid. On 26 April 1937, in the tenth month of the war in Spain, the ancient town of Guernica, for centuries the focus of Basque identity, had been attacked by a squadron of Luftwaffe bombers supplemented by a handful of planes from Mussolini. The aim was to bomb and burn the city center in its entirety. It was the Luftwaffe's chance to see what the new incendiary explosives were capable of, to judge how long it would take to turn a town into an ash heap, and what the effect of so doing would be on "civilian morale." (This last euphemism became the currency of cabinet rooms.) In this sense, Guernica was inaugural. It ushered in the last century's, and our century's, War of Terror—terror largely administered by the state—in which tens of millions would die.

6.2. Hugo Herdeg, *Guernica* in situ, Spanish Pavilion, World's Fair, Paris, 1937. Photograph, *Cahiers d'art.* Art & Architecture Collection, Miriam and Ira D. Wallach Division of Art, The New York Public Library.
6.3. François Kollar, Interior Court, Spanish Pavilion, World's Fair, Paris, 1937. KLL13542NNR0. Médiathèque de l'Architecture et du Patrimoine, Paris.

6.2

6.3

Unsurprisingly, Franco and the Luftwaffe took pains to conceal what had been done and by whom, though almost at once there were reliable reports from the ruins. A propaganda war followed. The Fascists spread the story that Guernica had been burned by Basque Communists, or perhaps an anarchist shock brigade, in retreat. Pillars of rectitude like T. S. Eliot were inclined to believe them. Picasso made his first sketches toward a picture of the bombing on May Day in Paris, five days after the raid. He appears to have begun work on the canvas itself about ten days later: the first photograph his companion Dora Maar took of the work in progress is dated 11 May (fig. 6.4).We can be fairly sure, from dated sketches done in conjunction with last-minute changes on the canvas, that the painting reached its final form on 4 June or very soon after. From first sketch to finished painting, that is, Picasso took just over five weeks; from the moment he began work on the full-size canvas, maybe twenty-six days.

The weeks were some of the worst of the century. Franco's forces moved

north and east on a broad front, closing in on the Catalonian heartland, and the Republic began to devour its own entrails. From 3 to 8 May in Barcelona, the Communist Party struck militarily against the supporters of POUM, the independent Marxist party, and CNT, the anarchist trade union. Five hundred people died in house-to-house fighting. POUM was outlawed by the Republic on 16 June. The party's imprisoned leader, Andrés Nin, was murdered by Stalinist agents five days later. Largo Caballero was forced from the premiership.

Naturally, Picasso's circle of friends was split by this moment of agony. Some, like Eluard and Aragon, had shrugged off the Moscow Trials, whose theater of lies had poisoned the opening months of the year. Others like Breton—who, ever the strolling player, came to pose with his wife in front of *Guernica* in progress—took the trials for a new Inquisition, and would never forgive Picasso for his later groveling to the Great Leader (figs. 6.5 and 6.6). Dora Maar's politics were leftist and anti-Stalinist: one of her previous lovers, Boris Souvarine, lives in history as the first of Stalin's real—meaning nauseated—biographers. We know that Picasso was in contact with left-wing friends in Catalonia. News reached him, almost certainly, of what had happened on the Barcelona streets. Georges Bataille may have been one conduit. The barn of a room in which *Guernica* was stretched and painted took up the top floor of a building in which, so Picasso seems to have believed, the action of Balzac's great story *Le chef-*

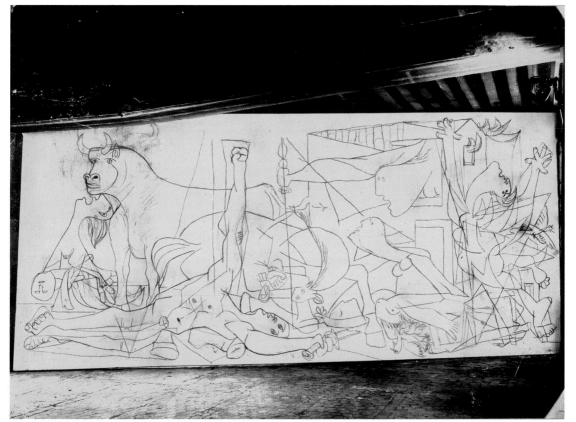

6.4

d'oeuvre inconnu had taken place (fig. 6.7). It was a resonance the painter treasured. But Dora Maar, who found the place for him, knew of it because it had been used as the meeting place for a group called *Contre-Attaque*, of which she had been a member. Whose attack was the one to be countered was a question that preoccupied the group. Breton as usual was ready with an answer: our aim, he told *Le Figaro*, was "to maintain the revolutionary activity that had been betrayed by Moscow."

Do not imagine that any of this—the familiar farce and tragedy of the left in the twentieth century—was lost on Picasso as he brought his painting into being. But the timescale I have given puts "context" in perspective. *Guernica* was planned and painted in the space of five weeks. Making the thing was an astounding feat of concentration. All its politics—all its

6.4. Dora Maar, *Guernica* in progress, state 1, May–June 1937. Gelatin silver print. Musée Picasso, Paris. MP1998-270.

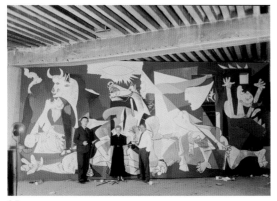

6.5

6.6

6.7

response to Fascism and Communism and the new face of war—were in the picture.

∎ ∎ ∎

Guernica, to reiterate, is twenty-five and a half feet long and a little over eleven and a half feet high. This is immensely bigger than any painting designed for a wall that Picasso had done previously. (Theater curtains are a genre unto themselves.) I think that from the artist's point of view the sheer height of the canvas—it could just be wedged, perhaps tilted slightly forward, under the beams of the *Contre-Attaque* assembly room— may have been even more of a challenge to his established ways of looking than the panoramic width. Painters of murals are pragmatic about lateral spread. They know that beyond a certain point it is simply not possible, and maybe not desirable, to hold the elements of an incident-full relief together in one great Gestalt. They settle for what critics of Jacobean tragedy call "episodic intensification." In the case of *Guernica*, it is obvious that the group at the center dominates, and the rhyming agonies on either side—the woman falling from the burning building, the mother shrieking under the bull's chin—are subordinate. Notice the way the mother and bull have been miniaturized—pushed back in space, and made to stand on a different part of the ground plane from that supporting the main action. And look, correspondingly, at the slotting of the falling woman into a largely separate compartment at right, again set back from the foreground figures: a cutout facade of a house behind her with a window punched through it; the bold diagonal of what seems like a ceiling going up to the picture's top corner; and a door at the edge of things, opening onto a sliver of outside world—though whether the door itself swings forward into room-space or out into the space of flames is undecidable (fig. 6.8). (A great triangle of gray and white slams down from the falling woman into the foreground, slicing the knee of a woman close to us; but once the viewer comes to see, a moment later, that the falling woman herself

6.5. Dora Maar, Picasso, André Breton, and Jacqueline Lamba in front of *Guernica* at the Grands-Augustins studio, May–June 1937. Flexible negative. Musée Picasso, Paris.
6.6. Unknown photographer, Picasso looking at a picture of Joseph Stalin on 1 November 1949, in Rome. Photograph.
6.7. Dora Maar, Picasso sitting on the ground working on *Guernica*, post-state 8[?], May–June 1937. Gelatin silver print, 20.8 x 20.1 cm. MP1998-281. Musée Picasso, Paris.

reaches no lower than the bizarre little striped "frock" pinned to her arm-pits, canted off to the right with flames and toes protruding from it, the figure reverts to a space—a largely incomprehensible space—of its own.) Left and right sides, we could say, are wings to an altarpiece.

Painters are pragmatic, in other words, about the kind of play between center and periphery that is possible in a picture unfurling over twenty-five feet. Some viewers will find the pragmatism, the casual hierarchy of episodes, unsatisfying. If I do not, it is because I think that Picasso so completely solved the problem that for him was primary: that of the painting's height and ground plane. Eleven and a half feet is a true change of *world* for Picasso (fig. 6.9). It puts the top of the painting—the ceiling, the skyline, the felt ability of the depiction to contain space even where it threatens to slide off into invisibility—out of reach. And what could be more of a threat? For a sense of containment—an imagining of space as finite, and the making it fully *there* in the painted rectangle—is what

Picasso's painting most deeply needs. Normally, if a painting of his loses hold of its upper edge—if the top boundary of the picture is not every bit as present and determinant a fact of viewing as the line along the picture's floor—it loses hold of everything. Space has slipped through its grasp. And therefore, as we know by now, so does a set of felt equivalents for the things—the bodies, the agonies—the space contains.

I think, as I say, that Picasso solved the problem. He found ways to make the painting's height work for him. *Guernica*, to put my argument baldly, is a picture that makes its giant size—a giant being always essentially *tall*, with all of its other dimensions following from that—work to confirm a wholly earthbound, and essentially modest, view of life. Life, says the painting, is an ordinary, carnal, entirely unnegotiable value. It is what humans and animals share. There is a time of life, which we inhabit unthinkingly, but also a time of death: the two may be incommensurable, but humans especially—from the evidence of palaeolithic burials it seems a species-defining trait—structure their lives, imaginatively, in relation to death. They try to live with death—to keep death present, like the ances-tors whose bones they exhume and re-inter. But certain kinds of death

6.8. Picasso, detail of *Guernica*, fig. 6.1.
6.9. Dora Maar, Picasso painting *Guernica*, state 3, 1937. Gelatin silver print, 23.9 x 17.8 cm. Inv. MP1998-202. Musée Picasso, Paris.

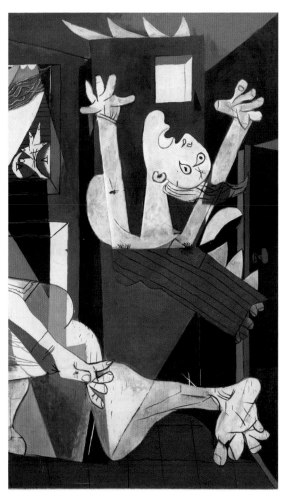

6.8

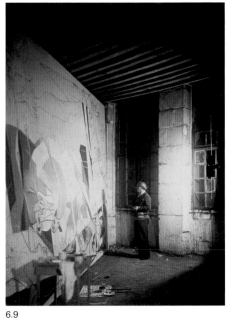

6.9

break that human contract. And this is one of them, says *Guernica*. Life should not end in the way it does here. Some kinds of death, to put it another way, have nothing to do with the human as Picasso conceives it—they possess no form as they take place, they come from nowhere, time never touches them, they do not even have the look of doom. They are a special obscenity, and that obscenity, it turns out, has been a central experience of the past seventy years.

This, in a nutshell, seems to me the measure of *Guernica*'s achievement. It finds a way to propose this, visually. What that way is will be my main subject.

. . .

Picasso himself rarely talked about pictures he had done, nor should we expect him to. He made a few offhand remarks about *Guernica* in retrospect, one or two of which I have already quoted. He tried—but of course failed—to head off the iconographers, and insist that a bull is a bull. (I shall follow his lead in this.) But there is one moment, I feel, in which he says something worth thinking about. Two moments, actually: both Malraux and Gilot report essentially the same conversation. It has to do not directly with *Guernica*, but with Goya's *Third of May 1808* (fig. 6.10). Naturally in talking about the one he knew he was talking about the other. Malraux reports the exchange as specifically happening in 1937, just before *Guernica* went off to the Spanish pavilion. Probably an artifact, this dating, but the connection is clear. The dark sky in the *Third of May*, says Picasso,

> is not a sky, it is just blackness. The light takes two forms. One of which we do not understand. It bathes everything, like moonlight: the sierra, the bell-tower, the firing squad, which ought to be lit only from behind. But it is much brighter than the moon. It isn't the color of moonlight. And then there is the enormous lantern on the ground, in the center. That lantern, what does it illuminate? The fellow with upraised arms, the martyr. You look carefully: its light falls only on him. The lantern is Death. Why? We don't know. Nor did Goya. But Goya, he knew it had to be like that.

6.10. Francisco Goya, *Third of May 1808*, 1814. Oil on canvas, 268 x 347 cm. Museo del Prado, Madrid.

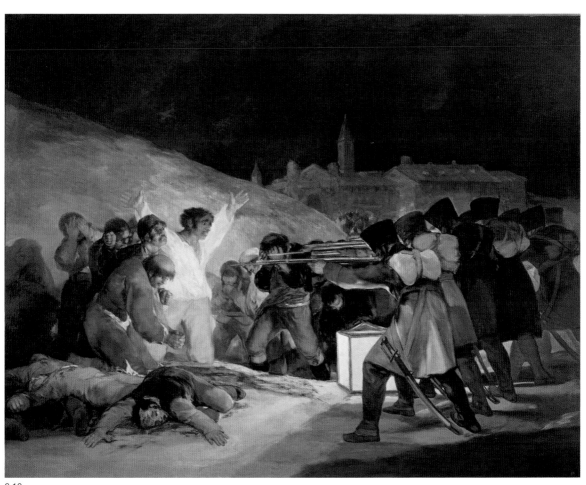

6.10

argument—they are profoundly difficult self-instructions for the painter we have come to know. They lead him away from the space in which he lives. "Public" and "political," so Picasso's first attempts at imagining the scene suggest—I show a study done in pencil on gesso, dated May 1—must mean *happening outside* (fig. 6.11). But is the outside a space Picasso can truly think, pictorially? "I never saw one," remember him saying to Geneviève Laporte when she asked him why he never painted landscape. "I've always lived inside myself." Is the outside a place Picasso can *people*? Can fill with suffering creatures, that is, as opposed to whimsical players in a dreamscape? He tries again the following day, using the same old-master medium (fig. 6.12). He is trying to be serious. But the questions persist.

I think we can best take the measure of these first attempts by circling back to the four years I have skipped over in the lectures, 1932 to 1936. They are a complex, and in many ways unhappy, time. They seem to end, for much of 1936, in as much of a crisis of confidence as Picasso was ever capable of. He paints almost nothing for months on end, engraves spasmodically, pours his energies into a weird (and to my mind, bad) poetry. *Guernica*, among other things, is a convulsive awakening from this previous trance.

There are many facets to the unhappiness, but I seize on one that connects with my story. In the mid-1930s, Picasso began to make the outside world his own. Sometimes it was the open space of the bullring, and sometimes a *terrain vague* of myth (figs. 6.13 and 6.14).The beasts no longer knock at the window with their snouts: they are down in the arena fulfilling their destiny or circling the walls of Troy. And all of this—I should declare my hand as a critic—is accompanied by a massive drop in aesthetic temperature. If what Picasso is reaching for again is a kind of classicism, then the new one only goes to confirm the true seriousness—the massive ambition—of the style of the 1920s, which had gone on fighting for an epic space made out of Cubist materials (fig. 6.15). The fight is over in the new decade. A token exterior has won.

6.11. Picasso, Study (IV) for *Guernica*, 1 May 1937. Pencil and oil on gesso on wood, 53.5 x 64.5 cm. Museo Nacional Centro de Arte Reina Sofía, Madrid.
6.12. Picasso, Study (V) for *Guernica*, 2 May 1937. Pencil and oil on gesso on wood, 60 x 73 cm. Museo Nacional Centro de Arte Reina Sofía, Madrid.

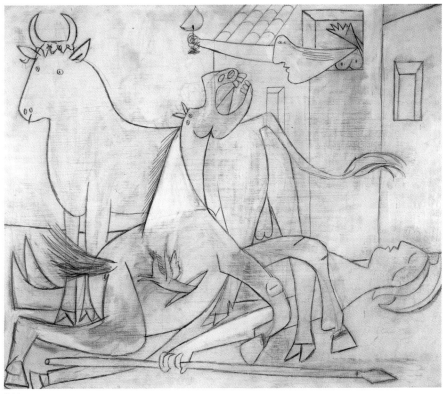

6.11

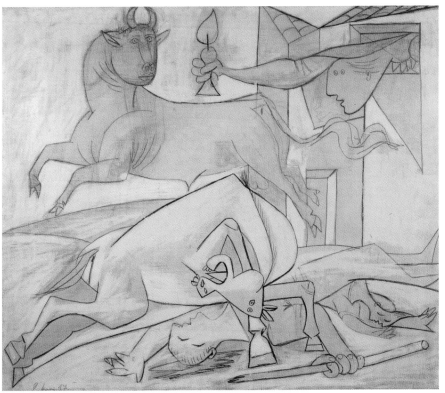

6.12

6.13

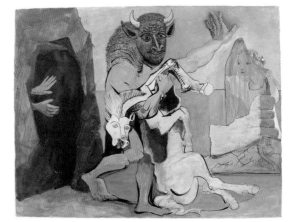

6.14

6.15

6.16

Things are more complicated than this, of course. Picasso is never dismissible. There are real achievements in these years—real imaginings of space, even—but the question to ask, with *Guernica* in mind, is achievements of what kind? My answer begins from a painting dated March 1936 (fig. 6.16). It is done in pen and crayon, with a single strip of newsprint pasted across the middle, and it is small: just over thirteen by twenty inches. Therefore the comparison with *Guernica* is a touch forced, but nonetheless telling. Commentators on *Guernica* often make the point, sometimes disapprovingly, that the mural makes use of many of Picasso's stock properties: that it smells of the bullring, that its women and bits and pieces of warriors have migrated from the beach or studio. The point is obvious, and *Le crayon qui parle*—this is the phrase in the little collage's newspaper that seems to have sparked the 1936 invention—confirms it. So many of the elements of *Guernica* are already present in *Le crayon qui parle*: the resemblances are uncanny: a dark house to the right, with

6.13. Picasso, *Wounded Minotaur, Horse, and Figures*, May 1936. Pen and India ink, gouache, 50 x 65 cm. MP1165. Musée Picasso, Paris.
6.14. Picasso, *Minotaur and Dead Mare Outside a Cave*, Juan-les-Pins, May 6, 1936. India ink, gouache, 50 x 65 cm. MP1163. Musée Picasso, Paris.
6.15. Picasso, *The Pipes of Pan*, 1923. Oil on canvas, 205 x 174 cm. Musée Picasso, Paris.
6.16. Picasso, *Le Crayon Qui Parle*, 1936. Crayon, ink, and pasted paper, 33.6 x 50.8 cm. Collection Riane Gruss.

sun or fire glowing through its windows; a chopped-off head of a man—a bearded hero, maybe a giant—on the ground, half buried in the grass; what appears to be a source of light in the sky, seemingly held by a hand, with long streaks of ink tracing its beams across the picture plane; and an agonized figure at the center, half human but with the head of a horse or a monster—maybe crucified, maybe hung in a noose from the tree branch. Perhaps we could see the collage as a night repeat of the 1930 *Crucifixion* (fig. 3.5).

The point is not simply to enumerate the features the little painting shares with *Guernica*, but to suggest how ordinary these features became for a while in Picasso's art, and above all in what kind of *outside* they existed. For *Le crayon qui parle* is a landscape. And the landscape is essentially weightless: the light shines through its ruined structures, the main figure is made of ectoplasm, the tree mimes horror, the ladder leans whimsically against the wall. It is a space of fantasy, of free association—a Surrealist lantern slide. So the question follows: If this is the kind of exterior that seems to go naturally, in Picasso's case, with fire and agony and dismemberment, then how on earth could those modes of experience be put back into the world—given weight, made ordinary and substantial? Is not the outside, for Picasso, always going to be a dreamscape (figs. 6.11 and 6.12)? The imperative to make pain public, it follows—if that is taken to mean situating it in an outside of sorts—is, for Picasso, deeply at war with the imperative to make pain incarnate.

This is the problem that preoccupies him for the next five weeks. The making of *Guernica* turns, I think, on the devising of a space to contain the action that would not be this fairytale edge of the city. What in the end replaces it is hard to characterize. That is the point. For it cannot be room-space, exactly: I am not going to tell the story of an artist returning, maybe reluctantly, to the small world he knows and making his final masterpiece out of it. Certainly the space of *Guernica* has something of the character of a room: it is paved, with what look like tiles; it appears to open out, left and right, into a further emptiness beyond it, through doors or transparent side walls; and at either side at the top there seem to be lines in perspective fixing the room's corners; there is a kind of lightbulb in the ceiling, or where a ceiling could be; even a few tentative beam lines. Anne Baldassari has suggested that as the painting proceeded in the assembly room, wedged against the bare rafters, and Picasso digested the evidence

of Dora Maar's tremendous photographs of it, the mural introjected, as it were, certain features of its actual surroundings. It became more like the space it was made in. Well, yes and no. As the weeks went by *Guernica* may have taken on certain *features* of room space, but I do not think this means—particularly at actual size, when the top of the picture is almost out of reach, visually—that its space ends up looking contained and intimate. It is not a space into which the outside comes as light does through a window, in the way of 1924 (fig. 2.1). The outside is there, all right—but as inruption, instantaneity, horror. Somehow or other the outside has to be made present in the picture as a proximity that is absolutely foreign to us—absolutely nonhuman. This is a huge reversal of the Cubist intuition. No wonder it was such a struggle.

And this, by the way, is the level at which *Guernica* connects most deeply with the Tehran *Painter and Model* (fig. 4.1).

■ ■ ■

The first real step Picasso takes toward imagining how the mural might be organized happens on 9 May, with a drawing in pencil measuring eighteen by nine and a half inches (fig. 6.17). The sketch faces up to the difficult proportions of the pavilion wall space, though it is still not wide enough in relation to its height. It is a strange achievement, in that it contains so many elements that were to persist in the picture's future—not just the characters and incidents, but decisions about form—and yet next to nothing of *Guernica*'s effect. The bull, the horse, the woman with the lamp, and a mother cradling a dead baby are present. The choice for darkness seems to have been made—the actual bombing, one should note, took place in late afternoon, beginning at four-thirty and continuing over three hours. The lamp in the sketch flickers against a black sky; flames burst up from a building. All across the upper half of the drawing there is a checkerwork of hard rectangular apertures, which have the look of doors or windows with the wall thickness carefully shaded in, alongside other hard-edged lights and darks with no fixed depth or location. Out of a window toward the right comes a clenched fist; and there are two other fists, just as abstract and improbable, over to the left of the bull. If one fixates on certain areas in the background—on the area around the flames and fist at top right, in particular—one can imagine oneself already in *Guernica*'s black and white world. But the exercise is misleading.

Spatially, taken as a whole, this composition sketch is still firmly a variant on the previous pencil-on-gesso exteriors. Tiled roofs hold the center distance: the townscape has not come far from Picasso's ideas for Pulcinella, seventeen years before (fig. 6.18). Because the foreground is crammed with fallen bodies—the agonized horse, the mother and baby, three corpses, one clasped in the hands of a keening woman—it takes a little time to realize how much of a further deep ground plane is suggested in the sketch, leading back to the city, with figures laid out across it horizontally and diagonally. The mother with the dead baby is the epitome of this. Logically, she is back in an undefined middle ground, on the far side of the horse's splayed hindquarters; but visually, one part of us registers the horse's haunches as belonging to *her*. The switch is a typical piece of Picasso eroticism (and it is important, by the way, that in the final painting sex and animality are decidedly not fused); but above all, for our

6.17. Picasso, Study (VII) for *Guernica*, 9 May 1937. Pencil on paper, 24 x 45.3 cm. Museo Nacional Centro de Arte Reina Sofía, Madrid.
6.18. Picasso, Scenery, curtain, and costume designs for Sergei Diaghilev's ballet *Pulcinella*, 1920. Graphite, india ink, and gouache, 20 x 26.6 cm. Inv. MP1760. Musée Picasso, Paris.

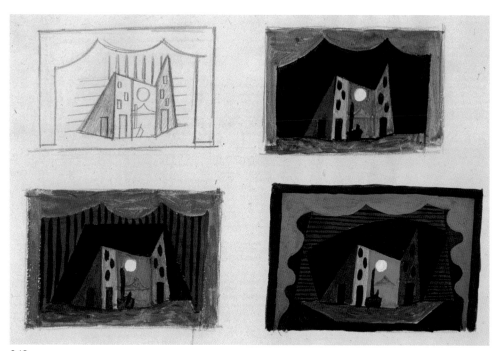

6.18

present purposes, it concentrates the study's whole indecision about near and far. At certain points the "outside" seems to move forward, locking into black-white pattern. But mostly the town keeps its distance. Bull and lamp-bearer belong to the houses. A great cartwheel, massive and silhouetted, acts as a barrier between stage front and stage rear.

The space achieved in the final *Guernica*, in other words—the new kind of inhuman proximity I have talked about—is present only locally in the sketch. The miniature scale of things here—remember the sheet is a foot and a half wide—seems to have made the artist feel he had to hollow things out and establish intervals. He looks to be working on the assumption that the eventual big painting would similarly be bound to have a depth commensurate with its surface area. It was not till two days later, 11 May, that the first real breach with the dream exterior occurred. And it happened, typically for Picasso, when the question of scale was faced head on. The canvas was stretched, the floor was cleared, work began. No more than a day or so afterwards, Dora Maar took the first photo (fig. 6.4).

∙ ∙ ∙

It is stupendous, this first state of things. Clement Greenberg later went on record as thinking it "much more successful, so far as one can tell from photographs, than any of the later stages it went through." He meant to provoke, but one sees what he means. I look at state one of *Guernica* and immediately think of the wonderful pen and watercolor drawing by Ingres, *Self-Portrait of the Artist at Work on His "Romulus" in Trinità dei Monti* (fig. 6.19). The comparison operates at several levels. Both documents exult in the actual, visible enormity of the task called history painting. And both record the moment—the essential, shamanistic moment in the history-painting tradition as Frenchmen conceived it—at which, after the plotting and painstaking of preliminary studies, the first strictly linear form of the whole appeared, out of thin air, in the vast empty rectangle. It is hugely important, I think, this decision of Picasso's to recapitulate the procedures of Ingres and Géricault: above all, to go back to the moment of pure line—depthless line—at the beginning of things. Line, you will see immediately by contrast with the sketch of two days previously, puts the image on the picture plane, and all but collapses the crowded middle ground. The lamp-bearer leans out of the window, straight past the women underneath. The bull spreads out laterally and loses his shading. One figure from among the tangle of fallen warriors reaches up, maybe rigid in a last spasm, and lays out his chest, his torso, his penis, both his legs, all in strict parallel to the picture plane. It is as if the wild hindquarters of the horse in the study have migrated to the hero. And just to be sure that the viewer feels the pressure of the picture surface on these various forms, each moved closer and closer to it, the surface is traced out also as simple geometry—a crisscross of verticals and diagonals, sometimes extrapolated from the forms they approximate, sometimes seeming to suggest a further order, of light or recession, that as yet has no thing in the world to adhere to.

Line like this recalls us to surface: that would be one way of putting it. Ingres's ability to go on relishing that fact is what makes him one of Picasso's main gods. But of course—the photograph shows it—line is also transparency. Space flows through it unobstructed. It cannot make space materialize, as the palpable, close thing Picasso most deeply felt it to be. The further making of *Guernica*, to put it in a nutshell, was a sequence of attempts to solve this riddle. Could one have space finally register on the

6.19

surface, felt as a heavy, breathable, confining reality, without a picture of this size becoming all obstruction—all detail, all brilliant bits and pieces?

One painting from the 1920s that is sometimes invoked as a premonition of *Guernica* is *Studio with Plaster Head* from 1925 (fig. 1.25). It is a nice juxtaposition. The smashed fragments of a statue and the Pulcinella-type townscape do resonate. But I would say that the essence of the comparison is to show us the kind of spatiality *Guernica* had to avoid—meaning the multiplication of compartments and incidents, the *horror vacui*, the greater and greater pressure of everything against the picture plane and picture edge.

■ ■ ■

6.19. Jean-Auguste-Dominique Ingres, *Self-Portrait of the Artist at Work on His "Romulus" in Trinità dei Monti*, 1812. Watercolor, pen and brown ink, and graphite on paper, 46.4 x 56.6 cm. Musée Bonnat, Bayonne.

This lecture, again, cannot do justice to its subject. There are, for instance, now known to be nine photos taken by Dora Maar of *Guernica* in progress, plus a closeup of the horse's head early on, and one or two shots of Picasso at work, with the painting shown obliquely or in part. Any one of these states deserves more attention than it has so far been given in the literature. (Even Arnheim's book, which is marvelous on the painting's preparatory material, is oddly short-winded when it comes to Maar's photos, especially of the canvas in its final two weeks.) A full account of *Guernica* state one, to return to it momentarily, would certainly have to go farther with the Ingres comparison (fig. 6.20). It would have to reflect on the depth of Picasso's dreaming in front of the actual *Romulus and Acron*, which clearly he went to see in the École des Beaux-Arts; and on his whole strange reimmersion in the painting of the French Revolution. I have no doubt that the fallen warrior, the upraised fist, and even the dialogue of hero and horse, are a condensed dream image of the great ground plane and midground action in the *Romulus* toward the right—which is itself a de-realization of the same pattern of death and animality in David's great *Sabines* (fig. 6.21). And this in turn—since we know by now that Ingres usually appears in Picasso when sexuality is in question—would lead to the uniqueness in Picasso's work of this moment of homoerotic male beauty. (It seems to me odd that this uniqueness has not been recognized.) The turn of the hero's nakedness into the picture plane is charged—I would say, naive—in its equation of resistance with phallic perfection of form. Again the comparison with the drawing from two days earlier is telling (fig. 6.17).

One of *Guernica*'s signal achievements, as I have said, is to have death acted out by women and animals without the action partaking of the erotics of the bullring. Women just *are* the actors in Picasso's world—always. It may go on being a problem for us that what they perform, too much of the time, is sex and death. Women are "machines à souffrir." We can take that aphorism as compassionate or gloating according to our preference—it is part of a longer and deeper debate with Gilot about the actual state of the war of the sexes—but for present purposes what matters is

6.20. Jean-Auguste-Dominique Ingres, *Romulus Victorious over Acron,* 1812. Oil on canvas, 265 x 530 cm. Louvre, Paris.
6.21. Jacques-Louis David, *Intervention of the Sabine Women,* 1799. Oil on canvas, 385 x 522 cm. Louvre, Paris.

6.20

6.21

how the attitude plays out in the picture of a city burning. I think compassion rules. And Picasso knows full well that in order for it to do so he must defuse—throw into reverse gear—his normal association of violence with the sexual act. The conflation of horse and mother in the 9 May drawing, or the woman's hands in the same sketch caressing the corpse—these are, so to speak, Picasso's normal imaginings. And state one of *Guernica*, two days later, is a first attempt—as I said, a naive attempt—at expunging normality by simply reversing the sexual signs. If the male hero could concentrate the erotic energy in his fist and chest, then maybe the maenad over to the right—who is, I suppose, a daughter of the maenad of 1925—could agonize without her agony being desirable.

It is simple-minded, with the simplicity of repression. But it goes to show the erotic stakes of *Guernica*; and a full account of the picture's making would have to trace the way this initial homoeroticism—this borrowing whole from David-type theater—was gradually worked out of the system. One great thing that had to go, of course, was the clenched fist. It grew bigger (fig. 6.22); it gathered itself a phallic halo of sunlight and harvest festival (fig. 6.23); it blew away (fig. 6.24). Francis Frascina has argued that one main reason it vanished was the state of things in Barcelona just as Picasso was working: the blood of anarchists in the streets, and the triumph of the Party. The clenched fist was more and more, at this moment, a Stalinist symbol. Frascina may be right. And of course, as Arnheim long ago argued so eloquently, there are complex structural reasons why the picture space could not go on hanging so decisively from a central unbroken spine. But partly the painting-out, I am suggesting, is to be understood as issuing from a kind of embarrassment on Picasso's part. State one had been too beautiful. Too male. Too Greek. It was transparent about too much.

■ ■ ■

6.22. Dora Maar, *Guernica* in progress, state 2, May–June 1937. Gelatin silver print. Musée Picasso, Paris. MP1998-215.
6.23. Dora Maar, *Guernica* in progress, state 3, May–June 1937. Gelatin silver print. Musée Picasso, Paris. MP1998-219.
6.24. Dora Maar, *Guernica* in progress, state 4, May–June 1937. Gelatin silver print. Musée Picasso, Paris. MP1998-207.

6.22

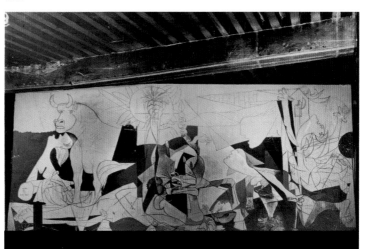

6.23

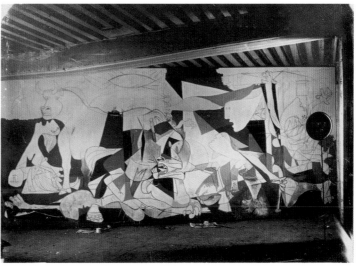

6.24

From monster to creature is not necessarily a great step. It is true that Picasso's monsters up to 1937 had been predominantly female, and attuned to the fears and unfamiliarities of sex, but this had never entirely closed off other possibilities. It did not define the genre. Monstrosity, we have seen, could be another name for endurance—the bare bones of the matter (fig. 5.22). Monsters could have pathos (fig. 2.40). Their ugliness was often as much pitiable as threatening, and the picture's relegation of them to outer darkness a metaphor for human ruthlessness toward those—or those aspects of themselves—deemed different. Goya's horror at cruelty—his recognition of the human ability to deface and deform, to make monsters out of living flesh—is rarely far away.

The agony and dignity of the women and animals in *Guernica*, in other words, was long prepared. They derived from previous thinking. But of course Picasso was also aware of the dangers. The hero of *Guernica* state one is surrounded, especially as one's eye moves right across the canvas, by women still unavoidably registering as his partners in a sexualized dance. They shriek like Glauce in her flaming coat, or sleep, half naked, like a fallen Amazon (figs. 6.25 and 6.26). Sex and death are intertwined. The world of the sarcophagi is near. An immense effort of pictorial will would be needed if women's bodies, in such a context, were to obey a different logic.

Eventually they did. A first clue to the way Picasso reimagined his actors comes clear if we leap straight from the mural's state one to state ten—the painting delivered to the pavilion—and compare the drawing of women's bare breasts. The breasts in state one are mainly generic—signs for rotundity, sexual markers. There is already an exception to the rule, in the strange flat flanges belonging to the screaming mother at left. And what happens as work goes on in the painting's later stages is a generalization, or intensification, of that first idea—it moves out to the other participants. Partly, again, this proceeds by repression: the sarcophagus Amazon is painted out, and the frenzy of the woman in flames is, step by

6.25. Sarcophagus with scenes from the story of Medea, marble, c. 200 CE. Antikenmuseum, Basel und Sammlung Ludwig.
6.26. Sarcophagus depicting the Battle of the Amazons, marble, c. 140–150 CE. Roman. Musei Capitolini, Rome.

6.25

6.26

step, overtaken by a kind of coffin—a Cubist incinerator—into which her three dimensions disappear. Breasts remain, of course—as they must, signs of ultimate succor, drying and shriveling as death takes charge. (I have no doubt that the terrible episode in Delacroix's *Massacres at Chios*, where a child scrabbles for a last hold on his dead mother's nipple, was on Picasso's mind [fig. 6.27].) Compare the first form of the stumbling woman's breasts in state one with that in the finished picture; or, better still, compare the way the breasts of the woman holding the lamp are treated (fig. 6.28). Abstract half-circles change into vulnerable, unlovely exposures. Rotundities become surfaces—in the window, the breasts are pressed painfully against the glass, with two spiked nipples pointing in opposite directions.

I seize on this detail—a charged detail, obviously—because it epitomizes a wholesale change of idiom. And it is difficult to put the new vision of the body in a nutshell. The staccato drawing of the victims' contours—look at the breasts and nipples of the stumbling woman—seems to have come in tandem with their relocation in space. Again the right-hand side of *Guernica* state one is the proper foil. Bodies come closer as state follows state: the world the women belong to (the house from whose window the lamp-bearer issues, for instance) presses against the picture plane, so that the breasts in the window are a kind of synecdoche for the picture's spatiality as a whole. I shall say more about *Guernica*'s version of closeness in a moment; let me just point, for now, to the effect of closeness on the actors' flesh. Again, things are complex. No doubt proximity (and the arrival of strong black-and-white contrasts) result in a freezing and flattening of form overall, a stamping of everything into hard silhouette. The actual drawing of the lamp-bearer, for instance, hardly changes from state one to state ten, but her place in the pictorial action—her leap forward into *too much* visibility—is utterly different. She is seeing—seeing the not-to-be-seen—incarnate. Seeing reduces her to a sign. But flattening and simplifying are only part of what goes on. The stumbling woman (compare state one) acquires a lurching, propulsive weight as she comes nearer, with feet and knee desperate to support a body off balance. Toes

6.27. Delacroix, detail of foreground in *Scene from the Massacres at Chios*, 1824. Oil on canvas, 419 x 354 cm. Louvre, Paris.
6.28. Picasso, detail of *Guernica*, fig. 6.1.

6.27

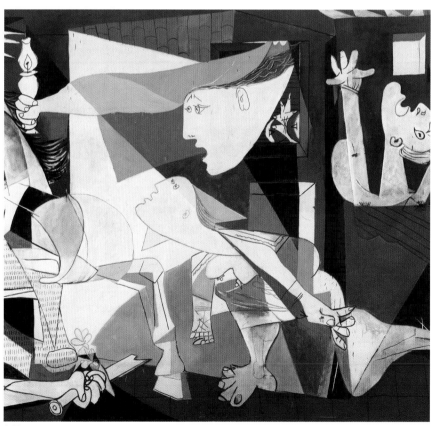

6.28

splay and swell. Even the hieroglyph of the falling woman is given a steel-gray shading (seemingly at the last minute), so that her hands and neck are almost as strong a note, in terms of stressed solidity, as the neck and muzzle of the horse.

The falling woman emblematizes the new style. She is swallowed by the compositional machine; but the swallowing comes across as truly grating and atrocious—as well as crazy and grotesque—because so much has been done to make the woman a thing of flesh, with a claim on life to the bitter end. Everywhere in *Guernica* the shards of the painting's light-dark architecture (its blast effect) slash across women's bodies. Look at the door through which—though never for me comprehensibly—the woman in the foreground is stumbling. Look at the guillotine severing her knee. Or the falling woman's preposterous toes, emerging at right from her striped straightjacket. All this could easily have registered as bodies marching predictably to a "Cubist" drum: puppets in a rigid theater. If, as I think, it does not, that is because the horror and inquisitiveness of the women—their bearing witness even at the point of extinction—have been given sufficient substance. What fixes and freezes them is felt as a mechanism, a rack. The bomb is the abstractness of war—war on paper, war as war rooms imagine it, war as "politics by other means"—perfected. Here is what happens when it comes to earth.

■ ■ ■

The erotics of *Guernica*, then, is one among several stories worth telling, and still largely to be told. But my story is space. And even here I shall be selective. There are, to repeat, nine steps toward the picture's final form. I leap to a moment quite close to the end (figs. 6.29 and 6.30).

By the time Picasso was working on the picture as we see it in these photos—probably two weeks or more into the process, maybe during the first days of June—the basic tonal and spatial structure of the scene had been long decided. The painting would be organized around a repeated

6.29. Dora Maar, *Guernica* in progress, state 6, with collaged papers, May–June 1937. Gelatin silver print. Musée Picasso, Paris. MP1998-211.
6.30. Dora Maar, *Guernica* in progress, state 8, May–June 1937. Gelatin silver print. Musée Picasso, Paris. MP1998-284.

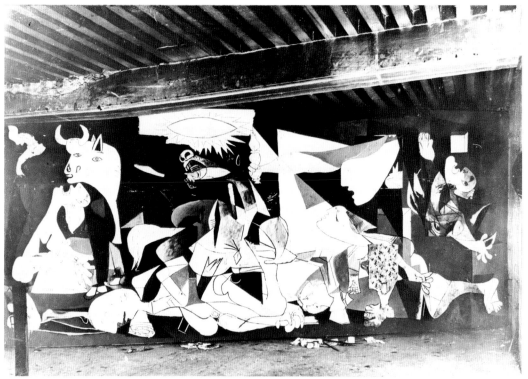

6.29

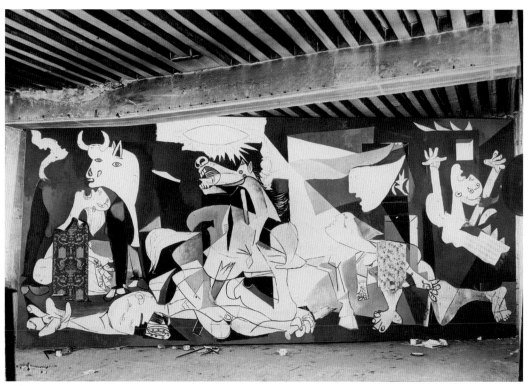

6.30

pattern of polarized lights and darks—a triangulation. Things would flash up in the glare of high explosive. Look, for instance—this is clearer in the finished painting—at the gray and white geometry emanating from the lamp (though of course from more than the lamp); or better, the deep black slashing across the doorframe underneath the lamp-bearer; or the flames, the window, the strange ceiling line top right. *Guernica*'s critics have always objected that this black-white geometry is crude. Its triangles are academic. I am sure they are right, but the answer to them—I think it is the one Picasso was struggling for all through the last weeks—was to engineer a kind of heavy, empathetic activity in and around the geometry, on the surface, in the nearness of the foreground, that would counter-weigh the abstractness of the lighting. I think he did; but I think it was hard.

A lot depends on real size. *Guernica* suffers hugely—it is the price of fame—from being continually miniaturized and disembodied in the world of mechanical reproduction. The reader should try to build into her judgment of what I say about its spatiality an awareness—a memory or imagining—of what it is like to be in front of the picture itself. Remember that one's sense of physical location in regard to the scene—and I mean by this not one's measured height against it, but one's imaginative projection into its space—is that it is hugely bigger than oneself: that at most a viewer comes up to the horse's chest. And this gigantism is, again, of a new kind for Picasso. It is not really captured by the word "monstrosity," and is wholly unlike the weird ballooning of some of Picasso's late 1920s monuments. The immense moon face of the lamp-bearer epitomizes the new affect. We are, to borrow the phrase from Leiris, on a level with the giants, *terre à terre*, looking up: into a world that is flattened and vulnerable—the pinned-paper feel of the horse's body is notorious—but heavy, ordinary, standing on the same ground as ourselves. Even the paper horse is massive; the wound in its side puckers and gapes, inviting a queasy touch. And of course the artifact of the half-tone or the jpg utterly travesties this physical relation. The best I can do is offer a photograph taken in front of the real thing, from ten yards away or more—in no sense is it creating a false proximity to wage war with the jpg's false distance (fig. 6.31). I think it registers at least the *kind* of seeing—of imaginative relation—*Guernica* intends.

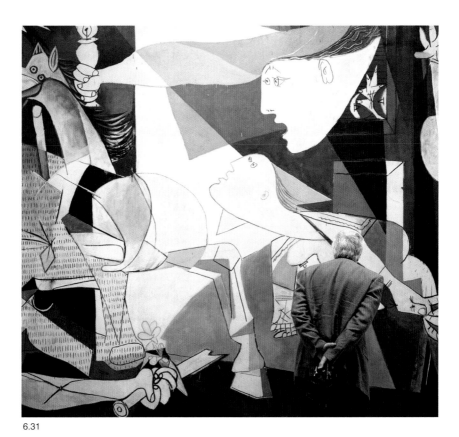

6.31

What can I say, then, about the painting's physicality? Well, at least this much. First, we are certainly back in a world of nearness, with everything spilling and straining toward us. But this does not turn, in the end, on the making of an overall container for the action: it does not turn on an outside-inside distinction. It could hardly be clearer that Picasso decided finally to offer us bits and pieces of both: the skyline up top, for example, changes constantly from ceiling to roofscape. This might be irritating—a sign of the painter's inappropriate cleverness—if it mattered. But in situated vision it does not. The upper part of the picture is *accompaniment*: all that matters about it is that from it or through it—we cannot tell which—explodes the blank instant of tungsten. Space, insofar as it survives this abstraction, is *here*, lower down, closer to us, in the weighted, grounded, bottom-heavy world of the giants. Space is a matter of silhouettes and

6.31. Andrew Moisey, *Guernica,* with spectator, 2008. Photograph.

painted cutouts constantly jockeying for attention with quite other kinds of extension, still solid or organic or even diaphanous: the horse's neck and jaws, for example, with their iron-hard shading; the slight (illusionistic) billow of the curtain as the lamp-bearer pushes it aside; the push—the flow, almost as if she is squeezed from a tube—of the lamp-bearer's face toward somewhere right over our heads.

It is not right, as several commentators have reminded us, to describe *Guernica* as black and white. It is mostly in gray, and the grays have been marked and modulated at every point, sometimes with almost florid drips and flourishes, so that they carry the reminder of flesh and horsehair and flimsy material and *touch*. The flash bulb bleaches and flattens the surfaces; but the middle register—the arm and the curtains, the horse's stretched muscles, the stumbling woman's bunions—survives.

All of this was hard won, as I say, and much of it came late (figs. 6.29 and 6.30). Our best guess is that by the time Dora Maar took her photos of states six and eight of *Guernica*, work in the studio had only a week to go. One thing that has always fascinated commentators about these two moments is that in them Picasso seems to have pinned or stuck pieces of patterned, presumably colored, paper onto his painting's blacks, whites, and grays. The stick-ons were more than a passing whim. Both pieces of paper in state six are applied to the woman lurching across the foreground at right: one of them is a loose patch of wallpaper, the other has been carefully cut to the shape of the woman's headscarf. There follows an interim, maybe a day or so, when the pieces disappear and work goes on in other areas—notably the woman falling from the flaming house (fig. 6.32). Again Maar captures the moment. Then the pieces are stuck on again, both of them just slightly differently placed, and two more pieces are added: a wallpaper strip pasted over the grieving mother's dress, and the first form of the comic book cutout—again, made from what looks like wallpaper—meant as the falling woman's frock.

We have returned to the world of Cubism, which is one reason these two states of the picture are so poignant. And no doubt the pinned-on papers, though in the end Picasso discarded them, were what provoked the most obviously "Cubist" feature of the final work: the lines of black stippling that point by point, suddenly in June, spread over more and more of the horse's body, turning it partly into a newsprint image of itself.

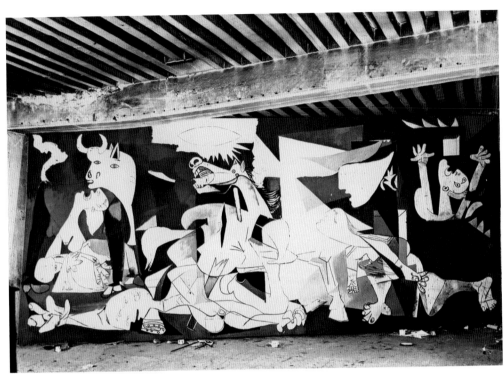

6.32

275

I interpret the moment of collage thus. Firstly, structurally, the pieces are a last effort at preserving room-space. State eight speaks to this most touchingly. For a week or more previously—ever since the clenched fist had been painted over—the basic light-dark structure of *Guernica* had flattened and compartmentalized the action, putting it nowhere in particular. State one had envisaged the scene taking place outdoors, as in the preliminary studies, at the edge of a town or maybe a small plaza; and subsequent states of the painting, though less and less concerned with the action's whereabouts, essentially preserved that fiction. But finally the room reasserts itself. Collage is *wallpaper*, after all. It is intimacy, texture, tangibility—the smell of paste, the neatness of pins. So partly the moment of collage here—understood now as an impulse, a compulsion, to which Picasso was drawn without any full sense of what he was doing—is nostalgic, reparative, and fated not to last: it is the great backward dream

6.32. Dora Maar, *Guernica* in progress, state 7, May–June 1937. Gelatin silver print. Musée Picasso, Paris. MP1998-277.

of early twentieth-century modernism putting in a last appearance. But this on its own, in my view, would not explain the persistence of the collage idea, however muted, in the final painting—the paper horse, the striped dresses left and right. For the problem at this point was technical, and collage did address it. Even this late in the day, with the ebb and flow of monochrome long established as the painting's matrix, Picasso looks to have been uncertain about whether the light-dark geometry of *Guernica* really made atrocity happen on the surface—or happen enough on the surface—or whether it would end by opening the illusion backward, in perspective, into a space that was simply vague. It is *the* problem of modern painting as Picasso conceived it, only now given a special ethical and political dimension. The light must be abstract, mechanical; the space must be something the mind can touch.

The collage pieces, then, are "surface" retrieved. They give bodies back their substance. I do not believe Picasso ever seriously entertained the idea of changing his painting's whole pictorial economy at the eleventh hour, or even of introjecting here and there a note of color. He was thinking about what, in painting, kept the world close to the picture plane— above all, about how much differentiation of surface texture, surface incident, was needed to interrupt the light-dark machine. He wanted proximity but not intimacy. In the end, he saw, commas of horsehair would be enough.

▪ ▪ ▪

But this was because in the meantime he had found a solution for the picture's most unresolved aspect: its ground level.

Let me return for a moment to Goya's *Third of May* (fig. 6.10). What Picasso seems to have thought so astonishing about the painting was the way Death was everywhere and nowhere in it, as a kind of unwordly illumination, but also *there* in one place on the ground, in the lantern. This is the dialectics of genius, and Picasso (for once) is entirely serious when he tells Malraux and Gilot that he does not know how Goya did it. *Guernica* is on his mind. He knows his painting will be a much lesser thing— maybe even a fake or a failure—if it does not find a way to repeat Goya's doubleness. Death must again be abstract immediacy, but also something happening to real bodies. And gravity and proximity—the qualities that sum up real being-in-the-world for Picasso—are ultimately nothing if

those subject to them do not have "standing." The horse and the woman, and even the hollow bits of the hero, must be in touch with the ground underfoot.

But what ground? This is still more or less an open question, it seems to me, as late as *Guernica* state eight (fig. 6.30). The broken shards of the warrior, the hoofs of the horse, and the Bataillesque big toes of the woman careering through the door—they all fall into the bottom edge of the picture there like so many weightless, unlocated floaters. It may even be that Picasso had the idea at this stage that groundlessness—vertigo—was to be the painting's predominant note. The falling woman would dictate things.

In the end she did not. And the change of direction, when it comes, happens fast. Look at the ninth of Dora Maar's photos, taken a matter of hours before Picasso decided the painting was finished (fig. 6.33). Notice that as soon as the surfaceness rediscovered in the collage pieces begins to be put into the painting, comma by comma, across the horse's back and belly, the whole balance of space and floor in *Guernica*'s bottom two feet begins to shift. The hoofs have legs to attach to, the broken statue becomes three-dimensional. Cutout surface is answered by hard ground level. A grid of tiling springs up, anchoring the painting's whole spatiality. Look what it does, for instance, to the long hard-edged diagonal, like the bottom of a wall or even an upended door, that pushes back into space behind the stumbling woman, the horse's front hoof, and the warrior's broken sword (fig. 6.34). This line, as a basic structuring idea, had been there for days, maybe weeks. It seems to have arrived at the same time as the first pinned-on papers. But it does not really operate on *Guernica*'s foreground—it does not carve out sufficient space for the foreground actors to stand on—until the grid is painted in. Then everything seems to harden and clarify. The curving gray shadow midway across the wall—is it the shadow cast by the curtain hanging over the lamp-bearer's forearm?—snaps into visibility. The horse kneels heavily on the tiles.

I love the photo Dora Maar took of Picasso squatting on the studio floor by *Guernica* and pondering—of course this is me adding thought bubbles—just what it would take to materialize the still abstract last inches of the illusion (fig. 6.35). In the end the creatureliness he was looking for came easily, almost naively; but only because he saw finally how surface

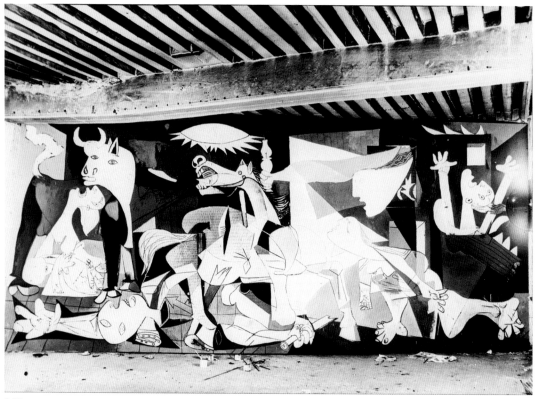

6.33

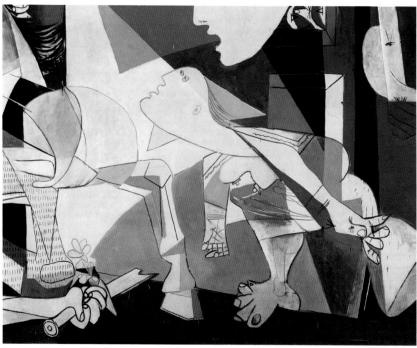

6.34

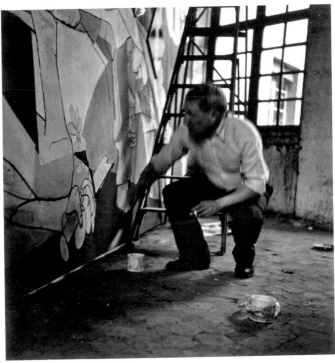
6.35

and grounding could coexist. Forms spread out along the nearest possible front edge of the floor plane, as if no more than a few inches from us; up above, bodies switched to and fro between paper thinness and stamping solidity; and the squares of the tiling were pushed back beyond the great bodies, making them seem closer still. This was proximity, in a word, but reinvented. It was flatness finding its feet.

∎ ∎ ∎

These lectures have been about truth in painting, and here at the end I should try to sum up. We know from the briefest glance at Picasso that a

6.33. Dora Maar, *Guernica* in progress, state 9, May–June 1937. Gelatin silver print. Musée Picasso, Paris. MP1998-211.
6.34. Picasso, detail of *Guernica*, fig. 6.1.
6.35. Dora Maar, Picasso painting *Guernica*, state 7[?], 1937. Gelatin silver print, 20.7 x 20.2 cm. Inv. MP1998-280. Musée Picasso, Paris.

6.36

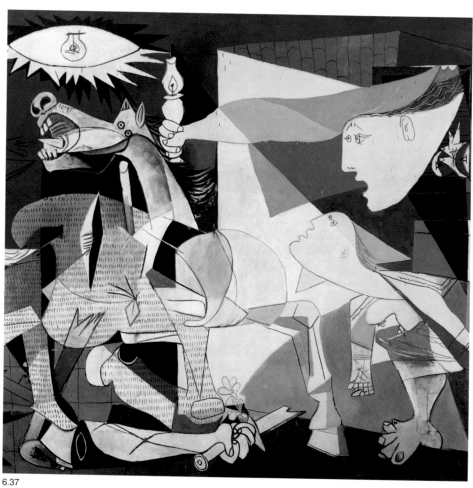

6.37

great deal of what had previously counted as tests of truth in depiction carried no weight with him any longer. Lifelikeness and verisimilitude (those two strange coinages) are left behind. That is to say, the painter does not wish to persuade us that the world he has created is continuous with ours, or even, exactly, equivalent to it. Strangeness is a value: *Guernica* speaks to that. Picasso's is not a world in which the enclosing envelope of space is ever transparent and homogeneous, with bodies occurring as finite interruptions of it; things do not teem with surface detail, necessarily, and actors do not address us—do not "look back" at us—from a securely human situation. And yet the idea of "world" persists. And therefore, I have been arguing, there is one thing painting finds indispensable: namely, space—the making of an imaginatively habitable three dimensions, one having a specific character, offering itself as a surrounding whose shape and extent we can enter into. In Picasso's case, "imaginatively habitable" equals making an interior of sorts. Now and then I have called this constant trajectory providing a space for being "in," or providing a room. And maybe my adding an "a" to "room" here is redundant; because providing room—the sine qua non of the human for Picasso—just is, for him, providing *a* room, a specific and familiar floor, wall, wainscot, window. . . . Being, for human beings—and how deep is the pathos of that recursive noun—seems to have as its very precondition being "in": reaching out, really or imaginatively, and feeling the limits of a place.

281

I hope that saying this helps to bring the achievement of *Guernica* into focus. For suppose modernity were to come upon an instant in which the whole imaginative structure of habitation—of being "in," of shaping the world around an implicit model of room and window—looked death in the face (fig. 6.36). Suppose this were more than a one-time atrocity. Suppose that in the bombing of Guernica modernity in some sense encountered its future and saw a whole form of life collapsing—ceasing to exist as the determinant form of the human. How on earth was painting to represent such an ending without falling itself into a spatial rubble, a spatial *nothing*; maybe propped up—or distracted from, as by a conjurer's misdirection of attention—by foreground melodrama? This was the problem. There will, I think, always be disagreement about whether Picasso solved

6.36. Picasso, *Window Open to the Sea, and Airplane in the Sky*, October 1919. Gouache on paper, 19.5 x 11.1 cm. Musée Picasso, Paris. Inv. MP856.
6.37. Picasso, detail of *Guernica*, fig. 6.1.

it. But what I want to suggest, above all—what I hope these lectures have made it possible to suggest—is the enormity of the task, and how tackling it entailed, for Picasso, reinventing his whole worldview (fig. 6.37). That I can even claim he rose to the challenge—that he found a way finally in *Guernica*, right at the end, to make his humans and animals come near us and place them on the ground; and a ground that was neither outside nor in, exactly, but the floor of a world as it might be the very instant "world" was destroyed; and where women and beasts, in spite of everything, still fought to stay upright and see what was happening. . . . That I can claim this at all (this enormity), and hope to persuade you, is more than enough.

Acknowledgments

This book is based on the fifty-eighth A. W. Mellon Lectures in the Fine Arts delivered at the National Gallery of Art, Washington, DC in spring 2009. I am immensely grateful to Elizabeth Cropper, dean of the Center for Advanced Study in the Visual Arts at the National Gallery, for inviting me to give the lectures, and for her kindness and engagement all through the process. I remember saying to Elizabeth at the end of the final lecture that I had had the time of my life that spring, and the verdict still stands. People at the National Gallery could not have been more helpful: I owe a special debt of gratitude to Therese O'Malley, Peter Lukehart, and Faya Causey for their care and good humor; to Martha Schloetzer, research assistant extraordinary; and to Jeannie Bernhards, who presided over my "last slide show" with a nostalgic smile.

Michael Fried told me early on that the audience in Washington was special, and so it proved: their intensity of attention and generosity of response were, from the first minutes of lecture one, an inspiration. Most of the audience I did not know, but of course some faces I recognized. It mattered enormously that Ruby Clark, Jesse Deans, and George Wagner were in the room at certain points: they had shared in the lectures' making. I was and remain deeply touched by the presence at all six lectures of Nancy Locke, Christopher Campbell, and their children Catherine and Lachlan—touched by their voyaging from Pennsylvania, their responses, their friendship. It seemed right and proper to see Wendy Lesser and Richard Rizzo, my Berkeley companions for two decades, listening to lecture 4. Michael Fried came, and as always his suggestions went to the heart of the matter. Charles Dempsey was trenchant and supportive from start to finish. The

285

recollection of Rosalind Krauss sitting back in the center of the auditorium on two occasions is one I treasure. My dear friend David Stewart flew from Tokyo to hear one of the talks. . . . And something of the flavor of the last lecture is conjured up by the memory of raising a glass afterwards in a room that included my two oldest friends, Donald Nicholson-Smith and Krishan Kumar, and discovering that the two of them had not met since the time we were students together forty years earlier.

I have been working on Picasso for longer than I care to remember—Elizabeth Cropper's invitation was the spur I needed to bring the process to some kind of conclusion—and many people have helped. Hannah and James Everett, Sam Clark, and Catriona Biggart certainly did. Having started this book by saying a few hard words (which I don't retract) about the general strange current of writing on Picasso, I am glad to be able to record my debts to those swimming against the tide. A quick look at the book's notes will indicate Rosalind Krauss's influence—all the more important because it so often forced me to clarify why my own emphases had to be different. In 2007 I convened a conference at the University of California, Berkeley on "Picasso in the Late 1920s," and the roll call of participants is a good first clue to others whose work I have learnt from: Elizabeth Cowling, Lisa Florman, Jeremy Melius, and Charles Miller gave papers, and Jay Bernstein, Yve-Alain Bois, Benjamin Buchloh, Hal Foster, Chris Green, Amy Lyford, Garrett Stewart, Anne Wagner, Margaret Werth, and Sebastian Zeidler responded. Many of these people—their work and conversation—helped me in ways that go far beyond this one event. I taught graduate and undergraduate seminars on Picasso many times at Berkeley over the years, and owe a great deal to students who took part in them; and to Marnin Young and Jeremy Melius, who helped with research.

Kaja Silverman was and is a true friend: it was typical of her that in the aftermath of the Mellon Lectures (and at a moment in Berkeley when the continuing life of the humanities at the university was under threat) she insisted on my giving three of the series on our home turf, and put together an unforgettable trio of introductions to the lectures by herself, Judith Butler, and Anthony Cascardi. Judith Butler had previously been good enough to co-teach a graduate seminar with me on Ethics and Aesthetics in Nietzsche—a hugely enjoyable experience, which helped to deepen the lectures' Nietzschean dimension.

Parts of the book were given as lectures in other places, and questions made a difference. In particular I remember the response to a talk on *Guernica* given at the Siemens Foundation in Munich: Klaus Herding's and Willibald Sauerländer's suggestions, and Mrs. Sauerländer's quiet testimony to me afterwards on the reality of life under the bombs. What she said resonated with my childhood memories of grownups, on great occasions, talking about the blitz.

Many aspects of this work on Picasso were enabled by a Distinguished Achievement Award from the Andrew W. Mellon Foundation: it made possible the 2007 conference, it meant the Nietzsche seminar could explore the Nietzsche-Wagner connection, it paid for ten days in Madrid with a group of students, it brought Malcolm Bull to Berkeley to speak about Nietzsche (and Henry Staten to respond), it gave me time off from teaching, it took me far and wide to see paintings. Looking back, I still can't quite believe my luck.

Berkeley was a staunch supporter of my work through two decades, in ways I shall not forget: I am grateful in particular to the George C. and Helen N. Pardee Chair, and for help at earlier stages from the Humanities Research Fund.

The university was a fine place to do art history, and the Bay Area a fine place to call home: without Darcy Grimaldo Grigsby, Iain Boal, and Joseph Matthews this book would have lacked that essential ingredient, an imagined reader over my shoulder. So typical of Iain that the night after the lecture on *Guernica*, in that first Obama springtime—heavy with wishful thinking, no doubt, but still, I believe (as a reader of Faulkner and *The Peculiar Institution*), a moment in history—he took us off to the Lincoln Memorial, crowded with people at midnight, for a nonreverential reading of the Second Inaugural!

At Princeton University Press, I am especially grateful to Alison McKeen, my editor, to Pamela Schnitter, patient and imaginative designer, and to Beth Clevenger, Sara Lerner, and Terri O'Prey, who oversaw the book's production. At the National Gallery of Art, Sara Sanders-Buell did a great job of searching out illustrations. In the book's late stages Yve-Alain Bois offered wise advice, and Christopher Campbell worked his magic with a vital image.

Finally, once again, my deepest thanks, and more than thanks, go to Anne Wagner, whose view of Picasso, and of much more than Picasso, is threaded through every page. She is always the reader most deeply dissatisfied with what I have written, because she expects the most; and therefore the reader who is kindest. As the man said: Au fond, il n'y a que l'amour.

Notes

ABBREVIATIONS FOR NOTES

Boggs Jean Sutherland Boggs, *Picasso and Things* (Cleveland, 1992)

C G Clement Greenberg, *The Collected Essays and Criticism*, ed. John O'Brian, 4 volumes (Chicago, 1986–1993)

Cowling Elizabeth Cowling, *Picasso, Style and Meaning* (London, 2000)

Daix Pierre Daix and Jean Rousselet, *Le Cubisme de Picasso: Catalogue raisonné de l'oeuvre peint 1907–1916* (Neuchâtel, 1979)

Gilot Françoise Gilot and Carlton Lake, *Life with Picasso* (New York, 1964)

Gilot Fr. Françoise Gilot and Carlton Lake, *Vivre avec Picasso* (Paris, 1965)

Palau Josep Palau I Fabre, *Picasso, From the Ballets to Drama (1917–1926)* (Cologne, 1999)

Propos Marie-Laure Bernadac and Androula Michael, eds., *Picasso Propos sur l'art* (Paris, 1998)

INTRODUCTION

"Pound, Parker, Picasso . . . ": Philip Larkin, *All What Jazz: A Record Diary, 1961–68* (New York, 1970), pp. 22 and 27. Larkin adds Pollock to the list as an afterthought, as well as Henry Moore and James Joyce. "I dislike such things not because they are new, but because they are irresponsible exploitations of technique in contradiction of human life as we know it. This is my essential criticism of modernism, whether perpetrated by Parker, Pound, or Picasso: it

helps us neither to enjoy nor endure." My defense of Picasso takes the charge seriously.

"He reprinted Basil Bunting's poem . . . ": Philip Larkin, ed., *The Oxford Book of Twentieth-Century English Verse* (Oxford, 1973), p. 322.

"Toujours à respirer si nous en périssons . . . ": Stéphane Mallarmé, "Le Tombeau de Charles Baudelaire," in Mallarmé, *Oeuvres complètes* (Paris, 1970), p. 70.

"The idiot X-equals-Y biography . . . ": See Rosalind Krauss, "In the Name of Picasso," in her *The Originality of the Avant-Garde and Other Modernist Myths* (Cambridge, Mass., 1985) for a brave (but fruitless) attempt to stem the tide.

"Yes, as you say, painting is only being kept alive by Picasso . . . ": Centre Georges Pompidou, Musée National d'Art Moderne, *Daniel-Henry Kahnweiler, marchand, éditeur, écrivain* (Paris, 1984), p. 147.

Notes to Lecture 1

> Oui la peinture n'est supportée que par Picasso, comme tu le dis, mais combien merveilleusement. Nous avons vu chez lui, il y a deux jours, deux tableaux qu'il venait de peindre. Deux nus qui sont peut-être ce qu'il a produit de plus grand, de plus émouvant. "Il semblerait qu'un satyre qui viendrait de tuer une femme aurait pu peindre ce tableau," lui ai-je dit à propos de l'un d'eux. Ce n'est ni cubiste, ni naturaliste, c'est sans artifice aucun de peinture, c'est très vivant, très érotique, mais d'un érotisme de géant. Depuis bien des années, Picasso n'avait rien fait de pareil. "Je voudrais peindre comme un aveugle," avait-il dit quelques jours plus tôt, "qui ferait une fesse à tâtons." C'est bien çà. Nous sommes sortis de là, écrasés.

The passage immediately follows a more characteristic Kahnweiler set of reflections on his own Protestantism and Prussianness, on Fichte and self-identity, and art's autonomy (in 1932): "L'agitation des hommes est peu de chose, et dans quelques siècles, n'occupera que 20 lignes dans les manuels d'histoire, mais les oeuvres vivront . . ."

"Whether he likes it or not, man is the instrument of nature . . . ": Christian Zervos, "Conversation avec Picasso," *Cahiers d'art* (1935), cited in Propos, p. 33.

"Why do you think I date everything I do? . . . ": Brassaï, *Conversations avec Picasso* (Paris, new edition 1997), p. 150.

"I think the work of art is the product of calculations . . . ": Dor de La Souchère, *Picasso à Antibes* (Paris, 1960), cited in Propos, p. 135.

"You start a painting and it becomes something altogether different . . . ": Daniel-Henry Kahnweiler, "Entretiens avec Picasso au sujet des *Femmes d'Alger*," *Aujourd'hui* (September 1955), cited in Propos, p. 72.

"I believe in phantoms . . . ": Daniel-Henry Kahnweiler, "Gespräche mit Picasso," *Jahresring 59/60* (1959), cited in Propos, p. 92.

"Mark Mazower's terrible conspectus . . . ": Mark Mazower, *Dark Continent: Europe's Twentieth Century* (London, 1998).

"The Century of Violence . . . ": The actual title being David Thomson, ed., *The Era of Violence 1898–1945* (Cambridge, 1960). The general editors of *The New Cambridge Modern History*, in which Thomson's volume appeared, quickly ordered a revised edition called *The Shifting Balance of World Forces*.

"Did the century's disasters have a shape? . . . ": The political implications of this view of the twentieth century are developed in my "For A Left with No Future," *New Left Review* 74 (March–April 2012).

"The time of human smoke . . . ": See Nicholson Baker, *Human Smoke: The Beginnings of World War II, the End of Civilization* (New York, 2008).

"Buchloh, for instance, is unbeatable if this is the test . . . ": Benjamin Buchloh's view of the century is put forward most substantially in his essays on Gerhard Richter; most baldly in his "Figures of Authority, Ciphers of Regression: Notes on the Return of Representation in European Painting," *October* 16 (Spring 1981); but versions of the view pervade his *Neo-Avantgarde and Culture Industry, Essays on European and American Art from 1955 to 1975* (Cambridge, Mass., 2000).

LECTURE 1

"Au fond il n'y a que l'amour . . . ": Efstratios Tériade, "En causant avec Picasso," *L'Intransigeant* (1932), cited in Propos, p. 27.

"If I do a nude, I want you to think it's a nude . . . ": André Malraux, *La Tête d'obsidienne* (Paris, 1974), p. 110.

"I continue with things smaller still . . . ": See Palau, figs. 836 and 883, and p. 233, and Cowling, p. 334 (on the tempera *Composition*). Cowling suggests that Picasso was aware of Mondrian by this time, and was interested in Purism. I feel that 1920 is too early for Mondrian really to have been an active point of reference. The hard-edged abstraction Cowling points to in Picasso's work from this period strikes me as emerging naturally, or at least predictably, from the Cubism of 1915–16. Several paintings done in Barcelona in 1917 (e.g., *Seated Man at a Table* and *Woman in Armchair*, Palau, figs. 108 and 121) already anticipate the stripped-down idiom of *Woman Sitting in Armchair* done in December the same year (Palau, fig. 209).

"A comparison with Matisse's *Open Windows* . . . ": See, for a more general discussion of the Matisse-Picasso connection, Yve-Alain Bois, *Matisse and Picasso* (Paris, 1998), and Elizabeth Cowling et al., *Matisse Picasso* (London, 2002), esp. pp. 123–75. The Düsseldorf *Open Window* does not figure in either book,

and is rarely mentioned in the literature. It seems not to have been included in any of the retrospectives from 1932 on; in contrast even to the Tehran *Painter and Model*, which was shown (from Picasso's own collection) in 1932, 1947 (at the Palais des Papes in Avignon), and 1953 (at the Musée des Arts Décoratifs), though never in London or New York.

"The wish to simplify and dematerialize . . . ": As examples in the period 1917–21, besides *Woman Sitting in Armchair*, I would single out the 1918 series of geometrical still lifes (Palau, figs. 229–35, with the Musée Picasso's *Composition with Glass and Pipe* as a high point), *Man Sitting on Chair*, summer 1918 (Palau, fig. 312), *Guitar and Fruit Bowl on Table*, 1918 (Palau, fig. 329), *Stemmed Glass and Pipe in Grey Circle*, 1919 (Palau, fig. 351), *Mandolin on Pedestal Table*, 1920 (Palau, fig. 685), *Composition Based on a Chair*, 1920 (Palau, fig. 689), *Guitar*, March 1920 (Palau, fig. 707), *Oval Composition*, April 1920 (Palau, fig. 714), *Mandolin* and two versions of *Guitar and Score on Table* from summer 1920 (Palau, figs. 774–76), the astonishing *Arabesque of Woman in Armchair*, July 1920 (Palau, fig. 797), *Arched Structure with Guitar*, Sep. 1920 (Palau, fig. 852), *Lines in Reverse Perspective*, fall 1920 (Palau, fig. 870), an exquisite *Oval Composition*, fall 1920 (Palau, fig. 903), *Guitar and Table*, fall 1920 (Palau, fig. 941), and *Geometrical Guitar and Score*, April 1921 (Palau, fig. 1002). One or two of these works are slight, but most are entirely serious and fully realized, and the sequence as a whole—other works could be added—testifies to a constant strain of experiment in Picasso at this time. See Boggs, pp. 134–37 and 180–89 for discussion of works connected to the group, including mention of the tempera *Composition*.

"Nature never produces the same thing twice . . . ": Gilot, p. 59.

"Here is where I diverge from recent writers . . . ": See the searching discussion in Rosalind Krauss, *The Picasso Papers* (New York, 1998), pp. 112–54, which argues for the deliberately "pastiche" quality of Picasso's post-war classicism. Compare, among discussions in Picasso's lifetime, Carl Einstein, "Picasso," *Neue Schweizer Rundschau* 4, Zurich (1928), translated in part in Marilyn McCully, ed., *A Picasso Anthology, Documents, Criticism, Reminiscences* (Princeton, 1982), pp. 166–70: "These works proclaim a titanic archaism. Picasso has carried Greekness far beyond Maillol into a realm of colossal myth. . . . Through these figures Picasso has found his way back into history, and into what is quasi-officially designated as Nature. The world, as objectively assessed, had been conquered by the individual will, and Picasso has presented his own age with a new set of figurative images." Einstein admires unreservedly the "polyphony of styles" and tension between opposites in Picasso in the 1920s, but I take him not to be arguing that the restlessness and in-

consistency, even within any one chosen stylistic moment ("classicism" in Picasso's case entailing an austere linearism one year, a hyperbolic massiveness the next), at all weaken or ironize individual performances. Krauss too, I think deliberately, leaves the question open.

"Objects are simple . . . ": Ludwig Wittgenstein, *Tractatus Logico-Philosophicus,* revised trans. David Pears and Brian McGuiness (London, 1974), pp. 7–8. Subsequent quotations are all from page 7.

"To quote one commentator . . . ": David Pears, *Wittgenstein* (London, 1971), p. 67.

"Gilot remembers Picasso quoting Valéry on one occasion . . .": Gilot, p. 270. I have translated the French text here (which does not, as far as one can reconstruct the strange history of the book's making, necessarily have priority, but sometimes adds material to the English publication, and sometimes seems more carefully worded): see Gilot Fr., p. 253.

"It was just at this period that we were passionately preoccupied with exactitude . . . ": Efstratios Tériade, "Une visite à Picasso," *L'Intransigeant,* 27 (November 1927), in Tériade, *Écrits sur l'art* (Paris, 1996), p. 162.

"An old grab bag for everyone to reach into . . . ": Gilot, p. 270, compare Gilot Fr., p. 253.

"Some people call my work for a period 'surrealist' . . .": Jerome Seckler, "Picasso Explains," *New Masses* (13 March 1945), cited in Dore Ashton, ed., *Picasso on Art, A Selection of Views* (New York, 1972), p. 137. (Ashton's text is taken from Seckler's manuscript, which was shortened in *New Masses.*)

"It was because we felt the temptation, the hope . . . ": Gilot, p. 75. (The passage is quoted again, more fully, in lecture 2.)

"Pictorial form is the possibility that things are related to one another . . . ": Wittgenstein, *Tractatus,* p. 9.

"It is only as an aesthetic phenomenon . . . ": Friedrich Nietzsche, *The Birth of Tragedy and The Case of Wagner,* trans. Walter Kaufmann (New York, 1967), p. 52 (from *The Birth of Tragedy*).

"Find[ing] salvation only in appearance . . . ": Ibid., p. 22 (from "Attempt at Self-Criticism," 1886).

"It is not very probable that the builders of Gothic structures read Thomas Aquinas . . . ": Erwin Panofsky, *Gothic Architecture and Scholasticism* (New York, 1957), p. 23.

"Another kind of organism coming across the one on earth . . . ": See, for instance, the opening to "Truth and Lie in the Extra-Moral Sense," in Daniel Breazeale, ed. and trans., *Truth and Philosophy: Selections from Nietzsche's Notebooks of the 1870's* (Atlantic Highlands, 1979), p. 79.

"[All] these hard, strict, abstinent, heroic spirits . . . ": Friedrich Nietzsche, *On the Genealogy of Morality*, trans. Maudmarie Clark and Alan Swensen (Indianapolis, 1998), pp. 108–9.

"And here again I touch on my problem . . . ": Ibid., p. 117.

"I have long since come to an agreement . . . ": Gilot, pp. 124–25. Compare Gilot Fr., p. 117. The French text has further hints of Picasso's thinking on the relation of his *élan intérieur* ("mon dynamisme créateur") and the exterior world: see p. 253.

"The will to truth has ended . . . ": Nietzsche never quite says this in the final pages of *Genealogy of Morality*, and there is always in his thinking a powerful countercurrent to the idea that man will ever be able to move completely into the space of untruth: "To say again at the end what I said at the beginning: man would much rather will *nothingness* than *not* will . . ." (*Genealogy*, p.118). That is, nothingness has to be asserted as a value of some sort, a truth, a telos. Thus far in history, the most powerful instance of the will to nothingness in human affairs has been the ascetic ideal. It is never clear in Nietzsche (and not meant to be, I think) whether a new cult of art—"art, in which the *lie* hallows itself" (*Genealogy*, p. 111)—is envisaged as that will's future enduring form. Many of Nietzsche's readers, as he came to regret by the time of "Attempt at Self-Criticism," had no doubt that art would fill the bill.

LECTURE 2

"When the picture was first shown to the public . . . ": See Charles Vrancken, *Exposition Picasso*, Galeries Georges Petit (Paris, 1932), p. 53 and plate facing p. 60; Angelica Rudenstine, *The Guggenheim Collection: Paintings 1880–1945* (New York, 1976), pp. 610–11; Dorothy Kosinski, "G. F. Reber: Collector of Cubism," *Burlington Magazine* (August 1991), on the painting's first owner; Boggs, p. 214; Michael Fitzgerald, *Making Modernism: Picasso and the Creation of the Market for Twentieth-Century Art* (New York, 1995), esp. pp. 153–226 (a narrative of Picasso's relations with the dealer Paul Rosenberg); Tobia Bezzola, *Picasso by Picasso: His First Museum Exhibition 1932* (Munich, 2010), esp. pp. 26–45 (essay by Christian Geelhaar) and pp. 76–101 (essay by Simonetta Fraquelli with installation shots of the Georges Petit show).

"The cluster of large-scale paintings . . . ": See Daix, no. 811 (*Guitar on Table*, 1915, Kunsthaus Zurich), Daix, no. 812 (*Guitar and Clarinet on Mantelshelf*, 1915, Metropolitan Museum, New York), Daix, no. 843 (*Woman with Guitar*, 1915, private coll., New York), Daix, no. 844 (*Harlequin*, 1915, MoMA, New York), Daix, no. 886 (*Guitar, Clarinet, Bottle on Table*, 1916, Galerie Beyeler,

Basel), Daix, no. 889 (*Man Leaning on Table*, 1915–16, Pinacoteca Giovanni e Marella Agnelli, Turin), Daix, no. 890 (*Guitar Player*, 1916, Moderna Museet, Stockholm), Daix, no. 891 (*Man in Front of Fireplace*, 1916, Musée Picasso, Paris), Daix, no. 892 (*The Fireplace*, 1916, St. Louis Art Museum, St. Louis), and Daix, no. 893 (*Violin on Mantelshelf*, 1916, Picasso Estate). These paintings have rarely been treated as a set or sequence. Cowling points to *Harlequin* as typical of an "anti-rococo group" of works from this time, with *Man Leaning on Table* as its crowning achievement: see Cowling, pp. 287–93. Jean Boggs has good things to say about *The Fireplace*, especially about the explicitly domestic note sounded in 1916: see Boggs, pp. 133 and 176–77. John Richardson's chapter on *Man Leaning on Table* is a textbook example of drowning a picture in gossip: see John Richardson and Marilyn McCully, *A Life of Picasso, Volume 2: 1907–1917* (New York, 1996), pp. 407–17.

"A style spoke for us . . . ": I cannot find the phrase, though both painter and critic repeatedly come close. See, for instance, Picasso's words reported by Gilot, pp. 74–77, which revolve around the question of Cubist style and the wish to escape from individualism. Phrases very close to "a style spoke for us" occur regularly in Greenberg; for instance, objecting to the expressive distortions favored by recent French artists: "The trouble is, however, that these distortions do not inhere sufficiently in *style*. Like the distortions in most of Picasso's recent work, they are arbitrary in an ultimate sense, not compelled by a style that is the emotion itself . . .": see Greenberg, "Review of the Exhibition Painting in France" (February 1947), C G, vol. 2, p. 130. Cubism was Greenberg's preferred example of a style capable of just such compulsion, "the only style adequate to contemporary feeling," "the only one capable of supporting a tradition which will survive into the future and form new artists": see his "The Decline of Cubism" (March 1948), ibid., p. 213. For a further, unabashedly Marxist statement on the relation of style to "spirit of the age," see his "Our Period Style" (November 1949), ibid., pp. 322–26.

"Walter Benjamin was right . . . ": The idea that the ludicrous and off-putting remnants of the immediately previous generation's fashions might preserve traces of the unrealized potential of early capitalism—in particular traces of its dreams of a new urban life—pervades Walter Benjamin, *The Arcades Project*, trans. Howard Eiland and Kevin McLaughlin (Cambridge, Mass., 1999). It is accompanied by a set of reflections on the meaning of the nineteenth-century interior, which is by no means confined to Convolute I, "The Interior, The Trace." The opening sections of Convolute K, "Dream City and Dream House," are especially rich: in them Proust is a crucial figure, and Proust's retrospective hymn to the dream interior—his "experimental

rearrangement of furniture in matinal half-slumber" (Convolute K1, 2)—does seem the proper literary partner to Cubism's great act of revival and celebration. For a parallel discussion, see Charles Rice, *The Emergence of the Interior: Architecture, Modernity, Domesticity* (New York, 2006).

"Roger Fry says of Picasso . . . ": Roger Fry, "Picasso," *New Statesman* (29 January 1921): 503–4 (reviewing a show at the Leicester Galleries).

"All instincts that do not discharge themselves outwardly . . . ": Nietzsche, *Genealogy of Morality*, p. 57. For Nietzsche's horrified awareness of the creative power of inwardness and "bad conscience," see ibid., p. 59, which links with the *Genealogy*'s whole ambivalence toward the forms of consciousness it describes. The ascetic ideal, "conscience," *ressentiment*, and "the whole anti-sensual metaphysics of priests," are loathsome, but they are (Nietzsche recognizes reluctantly) what has made human beings human. "[I]t was on the soil of this essentially *dangerous form* of human existence, the priestly form, that man first became *an interesting animal*, . . . only here did the human soul acquire *depth* in a higher sense and become *evil*—and these are, after all, the two basic forms of the previous superiority of man over other creatures! . . .": ibid., pp. 15–16. The suspicion or fear that a future art might only preserve this inwardness and "depth"—but now as pure empty gesture, a reminiscence of a vanished other-worldliness—is one of the things that, for Nietzsche, stands in the way of a whole-hearted embrace of art as the form of Untruth. Nietzsche on abstract art would have been worth reading.

"Interpreters have been struck, understandably, by the mood of impatience or aggression . . . ": See Rosalind Krauss, "Life with Picasso, Sketchbook No. 92, 1926," in Arnold Glimcher, ed., *Je Suis le Cahier: The Sketchbooks of Picasso* (Boston and New York, 1986), pp. 113–23; and Cowling, pp. 355–59.

"I never saw any. . . . I've always lived inside myself . . . ": Geneviève Laporte, *"Si tard le soir, le soleil brille", Pablo Picasso* (Paris, 1973), p. 44.

"The line of open windows he had done that summer at Saint-Raphaël . . . ": Among many treatments, see Brigitte Léal, "Picasso's Stylistic 'Don Juanism': Still Life in the Dialectic between Cubism and Classicism," in Boggs, pp. 30–37, and catalogue entries, pp. 180–85; Krauss, *The Picasso Papers* pp. 192–201; and Yve-Alain Bois, *Picasso Harlequin 1917–1937* (Milan, 2008), p. 122.

"Give Le Corbusier a year or two . . . ": See Katharina Schmidt and Hartwig Fischer, eds., *Ein Haus für den Kubismus: Die Sammlung Raoul La Roche* (Basel, 1998); and the discussion of Le Corbusier's villa in relation to Lipchitz's sculpture in Christopher Green, *Picasso: Architecture and Vertigo* (New Haven and London, 2005), pp. 169–74.

"The best commentators on Still Life . . . ": See Boggs, p. 214; and Cowling, pp. 372–74 and 460–62. Cowling sees the Guggenheim *Still Life* as strongly physiognomic or "anthropomorphic," triggering a series of sexually charged projections.

"Michael Fried might say that the concept that is needed in the case is 'facing-ness' . . . ": See, for instance, the discussion of Manet and facing-ness in Michael Fried, *Manet's Modernism: or The Face of Painting in the 1860s* (Chicago, 1996), pp. 17, 310–11, 405–6, which Fried has developed since in relation to painting and photography of the recent past. See the discussion of Thomas Ruff in Michael Fried, *Why Photography Matters as Art as Never Before* (New Haven and London, 2008), pp. 149–52, and the chapter on Anri Sala in his *Four Honest Outlaws: Sala, Ray, Marioni, Gordon* (New Haven and London, 2011), especially the remarks on Manet, pp. 58–59.

"Auden writes somewhere . . . ": Wystan Hugh Auden, "In Praise of Limestone," *Collected Poems* (New York, 1991), p. 540.

LECTURE 3

"It was painted as a picture . . . ": Cited in Elizabeth Cowling, *Visiting Picasso: The Notebooks and Letters of Roland Penrose* (London, 2006), p. 276.

"A stupendous survey of his recent work . . .": See Fitzgerald, *Making Modernism*, pp. 158–69. Photographs of the show from the Rosenberg archive, including a shot of *Three Dancers* in situ, are published in Fitzgerald. Sadly, the photos have disappeared. My thanks to Mrs. Elaine Rosenberg for her kindness in making the archive available to me, and to Donald Prochera, the archivist, for his help in providing the photo of *Open Window* on the stair, and in trying to track down the 1925 installation shots.

"It's a funny thing, flesh . . . ": Cowling, *Visiting Picasso*, p. 276 (responding to reports of Winston Churchill's funeral).

"Much has been made, iconographically . . . ": From the extensive literature, see Lawrence Gowing, "Two Notable Acquisitions," *Tate Gallery Annual Report* (1964–65): 7–12; Ronald Alley, *Picasso: The Three Dancers* (Newcastle, 1967); John Golding, "Picasso and Surrealism," in Roland Penrose and John Golding, eds., *Pablo Picasso 1881–1973* (New York, 1973), esp. pp. 77–85; Ronald Alley, entry on *Three Dancers* in the *Catalogue of the Tate Gallery's Collection of Modern Art* (London, 1981); Lydia Gasman, *Mystery, Magic, and Love in Picasso, 1925–1938: Picasso and the Surrealist Poets* (New York, 1981), pp. 623–60, 700–755 (the most thoroughgoing attempt to read the painting in high Surrealist terms; for example, p. 755: "Possessed, the maenad takes over

death's weapons and turns them into bodily weapons against death, into killing teeth, masked eyes, eye-breast and magic nails-toenails. Torn between being killed and killing, the maenad in a supreme effort creates the crescent moon, a foetus pregnant with life."); Cowling, pp. 463–69; John Richardson and Marilyn McCully, *A Life of Picasso: The Triumphant Years 1917–1932* (New York, 2007), pp. 276–83 (for example, p. 282: "The crucifical dancer at the center is usually said to stand for Olga: her terse little dash of a mouth; her right leg as stiff and straight as if still in plaster; and—a surprise from someone as genitally focused as Picasso—nothing, but nothing, between her thighs," etc.); Lisa Florman, "Picasso circa 1925: Décor, the Decorative, and Difference," in Bois, *Picasso Harlequin*, pp. 47–57. I also learned from a fine unpublished Berkeley seminar paper by Heather Galles, "Resurrecting Formalism: Pablo Picasso's Three Dancers and the Crucifix That Isn't."

"I think [the canvas] ought to be called 'The Death of Pichot' . . . ": Cowling, *Visiting Picasso*, p. 276.

"One of Picasso's great subjects was faces and doubling . . . ": See the early discussion by Robert Melville, "The Evolution of the Double Head in the Art of Picasso," *Horizon*, November 1942, p. 343–51.

"The two-facedness of the middle protagonist . . . ": Some viewers, I found out when I delivered the lectures in Washington, see the dancer staring toward us, face front, with the large "ear/mouth" at left reading as an upturned eye. I am unable to hold on to this third configuration for more than an instant, so for me it does not interfere with the main duck-rabbit; but for others it may do, and I have no doubt Picasso was aware of it.

"Looking for other pictures like it . . .": Cowling, *Visiting Picasso*, p. 276.

"Much easier to accept as a figure in motion . . . ": Compare the X-ray evidence, discussed best in Florman, "Picasso in 1925," pp. 51–53.

"This will to truth, however, this remnant . . . ": Nietzsche, *Genealogy of Morality*, p. 116.

"Art, to state it beforehand . . . ": Ibid., p. 111.

"To impose upon becoming the character of being . . . ": Friedrich Nietzsche, *The Will to Power*, trans. Walter Kaufmann and Reginald Hollingdale (New York, 1967), section 617, p. 330.

"Nietzsche prefers his set for aesthetic reasons . . . ": See, for example, Nietzsche, *Will to Power*, section 822, p. 435: "Truth is ugly. We possess *art* lest we *perish of the truth*"; or section 842, p. 444: "[The grand style] has this in common with great passion, that it disdains to please; that it forgets to persuade; that it commands; that it *wills*—To become master of the chaos one is; to compel

one's chaos to become form . . ."; or section 853, p. 451: "[T]here is only *one* world, and this is false, cruel, contradictory, seductive, without meaning. . . . We have need of lies in order to conquer this reality, this 'truth,' that is, in order to *live* . . ." Again, Nietzsche is always aware of the dangers inherent in such a revaluation of the "aesthetic": section 853 is a sketch for the critique of *The Birth of Tragedy* eventually contained in that book's new 1886 preface. But neither the sketch nor the preface, in my view, ends up renouncing *The Birth of Tragedy*'s picture of the world and its conclusion that "art is *worth more* than truth."

"Nietzsche knew this, in fact . . . ": For example, Nietzsche, *Will to Power*, section 533, p. 290: "Thus it is the highest degrees of performance that awaken belief in the 'truth' . . ." (quoted in full in lecture 5). Compare ibid., sections 694, 696–97, pp. 369–70. These ideas are sometimes developed specifically with reference to art. "[T]he feeling of *power* applies the judgment 'beautiful' even to things and conditions that the instinct of impotence could only find *hateful* and 'ugly'. . . . From this it appears that, broadly speaking, a *preference for questionable and terrifying things* is a symptom of strength": ibid., section 852, p. 450. Only "broadly speaking," because Nietzsche is all too conscious that a factitious "art of the terrifying" will regularly accompany a true tragic pessimism, as its false shadow: Wagner's music, and its former appeal to him, are his example. Nietzsche on Surrealism would have been worth reading.

"Collage was happy with deception . . . ": Compare the account of collage developed by Rosalind Krauss first in her "Re-Presenting Picasso" *Art in America* (December 1980): 90–96, and then in a series of essays summed up in her *The Picasso Papers*, pp. 25–85; and by Yve-Alain Bois in "Kahnweiler's Lesson," in his *Painting as Model* (Cambridge, Mass., 1990), pp. 65–97, and "The Semiology of Cubism," in Lynn Zelavansky, ed., *Picasso and Braque: A Symposium* (New York, 1992), pp. 169–95.

"Untruth in Picasso is always terrible . . . ": The 1926 series of *Guitars* could be seen, it follows, as an attempt to modulate collage into the key of Untruth; or to have Untruth (the melodrama of dishcloth and nails) finally emerge as the Other to collage's continuing playfulness and domesticity (the lacy guitar miniatures in their cozy corners).

"An old copy of it for his own collection . . . ": See Marie-Laure Besnard-Bernadac et al., *The Picasso Museum, Paris: Paintings, Papiers Collés, Picture Reliefs, Sculptures, Ceramics* (New York, 1986), catalogue no. T. 43, p. 244.

"Through the long succession of millennia . . . ": Nietzsche, *Will to Power*, sections 229–30, pp. 132–34.

"Mediterranean values, he likes to think them . . . ": See the opening pages of *The Case of Wagner*, in Nietzsche, *The Birth of Tragedy and The Case of Wagner*, pp. 157–60: "*Il faut méditerraniser la musique.*"

"Playing hide-and-seek behind a hundred symbols . . . ": Ibid., p. 178.

"Menzel's glorious *Crown Prince Frederick* . . . ": See the entry in Claude Keisch and Marie Riemann-Rehyer, eds., *Adolphe Menzel 1815–1905* (New Haven, 1996), pp. 298–301, and the tremendous discussion in Michael Fried, *Menzel's Realism: Art and Embodiment in Nineteenth-Century Berlin* (New Haven, 2002), pp. 186–98.

LECTURE 4

"Malraux recalls Picasso calling the painters . . . ": Malraux, *La Tête d'obsidienne*, p. 134: "Et que je retrouve dans les avatars d'un autre quidam inspiré, celui du *Peintre et son modèle*, qu'il appelait affectueusement: 'Ce pauvre type' . . ."

"Hung at the end of a long gallery on the Quirinal . . . ": See Ester Coen, ed., *Metaphysica* (Rome, 2003), pp. 56–57 (by far the best reproduction). The painting was also exhibited at the Fondation Beyeler in Basel in 2005: see Anne Baldassari, ed., *The Surrealist Picasso* (Paris, 2005), fig. 20, p. 71; and in Zurich in 2010–11, see Bezzola, *Picasso by Picasso*, p. 159.

"Only then did it acquire a proper title . . . ": In *Cahiers d'art* the picture was called simply *Peinture*. In *Documents* it is still untitled. (The notation "Atelier du peintre" signals its whereabouts, not its subject.)

"Picasso had made it available to Waldemar Georges . . . ": See Waldemar Georges, *Picasso, dessins* (Paris, 1926); the Georges plate is reproduced in Alfred Barr, *Picasso: Fifty Years of His Art* (New York, 1946) p. 89 ("owned by the artist").

"Picasso is a painter who feeds on his past . . . ": The 1927 painting has very little in common, I feel, with the *Painter and Model* done a year earlier (Musée Picasso, Paris), though clearly that painting inaugurated the new line of work. The enormous canvas from 1926 (it measures 68 by 100 inches) has its own kind of frantic, overcrowded interest, but it strikes me as in the end fatally over-ingenious and fluent, and certainly it fails to deliver—this with Picasso is always the ultimate test—an overall organizing Gestalt. Put the paintings from 1926 and 1927 side by side, and the problems of the prototype are clear: rarely in Picasso is one "masterpiece" so clearly intended to correct another. The aperture idea, for example, which is already present in 1926, seems little more than a compositional device there (in a painting that desperately needed one): none of the apertures' later semantics—their materializing of the picture plane, their condensation of the male-female drama—seems to

me in evidence. For a more favorable view of the painting, see Sebastian Zeidler, "La *Grundoperation* de Picasso. Une lecture de Hegel par Carl Einstein," *Les Cahiers du Museé national d'art moderne* (Autumn 2011): 108–25.

"Sketchbook experiments and connected loose-leaf drawings . . . ": See Brigitte Léal, *Musée Picasso: Carnets, Catalogue des dessins*, vol. 2 (Paris, 1996), catalogue no. 31, pp. 37–45, and catalogue no. 34, pp. 65–74; and Michèle Richet, *The Picasso Museum, Paris: Drawings, Watercolors, Gouaches, and Pastels* (New York, 1989), catalogue nos. 908 and 909, p. 292.

"Melius's looking and thinking . . . ": Jeremy Melius, "Inscription and Castration in *The Painter and His Model*," paper delivered at the conference *Picasso in the Late 1920s*, University of California, Berkeley, 2007. A revised version of the paper will be published shortly.

"Occasionally it is suggested in the literature . . . ": See, for example, Robert Rosenblum, "Picasso's Blond Muse: The Reign of Marie-Thérèse Walter," in William Rubin, ed., *Picasso and Portraiture: Representation and Transformation* (New York, 1996), pp. 337–83.

"Picasso's inability to see the human world in any other terms than the monstrous . . . ": For a psychoanalytic version of the argument, see Carl Gustav Jung, "Picasso," *Neue Zürcher Zeitung* (13 November 1932), written in response to the Zurich retrospective, *Painter and Model* included; translated in McCully, *A Picasso Anthology*, pp. 182–86; for a Marxist variant, aimed in particular at *Guernica* and *Dream and Lie of Franco*, see Anthony Blunt, "Art: Picasso Unfrocked," *The Spectator* (8 October 1937): 584. (William Coldstream, in the letters that followed in *The Spectator*, gave Blunt Larkin-type backing.)

"As Roger Fry once put it . . . ": See Fry, "Picasso," *New Statesman*: 503.

"He claims that the Papin sisters are insane . . . ": See Daniel-Henry Kahnweiler, "Entretiens avec Picasso," *Quadrum*, Brussels, no. 2 (November 1956), cited in Propos, p. 75 (reporting a conversation of 30 November 1933).

" 'Drama' is a word that keeps coming up . . . ": See, for example, Gilot, p. 59–60: "The pure plastic act is only secondary as far as I'm concerned. What counts is the drama of that plastic act, the moment at which the universe comes out of itself and meets its own destruction."

"I never 'appreciate,' any more than I 'like' . . . ": Gilot, p. 266.

"Putting the nose out of joint . . . ": See, for example, Kahnweiler, "Gespräche mit Picasso," cited in Propos, p. 92: "This 'nose out of joint,' I painted it deliberately. You understand: I did what was necessary to *force* [people] to see a nose."

"When I was a child, I often had a dream . . . ": Gilot, p. 119. Compare Roland Penrose, *Picasso: His Life and Work* (second edition, New York, 1962) p. 220:

"Picasso once told me how, when very young, he used to crawl under the dinner table to look in awe at the monstrously swollen legs that appeared from under the skirts of one of his aunts. This childish fascination by elephantine proportions impresses him still."

"Things that exist immediately and totally for the child . . . ": Henri Wallon, "The Origins of Thought in the Child," in Gilbert Voyat, ed., *The World of Henri Wallon* (New York, 1984), p. 86 (extracted from Wallon, *Les origines de la pensée chez l'enfant*, 1947). My thanks to Donald Nicholson-Smith for help with Wallon.

"Elsa Köhler and Charlotte Bühler . . . ": See Elsa Köhler, *Die Persönlichkeit des dreijähringen Kindes* (Leipzig, 1926), and Charlotte Bühler, *Kindheit und Jugend: Genese des Bewußtseins* (Leipzig, 1928). Wallon's *Origines du caractère chez l'enfant* was published in its first form in 1930, then finally in 1934. Jacques Lacan's "Le stade de miroir" was first presented to the 14th International Psychoanalytical Congress in 1936. The 1949 revised version is translated in Jacques Lacan, *Écrits: A Selection* (New York, 1977). For an account of the strictly psychoanalytic culture of Paris between the wars (in which Wallon hardly figures), see Elisabeth Roudinesco, *Histoire de la psychanalyse en France, 1, 1885–1939* (revised edition, Paris, 1994), pp. 343–411.

"[It] emerges from passionate interactions . . . ": Henri Wallon, "The Role of the Other in the Consciousness of the Ego," in Voyat, *The World of Henri Wallon*, p. 96 ("Le role de l'autre dans la conscience du moi," first published in 1946).

"You, no less than nature and history, will become for yourselves . . .": Nietzsche, *Will to Power*, section 83, pp. 51–52. (It is, as so often in Nietzsche, a paraphrase of Pascal rather than a quote.)

LECTURE 5

"That I may reduce the monster to/Myself . . . ": Wallace Stevens, "The Man with the Blue Guitar," in *The Collected Poems of Wallace Stevens* (New York, 1955), p. 175.

"Imagining that body becoming a sculpture . . . ": My subject is the imagining of sculpture, or of the body in something like sculptural form, in Picasso's painting. I have deliberately left aside the experiments with sculpture proper Picasso made at this time, though the way in which actual sculptural practice, or preparation (in sketchbooks) for such practice, affected the "sculptural" in paint is obviously part of the story. See, for example, Werner Spies, *Pablo Picasso on the Path to Sculpture: The Paris and Dinard Sketchbooks of 1928*

from the Marina Picasso Collection (Munich and New York, 1995), especially the essay "Six Months in the Development of Picasso's Oeuvre," pp. 5–35; and Elizabeth Cowling, "The Painter as Sculptor: Picasso in the late 1920s," in Bois, *Picasso Harlequin*, pp. 71–87. I have tried to think about the "sculptural" as part of Picasso's wider, often unhappy, attempt in the late 1920s to relocate the body in the world: the terms monument, monster, and "outside" cannot be disentangled in Picasso's imagination, and the making of actual sculptures seems to me to have done little to solve the problem of the three terms' coexistence in paint.

"The paintings in question have been much admired . . . ": Beginning with Carl Einstein, "Pablo Picasso: Quelques tableaux de 1928," *Documents*, no. 1 (1929): 35–38. Cowling, in "The Painter as Sculptor," pp. 77–78, briefly discusses the relation of *The Studio* and the 1928 *Painter and Model* to the Tehran painting of the previous year.

"The strip is a device borrowed from Matisse . . . ": See the treatment of Picasso's somewhat nervous signaling of his quotations in Bois, *Picasso and Matisse*, pp. 41–46.

"She too—it too—can be reinserted between table and wallpaper . . . ": Compare Gasman, *Mystery, Magic, and Love* on the 1929 *Head*, pp. 358–59: "The dark interior of the head is the realm of destruction. It contains dried out vegetation and an insect resembling a fly, i.e. a messenger of Death who is a symbol of Olga." Artaud, Bataille, and Leiris's poem "La mère" are adduced. (The excesses of Gasman's picture of Picasso are obvious, but her account is sincere and consistent, rooted in deep knowledge of Surrealist poetry, and in many ways preferable to the common wisdom on the artist. Compare her overall view of Picasso between the wars with Greenberg's account of the same period, summarized later in this lecture: "Picasso, after cubism . . . created in the 1920s and 1930s the art he believed this century best deserved. . . . Seldom do the compassion of his blue and rose periods and the balance of his cubism reappear in these decades. His art became a sort of caricatural *crimen lease majestatis humanae*, because humanity provoked him with its chain of crimes," ibid., p. 527. The question remains, for all Gasman's efforts: How much did Picasso really belong to the mental world of his poet friends? The friends themselves were never sure.)

"A woman, or something like a woman . . . ": After its appearance in a prime place in the Picasso special issue of *Documents*, no. 3 (1930): 114, the painting has had almost as scanty a place in the literature as the Tehran *Painter and Model*. See the brief catalogue entry in William Rubin, *Picasso in the Collection of the Museum of Modern Art* (New York, 1972), p. 134. On the *Documents*

"Hommage à Picasso," see Dawn Ades, "Picasso in *Documents,*" in Bois, *Picasso Harlequin,* pp. 59–69; Charles Miller, "Pablo Picasso," in Dawn Ades and Simon Baker, eds., *Undercover Surrealism: Georges Bataille and Documents* (London, 2006), pp. 214–21; and Charles Miller, "Bataille with Picasso: *Crucifixion* (1930) and Apocalypse," *Papers of Surrealism* 7 (2007).

"The figure is facing our way . . . ": The signs are not unequivocal. Some viewers, I know, take their cue from the figure's buttocks and see the whole body turned toward the horizon; but for me the navel is a stronger, more focal sign, and breasts, neck and head strike me as compatible with it. And the light itself—the way the figure seems to face it and catch it full on—reinforces the orientation.

"I am like the giraffe . . . ": Dor de La Souchère, *Picasso à Antibes,* cited in Propos, p. 134.

"What is beauty, anyway? . . . ": Gilot, p. 266.

"Michel Leiris published an essay . . . " Michel Leiris, "Toiles récentes de Picasso," *Documents,* no. 2 (1930): 57–70—a much richer piece of criticism, in my view, than Einstein's Procrustean "Quelques tableaux." Among the key passages in Leiris, see p. 62: "Picasso ne cesse de nous donner lui-même l'exemple admirable de quelqu'un qui se tient de plain-pied avec toutes les choses, les traite aussi *familièrement* qu'il est possible . . ."; p. 64: "Dans le plupart des tableaux de Picasso on remarquera que le 'sujet' (s'il est permis d'employer une telle expression) est presque toujours tout à fait *terre à terre,* en tout cas jamais emprunté au monde fumeux du rêve, ni susceptible immédiatement d'être converti en symbole,—c'est à dire aucunement 'surréaliste.' Toute l'imagination porte sur la création de nouvelles formes, situées ni au-dessus ni au-dessous des formes quotidiennes, mais vraies comme elles, quoique différentes et tout à fait nouvelles"; and p. 70: "Leur ordonnace a beau n'avoir que peu de rapports avec celle suivant laquelle sont groupés nos organes, ce sont ni des fantômes ni des monstres. Ce sont d'autres créatures que nous, ou bien plutôt, les *mêmes,* mais d'une forme différente, d'une structure plus éclatante, et, par dessus tout, d'une merveilleuse évidence."

"Dated on the stretcher 7 April 1929 . . . ": See Christian Zervos, *Pablo Picasso, vol. 7, Oeuvres de 1926 à 1932* (Paris, 1955), catalogue no. 252.

"Each new object, each new combination of forms . . . ": Leiris, "Toiles récentes de Picasso," p. 70:

> Chaque nouvel objet, chaque nouvelle combinaison de formes qu'il nous présente est un nouvel organe que nous nous adjoignons, un nouvel instrument qui nous permet de nous insérer plus humainement dans la nature, de

devenir plus concrets, plus denses, plus vivants. Il faudrait une imbécilité sans égale pour aimer ces oeuvres sous le prétexte mystique qu'elles nous aident à nous débarrasser de nos défroques humaines en étant *surhumaines*. Si l'on devait employer ce terme 'surhumain,' ce serait plutôt dans le sens qu'elles sont le comble de l'humain, ainsi que le sont les plus grandioses des créations mythologiques, qui sont démesurées, mais ne cessent pourtant jamais de faire sonner la terre sous leurs pieds.

There are echoes in the last sentence of Carl Einstein's remarks on Picasso's classicism in the *Neue Schweizer Rundschau* article of the previous year.

"Then Pablo started off on a long philosophical monologue . . . ": Gilot, p. 157.

"Let's play at hurting ourselves . . . ": Pablo Picasso, *The Four Little Girls*, trans. Roland Penrose (London, 1970), p. 17.

"As though an artificer, after contriving/A wheel-work image . . . ": Robert Browning, "The Flight of the Duchess," in Browning, *The Poems* (Harmondsworth, 1981), vol. 1, p. 429.

"Picasso was a very great artist . . . ": Greenberg, "Picasso as Revolutionary" (December 1956), C G, vol. 3, pp. 274–75.

"[Picasso] began apparently to think in art-historical terms . . . ": Greenberg, "Picasso at Seventy-Five" (October 1957), C G, vol. 4, p. 30, with the last sentence added to the text as revised in Greenberg, *Art and Culture* (Boston, 1961), p. 63.

"Obsessed by a . . . nostalgia for the monstrous . . .": Greenberg, "Review of Exhibitions of Joan Miró and André Masson" (May 1944), C G, vol. 1, p. 208 (Masson is being accused of a similar nostalgia).

"[The] error consists in pursuing expressiveness . . . ": Greenberg, "Review of Exhibitions of the Jane Street Group and Rufino Tamayo" (March 1947), C G, vol. 2, p. 133. (The error is Tamayo's, but it is "the same as that made so frequently by Picasso since 1930.") I find most disparagement of Greenberg tiresome, but of course it is true that his threshold for acceptable "expressiveness and emotional emphasis" in art was low.

"Where Picasso himself did the hang . . . ": On the Georges Petit show, see the first note to lecture 2, especially Fitzgerald and Fraquetti. On the 1930 hanging, see Fitzgerald, *Making Modernism*, p. 186.

"The first idea for *Figure* crops up . . . ": See Léal, *Musée Picasso: Carnets*, vol. 2, catalogue no. 38, p. 115.

"If Zervos's catalogue is to be believed . . . ": See Zervos, *Pablo Picasso, vol. 7*, catalogue no. 115. Again a painting rarely mentioned in the literature, though beautifully reproduced in Bernice Rose, *Picasso and Drawing* (New York, 1995), fig. 39.

"We have a sheet of drawings . . . ": See Richet, *The Picasso Museum, Paris: Drawings,* catalogue no. 917, p. 295.

"She tells the story of André Gide . . . ": Gilot Fr., p. 235 ("et, en plus, je ne trouve aucune figure charmante"). "Toutes choses . . ." appears as an epigraph on p. 203.

"Like any artist, I am primarily the painter of woman . . . ": Gilot Fr., p. 278. (Not in English edition. I have reversed the order of Picasso's sentences.)

"When I paint a woman in an armchair . . . ": Malraux, *La Tête d'obsidienne,* p. 128.

"I am a woman . . . ": Laporte, *Si tard le soir,* p. 127, cited Propos, p. 131.

"A bone wave-whitened and dried in the wind . . . ": William Butler Yeats, "Three Things," in *The Collected Poems of W. B. Yeats* (London, 1958), p. 300.

"The statues will have gone back to be things about . . . ": Wallace Stevens, "An Ordinary Evening in New Haven," in *The Collected Poems of Wallace Stevens,* p. 473.

"It is the highest degrees of performance . . . ": Nietzsche, *Will to Power,* section 533, p. 290.

LECTURE 6

"Some of the facts of *Guernica*'s occasion and surroundings . . . ": From the massive literature, see Catherine Freedberg, *The Spanish Pavilion at the Paris World's Fair of 1937* (New York, 1986); Ellen Oppler, ed., *Picasso's Guernica* (New York, 1988); Herschel Chipp, *Picasso's Guernica: History, Transformations, Meanings* (Berkeley, Los Angeles, London, 1988); Werner Spies, "*Guernica* und die Weltausstellung Paris 1937," in Spies, *Kontinent Picasso: Ausgewählte Aufsätze aus zwei Jahrzehnten* (Munich, 1988); and more recently, with a synthesis of current understanding of the Paris World's Fair, Carlo Ginzburg, "The Sword and the Lightbulb: A Reading of Guernica," in Michael Roth and Charles Salas, eds., *Disturbing Remains: Memory, History, and Crisis in the Twentieth Century* (Los Angeles, 2001), pp. 111–77.

"Breton . . . came to pose with his wife in front of Guernica . . . ": See Anne Baldassari, *Picasso, Life with Dora Maar: Love and War 1935–1945* (Paris, 2006), fig. 66, p. 171.

"Picasso was in contact with left-wing friends in Catalonia . . . ": See, for example, Francis Frascina, "Picasso, Surrealism and Politics in 1937," in Silvano Levy, ed., *Surrealism: Surrealist Visuality* (Edinburgh, 1996), p. 130, citing various sources, including Bataille's autobiographical notes; and Gertje Utley, "From *Guernica* to *The Charnel House*: The Political Radicalization of the Artist," in Steven Nash, ed., *Picasso and the War Years 1937–1945* (New York, 1998),

pp. 69–79 and notes 28–30, p. 238. It remains hard to form a picture of Picasso's political engagement at this moment. Some of his closest friends stayed aloof: the memoirs of the faithful Sabartés, for example, pass over *Guernica* in total silence: see Jaime Sabartés, *Picasso, Portraits et souvenirs* (Paris, 1946).

"The meeting place for a group called *Contre-Attaque* . . . ": See Sidra Stich, "Picasso's Art and Politics in 1936," *Arts Magazine* 58 (October 1958): 113–18. Compare Baldassari, *Picasso, Life with Dora Maar*, pp. 165–75 for the most recent account of *Guernica*'s production and Maar's photographs.

"Breton as usual was ready with an answer . . . ": See Frascina, "Picasso, Surrealism and Politics," p. 130, citing Robert Short, "Surrealism and the Popular Front," in Francis Barker et al., eds., *The Politics of Modernism* (Colchester, 1979).

"A central experience of the past seventy years . . . ": From the many discussions, see Sven Linqvist, *A History of Bombing* (New York, 2001); W. G. Sebald, *On the Natural History of Destruction* (New York, 2004); Ian Patterson, *Guernica and Total War* (Cambridge, Mass., 2007); and Baker, *Human Smoke*. On Picasso's fear of bombing in 1939–40, see Lydia Gasman, "Death Falling from the Skies: Picasso's Wartime Texts," in Nash, *Picasso and the War Years*, pp. 55–67.

"The dark sky in the *Third of May* . . . ": Malraux, *La Tête d'obsidienne*, p. 42.

"Goya in the *Third of May*, she remembers Picasso saying . . . ": Gilot Fr., p. 276–77.

"Je vis plus avec lui qu'avec Staline . . . ": Malraux, *La Tête d'obsidienne*, p. 125. ("Qu'est-ce qu'il dirait s'il voyait Guernica, Goya? Je me demande. Je crois qu'il serait assez content? Je vis plus avec lui qu'avec Staline.")

"He was not sure he could do the sort of painting they wanted . . . ": See Chipp, *Picasso's Guernica*, p. 17. Josep Lluis Sert's recollections of the meeting varied: see his contribution to a Guernica symposium in New York in 1947, reprinted in Oppler, *Picasso's Guernica*, pp. 198–200, which paints a picture of an enthusiastic Picasso, and compare Sert's manuscript notes in the Museum of Modern Art archives.

"I show a study done in pencil on gesso . . . ": In all the rest of the lecture I am deeply indebted to Rudolph Arnheim, *Picasso's Guernica: The Genesis of a Painting* (Berkeley and Los Angeles, 1962), whose analyses remain fundamental. My thinking was immensely helped by the students in a seminar on *Guernica* at Berkeley in 2008, Aglaya Glebova, Katie Hover-Smoot, Daniel Marcus, Julia Martinez, Camille Mathieu, Andrew Moisey, Marcelo Souza, and Mia You: for a revised version of one of the papers that came out of the

seminar, see Daniel Marcus, "*Guernica*: Arrest and Emergency," in Bois, *Picasso Harlequin*, pp. 101–11.

"He paints almost nothing for months on end . . . ": See Kathleen Brunner, *Picasso Rewriting Picasso* (London, 2004), pp. 24–77, for discussion of the 1936 poetry and *Guernica*'s relation to it (not always convincing, but tackling a difficult problem head on). Brunner and Ginzburg converge (independently) on Bataille as a possible *Guernica* "source": the evidence seems tenuous to me. Whatever the interest of Bataille's thought in general, his relevance as a critic of or influence on Picasso is limited. "Soleil pourri," in *Documents* 3 (1930): 173–74, his celebrated contribution to the *Documents* Picasso issue, is notably determined to say nothing about its ostensible subject, as if paralyzed (having set the cult in motion) by the threat of Picasso-worship.

"A painting dated March 1936 . . . ": See Marie-Laure Bernadac and Christine Piot, eds., *Picasso, Collected Writings* (Paris, 1989), p. 105. The collage was a gift to Paul and Nusch Eluard, inscribed as such. Compare Gasman, *Mystery, Magic, and Love*, pp. 1072–77: she sees an Eucharistic goblet, a "ruined castle of initiation," "a ladder standing for his access to mysteries hidden behind the façade of 'appearances' " "However, because of its explicitly magic inspiration, Picasso defensively mocked *Le crayon qui parle* and made it a quasi-parody of a Crucifixion." See also Roland Penrose, "Beauty and the Monster," in Penrose and Golding, eds., *Pablo Picasso 1881–1973*, p. 186.

"Anne Baldassari has suggested that as the painting proceeded . . . ": See Baldassari, *Picasso, Life with Dora Maar*, pp. 170–75. Baldassari's analysis is primarily concerned with Picasso's ingestion of formal features of "the photographic" (monochrome, polarized lighting, etc.) into *Guernica*, as a result of seeing the painting in Dora Maar's renderings; but she has suggestive things to say about the introjection of features of the surrounding studio space made visible—dramatized—in Maar's photos: see pp. 172, 174.

"Clement Greenberg later went on record as thinking . . . ": Greenberg, "Picasso at Seventy-Five," in Greenberg, *Art and Culture*, p. 65. The sentence is added to the original version in Greenberg, "Picasso at Seventy-Five" (October 1957), C G, vol. 4, p. 32. The whole discussion is unsparing, and its critique of *Guernica* focuses specifically on what Greenberg takes to be its unresolved spatiality:

> With its bulging and buckling, it looks not a little like a battle scene from a pediment that had been flattened out under a defective steam roller—in other words, as if conceived within an illusion of space deeper than that in which it was actually executed. And the preliminary studies for *Guernica* bear out this impression, being much more illusionistic in approach than the final result:

particularly the composition studies, two of which—done in pencil on gesso on May 1 and 2 respectively—are much more convincing in their relative academicism than the turmoil of blacks, grays and whites in the final version. (1957 text)

"Ingres's *Self-Portrait of the Artist* . . . ": See Robert Rosenblum, *Ingres* (New York, 1967), fig. 73, p. 50, and p. 94. For further brief discussion of *Guernica*'s relation to Ingres, plus an incisive account of the Goya connection, see Robert Rosenblum, "Picasso's Disasters of War: The Art of Blasphemy," in Nash, *Picasso and the War Years*, pp. 39–53, esp. p. 50. Rosenblum, here and elsewhere, is good on the ambivalence of Picasso's version of Ingres-idolatry, which always included (as any Ingres-worship should) an element of impatience and disrespect.

"After the plotting and painstaking of preliminary studies . . . ": On the first linear form of the Davidian history painting, see, for example, a propos Géricault's *Raft of the Medusa*, the reminiscences of Géricault at work collected in Lorenz Eitner, *Géricault, His Life and Work* (Ithaca, New York, 1983), pp. 175–80. Compare Cowling's discussion of *Guernica*'s relation to the Davidian tradition (she points out that Picasso would probably have seen a Géricault retrospective at Galerie Bernheim-Jeune in May 1937), and of the painting's debts, particularly in its early stages, to Greek and Roman sarcophagi: Cowling, pp. 581–84.

"Nine photos taken by Dora Maar . . . ": I have renumbered the captions for these photos to correspond to the nine states now known. One state—number five—is not illustrated here.

"Francis Frascina has argued that one main reason it vanished . . . ": Frascina, "Picasso, Surrealism and Politics," p. 142. (Frascina is understandably cautious about making the removal a specifically political act, meant to read as such. But for some of those in Picasso's inner circle who saw the fist disappear in May, the anti-Party significance would have been clear, I think, and probably unwelcome.)

"*Guernica*'s critics have always objected that this black-white geometry is crude . . . ": See, in addition to Greenberg, Walter Darby Bannard, "Cubism, Abstract Expressionism, David Smith," *Artforum* VI (April 1968): esp. 24–25; and Bannard, "Touch and Scale: Cubism, Pollock, Newman, and Still," *Artforum* IX (June 1971): esp. 61–63: both extracted in Oppler, *Picasso's Guernica*, pp. 299-305.

"As several commentators have reminded us . . . ": I am indebted in particular to Mia You's unpublished Berkeley seminar paper on *Guernica*'s color, "Gray," written in 2008.

"One thing that has always fascinated commentators about these two moments
. . . ": See, for example, Chipp, *Picasso's Guernica*, pp. 126–30, and Baldassari,
Picasso, Life with Dora Maar, p. 172. Elizabeth Cowling was extraordinarily
helpful in answering my questions about the "collage" episodes in Dora
Maar's photos, and her suggestions are active in what follows. (Interestingly,
the collage pieces are ignored by Arnheim in his discussion of the stages:
see Arnheim, *Picasso's Guernica*, pp. 124–28. By this point in his book, the
narrative of overall surface-depth organization—the search for *Gestalt*—has
largely edged aside questions of process and materiality.)

Photography and Copyright Credits

Permission to reproduce illustrations is provided by the owners and sources as listed in the captions. Additional copyright notices and photography credits are as follows. Numbers refer to figures, unless otherwise indicated.

Pablo Picasso / Artists Rights Society (ARS), New York **1.9.** © 2012 Estate of Pablo Picasso / Artists Rights Society (ARS), New York **1.10.** © 2012 Estate of Pablo Picasso / Artists Rights Society (ARS), New York **1.11.** © 2012 Estate of Pablo Picasso / Artists Rights Society (ARS), New York. Photo: J.G. Berizzi, Réunion des Musées Nationaux / Art Resource, NY **1.12.** © 2012 Estate of Pablo Picasso / Artists Rights Society (ARS), New York. Photo © Eric Baudoin **1.13.** © 2012 Estate of Pablo Picasso / Artists Rights Society (ARS), New York. Photo: René-Gabriel Ojéda, Réunion des Musées Nationaux / Art Resource, NY **1.14.** © 2012 Estate of Pablo Picasso / Artists Rights Society (ARS), New York. Photo: The Philadelphia Museum of Art / Art Resource, NY **1.15.** © 2012 Estate of Pablo Picasso / Artists Rights Society (ARS), New York. Digital image © The Museum of Modern Art / Licensed by SCALA / Art Resource, NY **1.16.** © 2012 Estate of Pablo Picasso / Artists Rights Society (ARS), New York **1.17.** © 2012 Estate of Pablo Picasso / Artists Rights Society (ARS), New York **1.18.** © 2012 Estate of Pablo Picasso / Artists Rights Society (ARS), New York **1.19.** © 2012 Estate of Pablo Picasso / Artists Rights Society (ARS), New York. Photo: René-Gabriel Ojéda, Réunion des Musées Nationaux / Art Resource, NY **1.20.** © 2012 Estate of Pablo Picasso / Artists Rights Society (ARS), New York **1.21.** © 2012 Estate of Pablo Picasso / Artists Rights Society (ARS), New York. Photo: Thierry Le Mage, Réunion des Musées Nationaux / Art Resource, NY **1.22.** © 2012 Estate of Pablo Picasso / Artists Rights Society (ARS), New York. Photo: Thierry Le Mage, Réunion des Musées Nationaux / Art Resource, NY **1.23.** © 2012 Estate of Pablo Picasso / Artists Rights Society (ARS), New York. Photo: Béatrice Hatala, Réunion des Musées Nationaux / Art Resource, NY **1.24.** © 2012 Estate of Pablo Picasso / Artists Rights Society (ARS), New York **1.25.** © 2012 Estate of Pablo Picasso / Artists Rights Society (ARS), New York. Digital image © The Museum of Modern Art / Licensed by SCALA / Art Resource, NY **1.26.** © 2012 Estate of Pablo Picasso / Artists Rights Society (ARS), New York **1.27.** © 2012 Estate of Pablo Picasso / Artists Rights Society (ARS), New York **1.28.** © 2012 Estate of Pablo Picasso / Artists Rights Society (ARS), New York **1.29.** © 2012 Estate of Pablo Picasso / Artists Rights Society (ARS), New York. Photo: J.G. Berizzi, Réunion des Musées Nationaux / Art Resource, NY **2.1.** © 2012 Estate of Pablo Picasso / Artists Rights Society (ARS), New York **2.2.** © 2012 Estate of Pablo Picasso / Artists Rights Society (ARS), New York. Photo © Christie's Images / The Bridgeman Art Library **2.3.** © 2012 Estate of Pablo Picasso / Artists Rights Society (ARS), New York. Photo: Kunstmuseum Basel, Martin P. Bühler **2.4.** © 2012 Estate of Pablo Picasso / Artists Rights Society (ARS), New York. Photo: The Cleveland Museum of Art **2.5.** © 2012 Estate of Pablo Picasso / Artists Rights Society (ARS), New York. Image © The Metropolitan Museum of Art **2.6.** © 2012 Estate of Pablo Picasso / Artists Rights Society (ARS), New York. Photo: Kunstmuseum Basel, Martin P. Bühler **2.7.** © 2012 Estate of Pablo Picasso / Artists Rights Society (ARS), New York. Photo: CNAC/MNAN/Dist. RMN-Grand Palais / Art Resource, NY **2.8.** © 2012 Estate of Pablo Picasso / Artists Rights Society (ARS), New York. Digital image © The Museum of Modern Art / Licensed by SCALA / Art Resource, NY **2.9.** © 2012 Estate of Pablo Picasso / Artists Rights Society (ARS), New York. Photo: Béatrice Hat-

ala, Réunion des Musées Nationaux / Art Resource, NY **2.10.** The Bridgeman Art Library **2.11.** The Bridgeman Art Library **2.12.** © 2012 Estate of Pablo Picasso / Artists Rights Society (ARS), New York. Photo: Kunstmuseum Basel, Martin P. Bühler **2.13.** © 2012 Artists Rights Society (ARS), New York / ADAGP, Paris. Photo: Jacques Faujour, CNAC/MNAN/Dist. Réunion des Musées Nationaux / Art Resource, NY **2.14.** © 2012 Estate of Pablo Picasso / Artists Rights Society (ARS), New York. Photo: René-Gabriel Ojéda, Réunion des Musées Nationaux / Art Resource, NY **2.15.** © 2012 Estate of Pablo Picasso / Artists Rights Society (ARS), New York. Photo: Philippe Migeat, CNAC/ MNAN/Dist. Réunion des Musées Nationaux / Art Resource, NY **2.16.** © 2012 Estate of Pablo Picasso / Artists Rights Society (ARS), New York. Photo: Jean-Gilles Berizzi, Réunion des Musées Nationaux / Art Resource, NY **2.17.** © 2012 Estate of Pablo Picasso / Artists Rights Society (ARS), New York. Image courtesy of the Board of Trustees, National Gallery of Art, Washington **2.18.** © 2012 Estate of Pablo Picasso / Artists Rights Society (ARS), New York. Photo: Béatrice Hatala, Réunion des Musées Nationaux / Art Resource, NY **2.19.** © 2012 Estate of Pablo Picasso / Artists Rights Society (ARS), New York. Photo: Béatrice Hatala, Réunion des Musées Nationaux / Art Resource, NY **2.20.** © 2012 Artists Rights Society (ARS), New York / ADAGP, Paris **2.21.** Photo: Scala / Art Resource, NY **2.22.** © National Gallery, London / Art Resource, NY **2.23.** Photo: Hervé Lewandowski, Réunion des Musées Nationaux / Art Resource, NY **2.24.** © 2012 Estate of Pablo Picasso / Artists Rights Society (ARS), New York **2.25.** © 2012 Estate of Pablo Picasso / Artists Rights Society (ARS), New York **2.26.** © 1922 Roger Viollet. Photo: Albert Harlingue / Roger Viollet / Getty Images **2.27.** © 2012 Estate of Pablo Picasso / Artists Rights Society (ARS), New York. Image © The Metropolitan Museum of Art **2.28.** © 2012 Estate of Pablo Picasso / Artists Rights Society (ARS), NewYork. Photo: The Paul Rosenberg Archives, a Gift of Elaine and Alexandre Rosenberg, III.B.3.91. The Museum of Modern Art Archives, New York **2.29.** © 2012 Estate of Pablo Picasso / Artists Rights Society (ARS), New York. Photo: Jean-Gilles Berizzi, Réunion des Musées Nationaux / Art Resource, NY **2.30.** © 2012 Estate of Pablo Picasso / Artists Rights Society (ARS), New York. Photo: bpk, Berlin / Nationalgalerie, Museum Berggruen, Staatlichen Museen / Jens Ziehe / Art Resource, NY **2.31.** © 2012 Estate of Pablo Picasso / Artists Rights Society (ARS), New York. Photo: Jean-Gilles Berizzi, Réunion des Musées Nationaux / Art Resource, NY **2.32.** © Succession H. Matisse / Artists Rights Society (ARS), New York. Photo: The Cleveland Museum of Art **2.33.** © 2012 Estate of Pablo Picasso / Artists Rights Society (ARS), New York. Photo: bpk, Berlin / Nationalgalerie, Museum Berggruen, Staatlichen Museen / Jens Ziehe / Art Resource, NY **2.34.** © 2012 Estate of Pablo Picasso / Artists Rights Society (ARS), New York. Photo: Béatrice Hatala, Réunion des Musées Nationaux / Art Resource, NY **2.35.** © 2012 Artists Rights Society (ARS), New York / ADAGP, Paris / FLC **2.36.** © 2012 Artists Rights Society (ARS), New York / ADAGP, Paris / FLC **2.37.** © 2012 Estate of Pablo Picasso / Artists Rights Society (ARS), New York. Courtesy Galerie Krugier & Cie, Geneva **2.38.** © 2012 Estate of Pablo Picasso / Artists Rights Society (ARS), New York. Photo: Walter Klein **2.39.** © 2012 Estate of Pablo Picasso / Artists

Rights Society (ARS), New York. The Paul Rosenberg Archives **2.40.** © 2012 Estate of Pablo Picasso / Artists Rights Society (ARS), New York. Photo: Jacques Faujour, CNAC/ MNAN/Dist. Réunion des Musées Nationaux / Art Resource, NY **2.41.** © 2012 Estate of Pablo Picasso / Artists Rights Society (ARS), New York. Photo: Réunion des Musées Nationaux / Art Resource, NY **2.42.** © 2012 Estate of Pablo Picasso / Artists Rights Society (ARS), New York **.43.** © 2012 Estate of Pablo Picasso / Artists Rights Society (ARS), New York. Archives de la Fondation Erik Satie, Paris **3.1.** © 2012 Estate of Pablo Picasso / Artists Rights Society (ARS), New York. Photo: Tate, London / Art Resource, NY **3.2.** © 2012 Estate of Pablo Picasso / Artists Rights Society (ARS), New York. Image courtesy Harvard College Library **3.3.** Photo: Scala / Art Resource, NY **3.4.** Photo: Erich Lessing / Art Resource, NY **3.5.** © 2012 Estate of Pablo Picasso / Artists Rights Society (ARS), New York. Photo: R. G. Ojéda, Réunion des Musées Nationaux / Art Resource, NY **3.6.** © The Trustees of the British Museum, London. All rights reserved **3.7.** © The Trustees of the British Museum, London. All rights reserved **3.8.** © 2012 Estate of Pablo Picasso / Artists Rights Society (ARS), New York. Photo: Tate, London / Art Resource, NY **3.9.** © 2012 Estate of Pablo Picasso / Artists Rights Society (ARS), New York **3.10.** © 2012 Estate of Pablo Picasso / Artists Rights Society (ARS), New York **3.11.** © 2012 Estate of Pablo Picasso / Artists Rights Society (ARS), New York. Photo: Tate, London / Art Resource, NY **3.12.** © 2012 Estate of Pablo Picasso / Artists Rights Society (ARS), New York. Photo © National Gallery in Prague 2012 **3.13.** © 2012 Estate of Pablo Picasso / Artists Rights Society (ARS), New York. Image © The Metropolitan Museum of Art **3.14.** © 2012 Estate of Pablo Picasso / Artists Rights Society (ARS), New York **3.15.** © 1922 Roger Viollet. Photo: Albert Harlingue / Roger Viollet / Getty Images **3.16.** Image © Victoria and Albert Museum, London **3.17.** © Succession H. Matisse / Artists Rights Society (ARS), New York. Digital image © The Museum of Modern Art / Licensed by SCALA / Art Resource, NY **3.18.** Photo: Hervé Lewandowski, Réunion des Musées Nationaux / Art Resource, NY **3.19.** Photo: Giovanni Lattanzi / Archart **3.20.** Photo: bpk, Berlin / Nationalgalerie, Staatliche Museen / Joerg P. Anders / Art Resource, NY **3.21.** Photo: bpk, Berlin / Nationalgalerie, Staatliche Museen / Joerg P. Anders / Art Resource, NY **3.22.** © 2012 Estate of Pablo Picasso / Artists Rights Society (ARS), New York. Photo: Tate, London / Art Resource, NY **4.1.** © 2012 Estate of Pablo Picasso / Artists Rights Society (ARS), New York **4.2.** © 2012 Estate of Pablo Picasso / Artists Rights Society (ARS), New York. Photo: Béatrice Hatala, Réunion des Musées Nationaux / Art Resource, NY **4.3.** © Collection Albert Harlingue / Roger-Viollet **4.4.** © 2012 Estate of Pablo Picasso / Artists Rights Society (ARS), New York **4.5.** © 2012 Estate of Pablo Picasso / Artists Rights Society (ARS), New York **4.6.** Photo: Patrice Schmidt, Réunion des Musées Nationaux / Art Resource, NY **4.7.** Photo: Erich Lessing / Art Resource, NY **4.8.** © 2012 Estate of Pablo Picasso / Artists Rights Society (ARS), New York **4.9.** © 2012 Estate of Pablo Picasso / Artists Rights Society (ARS), New York. Photo: Thierry Le Mage, Réunion des Musées Nationaux / Art Resource, NY **4.10.** © 2012 Estate of Pablo Picasso / Artists Rights Society (ARS), New York. Photo: Jean-Claude Planchet, CNAC/MNAM/Dist. Réunion des Musées Nation-

aux / Art Resource, NY **4.11.** © 2012 Estate of Pablo Picasso / Artists Rights Society (ARS), New York **4.12.** © 2012 Estate of Pablo Picasso / Artists Rights Society (ARS), New York. Photo: Thierry Le Mage, Réunion des Musées Nationaux / Art Resource, NY **4.13.** © 2012 Estate of Pablo Picasso / Artists Rights Society (ARS), New York. Photo: Daniel Arnaudet, Réunion des Musées Nationaux / Art Resource, NY **4.14.** © 2012 Estate of Pablo Picasso / Artists Rights Society (ARS), New York. Photo: Madeleine Coursaget, Réunion des Musées Nationaux / Art Resource, NY **4.15.** © 2012 Estate of Pablo Picasso / Artists Rights Society (ARS), New York. Photo: Béatrice Hatala, Réunion des Musées Nationaux / Art Resource, NY **4.16.** © 2012 Estate of Pablo Picasso / Artists Rights Society (ARS), New York. Photo: Thierry Le Mage, Réunion des Musées Nationaux / Art Resource, NY **4.17.** © 2012 Estate of Pablo Picasso / Artists Rights Society (ARS), New York. Photo: Thierry Le Mage, Réunion des Musées Nationaux / Art Resource, NY **4.18.** © 2012 Estate of Pablo Picasso / Artists Rights Society (ARS), New York. Photo: Thierry Le Mage, Réunion des Musées Nationaux / Art Resource, NY **4.19.** © 2012 Estate of Pablo Picasso / Artists Rights Society (ARS), New York. Photo: Thierry Le Mage, Réunion des Musées Nationaux / Art Resource, NY **4.20.** © 2012 Estate of Pablo Picasso / Artists Rights Society (ARS), New York. Photo: Thierry Le Mage, Réunion des Musées Nationaux / Art Resource, NY **4.21.** © 2012 Estate of Pablo Picasso / Artists Rights Society (ARS), New York. Photo: Thierry Le Mage, Réunion des Musées Nationaux / Art Resource, NY **4.22.** © 2012 Estate of Pablo Picasso / Artists Rights Society (ARS), New York. Photo: Thierry Le Mage, Réunion des Musées Nationaux / Art Resource, NY **4.23.** © 2012 Estate of Pablo Picasso / Artists Rights Society (ARS), New York. Photo: Thierry Le Mage, Réunion des Musées Nationaux / Art Resource, NY **4.24.** © 2012 Estate of Pablo Picasso / Artists Rights Society (ARS), New York. Digital Image © The Museum of Modern Art / Licensed by SCALA / Art Resource, NY **4.25.** © 2012 Estate of Pablo Picasso / Artists Rights Society (ARS), New York **4.26.** © 2012 Estate of Pablo Picasso / Artists Rights Society (ARS), New York **4.27.** © 2012 Estate of Pablo Picasso / Artists Rights Society (ARS), New York **4.28.** © 2012 Estate of Pablo Picasso / Artists Rights Society (ARS), New York **4.29.** © 2012 Estate of Pablo Picasso / Artists Rights Society (ARS), New York **4.30.** © 2012 Estate of Pablo Picasso / Artists Rights Society (ARS), New York **4.31.** © 2012 Estate of Pablo Picasso / Artists Rights Society (ARS), New York. Digital image © The Museum of Modern Art / Licensed by SCALA / Art Resource, NY **4.32.** © 2012 Estate of Pablo Picasso / Artists Rights Society (ARS), New York. The Bridgeman Art Library **4.33.** © 2012 Estate of Pablo Picasso / Artists Rights Society (ARS), New York **4.34.** © Salvador Dalí, Fundació Gala-Salvador Dalí / Luis Bunuel (LBFI) / Artists Rights Society (ARS), New York, 2012. Bunuel-Dali / The Kobal Collection / Art Resource. Photo: The Kobal Collection at Art Resource, NY **4.35.** © 2012 Estate of Pablo Picasso / Artists Rights Society (ARS), New York **5.1.** © 2012 Estate of Pablo Picasso / Artists Rights Society (ARS), New York. Image © The Metropolitan Museum of Art **5.2.** © 2012 Estate of Pablo Picasso / Artists Rights Society (ARS), New York. Photo: Mitro Hood **5.3.** © 2012 Estate of Pablo Picasso / Artists Rights Society (ARS), New York. Photo © Christie's

Images / The Bridgeman Art Library **5.4.** © Collection Albert Harlingue / Roger-Viollet **5.5.** © 2012 Estate of Pablo Picasso / Artists Rights Society (ARS), New York **5.6.** © 2012 Estate of Pablo Picasso / Artists Rights Society (ARS), New York. Digital image © The Museum of Modern Art / Licensed by SCALA / Art Resource, NY **5.7.** © 2012 Estate of Pablo Picasso / Artists Rights Society (ARS), New York. Digital image © The Museum of Modern Art / Licensed by SCALA / Art Resource, NY **5.8.** © 2012 Estate of Pablo Picasso / Artists Rights Society (ARS), New York. Photo: Jacques Faujour, CNAC/MNAN/Dist. Réunion des Musées Nationaux / Art Resource, NY **5.9.** © 2012 Estate of Pablo Picasso / Artists Rights Society (ARS), New York. Photo: Jean-Gilles Berizzi, Réunion des Musées Nationaux / Art Resource, NY **5.10.** © 2012 Estate of Pablo Picasso / Artists Rights Society (ARS), New York. Photography © The Art Institute of Chicago **5.11.** © 2012 Estate of Pablo Picasso / Artists Rights Society (ARS), New York. Photo: Moderna Museet / Stockholm **5.12.** Photo: Harry Bréjat, Réunion des Musées Nationaux / Art Resource, NY **5.13.** © 2012 Estate of Pablo Picasso / Artists Rights Society (ARS), New York. Photography © The Art Institute of Chicago **5.14.** © 2012 Estate of Pablo Picasso / Artists Rights Society (ARS), New York. Image courtesy of the Board of Trustees, National Gallery of Art, Washington **5.15.** © 2012 Estate of Pablo Picasso / Artists Rights Society (ARS), New York. Image © The Metropolitan Museum of Art **5.16.** © 2012 Estate of Pablo Picasso / Artists Rights Society (ARS), New York. Photo: J.G. Berizzi, Réunion des Musées Nationaux / Art Resource, NY **5.17.** © 2012 Estate of Pablo Picasso / Artists Rights Society (ARS), New York **5.18.** © 2012 Estate of Pablo Picasso / Artists Rights Society (ARS), New York. The Bridgeman Art Library **5.19.** © 2012 Estate of Pablo Picasso / Artists Rights Society (ARS), New York. Photo: Thierry Le Mage, Réunion des Musées Nationaux / Art Resource, NY **5.20.** © 2012 Estate of Pablo Picasso / Artists Rights Society (ARS), New York **5.21.** © 2012 Estate of Pablo Picasso / Artists Rights Society (ARS), New York. Photo: Jean-Gilles Berizzi, Réunion des Musées Nationaux / Art Resource, NY **5.22.** © 2012 Estate of Pablo Picasso / Artists Rights Society (ARS), New York. Digital image © The Museum of Modern Art / Licensed by SCALA / Art Resource, NY **5.23.** © 2012 Estate of Pablo Picasso / Artists Rights Society (ARS), New York **5.24.** © 2012 Estate of Pablo Picasso / Artists Rights Society (ARS), New York and © Bernheim-Jeune Galerie. Digital image © The Museum of Modern Art / Licensed by SCALA / Art Resource, NY **5.25.** © 2012 Estate of Pablo Picasso / Artists Rights Society (ARS), New York. Photo: Réunion des Musées Nationaux / Art Resource, NY **5.26.** © 2012 Estate of Pablo Picasso / Artists Rights Society (ARS), New York. Photo: Michèle Bellot, Réunion des Musées Nationaux / Art Resource, NY **5.27.** © 2012 Estate of Pablo Picasso / Artists Rights Society (ARS), New York. Photo courtesy of The Pace Gallery **5.28.** © 2012 Estate of Pablo Picasso / Artists Rights Society (ARS), New York. Photo: Thierry Le Mage, Réunion des Musées Nationaux / Art Resource, NY **5.29.** © 2012 Estate of Pablo Picasso / Artists Rights Society (ARS), New York. Photo: René-Gabriel Ojéda, Réunion des Musées Nationaux / Art Resource, NY **5.30.** © 2012 Estate of Pablo Picasso / Artists Rights Society (ARS), New York. Digital image © The Museum of Modern Art / Licensed by SCALA / Art Re-

(ARS), New York / ADAGP, Paris. Photo: Franck Raux. © RMN-Grand Palais / Art Resource, NY **6.30.** © 2012 Artists Rights Society (ARS), New York / ADAGP, Paris. Photo: Franck Raux, Réunion des Musée Nationaux / Art Resource, NY **6.31.** © 2012 Estate of Pablo Picasso / Artists Rights Society (ARS), New York. Photo © Andrew Moisey **6.32.** © 2012 Artists Rights Society (ARS), New York / ADAGP, Paris. Reprophoto: Franck Raux. Photo: © RMN-Grand Palais / Art Resource, NY **6.33.** © 2012 Artists Rights Society (ARS), New York / ADAGP, Paris. Photo: Jean-Gilles Berizzi. © RMN-Grand Palais / Art Resource, NY **6.34.** © 2012 Estate of Pablo Picasso / Artists Rights Society (ARS), New York **6.35.** © 2012 Artists Rights Society (ARS), New York / ADAGP, Paris. Photo: Franck Raux, Réunion des Musées Nationaux / Art Resource, NY **6.36.** © 2012 Estate of Pablo Picasso / Artists Rights Society (ARS), New York. Photo: Jean-Gilles Berizzi, Réunion des Musées Nationaux / Art Resource, NY **6.37.** © 2012 Estate of Pablo Picasso / Artists Rights Society (ARS), New York

Index

The Andrew W. Mellon Lectures in the Fine Arts 1952–2013